ART IN VIENNA

1898–1918

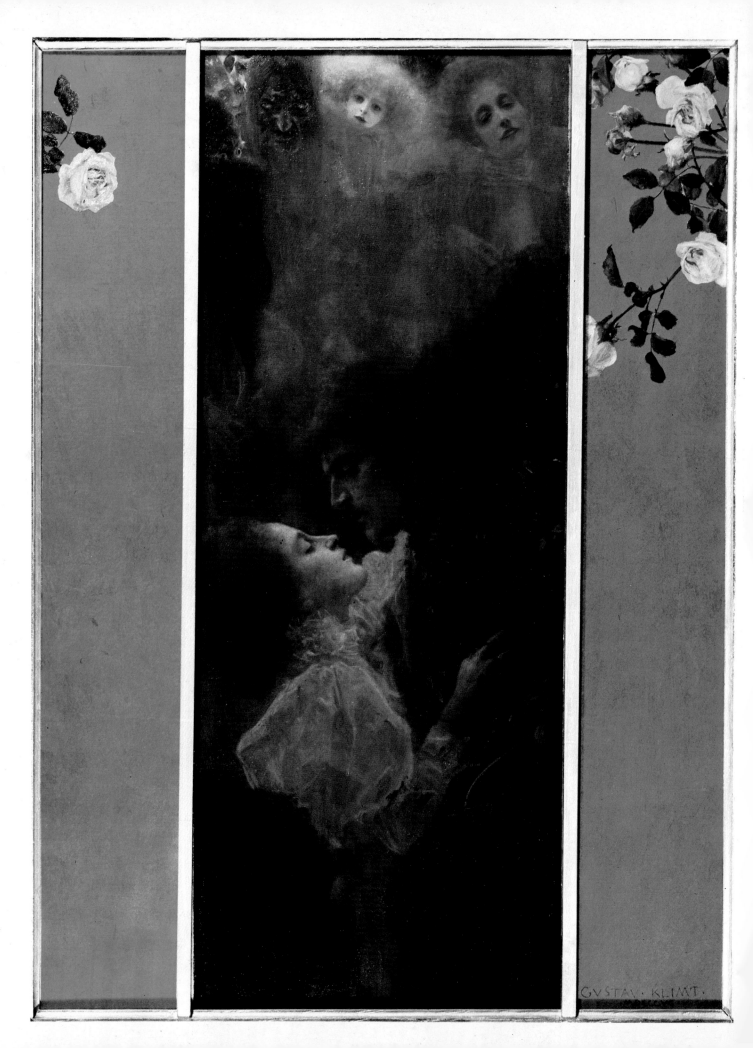

Peter Vergo

ART IN VIENNA

1898–1918

**Klimt
Kokoschka
Schiele
and their
contemporaries**

Phaidon

Phaidon Press Limited
Littlegate House, St Ebbe's Street, Oxford OX1 1SQ

First published 1975

Second edition 1981

© 1975 by Phaidon Press Limited

ISBN 0 7148 2222 1 (hardback), 0 7148 2224 8 (paperback)

Printed and bound in Singapore, under coordination by Graphic Consultants International Private Limited

Facing title-page
1. Gustav Klimt: *Love*, 1895.
Oil on canvas, 60 × 44 cm.
Vienna, Historisches
Museum der Stadt Wien

CONTENTS

Foreword 6

I Vienna 1900 9

II Secession
 The Beginnings 18
 The First Exhibition 26
 The Dedication of the House: Second Exhibition 33
 Ver Sacrum 40
 III–VI Exhibitions 44
 The 'Klimt Affair'—The University Paintings 49
 Exhibitions, 1900–1902 62
 Beethoven 1902 67
 XVI–XVIII Exhibitions, 1903 78
 The Split within the Secession 84

III Architecture and the Applied Arts 87
 The Ringstrasse and the Architecture of Historicism 88
 Otto Wagner, 1841–1918 90
 Joseph Maria Olbrich, 1867–1908 118
 Josef Hoffmann, 1870–1956 127
 The Wiener Werkstätte 132
 Palais Stoclet—The Stoclet-frieze 143
 Kabarett Fledermaus 148
 Alfred Roller, 1864–1935 156
 Hoffmann's later work 159
 Adolf Loos, 1870–1933 161

IV Kunstschau 1908–9: The Early Work of Kokoschka and Schiele
 Kunstschau 1908 179
 Oskar Kokoschka, born 1886 189
 Richard Gerstl, 1883–1908 200
 Kunstschau 1909—Vienna before the War 202
 Egon Schiele, 1890–1918 208

V Epilogue: Vienna 1914–18: The Later Work of Klimt and Schiele 219

Notes 242

Bibliography 250

Acknowledgements 252

Index 253

FOREWORD

THIS VOLUME is intended primarily as a source book. My aim has been to trace the origins of modern Viennese art, and to give an account of the influences which acted upon its development. I have selected for discussion what appear to me some of the most important works of architecture and visual art created in Austria during the first two decades of the twentieth century, and narrated the circumstances under which these works came into being. I have tried to see the principal events of these years through the eyes of those most directly involved: the artists themselves, their friends and opponents, contemporary writers and critics. Where possible, I preferred to use their words, rather than mine: their letters and diaries, their published statements and their private exchanges. I have for the most part refrained from purely subjective interpretation, in the hope that the reader's judgement may be formed by the available sources, and, above all, by the works themselves.

Much has been left out, largely because of lack of space. I have given no account of Viennese sculpture of this period, nor of important developments in film. Music and literature are discussed only in so far as they provide a point of comparison with the visual arts. The cultural situation of Vienna at the turn of the century is, on the other hand, discussed in somewhat more detail in the opening chapter, if only because this situation constituted not merely a background to, but also a determining influence upon what works, and what kind of works, were produced.

I owe a considerable debt of gratitude to the many institutions, friends and colleagues who have helped me in my work, among them Dr and Frau Hans Ulherr, Munich, and Mr and Mrs P. J. Bolton, Vienna, kind hosts during several research visits to Germany and Austria; C. N. P. Powell, British Council Representative in Austria and himself the author of a monograph on Viennese art at the turn of the century; Professor Georg Eisler, formerly president of the Vienna Secession; Direktor Dr Hans Aurenhammer and the staff of the Oesterreichische Galerie, Vienna; the Historisches Museum der Stadt Wien, and in particular Dr Hans Bisanz; Professor Dr Fritz Novotny, of the Department of Art of the University of Vienna; Professor Carl Schorske, of Princeton University; Professor Robert Clark, also of Princeton University, who communicated to me the results of his important work on Olbrich, as well as commenting on parts of my manuscript; and Christian M. Nebehay, Vienna, and Erich Lederer, Geneva, both of whom gave generously of their knowledge of the work of Klimt and Schiele. I should like to thank Marianne Feilchenfeldt, Zürich, for her help with photographs, and Professor Eduard F. Sekler, of Harvard University, for making important historical material available to me. Nearer to home, I am indebted to my colleagues in the Department of Art at Essex University, especially Professor Michael Podro, for their support; and to two generations of Essex students for their contributions and criticisms. I am grateful to Eve Cooper, Margaret Iversen

and Barry Woodcock for invaluable help with the illustrative material, and to my wife Jan, who read the manuscript and aided me in the choice of reproductions. Finally, a word of thanks to Keith Roberts, of Phaidon Press, for his understanding and patience, and to Simon Haviland and Jane Rendel, who saw the book through the planning and design stages.

PETER VERGO

University of Essex

Note to the Second Edition

In the six years that have elapsed since *Art in Vienna* was first published, a number of important new books on twentieth-century Austrian art have appeared in both English and German. For this reason, it was considered desirable to revise the bibliography and bring it up to date. At the same time, the opportunity was taken to correct a number of minor errors in the text. Otherwise, the text remains that of the first edition.

PETER VERGO

February 1981

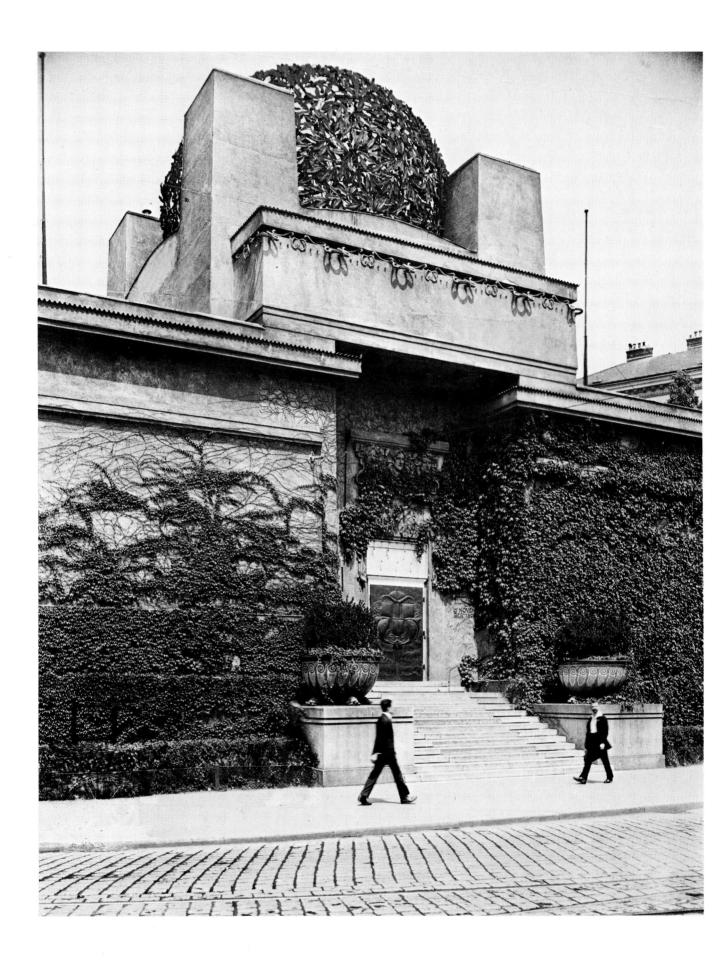

I · VIENNA 1900

THE RISE AND FALL of modern Imperial Vienna took place within a remarkably short space of time. The revolution of 1848 found the capital of the Dual Monarchy little changed since medieval times; by the outbreak of the Great War it had become, although still in Musil's words 'somewhat smaller than all the rest of the world's largest cities',[1] the highly developed centre of a largely prosperous, technologically orientated society. The later nineteenth century in Austria was a period of intensive industrialization, of investment and speculation. Although the self-styled 'liberal' bourgeoisie had—significantly for the future history of Europe—failed to usurp the political power of the aristocracy,[2] economically the middle classes, merchants and traders, bankers and financiers, were in the ascendant. This was the *Gründerzeit*—the promoter-years—an age in which fortunes could be made or lost overnight. It was also a period of rapid social expansion. Vienna, the hub of a vast, multi-racial Empire, attracted to itself countless thousands of Czechs and Magyars, Bohemians and Slovenes—citizens of far-flung, even mutually hostile provinces who found themselves, at the same time, united in an uneasy alliance under the ancient crown of the Habsburgs. The population of the capital increased more than four-fold during the reign of the Emperor Franz Joseph, from less than half a million in the 1850s to over two million by 1910, aggravating the already acute housing shortage. But if the building industry was unable to keep pace with the population explosion, technical and scientific advances in other fields succeeded one another with bewildering rapidity. The last decade of the nineteenth century alone witnessed the erection of the first electric lights on the Kohlmarkt (1893), the advent of the tram (1894), the vaulting of the river Wien and the regulation of the Danube Canal (1898), and the construction of the city's metropolitan railway network. In 1899 the first international automobile race was held in Vienna; ten years later, there were no less than three thousand cars on the streets of the city. Gustav Mahler, the difficult new director of the Imperial Opera, was an enthusiastic motorist. It was the age of the Zeppelin and the aeroplane, but also of the typewriter and the telephone. Life became easier. The achievements of technology, the advances made in the fields of medicine and the natural sciences, began to produce a real effect upon wider and wider circles of the population. Stefan Zweig, in his autobiography *The World of Yesterday*, wrote in glowing terms of this now-vanished epoch:

This belief in an uninterrupted, inexorable 'progress' had for that era in truth the force of a religion; indeed, people believed in 'progress' even more than in the Bible, and this belief appeared justified by the daily wonders of mechanics and science. A general raising of standards became ever more perceptible, more rapid, more widespread as this century of peace drew to a close. . . . Comfort penetrated from the houses of the nobility into those of the bourgeoisie; no longer was it necessary to fetch water from the well or from the corridor, to struggle to light

2. Joseph Maria Olbrich: *Secession building*, main entrance

the fire in the hearth. Hygiene spread, dirt disappeared. People became more beautiful—healthier, more robust, their bodies strengthened by sport; one saw fewer and fewer cripples, mutilated bodies, goitrous growths, on the streets. And all these miracles had been brought about by science, that archangel of progress. . . . What wonder, then, if this century basked in its own achievements, and regarded each new decade as the herald of a better order? The possibility of a relapse into a new barbarity, such as for instance war between the nations of Europe, seemed as remote as demons or witches; our forefathers were unshakable in their belief in the infallible power of tolerance and conciliation. In all seriousness they maintained that the differences between nations and beliefs would gradually disappear, and thus would peace and security, those highest of benefits, be shared among the whole of Humanity.[3]

Peace and security, the prosperity of the ruling classes, and the power and splendour of the Habsburgs—all these were reflected in the Imperial Jubilee celebrations of 1898, which marked the fiftieth anniversary of Franz Joseph's accession to the throne. The balls and marches, the parades, the endless round of official engagements, all manifested the 'outwardly still intact, hieratic order'[4] of the Austrian Empire; and, at the centre of these festivities, the seemingly ageless figure of the Emperor himself, whose unprecedentedly long reign played an important part in creating an illusion of continuity, of permanence. In reality, however, this permanence was not vested solely in any one individual; it was embodied in the political institutions of the realm, in the religion of the State and the law of the land, in the very economic structure of the country. 'Everything about our thousand-year-old Austrian monarchy', wrote Zweig, 'appeared grounded upon eternity, the State itself the ultimate guarantor of continuity.' He went on:

The rights granted to its citizens were enshrined in Acts of Parliament, the freely elected representatives of the people, every duty exactly defined. . . . Everyone knew just what he possessed and what he would inherit, what was allowed and what forbidden. Everything had its norm, its specific mass and gravity. The man of means could calculate exactly how much interest *per annum* his fortune would bring him, the civil servant or officer with equal exactitude the year in which he would gain promotion and the year in which he would retire. . . . Everything in this great realm had its fixed, immovable place; and in the highest place of all, the aged Emperor: but should he die, one knew (or thought one knew) that another would take his place, and nothing would change in all this carefully planned order. . . . Anything radical, anything violent seemed impossible in this Age of Reason.[5]

This sense of permanence had only one disadvantage: the Habsburg concept of dynastic power was inextricably linked with the ideals of stability and the preservation of the existing order; but this cultivation of the *status quo* brought in its train feelings of futility, a kind of intellectual and moral stagnation which presented a marked contrast to the technological and scientific advances of the day. For the sake of stability, Franz Joseph had created the most elaborate bureaucracy, the most efficient censorship in the whole of Europe. He himself was the keystone of an administrative edifice which was both bafflingly complex and almost totally

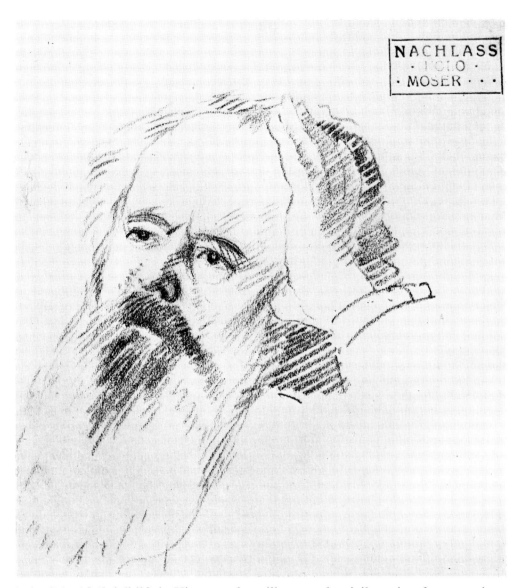

3. Kolo Moser: *Hermann Bahr*. Drawing. Vienna, Historisches Museum der Stadt Wien

inflexible. 'Official' life in Vienna—the military or the civil service, for example—was regulated down to the most minute details. Zweig's army officer or petty official could see stretching before him with appalling clarity the pre-ordained pattern of his existence, the established paths which it would be his destiny to follow. One knew at the age of twenty exactly where one would be at the age of fifty. The unforeseen, the irrational was excluded; not only the administrative, but also the academic and cultural institutions of the capital ossified beyond any possibility of change. 'Nothing happens here, absolutely nothing,' fumed the writer Hermann Bahr, who had brought a breath of fresh air into the stuffy *salon* atmosphere of Vienna by gathering around him a group of poets and intellectuals who soon became known under the sobriquet *Jung Wien* (young Vienna). In a two-volume collection of essays entitled *The Critique of Modernism* Bahr exposed the degeneracy brought about by the antagonism of old and new, the outworn intellectual habits of modern society, the 'exiguous, cringing, crippled' nature of the contemporary spirit:

That life and spirit have become divorced is the torment, the raging, feverish

sickness of our century. Life has become transformed, down to its very depths, and is transformed anew from day to day, restless and unstable. But the spirit remains old and rigid—motionless, immobile—and now it is suffering, lonely, deserted by life.

Thus we have lost our sense of unity, have fallen into deceit. The future is blooming all around us; but we are still rooted in the past. For this reason, there can be no peace, but only hatred and schism, enmity and violence. . . .

It is truth we desire. We must pay heed to that commandment which comes from without, and to our own inner yearnings. We must become as our environment. We must shake off the mould of past centuries—that same past which, long since faded, chokes our souls with its decaying foliage. We must be as the present. . . .

We must open the windows and let in the sun, the radiant sun of early May. We must open up our senses, and greedily listen and perceive. And with joy and reverence we shall greet that light which breaks triumphant into rooms emptied of the litter of the past.[6]

But despite outward appearances, despite Bahr's despairing cry, time was already, in Musil's striking phrase, 'moving as fast as a cavalry-camel'.[7] The increase in the suicide rate, the extraordinary growth in the number of esoteric cults, the emergence of such diametrically opposed movements as Zionism and German Nationalism, the resort to violence as a political weapon—in particular, the assassination in 1898 of the Empress Elisabeth, wife of Franz Joseph and cousin of the 'Swan King' Ludwig of Bavaria—all underlined the fact that the stability which appeared the most important feature of the Empire and its institutions was in essence illusory. Literature and art, too, those most sensitive seismographs of external events, registered the change which was taking place in Vienna, that sense of approaching disaster shared by many of its inhabitants. If official society remained rigid and unchanging, the alternative societies in which the city abounded, the famous café-circles of turn of the century Vienna, united poets and writers, artists and thinkers concerned to break through the complacency of intellectual life, conscious of the debility, the impending collapse only partly concealed by the elaborate façades.[8] In his *Brief des Lord Chandos* of 1902, Hugo von Hofmannsthal explored the duality of the relationship between self and world, the social and moral chaos which has its counterpart in the dissolution of language itself. But already in 1900, a doctor turned writer by the name of Arthur Schnitzler (like Hofmannsthal a member of Bahr's literary circle which met in the Café Griensteidl) had published a short story entitled *Leutnant Gustl*, which laid bare the inconsequentiality of a society held together only by convention, by an antiquated code of honour. *Gustl*, the first German narrative to be cast entirely in the form of the *innere Monolog*, is a milestone in the development of modern Austrian prose. The plot as such is unimportant. The author studiously refrains from imposing his opinions or interpretations upon the reader; instead, Gustl's own unspoken thoughts make apprehensible that collapse of moral sense which results from the alienation of the individual within society. The writer confronts his specimen with the objectivity of the man of science; diagnosis is the aim of the exercise. In its implications, however, this diagnosis goes far beyond

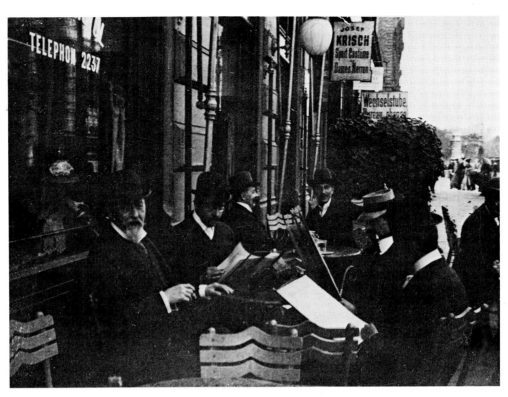

4. (*left*) Photograph *c.* 1904, showing Mahler walking along the Augustinerstrasse to the Opera House

5. (*right*) Photograph *c.* 1912, showing Otto Wagner, extreme left, in a street café and, next to him, Josef Hoffmann

the individual case of the perplexed lieutenant; it is Viennese society, no less, which is being placed under the microscope. Schnitzler, Sigmund Freud's immortal *Doppelgänger*, resembles the great founder of psychoanalysis in that his reflections rapidly carried him beyond the boundaries of neurological research into the as yet unexplored realms of human psychology. But also like Freud, Schnitzler's analysis of the individual sets up repercussions of significance not only in the individual instance, but for society in general. The character of Gustl as portrayed by his own cogitations reveals more clearly than any sociological study the impermanence of established values, the irrelevance of everything except instinct and a certain *amour propre*; in an important sense, the suicidal delirium of Schnitzler's anti-hero is an image of the cultural and moral suicide of Austria itself. In this sense, too, many of the most important literary works of the period are diagnostic in character. In his great novel *Der Mann ohne Eigenschaften* Robert Musil examined in breadth the bureaucratic establishment of what he called Kakania, 'that misunderstood state that has since vanished, which was in so many things a model, though all unacknowledged', as well as the forces of disruption, the current of anarchism which was never far from the glittering surface; while, in *Die Verwirrungen des Zöglings Törless*, the same author took as his subject the hallucinatory world of a young military cadet oppressed by half-conscious homosexual leanings and sadistic fantasies. Hallucination and fantasy, vision and dream play an increasingly important role in the literature of the years preceding the outbreak of war—the literary and poetical work of Kokoschka, for example, the dream world in which the endless battle of the sexes is played out in allegorical form. And always, behind it all, the premonition of some as yet unspecified turning point:

Somewhere there lurks a grim Fate, which may enter upon the scene at any moment. It might simply be death, or it might be something else, something unimaginable, which Fate has up its sleeve. Destiny bides its time. . . . This waiting upon the Unknown is no less agonizing than any other form of anticipation. If only it would come! . . . It is this sentiment which explains the universal rejoicing at the declaration of war . . . at last! the waiting is over! The Viennese sees in war not so much conflict as, above all, death. He does not go to fight, he goes to die.[9]

This sense of impending death finds its ultimate expression in Karl Kraus's amazing, unstageable drama *Die Letzten Tage der Menschheit*; or, in a simpler, more directly personal form, in the poem 'Unbeschreibliche Freude' from *Des Knaben Wunderhorn*, which Mahler chose for one of the songs in his cycle of the same name published in 1905:

> Ich zieh' in Krieg auf grüne Haid'
> Die grüne Haide, die ist so weit!
> Allwo dort die schönen Trompeten blasen,
> Da ist mein Haus von grünem Rasen.

> *I'm off to war in the green fields*
> *The green fields so far away*
> *Where the pretty trumpets blow*
> *I'll find my home in the earth below.*

The other outstanding preoccupation of *fin de siècle* Vienna, in literature and art as in life itself, was the whole subject of what Freud called the 'misunderstood and much-maligned erotic'. In an age which was, strictly, no longer one of belief, sexuality was regarded as much for pragmatic as for religious reasons as a disruptive, and therefore dangerous element, the very existence of which was not simply denied but—even in scientific circles—scarcely mentioned. (According to Zweig, Charcot, with whom Freud worked as a young man, once told him privately that he did indeed know the true cause of many cases of hysterical affliction, namely sexual repression, but that he had been forced to refrain from publishing his findings.) And yet this silence was essentially hypocritical; for while no school teacher, no textbook would ever mention subjects such as prostitution or sexual hygiene, it was at least tacitly assumed that the male offspring of respectable houses would, at one time or another, sow their wild oats, that the natural urges of male youth would find their inevitable object in the countless 'ladies of pleasure' who, under police surveillance, haunted well-defined areas of the old city, or in the erotic clubs and cabarets which carried on a clandestine existence behind the 'faultless, radiant façade' of the capital.[10] That women, on the other hand, should be moved by the same urges, even the same need for physical affection, offended against the notion of the sanctity of woman; thus, the daughters of well-to-do families were brought up in the sterilized atmosphere of convent schools and governesses, every book discreetly vetted, every outing chaperoned. Zweig recalls that fashion reflected contemporary attitudes towards the fair sex, the female figure tightly corseted, alternately stretched and cramped by bustles and wasp waists, swathed from neck to ankle in petticoats and frills, that even when engaged

in swimming or sport, young girls would still be encased from head to toe in voluminous garments, lest a glimpse of exposed flesh should open the way for some impropriety. 'The lines of the female figure', wrote Zweig, 'were so completely disguised . . . that even the bridegroom at the wedding feast had not the remotest chance of guessing from her appearance whether his future companion was straight or crooked, plump or thin, long in the leg or short in the thigh; this 'moral' epoch had not the slightest qualms about artificially reinforcing hair, bosom or any other part of the female anatomy for the purpose of deception, in order to make the subject conform to the accepted ideal of beauty.'[11] Small wonder if not only Schnitzler's *Reigen*, which probed the inconstancy of sexual relationships, but even the novels of Flaubert and Zola were rejected as immoral, if the barefoot dancing of Isadora Duncan provoked a scandal in conservative circles, if Klimt, whose paintings presented naked and unadorned Goethe's 'eternal feminine' (seen, it is true, through not impersonal eyes), was repeatedly accused of creating 'painted pornography'. Small wonder, too, if Vienna is often described as the city in which psychoanalysis needed to be invented. Not that Freud and his followers met with much gratitude from the Viennese themselves who, in so far as they took any notice of his theories at all, regarded the great analyst's views on subjects such as infantile sexuality and the origins of neurosis with a mixture of incredulity and horror. But for the most part, the discoveries of science and medicine, Zweig's 'archangels of progress', to say nothing of the triumphs of the human intellect and the human spirit, were met with indifference by the stolid burghers of Vienna. It is almost impossible to imagine the isolation in which the pioneers of knowledge and of culture found themselves at this time. 'Vienna in the first decade of the century', wrote Otto Friedländer, 'is one of the intellectual centres of the world, and she herself has no idea. . . . Two or three thousand people write words and think thoughts ␣␣␣ l overturn the world of the next generation—Vienna is oblivious. A tin␣ ␣␣ men: writers, politicians, academics, journalists, artists and civil serva␣ ␣␣ rs and doctors, preoccupied with the problems of the day, whose tho␣ ␣␣ determine the future of civilization. They are an island. No bridge unit␣ ␣␣ith the Viennese themselves. Only a small number of disciples—not schoois ␣ ␣low in their footsteps. The slumbering city vegetates in its own happy mediocrity and does not dream what great things are being thought and created in her midst.'[12]

As far as psychology was concerned, Freud's was a voice crying in the wilderness, and it was easy to ignore him. Wasn't he, after all, a Jew? 'Science is what one Jew copies from another,'[13] declared the deputy Bielohlawek, an aphorism which expresses in one economical sentence the prevalent anti-Semitism of the age. Politicians such as Karl Lueger, the popularly elected Mayor of Vienna (*der schöne Karl* in common parlance), or Georg von Schönerer, the self-styled 'Knight of Rosenau' and leader of the German Nationalist party, knew only too well how to exploit the widespread revulsion of feeling provoked by the intellectual and economic prominence of the Jewish bourgeoisie within Viennese society. The Jews not only dominated banking and commerce, science and industry; they had also usurped the cultural and artistic role traditionally played by the aristocracy. As far as the visual arts were concerned, Jewish bankers and industrialists, the professional classes generally, were among the most important patrons of the

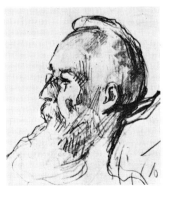

6. Emil Orlık: *Sigmund Freud reading*. Drawing.

Secession, of Klimt and Schiele, and their tastes, their commissions and likenesses, played a significant part in determining the content and appearance of the new art—so much so that one French critic dismissed Klimt's *Philosophy* (Plate 46), shown at the Exposition Universelle in Paris in 1900, with a sneer of 'goût juif'.[14]

This private patronage presents, however, a marked contrast to the reaction which in general greeted the manifestations of contemporary art in Vienna. The Viennese public was nothing if not conservative. Not only the new, the unfamiliar, but also the great was instinctively to be distrusted. 'The Viennese', wrote Bahr, 'will forgive anything . . . except greatness. It makes them uncomfortable. The very name Vienna . . . appears inseparable from charm, merriment and nonentity. Vienna signifies the opposite of seriousness.'[15] And he went on to ask: 'What will become of us? Anything at all? Is there any future for the city? Any possibilities? To understand the Viennese, it is necessary to realize the circumstances of Beethoven's death, and how Grillparzer lived.'[16] For Vienna had indeed a time-honoured tradition of humiliating great men. The list with which Bahr presents us is an impressive one: it includes, apart from Beethoven and Grillparzer, Hebbel and Bruckner, Waldmüller and Hugo Wolf, Klimt and Burckhard, Mahler and Mach. Only through humiliation could greatness be brought down to the level of the commonplace, made comprehensible. Added to which, there was a certain delight in the persecution of the great, the kind of popular scandal that is expressed by the specifically Viennese word *Hetz* (a hunt or chase). The Viennese public, once on the trail of some well-known personality, was merciless in its pursuit. Nothing relieved the monotony of everyday life better than a demonstration, a brawl, or some form of mass uproar. Audience behaviour was appalling. Concerts of modern music often ended in fisticuffs between performers and public. Mahler on one occasion intervened during a performance of one of Schoenberg's pieces, telling a member of the audience to stop hissing, only to be greeted by the retort: 'I hiss during your symphonies, too!'[17] Schoenberg himself was a frequent butt of popular indignation. The conductor Hermann Scherchen relates how he met the composer in the restaurant car of the train taking them both back to Berlin after the Viennese audience had broken up a concert in which Schoenberg's First Chamber Symphony had been performed. 'The master's usually peaceful countenance bore a downright pugnacious expression. His eyes full of defiance, he looked at me and asked: "Well, and what have you got to say about the scandal?" And, without waiting for a reply, he added: "I wish I'd had a revolver".'[18] Nor was it only the rabble who did their utmost to block the progress of modern art, the advances of scholarship and science. One thinks of the case of the distinguished doctor, Ignaz Philipp Semmelweis, who died insane after his pioneering work on infection had been discredited by his colleagues; or of the notorious 'protest of the professors', when academics of all faculties united to demand that the Ministry of Education should revoke the commission awarded to Klimt for the decoration of the university ceiling. Professional jealousy, narrow-mindedness, the conservatism of the public and the press, combined to create a powerful, at times almost irresistible force for reaction—powerful enough, at least, to hound Mahler from his post as director of the Opera House, drive Schoenberg to the brink of starvation, force Klimt to retire from public life, and cause Otto Wagner's outstanding building projects to remain as grandiose, unrealized dreams. 'What Messel was for Berlin', reflected

Bahr ruefully, 'Wagner could have been for Vienna—but Vienna didn't want it, any more than it wanted *Fidelio* or *Don Giovanni* or Grillparzer or Hebbel or Anzengruber—anyone, in other words, who is in earnest.'[19]

That such a situation, in which the philistinism and narrow-mindedness of critics and public vied with one another for pride of place, should have spawned a violent reaction on the part of artists themselves must appear inevitable, above all to those still charmed by a dialectical view of history. But equally, the particular environment, the political and cultural circumstances peculiar to Vienna at this time, played a decisive role in determining the singular, distinctive character of the new art. Not simply that an inexorable sense of finale, those premonitions of impending change to which reference has already been made, help to explain the nostalgic melancholy which typifies much of the painting and literature created in Vienna during the first years of the twentieth century. But also, faced with scorn and incomprehension, isolation and—often—poverty, the artist's gaze grew more distant, embracing a vision which lay beyond the immediate present— a vision which could be neither perfectly defined nor completely expressed, but which, in its scope, its infinite grandeur, transcended the boundaries of this vale of tears. Mahler wrote to his colleague, the conductor Willem Mengelberg, about his Eighth Symphony, the *Symphony of a Thousand*: 'I have just completed my Eighth. It is the greatest thing I have yet done, and so strange in form and content that I can scarcely describe it to you. Imagine that the cosmos itself begins to resound with the music of the spheres—these are not human voices, but suns and planets as they turn in their orbits.'[20] The sheer extent of Schoenberg's *Gurrelieder* (to say nothing of the enormous apparatus demanded by the composer), the apocalyptic magnitude of *Die Letzten Tage der Menschheit*, the grandiose symbolism of Klimt's University Paintings or of Wagner's unrealized city-planning projects—each is indicative of a desire to make perceptible an image, however imperfectly glimpsed, of a higher order which lay, in Nietzsche's words, '*jenseits von Gute und Böse*' (beyond good and evil). This transcendental striving, the mission of the artist as clairvoyant, is summed up in the poem by Stefan George which Schoenberg chose to set as part of the last movement of his Second String Quartet—a poem from the cycle *The Seventh Ring* entitled 'Entrückung' (Isolation):

> Ich fühle luft von anderem planeten.
> Mir blassen durch das dunkel die gesichter
> Die freundlich eben noch sich zu mir drehten.
>
> *I feel a breath from another planet.*
> *Pale visions loom through the darkness*
> *Which just now turned towards me friendly faces.*

As far as the visual arts were concerned, the revolution which actually took place proved to be of only limited duration. And yet, for a period, those artists and architects, designers and draughtsmen who came of age in this epoch succeeded in creating an art unique not only in the nature of the vision it embraced, but also—despite deviations and contradictions—in the identity of striving which linked the foremost protagonists of the Viennese *avant-garde*. In an important sense, the history of the development of modern art in Vienna is the history of one movement, its rise and decline, its schism and rebirth—the movement known as Secession.

II · SECESSION

The Beginnings

During the last decade of the nineteenth century, the visual arts in Vienna were dominated by two principal bodies: the Academy of Fine Arts (Akademie der bildenden Künste) and the Künstlerhausgenossenschaft (Genossenschaft bildender Künstler Wiens), an exhibiting society, founded in 1861 under the presidency of the architect August Siccard von Siccardsburg, to which nearly all the established artists of Vienna belonged. Between them, these two organizations exerted a virtual stranglehold upon the artistic life of the capital. The Academy had, it is true, a rival in the shape of the Austrian Museum for Art and Industry, which as early as 1868 established its own School of Applied Arts (Kunstgewerbeschule), after the model of the South Kensington Museum in London with its satellite school. But by far the greater number of artists of the future *avant-garde* still studied at one time or another at the Academy, the painters for the most part under the awesome tutelage of the renowned Professor Christian Griepenkerl.[1] The Künstlerhaus, by comparison a purely private organization, was able to pursue its course more or less unopposed by virtue of owning what amounted to the city's only exhibition building. It was thus in a position to influence, to a significant extent, not only government policy with regard to the arts, but also the formation of public taste, by means of its annual exhibitions. The Künstlerhaus was also, like the Academy, predominantly conservative in orientation.[2]

Hardly surprisingly, neither the Academy nor the Künstlerhaus afforded a very congenial meeting place for more revolutionary artists who, like most other people, congregated in Vienna's innumerable coffee-houses. Many of the younger, more progressive members of the Künstlerhaus met either in the café Zum Blauen Freihaus in the Gumpendorferstrasse, or in the Café Sperl. The Blaues Freihaus was the home of the majority of the painters, who even constituted themselves into an informal society which they named the 'Hagengesellschaft' or 'Hagenbund' after the proprietor of the café. The usual circle embraced the artists Rudolf Bacher, Adolf Böhm, Josef Engelhart, Johann Viktor Krämer, Friedrich König, Ernst Nowak, Alfred Roller and Ernst Stöhr—names soon to win an unexpected notoriety.[3] The Café Sperl was the haunt of the more exclusive 'Siebener-Club' (Club of Seven), which included Max Kurzweil, Leo Kainradl and Adolf Karpellus, the designer and graphic artist Koloman (Kolo) Moser, and the young architects Josef Hoffmann and Joseph Maria Olbrich. These rising stars of the architectural firmament, both winners of the coveted Prix de Rome at the Academy, were protégés of the greatest Viennese representative of the modern movement in architecture, Otto Wagner. Even Wagner himself was known on occasion to grace these gatherings with his presence. Here, outside the stuffy atmosphere of the Academy, one could discuss everything that was new and

7. Gustav Klimt: Detail from *Medicine*, showing the figure of Hygeia. The only surviving colour photograph of any of the three University Paintings

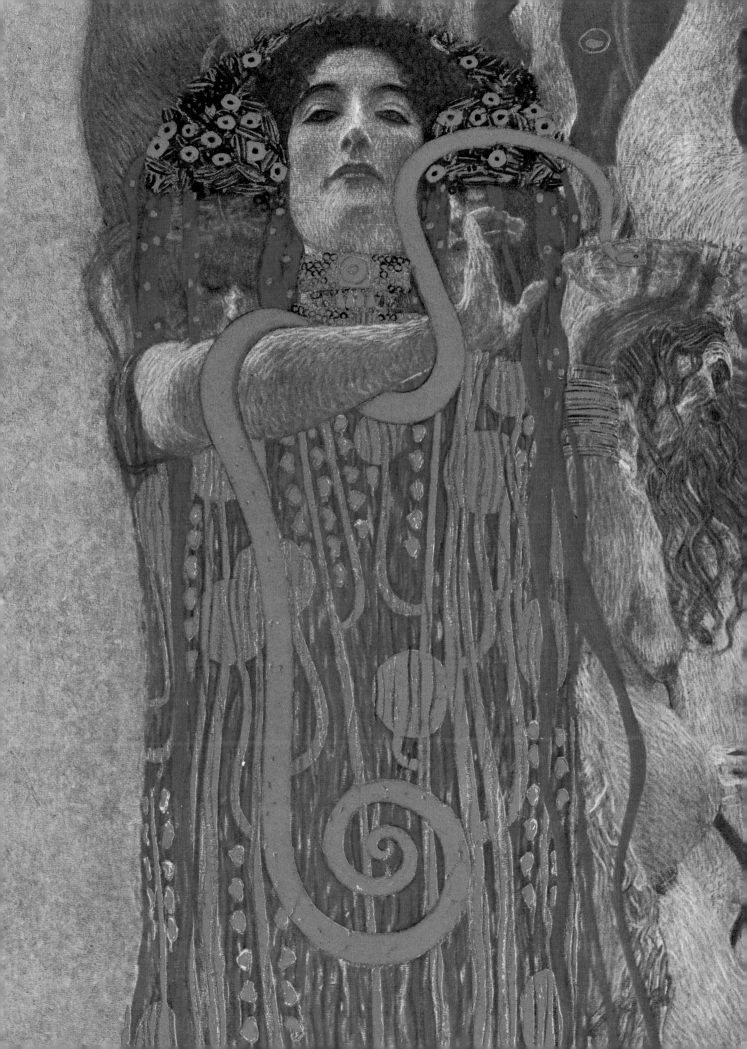

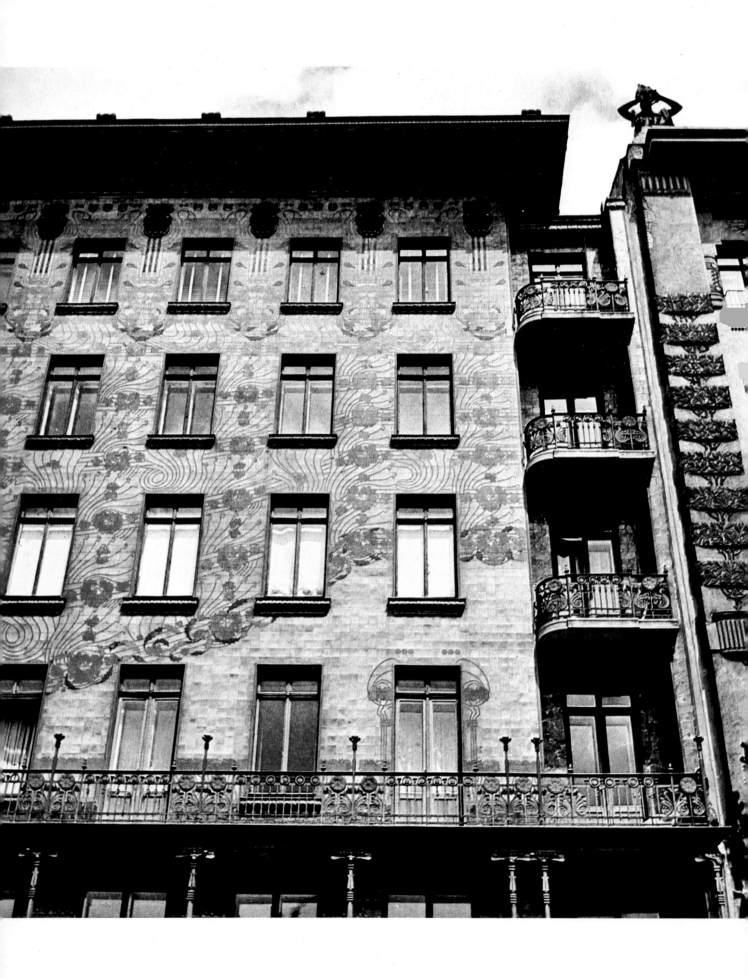

exciting: the most recent issue of the *Studio*, the latest developments in architecture and design. There was also a new series of the Viennese publisher Martin Gerlach's *Allegories* (1895–1900) to enthuse over, a set of folio volumes of graphic reproductions to which some of the foremost draughtsmen of the day had contributed: Moser, Engelhart, Carl Otto Czeschka (one of the most brilliant graphic artists among the future members of the Secession), as well as a somewhat older painter, Gustav Klimt, who, although apparently a member of the establishment, had recently emerged as leader of the young revolutionaries within the Künstlerhaus. Alternatively, one could bemoan the policies of that institution, the tedium of its exhibitions, and the undisguised political manœuvring which characterized its endless committee meetings.

The younger members of the Künstlerhaus could, admittedly, boast of some success in seeking to revolutionize its affairs. Several had even managed to usurp positions of importance on its juries and committees, from which vantage point they were able to impose their opinions on their less advanced colleagues. Their influence may be judged by the fact that, when the German Kunstgenossenschaft succeeded in preventing the artists of the Munich Secession from participating in the Third International Exhibition in Vienna in 1894, the Künstlerhaus was persuaded to invite the group for a separate show in December of the same year— a show which, by Viennese standards, enjoyed an extraordinary success.[4] It was also largely due to their machinations that a significant number of artists from abroad, among them Uhde, Segantini and Rodin, were invited to exhibit in Vienna during the mid-nineties; Segantini was awarded the large Gold Medal at the Society's annual exhibition in the spring of 1896, together with the sculptor Arthur Strasser. This state of affairs was, nevertheless, of short duration. The re-election of the arch-conservative and skilled bureaucrat Eugen Felix as president

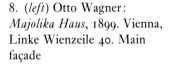

8. (*left*) Otto Wagner: *Majolika Haus*, 1899. Vienna, Linke Wienzeile 40. Main façade

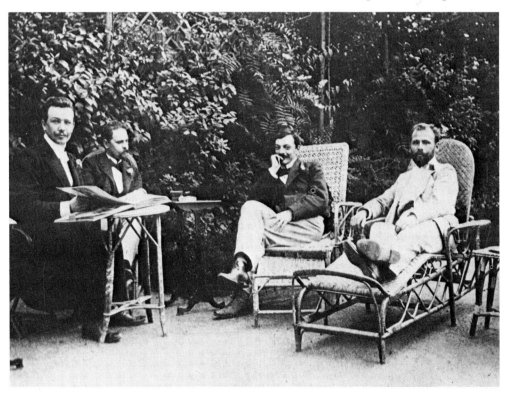

9. (*right*) Photograph *c*. 1898, showing Klimt, Moser and (*far left*) Olbrich in the garden of Wärndorfer's villa

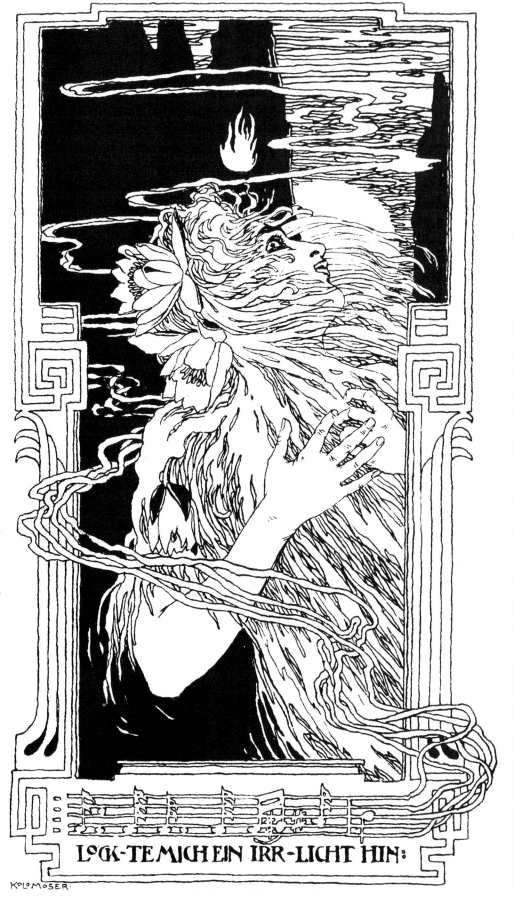

LOCK-TE MICH EIN IRR-LICHT HIN:

KOLO MOSER·

12. Josef Engelhart: *Self Portrait with Top Hat* (detail). Vienna, Oesterreichische Galerie

13. Johann Viktor Krämer: *Theodor von Hörmann*, *c.* 1895 (detail). Vienna Oesterreichische Galerie

10. (*opposite left*) Kolo Moser: '*Lockte mich ein Irrlicht hin*'. Drawing produced in connexion with the 'Ball der Stadt Wien', 1897. Vienna, Historisches Museum der Stadt Wien

11. (*opposite right*) Carl Otto Czeschka: *Wine and Dance*. Drawing. Vienna, Historisches Museum der Stadt Wien

of the Künstlerhaus (November 1896) marked the beginning of a new phase in the life of that organization. The more radical members were already irritated by the discrimination directed against the *plein-airiste* and Impressionist faction, especially the painters Josef Engelhart and Theodor von Hörmann (Plates 12 and 13). The latter had suffered unusually badly at the hands of the Künstlerhaus. He had been forced to beg, without success, for a showing of his work; in fact, the large memorial exhibition held shortly after his death in 1895 was the first occasion on which any significant number of his paintings was shown in Vienna. The writer Hermann Bahr, in a passionate article which traced the origins of the modern movement in Austrian art, described him as having been 'killed by the envy of his enemies'.[5] Felix himself, moreover, was seemingly responsible for manœuvres designed to exclude the younger elements within the Künstlerhaus from the most important exhibitions of Austrian art abroad. This combined with the frustrations caused by the commercial character of the society's exhibition policies to provoke a split within the organization, an event which soon proved to have far-reaching implications.

The younger members of the Künstlerhaus had long contemplated the formation of an independent, autonomous association of artists, after the precedent established by their colleagues of the Munich Secession.[6] Felix's tactics forced their hand. At a meeting held at the beginning of April 1897, a new society was formally inaugurated under the title *Vereinigung bildender Künstler Oesterreichs (Secession)*. Klimt, elected president of the new association, expressed his own and his colleagues' position in a letter to the *Künstlerhausgenossenschaft* committee:

As the committee must be aware, a group of artists within the organization has for years been trying to make its artistic views felt. These views culminate in the recognition of the necessity of bringing artistic life in Vienna into more lively contact with the continuing development of art abroad, and of putting exhibitions on a purely artistic footing, free from any commercial considerations; of thereby awakening in wider circles a purified, modern view of art; and lastly, of inducing a heightened concern for art in official circles.[7]

Klimt and his colleagues had not actually intended to offer their resignation (all but seventeen of the forty founding members of the *Vereinigung* were also members of the Künstlerhaus). At its meeting of 22 May 1897, however, the committee of the *Genossenschaft* succeeded in passing a motion of censure upon the dissidents. Klimt and eight companions left the meeting in silent protest. Two days later, he wrote again to the committee informing them of his resignation, together with that of twelve other artists: Stöhr, Krämer, Olbrich, Moser, Carl Moll, Rudolf Bacher, Rudolf von Ottenfeld, Hans Tichy, Anton Nowak, Julius Mayreder, Edmund von Hellmer and Felician von Myrbach. Engelhart, Eugen Jettel and Wilhelm Bernatzik telegraphed from Paris to announce their solidarity with the rebels. More resignations followed, among them Hoffmann, Kurzweil, Max Lenz and Wilhelm List. Krämer was formally expelled from the Künstlerhaus at a further meeting on 28 May. Otto Wagner, the last member of the opposition, resigned on 11 November 1899, by which date it had become clear that there was no longer any hope of effecting a reconciliation between the two mutually hostile associations.

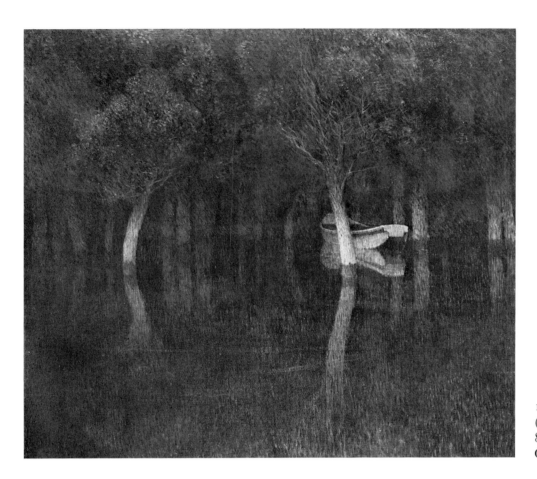

14. Carl Moll: *Dämmerung* (*Twilight*). Oil on canvas, 80 × 94.5 cm. Vienna, Oesterreichische Galerie

The Vienna Secession has frequently, but erroneously, been indentified with a particular artistic philosophy, a particular style. True, the central caucus within the organization included several of the leading Austrian representatives of the *Jugendstil* movement, the German variant of *Art Nouveau* which had begun during the last years of the century to revolutionize art and design on the Continent. Olbrich's exuberant early designs, in particular, are quintessential *Jugendstil*, with their animated line and blossoming ornamentation. The influence which Olbrich and his companions exerted was, from the beginning, a powerful one— so powerful that many critics rapidly came to associate *Jugendstil* with the 'group style' of the organization itself (the two terms *Jugendstil* and *Secessionsstil* were often used more or less synonymously by contemporary writers). Other commentators saw the Secession as leading a reaction against the prevalent naturalism of academic painting. Ludwig Hevesi, one of the most elegant writers of the epoch, and a fervent champion of modern art, wrote about one of the early exhibitions of the association: 'For two generations now, Nature has been posing as an artists' model. She is getting tired!'[8] And Hermann Bahr, an equally energetic propagandist of the Secession, had, as early as 1891, predicted the triumph of the modern in a collection of essays entitled, significantly, *The Conquest of Naturalism*. But in reality, the strength of the Secession lay precisely in its lack of any such programme. From its inception, it brought together 'Impressionists' and 'Naturalists', 'Modernists' and 'Stylists', as well as artists working in quite different fields: painters and designers, graphic artists and typographers, even

15. Wilhelm Bernatzik: *The Vision of St Bernard*. Oil on canvas, 105 × 201 cm. Vienna, Oesterreichische Galerie

architects such as Mayreder, all of whom allied themselves from the beginning with the new association.

It is worth singling out a number of founder-members of the Secession for closer examination. Olbrich and Hoffmann were both architects who were to develop a penchant for interior design; Moser was at this period known primarily as a draughtsman, although he too later devoted himself to a large extent to applied art and design, before turning entirely to painting (see pp. 153–5). Of the painters proper, Engelhart, Moll and Krämer were all strongly influenced by French art. Moll, in particular, having studied with the famous Viennese landscapist Emil Jakob Schindler (whose widow he later married), had progressed from the Naturalism of his master's mature manner, by way of a sombre, Symbolist-influenced style of landscape painting, to a more colourful Impressionism in his works of the early 1900s.[9] Among the graphic artists, Adolf Böhm was the most deeply influenced by the more abstract tendency inherent in *Art Nouveau*; several of his smaller works, especially his pastels, verge on the purely non-representational. Bacher and Bernatzik were at heart academicians; the former was in fact appointed professor at the Academy in 1903, and remained a member of the 'rump Secession' after Klimt and his friends resigned from the association in 1905. Bernatzik had spent some years in Paris, where he had studied in the studio of Léon Bonnat. His painting *The Vision of St Bernard* (Plate 15), purchased for the Austrian Imperial collections, reveals the influence of his training. Klimt himself was, at this date, perhaps the most successful of all the artists of the Secession. A whole series of wall and ceiling paintings, many of them executed in collaboration with the academic painter Franz Matsch for public buildings like the new Burgtheater or the Kunsthistorisches Museum (Plate 16), had met with such approval that both artists had been commissioned by the Ministry of Education to carry out a

25

16. Gustav Klimt: *Altar of Dionysus* (detail). Oil on stucco. Illustration for staircase of the Burgtheater 1886–8. Vienna, Burgtheater

cycle of decorative and allegorical designs for the great hall of the University of Vienna. Klimt had, so rumour told, even now nearly completed preliminary studies for three of the paintings, which were to allegorize the academic faculties of Philosophy, Medicine and Jurisprudence. Nothing about his early style, which was compounded of a rather robust, highly personal pre-Raphaelitism with an admixture of classical and antique elements, could have led anyone to foresee the dramatic change which was to occur in his work of the years immediately after the foundation of the Secession, or the furore which his designs for the university ceiling were to cause.

The First Exhibition

The most important aim which united the members of the newly formed association was their desire to awaken Austrian art from its slumbering provincialism, by bringing artists and public alike into contact with examples of work by the foremost contemporary European artists. The editorial of the first issue of *Ver Sacrum*, the organ of the Secession, declared:

We desire an art not enslaved to foreigners, but at the same time without fear or hatred of the foreign. The art of abroad should act upon us as an incentive to reflect upon ourselves; we want to recognize it, admire it, if it deserves our admiration; all we do not want to do is imitate it. We want to bring foreign art to Vienna not just for the sake of artists, academics and collectors, but in order to create a great mass of people receptive to art, to awaken the desire which lies dormant in the breast of every man for beauty and freedom of thought and feeling.[10]

This educative aim was also expressed in the statutes of the organization, according to which (paragraph 14) the profit from its independently organized exhibitions was to be used in part for the 'purchase of works shown in these exhibitions, which are then to be made over as a gift to one of the public galleries in Vienna'.[11] In this way, the Viennese public collections acquired, during the period 1898–1905, as many as nineteen works by contemporary foreign masters, including Segantini's *Die Bösen Mütter* (Plate 17) and van Gogh's *Plain at Auvers-sur-Oise*.

The organization of their first exhibition took the Secessionists nearly a year of intensive preparation. They were faced with two principal problems: the necessity of making contact with notable foreign artists who might be persuaded to lend their works for exhibition, and the difficulty of acquainting the Viennese public with their aims and ambitions without, as yet, having a suitable exhibition building at their disposal. Engelhart recalled:

One of the most important tasks of the association was that of making friends among artists abroad, and of making the public acquainted with our aims by showing their pictures in our exhibitions.

Since I knew many of the artists in question through my studies in Germany and France, and also possessed the necessary knowledge of languages, it devolved upon me to undertake trips to Germany, France, Belgium and England in the service of the organization. On these trips, I made the personal acquaintance of nearly all the great painters and sculptors of the day, and for the most part succeeded in convincing them of the honourable, artistic intentions of the newly founded association. In this way, I met the sculptors Rodin, Bartholomé, Lagae, the painters Besnard, Boldini, Brangwyn, Carrière, Dagnan-Bouveret, Dill, Herterich, Khnopff, Klinger, Lavery, Meunier, Puvis de Chavannes, Raffaëlli, Roll, Rops, Sargent, Swan, Uhde, Whistler and others.

17. Giovanni Segantini: *Die Bösen Mütter*, 1894. 105 × 200 cm. Vienna, Kunsthistorisches Museum, (Moderne Galerie)

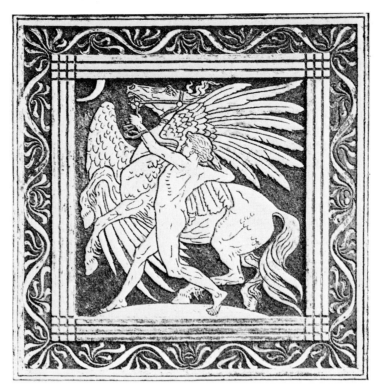

18. Walter Crane: *Pegasus.*
From *Ver Sacrum, I* (1898),
v–vi

All these and many other important artists willingly declared their support, and made their works available for the exhibitions of the Secession, as the new association was called.[12]

But where to exhibit? After months of work, it suddenly began to look as if the Secession's first exhibition was going to find itself without a home. Again Engelhart:

We wanted to give the public as soon as possible a proof of our existence and our ability. Since there existed in the whole of Vienna no exhibition building apart from the Künstlerhaus, we had to decide to rent as a start the premises of the then Horticultural Society on the Parkring. In order to avoid embarrassment, I took this step in secret and on my own responsibility. The Society demanded an exceptionally high figure for three months' rent, I think it was 8000 *Gulden*, but I had of necessity to accept, since the *Künstlergenossenschaft* [i.e. *Künstlerhausgenossenschaft*] were also intending to rent the rooms, and had I come a day later, the whole project would have been in vain.

The rooms were rearranged for our exhibition. Next to pictures by our own members we showed works by notable painters from abroad. Our exhibition was the first occasion on which anyone had been able to get some idea of the work of the best French, English, Belgian and German artists of the period.[13]

The exhibition opened on 26 March 1898. The poster and the cover for the catalogue were designed by Klimt (Plate 19). In addition to works by Austrian members of the association were to be seen exhibits by Brangwyn, Böcklin, Rodin, Segantini, Klinger, Whistler (lithographs), Stuck and Mucha. Puvis de Chavannes showed the cartoons for his *St Geneviève Triptych* commissioned for the Panthéon in Paris. Walter Crane, whose work was greatly admired by the Secessionists, featuring frequently in the pages of *Ver Sacrum*, contributed watercolours, drawings, book illustrations, and designs for wallpapers and stained glass (Plate 18). There was also a large section of nineteen paintings by the

19. (*right*) Gustav Klimt:
*Poster for the first Secession
exhibition*, 1898

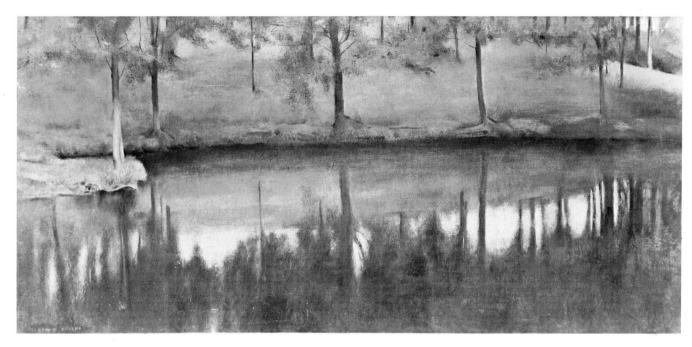

Belgian artist Fernand Khnopff who, together with Whistler, was one of the most important single influences upon the early work of the Secession, and of Klimt in particular. (One painting by Khnopff shown at this exhibition, *Still Water*, may be singled out as bearing an evident relation to the style of Klimt's early landscapes.) Both artists embody in their works a certain transcendental melancholy which goes beyond both language and image (Plates 20 and 21). In this, Khnopff resembles his great compatriot Maeterlinck; Bahr was quick to seize upon this affinity, in his review of the first Secession exhibition, when he wrote:

Khnopff paints what Maeterlinck writes. He is a painter of inner life. . . . Maeterlinck is fond of saying that what we say or do is unimportant; it is merely semblance, beyond which our real life lies concealed. . . . We know this better than we can prove, but in order to prove it we have to express it, and on the path to speech the essential somehow gets lost. It is this Inexpressible which Khnopff attempts to paint.[14]

The arrangement and hanging of the exhibition were the responsibility of Hoffmann and Olbrich. Their prime object was to enable, as far as the rather unsuitable surroundings of the Horticultural Society building would permit, the works displayed to create the optimum effect. In this respect, the efforts of the Secessionists represented at least a limited advance, compared with the exhibitions organized by the Künstlerhaus. Nearly all the pictures were hung at eye level, thus avoiding the traditional disputes over 'skying'. Pictures by the same artists were hung together, so that their work might appear as an organic unity. Particular attention was given to the backgrounds: matt white, dark red and dark green were the principal colours for the wall-coverings. The decorations, which included a frieze of stylized plant motifs, were of a dull gold, so that the setting 'might not become an end in itself'. Hoffmann created in addition a special room, which he called the '*Ver Sacrum* room' (Plate 22), which exemplified for the first time those

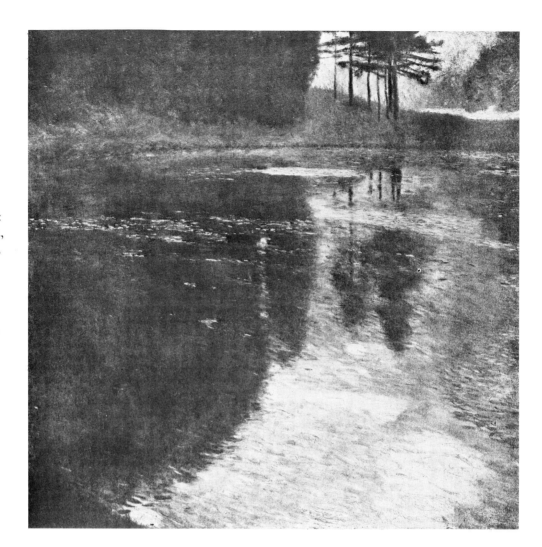

20. (*left*) Fernand Khnopff: *Still Water*, c. 1895. Vienna, Kunsthistorisches Museum, (Moderne Galerie)

21. (*right*) Gustav Klimt: *Still Pond*, c. 1899. Oil on canvas, 74 × 74 cm. Vienna, Marko Danilovatz

techniques of display, the emphasis upon clarity and effective use of space, which were to characterize the Secession's subsequent exhibitions.

The success enjoyed by this first exhibition surprised even its organizers. Some 57,000 visitors saw the show, and the eighth number of *Ver Sacrum* was able to announce the sale of no less than 218 of the works displayed. A last-minute sensation was the purchase of two major works by Segantini: *Alpenweide* (Alpine Meadow) and *Die Quelle des Uebels* (The Source of Evil).[15] The critics were also, for the most part, favourably disposed towards the new association. Bahr, already an enthusiastic supporter of the Secessionists, wrote in one of his newspaper reviews:

We have never yet seen such an exhibition. An exhibition in which there is not a single bad picture. An exhibition, in Vienna of all places, which is a resumé of the entire modern movement in painting. An exhibition which shows that we in Austria can boast of artists fit to appear beside the best of the Europeans, and measure themselves by their standard. A miracle! And, what is more, a great joke! For this exhibition has shown that, even in Vienna, art, real art, can be big business! The hawkers in the *Genossenschaft* must be wringing their hands! Business, Herr Felix, big business! Just think! The Viennese—your Viennese,

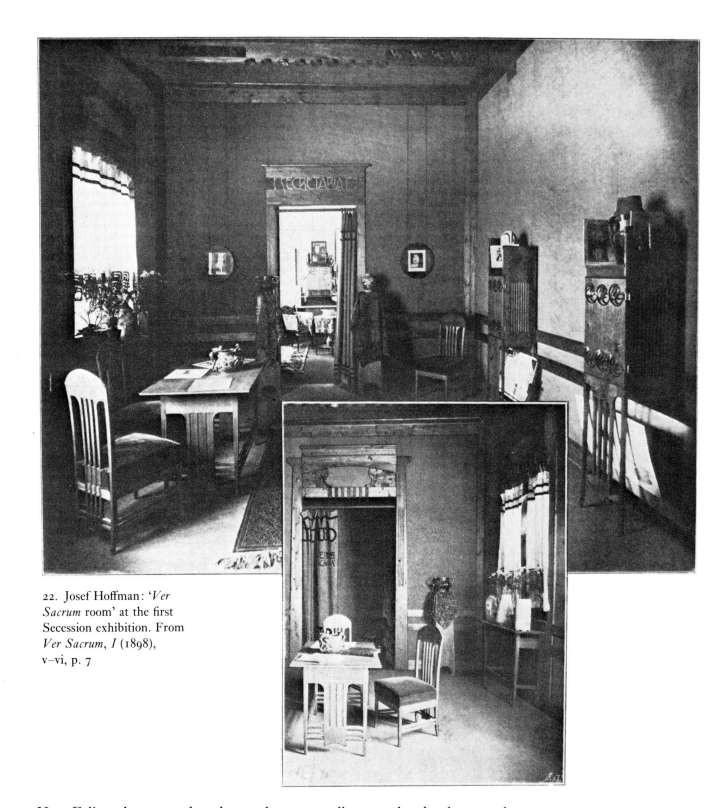

22. Josef Hoffman: 'Ver
Sacrum room' at the first
Secession exhibition. From
Ver Sacrum, I (1898),
v–vi, p. 7

Herr Felix, whom you thought you knew so well—come by the dozen to buy
works of art. They're buying Khnopff, Herr Felix!![16]

This sale-room character of the whole affair contrasts rather uncomfortably with
the frequent attacks which Klimt and his colleagues directed against the com-
mercial emphasis of the exhibitions organized by their rivals. But in fact, the

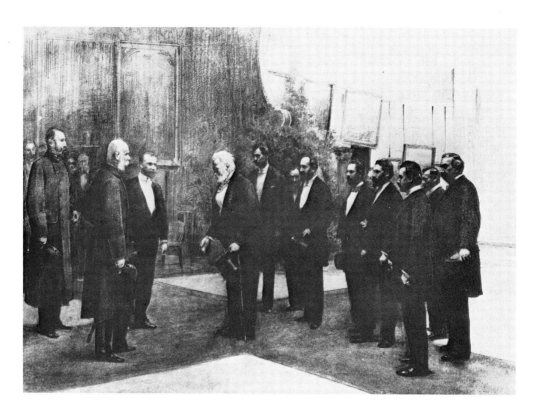

23. Rudolf Bacher: *The Emperor Franz Joseph at the first Secession exhibition,* (*1898*) *in the Horticultural Society Building, received by Rudolf von Alt and other members of the association.* Vienna, Historisches Museum der Stadt Wien

financial success of this first exhibition was not only richly deserved, but also sorely needed. Only now could the association begin to think of realizing its most important dream: the construction of a permanent exhibition building, a home of its own.

The Dedication of the House: Second Exhibition

The first problem was that of a site for the new building. Fortunately, the Secessionists had one great advantage: they had friends in high places. According to Engelhart, no less a person than the Mayor of Vienna, Karl Lueger, raised his voice in favour of their enterprise.[17] There was also Rudolf Mayreder, whose brother, the architect Julius Mayreder, was one of the founder-members of the Secession. Rudolf Mayreder was on Vienna's city council, and helped considerably in accelerating the whole business of planning permission.[18] Thanks to these and other connections, the association was accorded, after some hesitation over alternative locations, the lease of the area of ground beneath the windows of the Academy of Fine Arts giving on to the Friedrichstrasse, where the Secession building still stands. The first issue of *Ver Sacrum* was able to announce:

In recognition of the purely artistic aims of our association, the City of Vienna, in a decree of 17 November 1897, has made over to the former for the purpose of erecting an exhibition building an eminently suitable location next to the Academy, on the site of the projected Wienzeile. . . .

The construction of the association's exhibition building will commence as

soon as the season permits, and will be executed with all possible despatch. The design for the building has been entrusted to our member J. M. Olbrich.[19]

The foundation stone was laid on 28 April 1898. By cutting a few corners, the building was completed in an extraordinarily short space of time, ready for the association's second exhibition in November of the same year. It was a time of high hopes, exalted feelings, portentous inscriptions (the façade of the building was adorned with the words of Hevesi: *'Der Zeit ihre Kunst, der Kunst ihre Freiheit'*—to every age its art, to art its freedom), and no small number of witticisms. We are told that when, after the foundation stone had been laid, members of the Secession swarmed round to congratulate the venerable Rudolf von Alt, who had, much to the disgust of his former colleagues, deserted the Künstlerhaus to become honorary president of the new association, the aged watercolourist was heard to remark: 'If you've got any other foundation stones to lay, just give me a call, I'll be right round'.[20] Nor was the Viennese public behindhand in coining witty remarks as they watched, mostly with horror, the new building taking shape. Bahr observed:

If, these days, you pass by the river Wien in the early morning . . . you can see, behind the Academy, a crowd of people standing around a new building. They are office people, workmen, women who should be on their way to work, but instead stop in amazement, unable to tear themselves away. They stare, they interrogate each other, they discuss this 'thing'. They think it strange, they have never seen anything of the kind, they don't like it, it repels them. Filled with serious reflections, they pass on their way, and then turn round yet again, cast another look backwards, don't want to depart, hesitate to hurry off about their business. And this goes on the whole day.[21]

The 'Mahdi's Tomb' was one of the popular nicknames bestowed upon the new edifice. Some passers-by described it as looking like a 'cross between a glass-house and a blast-furnace'; others, yet more inventive, dubbed it 'the Assyrian convenience'. But when Olbrich's golden cupola was finally in place—a gilded, openwork sphere of laurel leaves and berries—then originated the building's most common nickname: 'the golden cabbage'.[22]

The poster for the second exhibition (12 November–28 December 1898) and the cover of the catalogue both display a vignette of the new building (Plate 25), as does the jacket of Bahr's volume of essays *Secession*. The foreword to the catalogue contains the historic words:

May this house become a home for the serious artist as for the true art lover. May they both, creating and enjoying, seeking and finding, be here united in this temple in sacred service, so that Hevesi's words, which our building bears on its brow, may in truth come to pass: To every age its art, to art its freedom.[23]

The exhibition continued the trend set by the association's first show at the Horticultural Society the preceding spring. Olbrich's building allowed, however, a far greater flexibility of spatial articulation than had been possible on the previous occasion. Among the exhibits, a section of particular interest was devoted to a group of architectural studies by Otto Wagner, not yet in fact a member of the association, and his pupils for a new Academy of Fine Arts, a project which

25. (*right*) Josef Maria
Olbrich: *Poster for the
second Secession exhibition*,
1898

24. (*below*) Caricature from
Figaro: 'An artistic judge-
ment'. The caption reads:
'Come on, Flockerl! Damn
the cur, I can never get him
past the corner where they
stick up the Secession
poster!'

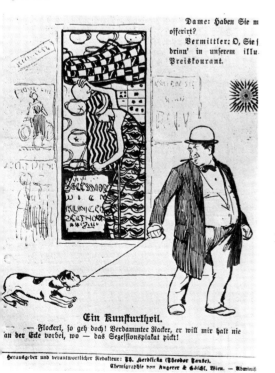

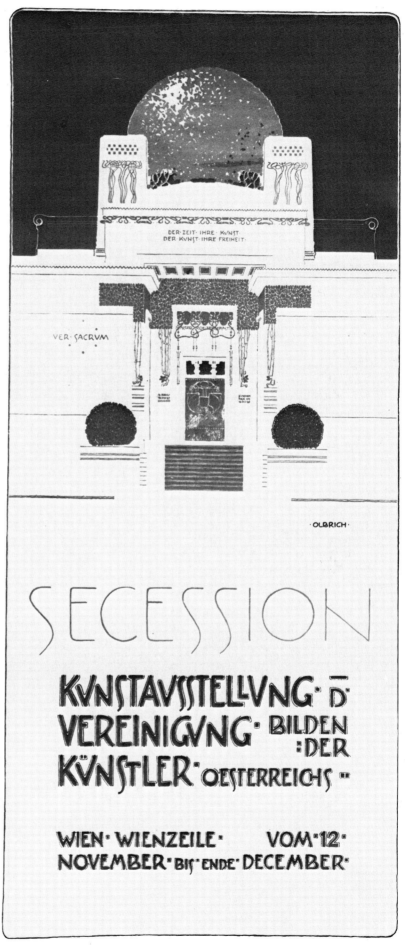

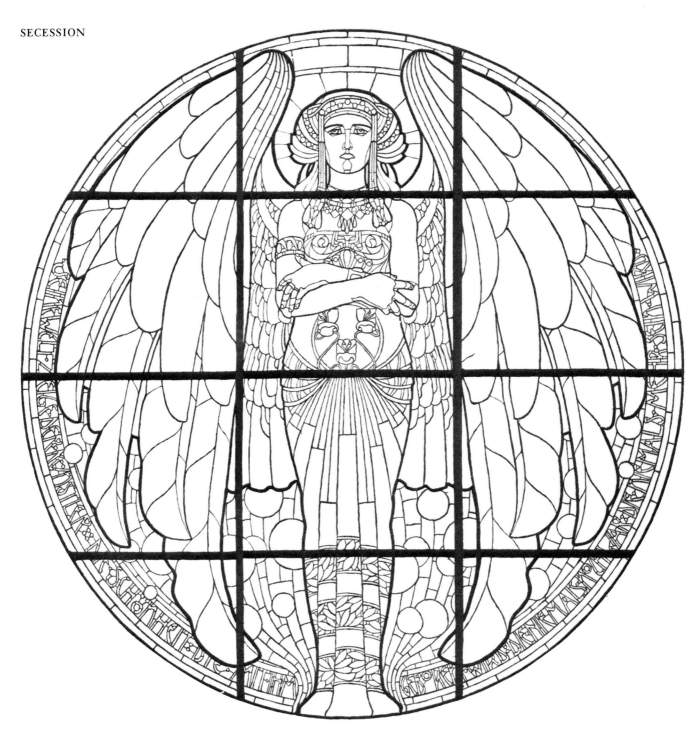

Wagner continued to revise, without any sign of official acceptance, until almost the outbreak of the First World War. Items by foreign artists included further paintings by Khnopff, and a section of works by the Swedish painter and print-maker Anders Zorn. There was, too, a whole room given over to the applied arts, in which were exhibited, *inter alia*, wallpaper designs by Olbrich and Moser. The latter also created the great circular stained-glass window *Die Kunst* in the vestibule of the building (Plate 26). Bahr wrote of him:

The stained-glass window *Die Kunst* and the wallpapers in the room devoted to the applied arts are by Koloman Moser, whom we know already from the pages of *Ver Sacrum* as a fluent, inspired, sometimes even somewhat light-minded draughtsman. He is a Viennese through and through. His inventions

seem to dance, to hover. . . . Old Socrates would have been pleased:παιδιᾶς χάριν, everything is but a game. The poor comedy of our lives could scarcely be portrayed with greater tenderness and elegance. Occasionally one perceives a gentle melancholy, like the merest shadow of a cloud, but it's gone in an instant. Occasionally a trace of weariness, as on the faces of pretty youths, but then the dance begins all over again. Sometimes a quiet sadness, which disappears as quickly as it came. παιδιᾶς χάριν, everything is but a game.[24]

The important place given to the applied arts at the second exhibition is revealing both of the influence exerted by the designers—Olbrich, Hoffmann, Moser, Roller and others—within the Secession itself, and of changing attitudes on the part of the European *avant-garde* towards the question of the relationship between art and design. As early as 1891, the Salon du Champ de Mars in Paris, pointing to the example of William Morris, of the pre-Raphaelites and Walter Crane, had displayed examples of applied art on an equal footing with works of painting and sculpture, previously regarded as belonging by right to a higher category of artistic endeavour. The Belgian designer and theorist Henry van de Velde, whom Bahr described as the 'greatest present-day maestro of interior design',[25] had, in his writings of the 1890s, also called for the unification of art, the re-evaluation of the role of craftsman and designer, the recognition that we are able 'to impress beauty upon every aspect of our lives, that the artist should no longer simply paint pictures, but rather create whole rooms, or even whole dwellings, with wallpapers and furniture as well as paintings'. This reappraisal of the status of the applied arts was characteristic of the early activity of the Secession. The editorial of the first number of *Ver Sacrum* declared:

And suppose one among you says 'But why do I need the artist? I don't like pictures', then we shall reply, 'Even if you do not like pictures, let us decorate your walls with beautiful hangings; would you not care to drink your wine out of an artistically fashioned glass? Come to us, we shall show you the design for a vessel worthy of the noble wine. Or do you wish for costly jewellery or a rare fabric to adorn your wife or loved one? Speak! Try, just once, and we will show you that you can become acquainted with a whole new world, that you too can conceive of and possess things of whose beauty you have never dreamed, whose sweetness you have never tasted!'[26]

The first two Secession exhibitions afforded, in addition, the opportunity of judging the most recent development of Klimt's art. The period of the inauguration of the Secession had coincided with the beginnings of a marked change in his style, a change for which his wider acquaintance with the work of other contemporary painters outside Austria must be held at least partly responsible. As a result of the divergent influences which affected him, his work became, for a period, extraordinarily varied. Thus, for example, the second exhibition showed side by side the beautiful early portrait of the young Sonja Knips (Plates 27 and 28), a picture imbued with that gentle impressionism which never entirely vanished from Klimt's art, and the famous *Pallas Athene* (Plate 29), emblem of the Secession, with its uncompromising frontality, stress upon surface pattern and cascade of golden armour. The latter work shows clearly the influence of

26. Kolo Moser: *Design for circular window, 'Die Kunst'*, 1898. From *Ver Sacrum, II* (1899), vol. iv, p. 31

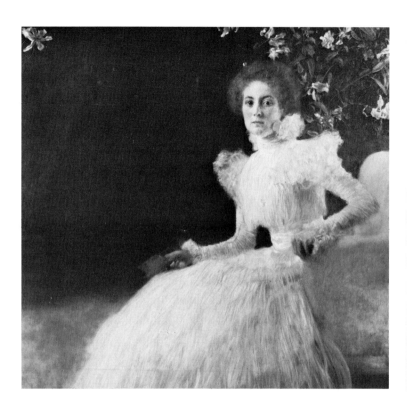

Jugendstil painting upon Klimt at this time, especially the work of the Munich painter Franz von Stuck. Not only Stuck's poster for the seventh exhibition of the Munich Secession, which likewise depicts the goddess of wisdom, but also his oil painting of the same subject (Plate 30) must have served Klimt as a precedent for his own composition. One altogether individual touch has, however, no obvious precedent in any of the sources to which Klimt might have turned: the tiny, naked female figure with outstretched arms which appears in the lower left-hand part of the canvas—a model in miniature for innumerable variations upon the theme of sexuality and the *femme fatale*.

Pallas Athene is also remarkable on account of its metal frame, designed by the artist and executed by his brother Georg, who made the great bronze doors for the main entrance of the Secession building. For Klimt, as for the other members of the Secession who stood closest to him, the traditional distinction between the role of the artist who paints pictures and that of the craftsman who designs their frames or arranges their hanging was a largely artificial one. His interest in craftsmanship, and in the techniques of ornament, predicts the direction his own art was subsequently to follow. In his works of the early 1900s, he experiments constantly with the decorative possibilities offered by the use of materials such as gold and silver, inlay and semi-precious stones; his pictures of this period were on several occasions criticized as not being paintings in the proper sense at all, but objects of applied art. This period of experimentation culminates in the *Stoclet-frieze* of 1905–11, the artist's most advanced use of a composite medium, and in the magnificent golden paintings of the years 1907–8; only in his last works did Klimt altogether renounce the use of ornamental techniques of this kind in order to turn once again to exploiting the resources of simple oil paint.

Christmas 1898 was a good time to stand back and attempt to review what

27. (*left*) Gustav Klimt: *Portrait of Sonja Knips*, 1898. Oil on canvas, 145 × 145 cm. Vienna, Oesterreichische Galerie

28. (*right*) Gustav Klimt: *Composition drawing for Sonja Knips*, 1898. Vienna, Historisches Museum der Stadt Wien

the Secessionists had accomplished in the first eighteen months of effort. Whether one considers the number of visitors to their exhibitions, or the financial or 'moral' success they had attained, the achievement had been remarkable. Their influence upon the pattern of artistic life in Vienna had already begun to make itself felt. Hevesi, in an article published in *Ver Sacrum* in July 1899, wrote:

In this last year, the whole of Vienna has become 'Secessionist'. . . . In old established circles, one tries to roll together the last remains of one's youthful dough and put new life into it; those same things which only a couple of years ago were rejected as quite unacceptable now win prizes.[27]

This success was not without its disadvantages. The fact that a number of commercial firms had become interested in exploiting the work of the designers within the Secession meant, inevitably, that their ideas soon became copied and debased. Bahr in fact foresaw just this kind of plagiarism in architecture when he wrote of Olbrich's Secession building: 'I fear that another six months and it will become a model after which avid imitators will erect churches, hotels and villas— all in the "Secession style". What a change in just a few years! What a change in artists' intentions! What a change in the demands of the public!'[28] It was, however, principally in the field of the applied arts, rather than of architecture, that such copying actually took place. Moser later recalled that the whole thing suddenly became a craze, that the shops could not get hold of enough examples of Secessionistic work. 'It became a trend', wrote Moser, 'an entire industry, the originals were imitated in a careless and tasteless fashion, and there we had in Vienna that "false Secession" of which Bahr so rightly warned us'.[29] It was partly as a reaction against this kind of plagiarism that Hoffmann and Moser later founded the Wiener Werkstätte, the exclusive craft workshops in which the 'true' style in design continued to be cultivated.

29. (*left*) Gustav Klimt: *Pallas Athene*, 1898. Oil on canvas, 75 × 75 cm. Vienna, Historisches Museum der Stadt Wien

30. (*right*) Franz von Stuck: *Pallas Athene*. Cologne, Hans G. Neef

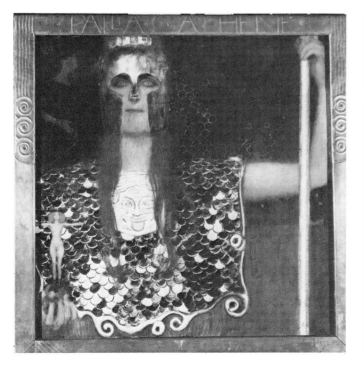

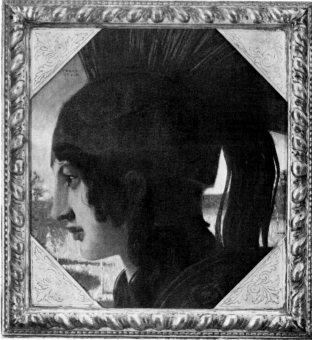

VEREINIGUNG
BILDENDER
KÜNSTLER
ÖSTERREICHS.

SECESSION.

Immer wird mir eine Scene unvergesslich bleiben. Es ist jetzt fünf Jahre her, ich hatte damals in der „Deutschen Zeitung" über das Elend unserer Kunst geklagt; an leiser Zustimmung fehlte es mir nicht, die sich freilich noch nicht unter die Leute traute. Da läutet es eines Tages bei mir, ich gehe offnen und sehe vor der Thüre einen ungeduldigen Officier, den ich nicht kenne. Der Hauptmann, eine vehemente Natur von einer strengen und fast drohenden Art, mit unwirschen Geberden, tritt ein, bestürmt mich gleich mit heftigen Reden und nun erfahre ich erst, dass er Theodor v. Hörmann ist, unser tapferer Hörmann, der uns seitdem entrissen worden ist. Er setzt sich zu mir und während er zornig, ungestüm mit den grossen Händen fuchtelnd und seine trübe Stimme heiser schreiend, die Ge-

nossenschaft schmäht, kann ich ihn betrachten: es ist etwas Wildes, Raufendes in seiner Weise, das doch mit seinen guten und herzlichen Augen nicht stimmt, und seine finstere, verfurchte Miene hat eine unbeschreibliche Müdigkeit und Trauer. Er steht auf und geht im Zimmer auf und ab, immer heftiger, erzählend, was er zu leiden hat, wie sie ihn hassen, die im Künstlerhaus, und dass ihnen nichts zu schlecht und zu gemein ist, um ihn zu kränken und zu bedrängen. Es thut mir wehe, den Schmerz des starken Mannes anzusehen. Ich frage endlich: „Aber was haben Sie den Leuten denn eigentlich gethan, dass sie Sie so hassen?" Da lacht er höhnisch und grell auf: „Gethan? Ich denen? Haha! Ich möchte halt ein Künstler sein ≡ ja, ich bin so frech! Und das verzeihen Einem die nie! Da lassen sie

31. Examples of book illustration. The headpiece is by Hoffmann, the smaller designs which embellish the text are by Roller. The text itself is Hermann Bahr's tribute to Theodor von Hörmann, quoted on p. 23. From *Ver Sacrum*, *I* (1898), i

Ver Sacrum

One of the Secession's most important ventures was the publication of its own journal, *Ver Sacrum* (the name means 'sacred spring'), which, both from an artistic and from a literary standpoint, was one of the outstanding periodicals of its day. The editors (prominent among them during the early years Alfred Roller) sought to realize new conceptions of layout and design, to create a unity out of the printed page, subordinating the individual processes of ornamentation and typography to a single purpose.[30] An important role was played by the illustrative material;[31] there were reproductions of works by corresponding members of the association from abroad, as well as valuable photographs of the interiors of the Secession's own exhibitions. The graphic contributions, mostly by the Austrian members, ranged from poetry illustrations and examples of graphic art proper, such as Böhm's *River of Tears* (Plate 33) or the fine series of sentimental–allegorical subjects by Max Kurzweil (Plate 35), to decorative vignettes and borders, and designs for objects of applied art such as the elegant picture frame by Hoffmann reproduced in the fourth issue (Plate 34). The literary aspect of the

32. Alfred Roller: *Cover
for the first number of*
Ver Sacrum, 1898

journal was no less noteworthy. *Ver Sacrum*, during its first two years of existence, could boast the collaboration of the most distinguished poets and *littérateurs* of the day, among them Rilke, Hofmannsthal, Maeterlinck (whose *Death of Tintagel* was reproduced in its entirety in the December 1898 issue), Knut Hamsun, Otto Julius Bierbaum, Richard Dehmel, Ricarda Huch and Conrad Ferdinand Meyer. The eleventh number for 1898 contained verses by Arno Holz, with decorative

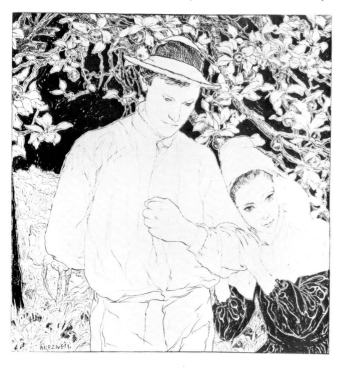

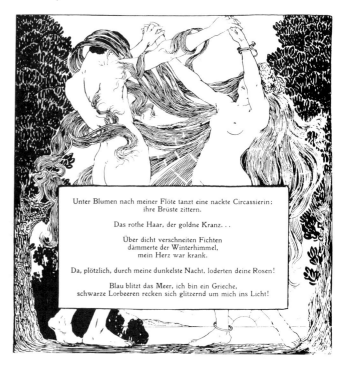

Unter Blumen nach meiner Flöte tanzt eine nackte Circassierin:
ihre Brüste zittern.

Das rothe Haar, der goldne Kranz...

Über dicht verschneiten Fichten
dämmerte der Winterhimmel,
mein Herz war krank.

Da, plötzlich, durch meine dunkelste Nacht, loderten deine Rosen!

Blau blitzt das Meer, ich bin ein Grieche,
schwarze Lorbeeren recken sich glitzernd um mich ins Licht!

33. (*opposite left*) Adolf Böhm: *River of Tears*. From *Ver Sacrum, I* (1898), i

34. (*opposite right*) Josef Hoffmann: *Design for a picture frame*. From *Ver Sacrum, I* (1898), iv

37. (*right*) Josef Hoffmann: *Kleinstadt Idyll*. Decorative border for a setting by the composer d'Albert of Max Bruns' poem 'Small Town Idyll'. From *Ver Sacrum, IV* (1901), p. 411

35. (*opposite left*) Max Kurzweil: *Drawing*. From *Ver Sacrum, I*, (1898), iv

36. (*opposite right*) Alfred Roller: *Decorative setting for a poem by Arno Holz*. From *Ver Sacrum, I* (1898), xi

surrounds by Hoffmann, Roller (Plate 36), Böhm, Jettmar, König and others. There were also frequent musical contributions, reinforcing the image of artistic unity *Ver Sacrum* sought to propagate. The last issue for 1901 reproduced facsimiles of eleven songs by composers such as d'Albert, Conrad Ansorge, F. Klose and Hugo Wolf, with decorations and ornamental borders by Hoffmann (Plate 37), Böhm, Roller, König, List, Müller, Friedrich, Bauer and Moser. There was, moreover, in addition to the usual issue of the journal, a *de luxe* edition containing original drawings and graphics, which appears to have been prepared largely by hand, since different copies of the same issue often display considerable variations one from another. A remarkable amount of time and attention was lavished on every aspect of the publication. It is also worth remembering that, apart from the one year when the magazine was brought out by the firm of E. A. Seemann and Company in Leipzig, the artists who contributed to *Ver Sacrum* gave their services for nothing.

The repeated changes of publisher (*Ver Sacrum* began by being published by the firm of Gerlach und Schenk in Vienna, then appeared for a year under the banner of Seemann and Company, only to end up by being published independently by the Secession itself) must give us some intimation of the difficulties which the

43

enterprise brought with it. There was also a significant change in policy after January 1900, when the magazine, which for the first two years had appeared monthly, began to be published every fortnight. The pressures of having to prepare two issues, rather than one, every month seems to have had a detrimental effect upon the standard of production; the later numbers of *Ver Sacrum* cannot compare with the earlier issues either as regards artistic quality or as regards the interest of the contributions they contain.

Ver Sacrum remains a document of the first importance for any student of the period, and one without which it would be impossible to obtain a complete picture of the activity of the Secession during the early years of its development. It was, however, as an exhibiting society that the Secession was founded; and it was through its exhibitions that the Secession sought to influence not only the development of modern Austrian art, but also the education of the Viennese public. It is, therefore, through the history of its exhibitions that the early fortunes of the association may best be followed.

III–VI Exhibitions

The Secession's third exhibition (12 January–20 February 1899) was unusual in that each contributor was allotted a room to himself. Two of the association's old friends from among the corresponding members, Max Klinger and Walter Crane, were again represented, the former with his enormous, religious-allegorical painting *Christ on Olympus* (Plate 38), the latter with studies for his frieze on the subject of Longfellow's ballad *The Skeleton in Armour*. The foreword to the catalogue contained the following description of *Christ on Olympus*:

Into the brightly coloured, cheerful world of the senses inhabited by the Olympians, there has suddenly irrupted a strange, stern apparition. With measured tread, dressed in a bright yellow robe, the founder of Christianity approaches Zeus, father of the gods, who is seated on a marble throne. Faced with this apparition, the hilarity of the gods is silenced as if by magic. In a flash, the realization has come upon Zeus that his dominion is at an end. Recoiled in stiff horror, he looks upon Christ, while Ganymede clings to him in fright. Eros turns with a gesture of distaste away from the earnest stranger, while Psyche sinks to her knees at the feet of Christ, with a gesture of humility laying her hands in his. Dionysus offers him a cup of nectar, which he solemnly rejects. Hera, Athene and Aphrodite, their divine dignity wounded, observe with an expression of the profoundest scorn the four female figures, clad in flowing garments, who bear the Cross, symbol of the Christian faith, behind its founder. Next to Zeus, with his back to the spectator, stands Hermes, and next to him Apollo, bearing his sister Artemis in his arms.[32]

Other participants included the Belgian Impressionist van Rysselberghe (an essay on Rysselberghe's work by the poet Emile Verhaeren appeared in the November issue of *Ver Sacrum* 1899), Constantin Meunier, and Eugène Grasset. A room

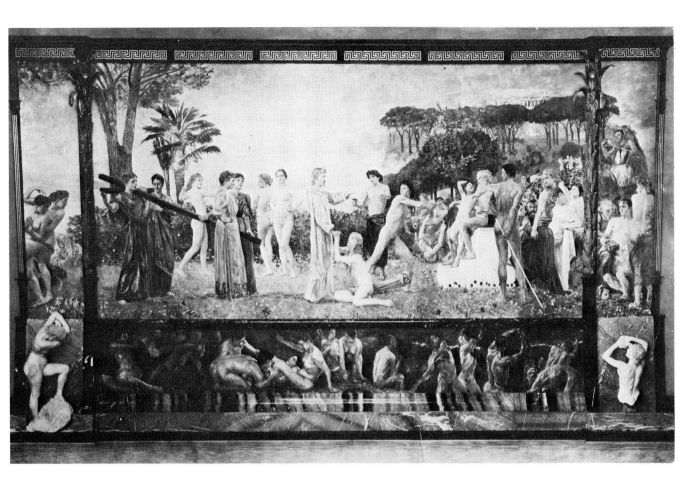

38. Max Klinger: *Christ on Olympus*, 1897 550 × 900 cm. Vienna, Kunsthistorisches Museum, on loan to Museum der bildenden Künste, Leipzig

was devoted to the work of the print-maker and graphic artist Félicien Rops, who had died the preceding summer. Engelhart, in a moving recollection of this great, often misunderstood artist, wrote of the unforgettable impression which Rops made on him:

His explanations of his drawings, which were at that time unable to be published on account of their excessively erotic character, were ready-made reviews—witty, intelligent, and filled with humorous charm.

His eyes glowed as he told of his journeys and his experiences. He spoke very simply, and with disarming good nature. The sarcasm which distinguishes his erotic compositions, the cynicism which they express became, in personal conversation, a high-spirited, superior understanding of human frailty.[33]

The fourth exhibition (18 March–31 May 1899) was again more traditional in character, consisting, like the first and second exhibitions, of a mixture of works by Austrian members of the Secession and by corresponding members from abroad. It took one important work as its centre-piece: the plaster *modello* of Arthur Strasser's monument *Mark Antony in his Chariot drawn by Lions* (a bronze cast of Strasser's work was shown at the Paris Exposition Universelle of 1900, and stands today beside Olbrich's Secession building).[34] Alfred Roller, who designed the poster for the exhibition (Plate 39), also showed the studies for his large mosaic *The Sermon on the Mount* for the Breitenfelder-Kirche in Vienna. There were, in addition, two important works by Klimt: his *Schubert at the*

Piano, commissioned by the patron Nikolaus von Dumba as a *sopraporta* for his music room (Plate 41), and the famous *Nuda Veritas* (Plate 40), acquired by Hermann Bahr, which bore as an inscription that apt quotation from Schiller: 'If thou canst not please all men by thine actions and by thine art, then please the few; it is bad to please the many.'

In retrospect, the first four exhibitions of the Secession must appear to us very much as a unity. Subsequent exhibitions were often to develop into something much more highly specialized, with the introduction of one-man shows, and also shows devoted to particular themes or particular kinds of art. Thus the fifth exhibition, which was open from 15 September 1899 until 1 January 1900, was remarkable for its time in that it was given over exclusively to drawings and graphics, largely by French artists, including Carrière, Renoir, Pissarro, Vallotton, and Puvis de Chavannes. Engelhart, who had recently been elected president of the Secession (Klimt had been president for the first two years of the association's existence; subsequent presidents 'reigned' for one year only), described the aims of this exhibition in the first issue of *Ver Sacrum* for 1900:

I for my part envisage the exhibition which we are planning as an exhibition not of graphics in the conventional sense, whereby drawings are presented as an end in themselves, but intend also that it should embrace drawing as an auxiliary of painting, and include therefore studies and sketches—i.e. graphics in the broad sense, the rendering of form in the plane. . . .

My purpose is to unite in this exhibition all these interesting efforts and results by French artists. It should, ultimately, also demonstrate that only knowledge of form can bring about that freedom the judicious employment of which distinguishes the work of art. One can hardly accuse the show of bias, and this seems to

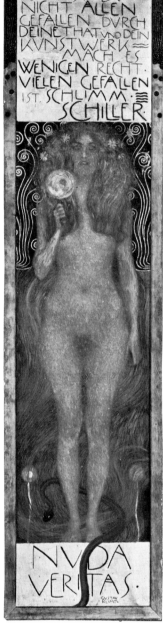

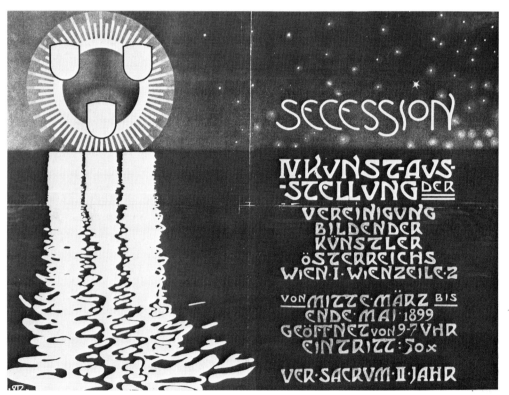

39. (*left*) Alfred Roller: *Poster for the fourth Secession exhibition*, 1899

40. (*above*) Gustav Klimt: *Nuda Veritas*, 1899. Oil on canvas, 252 × 56.2 cm. Vienna, Theatersammlung der Oesterreichischen Nationalbibliothek, on loan to Museum des 20 Jahrhunderts

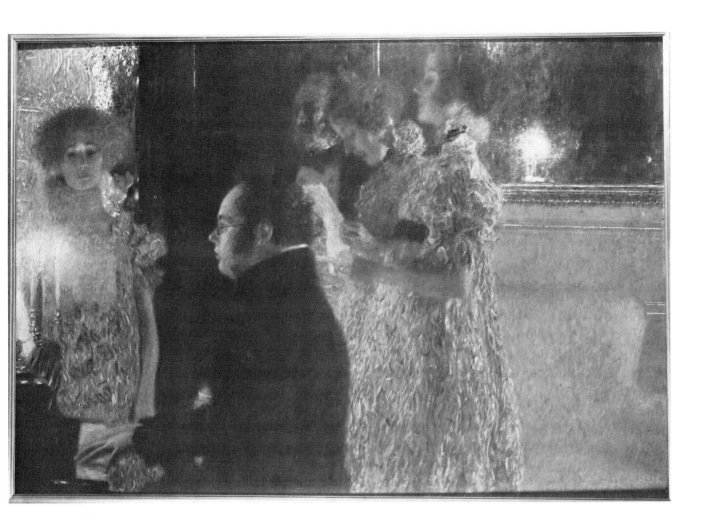

41. Gustav Klimt: *Schubert at the Piano*, 1899. Oil on canvas, 150 × 200 cm. Destroyed

me very important; for in my view, the necessary rejuvenation of the individual, and with it, of our association, can only be kept alive through variety.[35]

The exhibition was also remarkable in that the individual designers who participated in its arrangement—Hoffmann, Böhm, Moser and Auchentaller—were each allotted separate rooms out of which to create a suitable setting for the works displayed. Moser, in addition, designed for this exhibition one of the most beautiful of the early Secession posters (Plate 42). Despite its specialized nature, the show appears to have met with considerable success. Not so the sixth exhibition (20 January–25 February 1900), which was devoted entirely to Japanese art. The efforts of the association to bring to Vienna the foreign, the unknown and the exotic were met, on this occasion, with an evident lack of sympathy on the part of the Viennese public. A note in *Ver Sacrum* refers plaintively to the exceptionally low number of visitors. This exhibition is, none the less, worth remembering as one of the first serious attempts to draw attention to the relevance of Oriental art for the development of modern European painting.[36] It may also have awakened Klimt's interest in collecting asiatica; more than one later description of his studio in Hietzing refers to the collection of primitive, Oriental and exotic art which was to be seen there.[37]

If the sixth exhibition marked the first disappointment the Secession had to

SECESSION

V. KVNSTAVS=
STELLVNG DER
VEREINIGVNG
BILDENDER
KVNSTLER
OSTERREICHS

EINTRITT
50 KR

WIENZEILE·2

≡VER SACRVM II·JAHR

DRVCK v. ALBERT BERGER, WIEN 8.

42. Kolo Moser: *Poster for the fifth Secession exhibition*, 1899

face, the seventh (March–June 1900) signalled the outbreak of the first major scandal. Already, there had been ominous mutterings from press and public over the showing of Klimt's earlier works. Now, with the début of *Philosophy*, the first of the University Paintings, the storm broke.

The 'Klimt Affair'—The University Paintings

The history of the paintings goes back as far as 1891, the year in which the artistic commission of Vienna University submitted to the Ministry of Education plans for the decoration of the ceiling of the Great Hall, the Aula, of Heinrich von Ferstel's University building.[38] It was intended that the ceiling was to be adorned with oil paintings, not frescoes, which should apostrophize the university itself, its four faculties (Theology, Philosophy, Medicine and Jurisprudence), and narrate the history of its influence. The university authorities also suggested the names of several artists who might be invited to compete for the commission, among them Julius Berger, Franz Matsch, the brothers Gustav and Ernst Klimt, and Eduard Veith. The Ministry dismissed the notion of a competition, and in 1893 invited Franz Matsch to submit an overall programme for the decoration, a programme rejected by the artistic commission of the university on 9 November the same year. The Ministry of Education then asked Matsch and Klimt, whose earlier collaborative efforts had met with widespread official approval, to prepare a study for the central panel of the ceiling, proposing as the theme of the painting 'The Victory of Light over Darkness'. This study, together with two further sketches, was approved both by the Ministry and by the artistic commission of the university in the summer of 1894, and in September that year the commission for the central panel, the four smaller canvases representing the four faculties, and sixteen lunettes was awarded to the two artists jointly. It was, however, understood that there was to be a division of labour: the centre-piece and the panel representing Theology went to Matsch, while Klimt was to execute the three remaining *Fakultätsbilder*; of the lunettes, Klimt was allocated ten, Matsch six. With this division, the seeds of future disaster had already been sown. As early as May 1898, when the sketches for the centre-piece and the four *Fakultätsbilder* were submitted to a joint sitting of the artistic commission of the university and the fine arts commission of the Ministry of Education, difficulties arose; although specific criticisms were directed at Klimt, rather than at Matsch, both artists were forced to declare themselves ready 'within the limits of artistic freedom' to undertake such alterations as were deemed necessary to ensure the stylistic unity of their contributions. But it was not until the first full-size version of Klimt's *Philosophy* (Plate 46) was shown at the Secession in March 1900 that it became apparent that its author had embarked upon a new, entirely different course. The critic Richard Muther, who saw the picture on this occasion, has left us the following description of its impact:

Here, Klimt has surpassed himself; the commission gave added strength to his inspiration. How easily, how conveniently one might, in the event, have carried out such a commission. The painter takes the treasury of Classical forms, chooses one of the numerous female figures which, since the time of Raphael, have been decked with the label of Philosophy, alters it a little so as not to appear a mere copyist, and has thus fulfilled his task to the satisfaction of all concerned. For works which take as their starting point the accepted, the Classical, can be sure of success, despite the fact that their historical significance is nil. . . . Klimt, on the other hand, has copied no one, has borrowed no antique model. Out of his own, independent pondering he has created a work in which the whole weight of thought, the whole colouristic nervosity of our times are embodied. The Heavens open. Golden and silver stars twinkle. Points of light shimmer. Naked forms waft hither. The green mist gathers itself into tangible forms. A fiery head, wreathed in laurels, regards us with large, earnest eyes. Science struggles to attain the source of Truth, which remains none the less the imponderable Sphinx. We aspire to lift the veil, dare to take flight amidst the clouds. But the feeling of ignorance drags us back to earth.[39]

Muther's assertion regarding the originality of Klimt's painting may, at least on stylistic grounds, be met with a measure of scepticism. Like *Pallas Athene*, *Philosophy* shows distinctly the influence of contemporary German and Belgian Symbolist painting, especially the work of Khnopff (Plate 45). (Khnopff was one of the most significant 'corresponding members' of the Secession; a whole issue of *Ver Sacrum*, in December 1898, was devoted to reproductions of his works.) The figure of Philosophy herself, who, silent and wide-eyed, stares at the spectator from out of the lowest part of the picture, is strongly reminiscent of the Belgian artist's allegorical female portraits of this period; interestingly, Klimt's *première pensée*, which presented Philosophy as a seated female figure seen in profile, head in hand in the pose conventionally associated with reflection (Plate 44), is far more traditional in character than the frontal, staring face found in the final version of the picture. There is also a more immediate, local source for the compositional *concetto* the artist here adopts: Hans Canon's ceiling painting *The Circle of Life* in Vienna's Naturhistorisches Museum (Plate 47), a picture which Klimt would certainly have known at first hand. Not only the interwoven chain of human figures, but also many of the iconographic details of Klimt's *Philosophy* (the Sphinx, the globe) may with some certainty be traced back to Canon's painting.[40] By comparison, however, with Canon, Klimt presents us with an altogether unfamiliar, overtly pessimistic view of human existence. If the figure of Philosophy herself, crowned with laurels and wreathed in a veil, may be regarded as a symbol of that inalienable striving towards the mysterious, the transcendental, which characterizes much of Viennese *fin de siècle* art, if the strange glow which emanates from the Sphinx-like figure symbolizing Knowledge (or, according to Hevesi, the 'World Mystery') may be seen as an exhortation to pursue the search for truth, it is none the less the column of naked figures occupying the left-hand part of the composition, their tortured flesh and tragic mien representing, in Hevesi's words, 'desire and torment, toil and struggle, the striving, creative, suffering face of existence',[41] which remains the most striking pictorial

43. Vienna University, ceiling of the Aula. Reconstruction by Alice Strobl of the intended appearance, had the University Paintings been installed. Originally reproduced in *Albertina Studien, II* (1964), iv

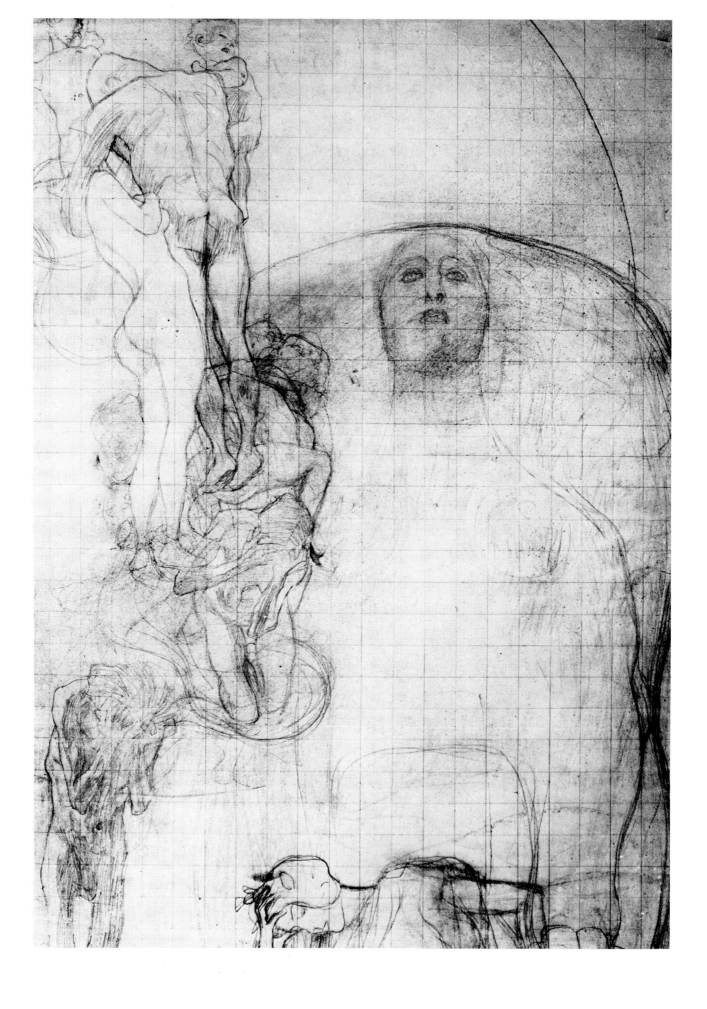

44. (*left*) Gustav Klimt: Composition drawing for *Philosophy*. Vienna, Historisches Museum der Stadt Wien

46. (*right*) Gustav Klimt: *Philosophy*. Oil on canvas, 430 × 300 cm. Exhibited at the seventh Secession exhibition, 1900. Ceiling painting for the Aula of Vienna University. Destroyed

45. Fernand Khnopff: *Suspicion*. From *Ver Sacrum*, *I* (1898), xii

image. Other critics, too, emphasized the essentially pessimistic mood of Klimt's allegory. The anonymous reviewer of the German periodical *Die Kunst für Alle*, for example, wrote:

The picture shows how humanity, regarded merely as a part of the cosmos, is nothing more than a dull, unwilling mass, which in the eternal service of pro-creation is driven hither and thither as if in a dream, from joy to sorrow, from the first stirrings of life to powerless collapse into the grave. Between lie only the brief

intoxication of love and the pain of separation. But love too is a disappointment, as joy and as experience. Only destiny remains always the same. Apart from the frigid lucidity of knowledge, apart from that cosmic mystery which remains ever veiled, humanity engages in the struggle for joy and for experience, remaining however no more than a tool in Nature's hands, exploited only for her immutable purpose, that of procreation.[42]

Philosophy unleashed the fury both of the public and of the popular press. In the face of such attacks, it is almost incomprehensible that Klimt was able to continue work on the other paintings of the series with apparent unconcern. It is an object lesson in the history of criticism to examine some of the more acri-

47. Hans Canon: *The Circle of Life*, 1884–5. Ceiling painting. Vienna, Naturhistorisches Museum

monious contemporary reviews of the exhibition, gathered together by Bahr in his book *Against Klimt*:

Even if we may willingly admit that anyone who studies thoroughly the different systems even of German philosophy alone must suffer an attack of mild insanity, none the less, there is no reason why Herr Klimt should inflict this painted madness upon us. ... If, in a word, a painter like Klimt, listening to the whispers of false friends and desiring a momentary *succès de scandale*, creates works which he can hardly defend before his own artistic conscience, then in truth, that is Klimt's transparent 'Philosophy'. ...

There has been so much talk of this picture that there are people who actually believe that it conceals a profound philosophical meaning. It is nothing but nonsense, translated into the medium of paint and executed upon a large canvas. ...

For us, it is a question of whether Klimt's painting has any artistic significance. The answer is no. And that's all there is to it. ...[43]

Strangely, Bahr neglected to include one of the most vitriolic of all the attacks on Klimt, that by Karl Kraus*, which appeared in the March issue of Kraus's periodical *Die Fackel* (The Torch):

His painting is the delight of the colour-blind, and all those who have no conception of philosophy applaud the profundity of his allegorical depiction. ...

The professors who protested against displaying *Philosophy* in the Aula of the university are, of course, presumptuous laymen, and need to be put right by critics who, after conquering all those difficulties which accumulate in two years of grammar school (or is it three years of primary school?) have penetrated the essence of painting and philosophy.[44]

Certain of the points raised by contemporary criticisms of Klimt's *Philosophy* at least merit more serious consideration. One of the most frequent observations about the painting was that it would have formed a less than harmonious contrast with the richly gilded decoration of the ceiling of the university Aula. This view was forcefully expressed in the petition, to which Kraus refers, addressed by a number of professors of all faculties of the university to the Minister of Education, Wilhelm von Hartel, the purpose of which was to prevent the placing of *Philosophy* in its intended setting. As some wit put it: 'With regard to Klimt's painting ... the university professors have taken the only possible stance—with their backs to the picture.' Another objection, already implied by the resolution of the artistic commissions of the ministry and of the university at their meeting of May 1898, was that the styles of Klimt and Matsch had become so fundamentally at variance that no satisfactory ensemble could any longer be expected to result from their collaboration. (One of Kraus's more reasoned criticisms was that Klimt had 'failed to accommodate himself' to Matsch's style.) Nor can Klimt's design be considered, properly speaking, as suitable for a ceiling painting; the

*Possibly because Kraus was no less abusive about Bahr himself; the phrase which occurs in the accompanying review 'after conquering all those difficulties which accumulate in two years of grammar school' is a reference to Bahr's book *The Conquest of Naturalism*.

height of the hall, some forty-five feet, would certainly have robbed *Philosophy* of a considerable part of its intended effect. Even Muther, who as we have seen wrote favourably of Klimt's painting, remarked:

In his picture, there is nothing but wafting and waving, trembling and shimmering. Ceiling paintings, on the other hand, are a kind of monumental poster. They best fulfil their purpose by working with strong colour contrasts or powerful, heraldic lines. Michelangelo had the same experience with the Sistine ceiling. Having begun by depicting scenes containing numerous figures, he later found that he had to limit himself to fewer and larger figures, because his paintings, seen from below, did not produce their intended effect. Klimt will perhaps be forced in his later paintings to make similar alterations if it transpires that *Philosophy*, once in position on the ceiling and observed from a distance, appears as nothing more than a blue-green chaos.[45]

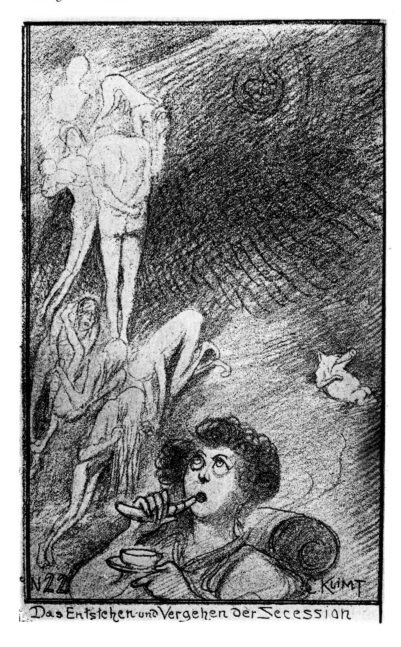

48. Caricature from *Figaro*: 'The rise and fall of the Secession'. A satire on Klimt's *Philosophy*.

Meanwhile, in the midst of this storm of disapprobation, Klimt's friends and supporters were far from idle. On 27 March, three days before the publication of the 'protest of the professors', the Secession ostentatiously laid in front of Klimt's work a wreath bearing the motto of the association: *Der Zeit ihre Kunst, der Kunst ihre Freiheit*. The petition also called forth a spirited rebuke from the professor of art history, Franz Wickhoff, who, in a telegram sent from Rome to the rector of the university, Wilhelm Neumann, declared in no uncertain terms that he held the latter responsible for the agitations of his more reactionary colleagues. Wickhoff, in addition, gave a lecture on 9 May 1900 to the University Philosophical Society defending Klimt's painting, under the provocative title 'What is Ugly?' The editorial board of *Ver Sacrum* were no less vocal in their counter-attack. The tenth issue of the journal for 1900 included an article 'Klimt's *Philosophy* and the Protest of the Professors', in which was quoted Lichtwark's famous dictum:

If someone adopts the well-known and often heard expressions 'I demand from the artist', 'the artist should', 'the artist must', this proves that he has no idea how the work of art comes into being. He may approach the applied arts, which exist for his service, with such demands, he may ask such things of the broad mass of artistic production, saleable wares which cater for an existing need. But no one in the world has any need of the work of art before it comes into being, with the sole exception of him who creates it.[46]

But by far the most moving and most beautiful defence of Klimt came from Hermann Bahr who, in a lecture given in the Bösendorfersaal for the writers' association Concordia, paid eloquent tribute to the artist whose work had called forth such bitter controversy:

The noise of hatred and envy, howling on the streets, reaches him only as if from a great distance, peaceful and good-natured, wreathed round with dreams. Perhaps he doesn't even hear it; or if he does, he just smiles sympathetically, for he has the remarkable assurance of all great men. . . . Praise and blame can give him nothing, take nothing from him. . . . The delights which he attains in the act of creating, when he sees his forms for the first time and, struggling with them, finally masters them, are so intense, so powerful that everything this world can offer, this little fame, honour, or miserable reward, laughable by comparison, totally vanishes. No, it is not a matter of him, but rather of us. It is not he who is threatened, but ourselves. Nothing can happen to him, but we shall become the laughing-stock of Europe.[47]

Philosophy was to be seen at the Secession exhibition only until the end of March. It then travelled to Paris, where it was shown in the Austrian pavilion at the Exposition Universelle, and was awarded the Grand Prix. Felix Salten later commented on Klimt's work:

Gustav Klimt is a Viennese. One can see this clearly from his pictures; it is expressed by their wholly individual, Viennese feeling. But one can also tell that Klimt is a Viennese from the fact that he is honoured throughout the world, and attacked only in Vienna.[48]

The second of the University Paintings, *Medicine* (Plate 49), was exhibited at the tenth Secession exhibition (15 March–12 May 1901). Here, for the first time, Klimt's admirers had the opportunity of judging whether he had been able to continue upon the same level of inspiration as in the earlier painting.[49] They were not disappointed. The two pictures are in fact closely related in their pictorial conception. In *Philosophy*, the struggling chain of humanity is juxtaposed with the veiled figure which rises out of the lowest part of the painting; in *Medicine*, the same human chain, here representing the various stages of earthly development (a theme which Klimt was also to treat in his later canvas *The Three Ages of Man* of 1905), looks for salvation to the figure of Hygeia (Plate 7), likewise rising out of the depths, bearing with her the miraculous healing power of Medicine. Ernst Stöhr wrote in *Ver Sacrum*:

Between Birth and Death, Life plays itself out, and Life itself, on its way from the cradle to the grave, brings with it that profound suffering for which Hygeia, the miracle-working daughter of Aesculapius, has found the mild and healing salve.[50]

Medicine was accorded a similar response to that which had greeted *Philosophy*. The scandal attained such proportions that questions were asked in Parliament, where the Minister of Education was forced to defend the original commission for the paintings. We reproduce here further excerpts from contemporary judgements, which for the most part emphasized the adverse reaction of the public:

Not everyone is a Richard Wagner simply because a couple of his works have been failures, nor a Böcklin, because he paints pictures which the public doesn't like ... these two symbolistic pictures are an affront to good taste, unsuitable for the location for which they were intended. ... The figures represented in these pictures might be suitable for an anatomical museum, not, however, for one of the public rooms of the university ... where they must, on account of their crudeness of conception and aesthetic deficiency, offend the general public. ...

In fact, [*Medicine*] surpasses in strangeness and monstrosity even the much disputed *Philosophy* by a considerable way. ... It is impossible to look at this picture without thinking of Zola's novel *L'Oeuvre*, with its tragic ending, in which the brilliant Claude, driven insane by failure, wants to unite the whole world and the whole of humanity in one picture. ...

Well, gentlemen, this is *Medicine*, Herr Klimt's latest work of genius ... now I beg you to try and think something sensible in front of this picture. I can't—the walls are turning, and my stomach too. Help, where's the emergency exit? ... Thank God, it's passed; *Medicine* has had its effect.[51]

Again, it is worth singling out at least one criticism for closer examination—that concerning the immoral or pornographic nature of Klimt's work, an accusation levelled at the artist both on this and on subsequent occasions. The anonymous critic of the *Salonblatt* wrote, for example, of that 'artistic licence' which served as the pretext for the introduction of offensive subject-matter into art, and continued:

49. Gustav Klimt: *Medicine*. Oil on canvas, 430 × 300 cm. Exhibited at the tenth Secession exhibition, 1901. Ceiling painting for the Aula of Vienna University. Destroyed

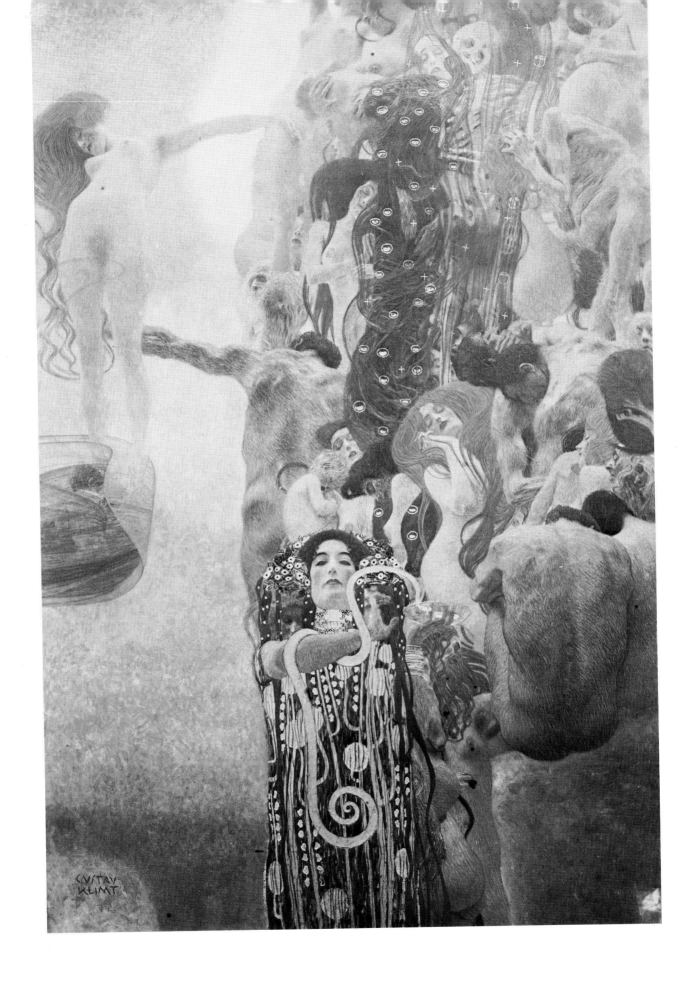

I should like to know what father, brother, or husband were able to take his daughter, sister, wife to the present Secession exhibition, and not be forced to leave the building in a state of acute embarrassment.[52]

In this particular instance, it is clear that Klimt's crime was to have ignored what one might call the canons of academic nudity. The standing female figure which occupies the upper left-hand part of *Medicine* contradicts, in its scathingly observed realism, the naturalistic conventions of Neo-Classical and Romantic painting upon which, for the most part, official taste was still nurtured. Indeed, this figure itself became an object of controversy, the academic authorities demanding that, if the figure had to be female, then it should be clothed, or, if it was unavoidable that it should be naked, then the artist should be made to substitute a male figure instead (an old photograph of an intermediate state of *Medicine* in fact shows the female figure draped). In more general terms, however, it was Klimt's preoccupation with the whole subject of female sexuality which frequently caused offence. This preoccupation plays an undeniably important role in his public, and still more in his private work; it is significant that, in his only attempt to characterize his own artistic personality, he wrote of his comparative lack of interest in 'my own person as the "subject of the picture", I am more interested in other people, above all, women'.[53] Sadly, many of Klimt's most beautiful drawings, particularly of his later period, are rarely exhibited, owing to their overtly erotic content (Plate 50).

Accusations of pornography appear to have disturbed Klimt but little. The writer Bertha Zuckerkandl tells of a significant later incident:

One morning there appeared in the *Neue Freie Presse* a review by their critic A. F. Seligmann of the exhibition in the Miethke Gallery, in which Klimt was described as a pornographer.

It was not yet midday when, without any previous arrangement, the closest members of Klimt's circle of friends came one after another and knocked on the firmly locked door of the studio in the Josefstädterstrasse. The same question was in everyone's mind: what did Klimt intend to do now? One friend gave voice to all our thoughts 'you must sue for libel'. And a well-known defence lawyer, who happened to be present, gave his opinion as follows, 'There's no judge and no jury who, confronted with this libel, could fail to decide in your favour'.

Klimt had been listening quietly, still working away at his easel. 'Herr Doktor', he now asked, 'how long would an action of this kind last?'. 'About two days', came the answer. 'But children', cried Klimt, 'I could spend those two days painting!' And that was an end of the matter.[54]

Jurisprudence, the third of the *Fakultätsbilder*, is discussed below; it seems, however, appropriate at this point to sketch briefly the subsequent tragic history of the paintings. *Philosophy, Medicine* and *Jurisprudence* were shown together for the first time at the Klimt collective exhibition at the Secession in 1903, and were approved by the artistic commission of the Ministry of Education. But Klimt, despite his usual imperviousness to criticism, had been cut to the quick by the vicious attacks to which he had been exposed, and by the continuing doubt as to the ultimate fate of his paintings. In 1904, he renounced the commission for

60. Gustav Klimt: *Reclining Woman*. Drawing. Vienna, Historisches Museum der Stadt Wien

the lunettes; finally, in a letter of 3 April 1905 to the Ministry of Education, he wrote:

His Excellency, Minister Dr von Hartel, has given me from his actions clearly to understand that my work has now become an embarrassment to those who commissioned it. If this task, which has consumed years of work, is ever to be completed, then I must seek to derive from it once again some satisfaction, and such satisfaction is totally lacking as long as, under the present circumstances, I must continue to regard it as a State commission. I am, therefore, faced with the impossibility of bringing this task, which is already so far advanced, to completion.[55]

With the help of the industrialist August Lederer, Klimt was able to repay the advance of 30,000 crowns which he had received for the pictures. Lederer acquired *Philosophy*, which Josef Hoffmann built into one of the rooms of the former's flat in the Bartensteingasse; *Medicine* and *Jurisprudence* were bought by Kolo Moser. The three paintings were again shown together in 1907 at the Galerie Miethke in Vienna, and at Keller and Rainer's in Berlin. The last occasion on which they were seen by the public was at the memorial exhibition held in Vienna in 1943 to commemorate the eightieth anniversary of the artist's birth. Any hopes there might have been of preserving them for the Austrian nation perished two years later in the flames of the Schloss Immendorf, where many of Klimt's

most important paintings, among them many works belonging to the Lederer family, including the two *sopraporte* painted for Dumba's music room, *Musik II* and *Schubert at the Piano*, had been evacuated for safe-keeping. Retreating S.S. troops set fire to the castle to prevent it falling into enemy hands. It was the most significant artistic loss suffered by Austria in the Second World War.

Exhibitions, 1900–1902

Quite apart from the scandals occasioned by the showing of Klimt's works at the seventh and tenth exhibitions, the years 1900–2 witnessed some of the most sensational shows in the early life of the Secession—shows remarkable for the participation of many of the major figures of the European *avant-garde*. Already at the seventh exhibition, there were to be seen in addition to the works by Klimt paintings by Khnopff and Toorop, Stuck's famous *Wild Chase*, and, of particular interest, a group of works by the Neo-Impressionist painter Paul Signac. The hanging of Signac's works apparently posed certain problems; the artist sent the secretary of the association, Franz Hancke, a long letter and a coloured diagram explaining how he had envisaged the relation between the various sizes and colour tonalities of the different pictures, and arguing for the inclusion of a group of watercolours which he had sent unasked:

I find, moreover, that there is in an exhibition of paintings nothing more agreeable than if the eye can find repose in the blacks and whites of drawings, or the pale tints of watercolours.[56]

The eighth exhibition (3 November–27 December 1900) was devoted principally to the applied arts. The current issue of *Ver Sacrum* declared:

Those who have attained the heights of civilized refinement in their daily life, even if they have otherwise little time for art, make certain demands upon the things which serve them, upon their whole environment, demands which can only be satisfied with the aid of art. This fact makes it unnecessary for us to indulge in tedious discussions as to the praiseworthiness of modern tendencies in design, or the right of modern artists' associations to arrange exhibitions of applied art.[57]

The organization of the show was mainly the responsibility of Hoffmann and of Felician von Myrbach, another founder-member of the Secession, and from 1899–1905 director of the Kunstgewerbeschule. Their aim was to introduce to Vienna the work of some of the foremost designers in Europe. The van de Velde-inspired *Maison Moderne* from Paris and Ashbee's Guild of Handicrafts were both represented, as were the artists of the Glasgow School: Charles Rennie Mackintosh, his wife Margaret Macdonald and the MacNairs. Room x of the exhibition, the layout of which was designed by Mackintosh and his wife, was set aside for their collection (Plate 51). This show marked the beginnings of cordial relations between the Secession and the British artists, who had been invited to Vienna specially for the occasion:

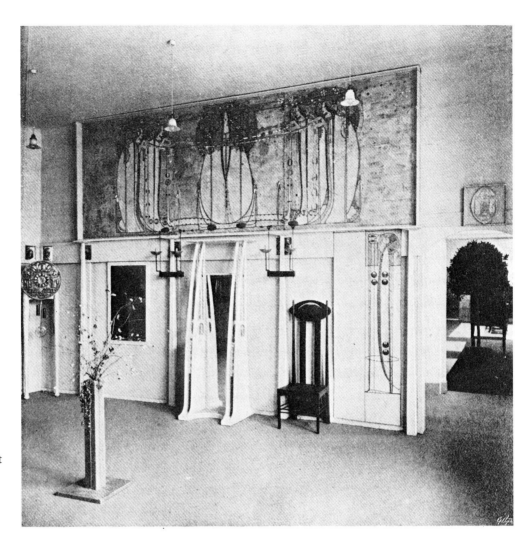

51. Photograph showing part of the Mackintosh room at the eighth Secession exhibition. From *Ver Sacrum*, *III* (1900), xxiv

Letter of C. R. Mackintosh to the committee of the Secession, 17 December 1900:

We feel very much indebted to you for . . . the honours you and your colleagues have offered us, and we will always remember with pleasure your kindness to us when we were in Vienna.

I know well the artistic achievement of your exhibition. I hope it is receiving that public recognition and support which it deserves.

> With kind regards,
> I am
> Yours sincerely,
> Chas. R. Mackintosh[58]

The British section made a profound impression upon the Viennese public. Of the critics, Hevesi was particularly taken with Ashbee's designs; in a review of the exhibition, he wrote:

Next to the Viennese, on this occasion a mixture of Wagner's complex splendour, Hoffmann's elegant logic and Moser's poetic refinement, it is extraordinary how

Ashbee's furniture designs stand out. As if they came from a rectangular planet
... everything vertical, at right angles, ninety degrees.[59]

If Ashbee's designs were unlike anything else shown at this exhibition, there was,
on the contrary, a manifest similarity between the work of the Glasgow school
and the elegant, decorative style of Hoffmann and Moser, with its contrasting
use of black and white—a similarity which is hardly surprising when one re-
members the vogue enjoyed by British designers on the Continent at this time,
especially in Germany. But Hoffmann, in particular, also seems to have admired
Ashbee's work; he signalled this admiration by buying one of the British artist's
salt cellars and spoons.[60] There were also more significant acquisitions. Hugo
Henneberg, for whom Hoffmann designed a villa in the suburbs of Vienna, bought
a cabinet by Mackintosh for his new home, as well as a writing-desk by Hoffmann.
The Minister of Education, von Hartel, bought a sideboard by Moser, entitled
The Miraculous Draught of Fishes (Plate 52). And Fritz Wärndorfer, who later
financed the foundation of the Wiener Werkstätte (see below, p. 132), bought a
silver brooch by Mrs Mackintosh, a drawing and two prints; he also commissioned
from Mackintosh designs for a music room, and from Hoffmann designs for a
new dining-room for his house, which rapidly became an object of pilgrimage
for amateurs of the modern movement in interior design.

After the eighth exhibition, the next few shows organized by the Secession again
manifest a certain change in direction, laying greater emphasis upon contributions
by Austrian members of the association, and upon the work of individual artists.
Thus, the ninth exhibition (13 January–28 February 1901) had as its centre-piece
a memorial show of works by the painter Giovanni Segantini, one of the protégés

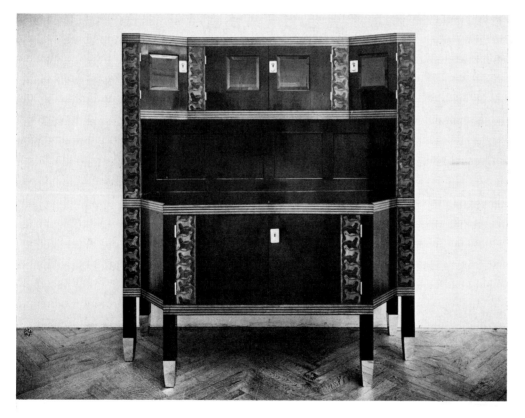

52. Kolo Moser: *Sideboard,
'The Miraculous Draught of
Fishes'*. Vienna, Museum
für angewandte Kunst

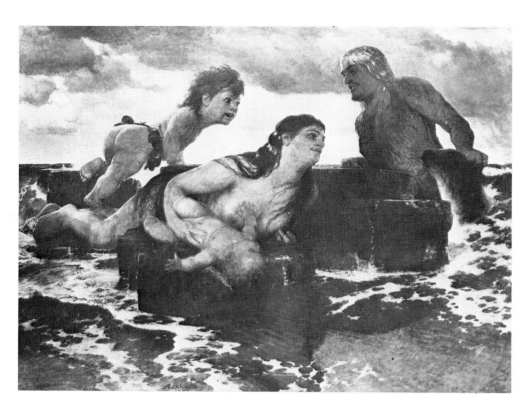

53. Arnold Böcklin: *Sea
Idyll*, 1887. Vienna,
Kunsthistorisches Museum
(Moderne Galerie)

of the Secession, who had recently died. A showcase contained the artist's last
letter to the editors of *Ver Sacrum* (the magazine had the previous year devoted
a whole issue to Segantini's work), together with a spray of Alpine flowers which
he had sent as a gift to his colleagues. The plaster model for Rodin's *Burghers of
Calais* was among fourteen items by the French sculptor which were also shown
on this occasion. The tenth exhibition, at which Klimt's *Medicine* made its début,
was a purely Austrian affair—the first time that corresponding members from
abroad were not represented. The catalogue foreword explained:

If we appear on this occasion without foreign guests, it is not because we mean
to celebrate a goal already attained, but because we wish to demonstrate our own
origins, the point of departure of our own creativity.[61]

The eleventh exhibition was devoted entirely to the work of the painter Johann
Viktor Krämer—the only one-man show during the early years of the Secession
apart from the sixteenth exhibition (1903), which was a collective show of Klimt's
works. The twelfth and thirteenth exhibitions included works by Munch, Toorop,
Hodler (whose pictures exercised a profound influence upon Klimt), Böcklin
(whose *Sea Idyll* was bought at the thirteenth exhibition by the Ministry of
Education) and Emil Orlik, who at the same exhibition showed a number of
pastels, watercolours and woodcuts from his recent voyage to the Far East. The
arrangement of the thirteenth exhibition, for which Moser was responsible,
marked a step towards greater informality; the review in the *Studio* refers to 'soft
and low old English couches in old red, and equally tempting armchairs, all
hidden in niches, such as one would naturally seek for a *tête à tête*'.[62] The reviewer,
A. S. Levetus, was less enthusiastic about the hanging of *Sea Idyll* (Plate 53),
which, 'built into a kind of easel stand, must needs, by the prominent position it

is placed in, cast shadows on the portraits hung "behind its back"'. But if she was in some doubt about the hanging, Levetus had no doubts as to the quality of the paintings by Klimt shown at this exhibition. Part of her review, one of the first really sensitive appreciations by a foreign critic, is worth quoting for its marvellously evocative description of Klimt's achievement as a colourist:

There are fewer portraits than usual. In fact, they are almost absent. Klimt, however, shows an unfinished picture of *A Lady*, clad in misty pearly grey, so delicately depicted that she seems enveloped in a cloud with a silver lining. Klimt also shows four other works: *A Forest of Fir Trees*, *Still Water*, *Seashore*, and *Gold Fish* (Plate 54). . . . In the *Forest* the artist shows us a long line of firs with their misty tints of blues and greens and browns, with the sun in the distance shedding his light upon them. We see the irregularity of trees, and recognize them as we have seen them in the Bohemian woods. *Gold Fish* is evidently destined for a decorative panel. . . . Throughout there is a tone of gold, and the fish seem swimming in the water, their fins move, their scales glisten, and a mermaid is playing with them as they swim by. Everything seems in a whirl, and other mermaids in the distance help to create a kind of intoxicating eddy. Here, too, the colouring is peculiar to Klimt, the delicate airiness which seems as if no brush had ever touched it, only a slight whiff—a puff, and the colour is there.[63]

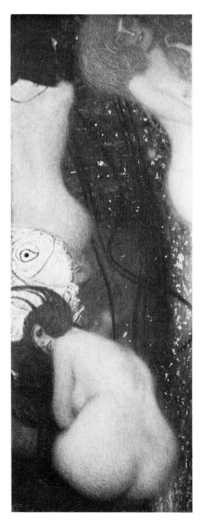

54. Gustav Klimt: *Gold Fish*,
1901–2. Oil on canvas,
181 × 66.5 cm. Solothurn,
private collection

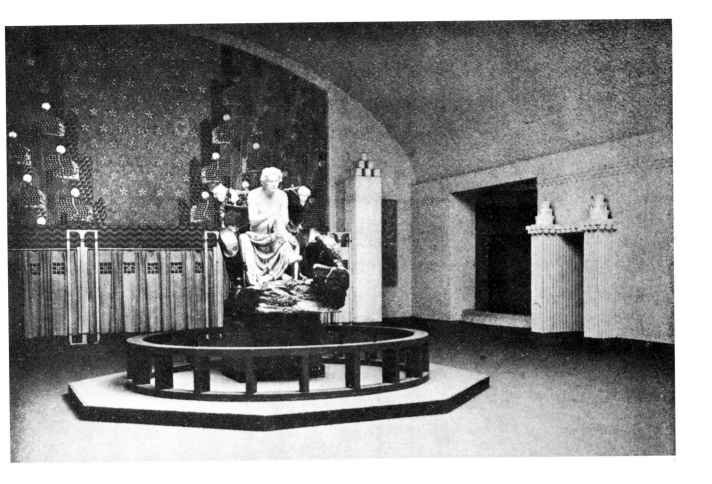

55. Alfred Roller: *Sinking Night*. Mural decoration for the central room of the fourteenth Secession exhibition, 1902. Max Klinger's statue of Beethoven is in the foreground. From *Ver Sacrum, V* (1902), p. 167

Beethoven 1902

Not all the later exhibitions of the Secession were to follow upon lines already laid down. The fourteenth exhibition (15 April–27 June 1902) differed dramatically from earlier shows in that its *raison d'être* was the presentation of a single work: Max Klinger's monumental polychrome sculpture of Beethoven (Plate 55). The friendly relations between the Secessionists and the Leipzig artist dated as far back as the very first exhibition in the Gartenbaugesellschaft; now, the Austrians felt it was time to give tangible expression to the reverence with which they regarded their older colleague. The foreword to the catalogue of the exhibition relates:

In the summer of last year, the association decided to interrupt the customary succession of exhibitions of pictures with a show of a different kind. . . . Our hope was to be able to make an outstanding work of art the centre-piece of our exhibition. Max Klinger's Beethoven monument was nearing completion. This hope, to provide a worthy setting for the profound and wonderful reverence which Klinger, in his monument, expresses for the great Beethoven, sufficed to call forth that *joie de travail* which, despite our knowledge that we were creating but for a few days, evoked lasting dedication to the task in hand. Thus came into being this exhibition, which one should not brand with the accusation of mere transitoriness.

We are well aware that this enterprise of ours is only an experiment, just as we know only too well with what self-sacrifice on the part of the individuals con-

cerned, and with what limited means, we have to work. Hoffmann, who was made responsible for the artistic organization of the whole, was obliged, therefore, to orchestrate this mighty chord in the simplest possible way, and yet to attempt to prepare one for those riches which shine like the jewels in Klinger's monument. May this exhibition be thus an act of homage to Max Klinger who, both through his creative activity and through his writings, has illuminated our whole view of art.[64]

This reverence felt by the Austrian artists extended to every aspect of the show. In order to allow Klinger's sculpture to create the maximum effect, Hoffmann, in one of the most successful of all his exhibition designs, transformed the Secession building into a kind of temple, adopting a three-naved arrangement which allowed the viewer glimpses of the *Beethoven* through apertures in the walls of the side rooms, but which forced him to approach the centre-piece of the exhibition by a roundabout route (J. A. Lux, Otto Wagner's biographer, likened the central room of the building to a 'sanctuary . . . which the visitor may not enter unprepared').[65] The catalogue, which from the point of view of typography and design likewise represents one of the Secession's outstanding achievements, reproduced in deference to Klinger's role as educator an extended extract from the master's treatise *Malerei und Zeichnung* (Painting and Drawing). There was also a private view at which Klinger himself was welcomed as guest of the association by the strains of Mahler's rearrangement of part of Beethoven's Choral Symphony. This private showing was followed by a 'Klinger Banquet' at the Grand Hotel, which brought together the artists and friends of the Secession, with Klinger and Klimt at the head:

The two masters sat next to one another. Two marvellous heads, which bore upon their expressive faces the stamp of powerful personalities. Klinger's face, with its halo of white hair and beard, had a fiery, youthful glow, and his small, narrow eyes sparkled. Gustav Klimt, with his brown face, his dark beard and somewhat lighter hair, presented a picture of blossoming health and exuberant strength. His being exuded *joie de vivre* and peace, the peace of a man who works hard and for once permits himself repose from all his labours. . . . There were many speeches and Emil Orlik, who had just come back from Japan, proposed a toast in made-up Japanese. Klinger spoke only a few words, expressing his thanks for the sympathy with which he had been greeted here in Vienna among artistic circles. Here, in this room, was true understanding, true harmony.[66]

One may wonder today what it was about Klinger's monument which was able to arouse the enthusiasm of the Viennese *avant-garde*. In his work in general, one can detect little which might lead one to dream of the existence of any kind of profoundly revolutionary content. One can, however, in the case of the *Beethoven*, point to the influence which his use of materials such as ivory, mother of pearl and semi-precious stones, the mixture of techniques out of which the sculpture was created, may have had upon Klimt. Klinger also appears to have influenced Klimt in other ways—especially in the form of allegory which he employs, the expression in symbolic-naturalistic terms of a grandiose, abstract philosophical conception. Contemporary critics, too, pointed to the abstract nature of the

Beethoven, 'no music paper, no music stand, no lyre, nothing to denote the musician. And yet everything is calculated for its musical effect, in order to be for the eye what Beethoven's compositions are for the ear, *visible music*'.[67] This abstract conception was also expressed by the murals which adorned the great central room of the exhibition building, in which Klinger's monument occupied the place of honour. 'Here', wrote Lux, 'any reminiscence of Nature, of the model, of anything human is banished, dissolved in merely decorative, almost geometrical forms, in which the lines of the human figure are indicated in a merely schematic fashion. Nature has become a symbol, in order not to disturb the spiritual unity of this work of architectonic fantasy'.[68] Among the other works created specially for the occasion, Hoffmann executed a number of what appear from contemporary photographs to have been completely non-representational sculptures, now lost (Plate 56).

One curious feature of this exhibition was its purposely ephemeral character, the policy of self-effacement adopted by the Austrian members of the Secession. As the catalogue makes clear, the works which they had contributed had been created solely to form a background to Klinger's monument, and were intended to last no longer than the exhibition itself; thus, not only Hoffmann's sculptures, but the great murals by Roller (Plate 55), Böhm (Plate 57) and Andri, and much more besides, were all destroyed when the exhibition closed. However, there were from the beginning protests at the suggestion of destroying the monumental fresco with which Klimt had decorated the long room to the left of the main entrance of the Secession building, the *Beethoven-frieze* (Plate 56), an enormous composition stretching over three walls, consisting of six plaster panels, painted in casein colours and decorated with gold and semi-precious stones. Of the

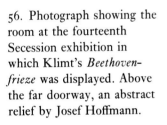
56. Photograph showing the room at the fourteenth Secession exhibition in which Klimt's *Beethoven-frieze* was displayed. Above the far doorway, an abstract relief by Josef Hoffmann.

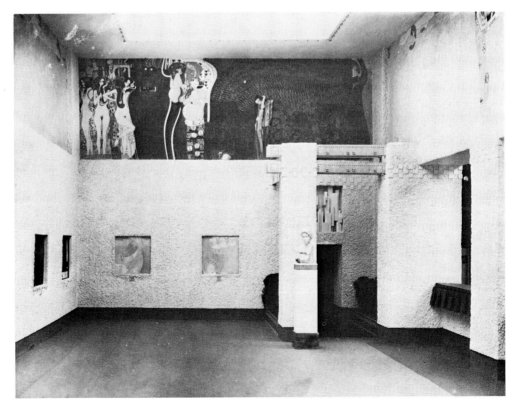

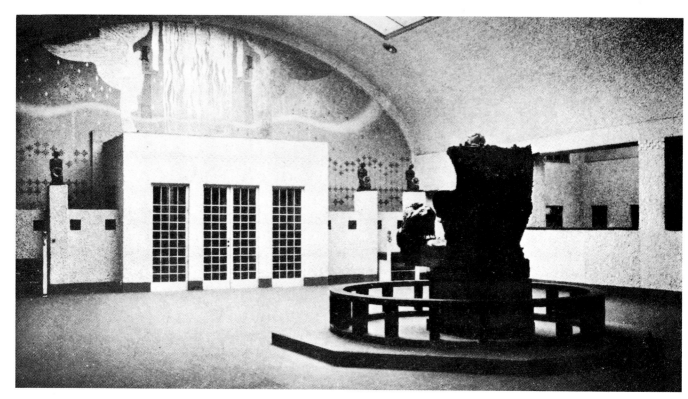

57. Adolf Böhm: *Dawning Day*. Mural decoration for the central room of the fourteenth Secession exhibition, 1902. From *Ver Sacrum, V* (1902), p. 168

defenders of the frieze, Hevesi was more than usually vehement, declaring that if, like the rest of the exhibition, Klimt's masterpiece was supposed only to serve the temporary end of illuminating the *Beethoven*, and then be destroyed, Austrian art would have suffered an irreparable loss.[69] Perhaps owing to his agitations, the *Beethoven-frieze* was left intact until after the large Klimt retrospective exhibition held at the Secession the following year; it was then carefully dismantled, passing first into the hands of the collector Carl Reininghaus, then becoming, at some time before 1915, part of the Lederer collection.[70] It was, however, spared the fate which the majority of Lederer's other paintings later suffered, and in 1972 was finally acquired, after protracted negotiations, for the Austrian nation.[71]

Klimt's frieze was intended to embody a specific programme: the progress of mankind from desire to fulfilment. The catalogue entry reads:

Decorative principle: regard for the disposition of the room, ornamented plaster surfaces. The three painted walls form a coherent sequence. First long wall, opposite the entrance: longing for happiness. The sufferings of Weak Humanity, who beseech the Knight in Armour as external, Pity and Ambition as internal, driving powers, who move the former to undertake the struggle for happiness. Narrow wall: the Hostile Powers. The giant Typhon, against whom even the Gods battle in vain; his daughters, the three Gorgons. Sickness, Mania, Death. Desire and Impurity, Excess. Nagging care. The longings and desires of mankind fly above and beyond them. Second long wall: longing for happiness finds repose in Poetry. The Arts lead us into the Kingdom of the Ideal, where alone we can find pure joy, pure happiness, pure love. Choir of Heavenly Angels. *'Freude, schöner Götterfunke'*. *'Diesen Kuss der ganzen Welt'*.[72]

The reasons for the artist's choice of subject-matter are somewhat obscure. The other background works shown at the exhibition were intended as some kind of comment either upon Klinger's sculpture or upon Beethoven in general; since

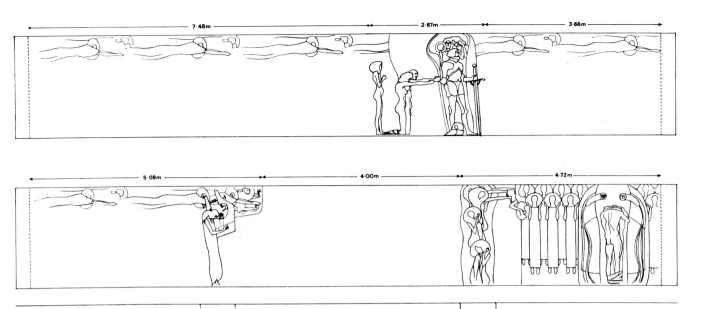

58. Drawing of Klimt's
Beethoven-frieze showing
the relationship between the
figural components of the
two long walls. Author's
reconstruction. Drawn by
B. Woodcock

Klimt selected two quotations from Schiller's 'Ode to Joy' to designate the last panel of the frieze, it would seem plausible to interpret the whole work as a visual paraphrase of the ideas and emotions expressed in the final, choral movement of Beethoven's Ninth Symphony, in which the composer sets the words of Schiller's poem. There are ample grounds for associating this movement with the exhibition in general, and with Klimt's frieze in particular. It had been an arrangement of part of the finale which greeted Klinger at the private opening; what is more, when a friend of Hevesi's had visited the Secession building just before the opening, he related that he had found Mahler and members of the Vienna Philharmonic practising this arrangement 'full blast' in the left-hand aisle of the building[73]—in the room, that is, in which Klimt's frieze was exhibited. Armed with this knowledge, one may discover in the sequence of the frieze what appear to be specific references to the curious structure which Beethoven employs in his setting of the Schiller ode. The 'longings and desires' of mankind, which fly above and beyond the giant Typhon and the three Gorgons (Plate 59), rejecting, as it were, the temptations of the Devil, the World and the Flesh, may be seen as the counterpart of that rejection of the themes of the preceding movements which occurs at the beginning of the finale of the Choral Symphony, in favour of the 'Joy' theme itself; while the 'triumph' of the human spirit, its arrival in the realms of 'pure Joy, pure Happiness, pure Love' (Plate 64), may be compared with the final apotheosis of the theme at the very end of the symphony.

There is, however, evidence to suggest that, although Klimt may certainly have had some such individual conception in mind, the overall message of the frieze was intended as a much more far-reaching allegory of the power, and, in particular, the abstract, inward nature of music. When the final panel was again exhibited at the Klimt collective exhibition at the Secession in 1903, it was identified on this occasion not by the Schiller quotation, but by the biblical '*Mein Reich ist nicht von dieser Welt*' (My Kingdom is not of this World). Here we have indeed a reference to Beethoven, but of a different kind. For this renaming of the final

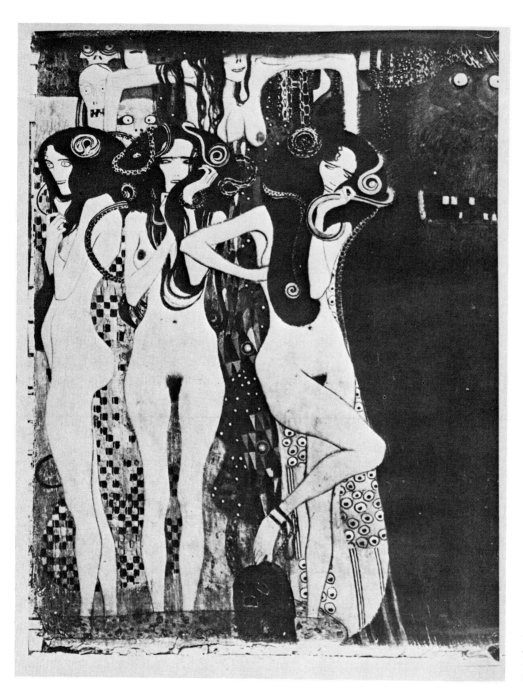

59. Gustav Klimt: *Beethoven-frieze*. Detail from 'The Hostile Powers'. Vienna, Oesterreichische Galerie

panel is surely a specific allusion to Richard Wagner's essay on Beethoven of 1870, in which Wagner's conversion to the Schopenhauerian vision of music, its supremacy among the other arts, being a pure reflection not only of the individual Will, but also of the inner essence of the world, is made manifest for the first time:

Just as, under the world-civilization of the Romans, Christianity emerged, so too music now breaks forth from amidst the chaos of modern civilization. Both say to us 'our Kingdom is not of this World'. That means, we come from within, you from without; we derive from the essence of things, you merely from their appearance.[74]

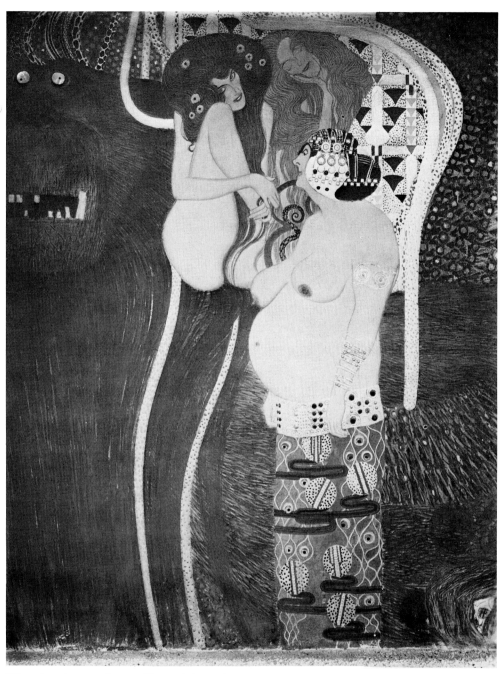

60. Gustav Klimt: *Beethoven-frieze*. Detail from 'The Hostile Powers'. Vienna, Oesterreichische Galerie

The *Beethoven-frieze*, like *Philosophy* and *Medicine*, aroused the violent passions of friend and foe. Once again, the popular press was filled with accusations of 'painted pornography'; one reviewer described Klimt's depiction of the figure of Impurity (Plate 60) as 'the utmost ever achieved in the field of obscene art'. Hevesi, on the other hand, called the work 'so perfect an expression of the artist's daring, autocratic personality' that it was 'difficult to restrain oneself from calling it his masterpiece . . . without question the high-point of modern decorative painting'.[75] His judgement, as so often, has proved correct. Now that the University Paintings are destroyed, the *Beethoven-frieze* must be regarded as one of the most important of Klimt's monumental works to have survived, equalled only by the *Stoclet-frieze*. Apart from the grandeur of the conception which it embodies, its

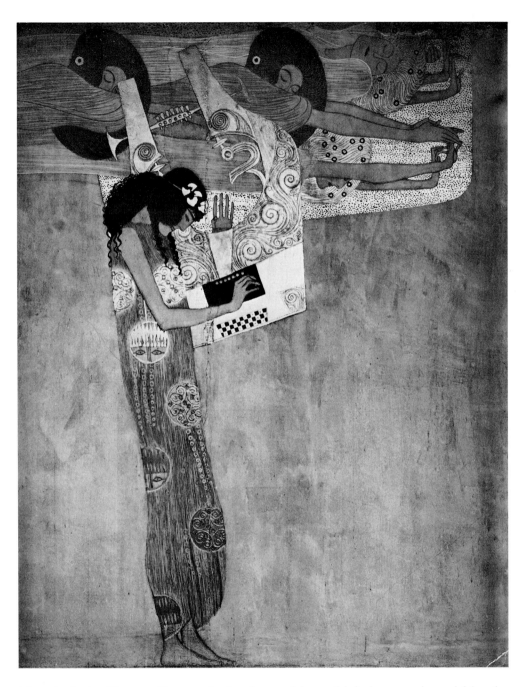

61. Gustav Klimt: *Beethoven-frieze*. Detail, 'Poetry'. Vienna, Oesterreichische Galerie

historical significance lies partly in the position which it occupies within the artist's *oeuvre*—a kind of summing-up of the most important influences upon his early mature style. The influence of *Art Nouveau* is perhaps less immediately striking than in the case of the University Paintings; on the other hand, that of Byzantine and Mycenaean ornament can be recognized in the decoration of the instrument carried by the figure of Poetry (Plate 61), and the jewellery worn by Excess (Plate 60)[76]—an influence which manifests itself likewise in the loops and whorls of the decorative motifs of the *Stoclet-frieze*. There is also a disarming sideways glance at the German Renaissance in the portrayal of the Knight in Armour on the entrance wall of the room (Plate 62). But the most marked debt is to a contemporary artist whom Klimt greatly admired: Ferdinand Hodler—

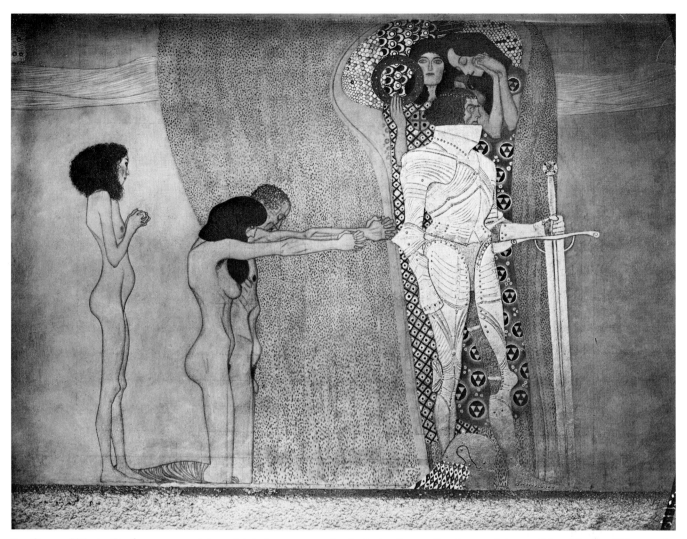

62. Gustav Klimt: *Beethoven-frieze*. Detail, 'The Sufferings of Weak Humanity'. Vienna, Oesterreichische Galerie

a debt which is seen particularly in the stylized repetitions of the Choir of Heavenly Angels, almost a paraphrase of the figures which appear in Hodler's painting *The Chosen One*, shown in Vienna the previous year at the twelfth Secession exhibition (later version, Plate 63). The Swiss painter himself tactfully acknowledged this influence, as well as expressing his admiration for Klimt's work, in an interview of 1905:

I like a picture to have clarity, and therefore I like parallelism. In many of my pictures I have chosen four or five figures in order to express one and the same feeling, because I know that repetition of one and the same thing deepens the effect produced. I have a particular preference for five, since an uneven number heightens the regularity of the picture and creates a natural centre-point. . . .

My favourite artists are Dürer and the Italian primitives. Of the moderns, I have a specially high opinion of Klimt. In particular, I love his frescoes: in them everything is fluent and still, and he too likes using repetition, which is the source of his splendid decorative effects. . . .

What is so admirable in Klimt is the freedom with which he treats everything. He is a personality who goes entirely his own way, and yet typically Viennese in his grace and tenderness. Of his three great ceiling paintings I only know *Philosophy*.

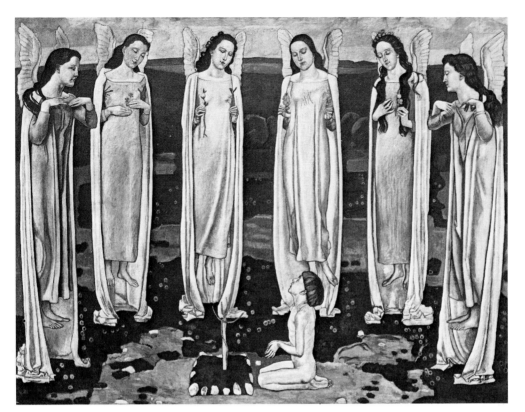

63. (*left*) Ferdinand Hodler:
The Chosen One, 1903.
Hagen, Karl Ernst Osthaus
Museum

64. (*below*) Gustav Klimt:
Beethoven-frieze. Detail,
'Choir of Heavenly Angels'.
Vienna, Oesterreichische
Galerie

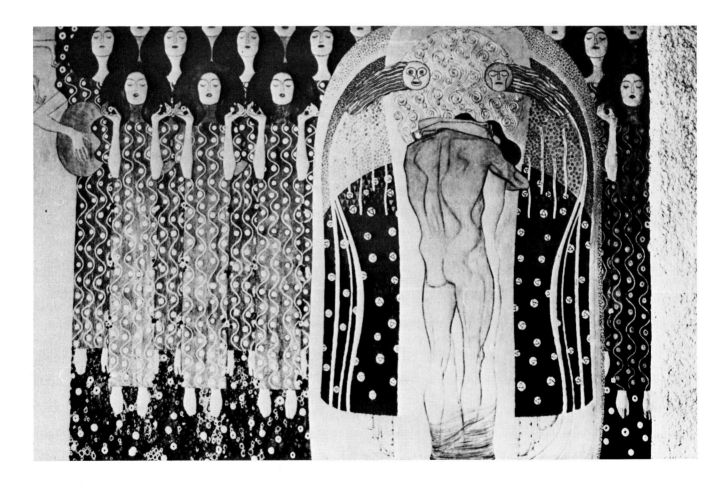

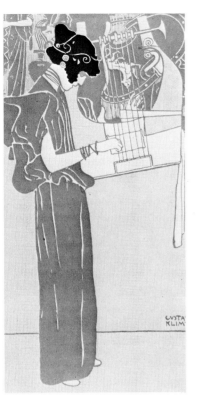

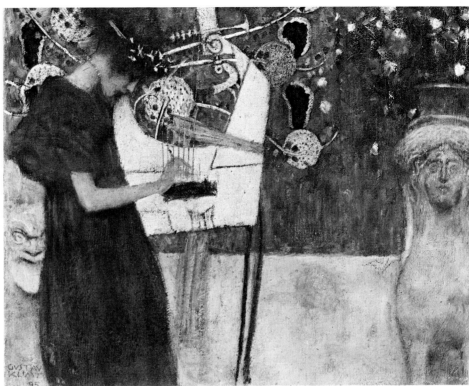

65. (*above*) Gustav Klimt:
Musik. Lithograph. From
Ver Sacrum, IV (1901),
p. 215

66. (*right*) Gustav Klimt:
Die Musik I, 1895. Oil on
canvas, 37 × 44.5 cm.
Munich, Neue Pinakothek

I like it less than the frescoes and the portraits, but I cannot regard them as a critic would, only as an artist, and then the harmony of colours, his manner of using paint seems to me wonderful. I like Klinger less—he always tries to say too much. Böcklin is a great artist, but somewhat too literary for my taste.[77]

The *Beethoven-frieze* also draws together many of the threads which run through Klimt's own earlier work. Particularly interesting is the figure of Poetry, which goes back to Klimt's painting *Die Musik I* (Plate 66), of which the artist produced at least two further variants: the colour lithograph *Musik* (Plate 65, reproduced in the fourth year of *Ver Sacrum*), and the more radically altered *Musik II*, which was commissioned as one of two *sopraporte* for Nikolaus von Dumba's music room. *Musik II* is also related to the *Beethoven-frieze* in that several of the preparatory drawings for the former are unmistakably after the same model as for the figure of Impurity in the later work. The central motif of the panel *My Kingdom is not of this World*, the naked couple who embrace beneath the watchful tutelage of sun and moon, not only recalls the mighty male torso which dominates the upward-striving chain of humanity in *Philosophy*, but also looks forward to the embracing figures of the *Stoclet-frieze* (Plate 126), and of the most famous of Klimt's later paintings, *The Kiss* (Plate 127).

XVI–XVIII Exhibitions, 1903

Two of the most important exhibitions during this early period of the Secession's activity remain to be discussed: the sixteenth exhibition ('The Development of Impressionism in Painting and Sculpture'), and the eighteenth exhibition, which was a retrospective in honour of Klimt. The sixteenth exhibition (January–February 1903), one of the most ambitious ever attempted by the Secession, was the product of an enormous collaborative effort. Bernatzik, then president of the association, had spent weeks in Paris, seeing Durand-Ruel and the other dealers in Impressionist paintings who had agreed to lend works for the occasion. The aid of the art historians Richard Muther and Julius Maier-Graefe was enlisted, private collectors approached for the loan of priceless treasures. The result was one of the largest and most important exhibitions of Impressionist and Post-Impressionist painting ever seen in Austria. The great French masters of the nineteenth and early twentieth century were all represented, among them Manet, Monet, Renoir, Degas, Pissarro, Sisley, Cézanne, van Gogh, Toulouse-Lautrec, Vuillard, Bonnard, Denis, Redon and Gauguin, as well as representatives of German Impressionism (Liebermann). Renoir's *Loge de Théâtre* and Manet's oil sketch for the *Bar at the Folies Bergères* were shown; van Gogh's *Plain at Auvers-sur-Oise* was presented by the Secession to the Moderne Galerie. The other Viennese public collections, on the other hand, distinguished themselves by ignoring altogether this opportunity of purchasing some of the most outstanding examples of early modern art. Among Vienna's private collectors, only Hermann and Gottfried Eissler had the taste and foresight to acquire on this occasion a number of fine examples of French nineteenth-century painting.

As important as the number of pictures shown was the expressly didactic intent of this exhibition. Impressionism was defined for the occasion in terms of the natural laws which govern the process of seeing, and of the painter's desire to reproduce this process. By thus avoiding any narrow historical or stylistic label, it was possible to include an extraordinary diversity of works of art ostensibly under the same general heading. The innocent visitor to the exhibition was prepared for works by the 'classical masters' of Impressionism by a selection of paintings 'which anticipate, in their mode of vision, the present-day school, and are closely related to it'—Dutch and Venetian canvases, among them works by Vermeer and Tintoretto, paintings by Velazquez, El Greco and Goya, 'the father of modern painting', as well as French nineteenth-century 'precursors' of Impressionism—Delacroix, Daumier, Monticelli.[78] In addition, a whole room was given over to Japanese woodcuts. The foreword to the catalogue explained: 'Just as we wish to show the great forebears of Impressionism from our own continent, so too we are showing the "old masters" of Japanese art: Hokusai, Utamaro.' There appears, however, to have been little attempt to document the precise influence of Japanese art upon the development of Impressionism. Particularly striking in this connection is the fact that only one work by Whistler, the *Violinist*, was shown on this occasion. Nor, strangely, do the Secessionists appear to have sought the co-operation of Samuel Bing, founder of the Parisian gallery L'Art Nouveau, and the most celebrated dealer in both modern and Oriental art. The

Japanese room marked the transition between the main part of the exhibition and the final section, entitled *Durchbruch zum Stil* (The Triumph of Style); from this point on, the *Jugendstil*-orientated artists—Klimt, Moser, Hoffmann and their colleagues—were known alternatively as the 'Stylists', by contrast with the 'Naturalists' and landscape painters of Engelhart's circle.

The *Klimt-Kollektive* (eighteenth exhibition, November–December 1903) was, apart from the one-man show of Krämer's work, the only exhibition during the early period of the Secession devoted to the work of a single artist. The setting, spacious and economical, was designed by Josef Hoffmann and Kolo Moser. The poster, and the cover of the catalogue, reproduced Klimt's vignette *Ars*; the exhibition itself gathered together no fewer than seventy-eight works, including thirty drawings and studies. Many of the star paintings from the early Secession shows were to be seen again: *Pallas Athene, Schubert at the Piano, Die Musik II*. Some of the most important of Klimt's early landscapes were included; sombre, mysterious, with an indefinable air of allegory, they seemed to embody the essence of the master's early manner. It was, above all, these landscapes which remained an unforgettable memory for the poet Peter Altenberg, who, in a deeply felt apostrophe of Klimt, later wrote:

Your sombre lakes, your woodland pools, your reed-girt mires are melancholic, wholly modern poems and songs. Your birch forests might reduce over-sensitive souls to tears, so lonely, so sweetly-gloomy are they! ... Likewise the naked bodies of all these women, ascetic, thin, tenderly tender, the fingers, the hands, the arms, the legs of these most fair, these creatures almost free from barren matter, the accursed bondage of which only oppresses the spirit and the soul.[79]

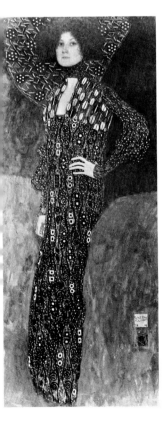

67. Gustav Klimt: *Emilie Flöge*, 1902. Oil on canvas, 181 × 84 cm. Vienna, Historisches Museum der Stadt Wien

Of the several portraits shown at this exhibition, an outstanding example is Klimt's depiction of his lifelong companion Emilie Flöge, painted in 1902 but now exhibited for the first time (Plate 67). This picture marks the artist's move away from the impressionist-naturalistic manner of his earlier work, for example the portrait of Sonja Knips of 1899 (likewise shown at the eighteenth exhibition), towards a flatter, more geometrical style. Here, one of the distinguishing characteristics of Klimt's later portraiture becomes apparent: the creation of an abstract pattern out of the garments of the person portrayed, from amid which the more naturalistically rendered figural details, the hands and face, emerge with a surprising intimacy. The repeated ornamental motifs of the Flöge portrait tell unequivocally of its author's prolonged love affair with *Art Nouveau*, in particular the more geometrical-decorative tendencies which characterize the work of the graphic artists and designers of the *Jugendstil* movement; on the other hand, the feeling of tenderness which imbues this work, and which finds expression in the butterfly-wing shimmer of the thinly painted canvas, reflects the closeness of the relationship between the artist and his sitter.

The juxtaposition of so many paintings in this exhibition also made manifest Klimt's extraordinary syncretistic ability, his facility in drawing upon the most diverse sources. Ernst Stöhr, in his foreword to the catalogue, wrote of him:

Sensitive, easily impressionable, he subsumes within his own work not only the fleeting characteristics but also the lasting values established by modern art in

its struggle for existence. As a decorative artist with a pronounced feeling for style, he has travelled the path from the sensitive observation of natural appearances to the purposive exploitation of Nature for his own ends.[80]

The visitor to the exhibition was able to verify for himself Stöhr's remarks on the development of Klimt's style by comparing the three University Paintings, here shown together for the first time. *Jurisprudence* (Plate 68), which Klimt at this date still regarded as unfinished (he had in fact continued work on the picture until the very opening of the exhibition), presents a striking contrast to the two earlier paintings. Far more decorative in intent than either *Philosophy* or *Medicine*, it marked the furthest step on the path towards what Hevesi called *Malmosaik* (literally, 'painted mosaic'). In *Jurisprudence*, the more naturalistic conventions of Klimt's earlier work are almost completely suppressed, along with the illusionistic space, the *di sotto in su* appropriate to an intended ceiling painting, in favour of a highly abstract, geometrical conception. (Klimt had, by the time of the eighteenth exhibition, perhaps begun to realize how slender were the chances of his paintings ever finding their way to their rightful setting; it is significant that, whereas the final versions of both *Philosophy* and *Medicine* approximate fairly closely to the preliminary composition studies, *Jurisprudence*, which is separated chronologically from the other two paintings by the *Beethoven-frieze*, differs entirely from the oil sketch submitted to the Ministry of Education in 1898.)[81] Colouristically, also, the three works display an interesting progression: *Philosophy* mainly blue and green, the starting-point of innumerable witticisms concerning its 'marine' appearance, *Medicine* in ceremonial reds and purples, with the lavish addition of gold for the figure of Hygeia, and finally *Jurisprudence*, gold and black, with other colours reserved almost exclusively for the three figures of Law, Justice and Mercy in the upper part of the canvas.

Hevesi first saw *Jurisprudence* some months before the *Klimt-Kollektive*, in the artist's studio in the Florianigasse, which had been rented specially for work on the University Paintings, since his normal *atelier* in the Josefstädterstrasse was too small. His description of the impact made upon him by the unfinished composition is invaluable not only because it describes the colours of the now lost picture, but also because it informs us of Klimt's method of working:

I first saw *Jurisprudence* . . . in the master's large studio, right out in the Josefstadt. . . . A metal door, on which were chalked the letters 'G.K.', and a notice 'Knock loudly'. I hammered with my fists, but the master himself was on the *qui vive*, and was at the door straight away. It was afternoon, thirty-five degrees centigrade. He had on only his usual dark smock, and nothing underneath. His life is spent in front of the great canvas, climbing up and down the ladder, pacing up and down, looking, brooding, creating out of nothing, trying, daring. He seems as if surrounded by a mist, wrestling with this element of uncertainty, kneading it, with both arms immersed up to the shoulders. The floor covered with drawings, many drawings for each figure, variants of every pose, position, movement. Never was a painter more fantastical, and yet more true to Nature. How many times has he drawn the old sinner who appears in *Jurisprudence* as the accused. This old, emaciated man, with sunken head and hunched back . . . he stands there, his gaze averted, already condemned. On that occasion, he looked like a

mere shadow on the canvas, tormented by three incorporeal ghosts. These three . . . twentieth-century lemurs, by Klimt out of the daughters of Toorop, yet unmistakably with their father's features . . . and then the reddish hair, these strange, comet-like tresses around their heads, studded with gold . . . golden snakes with gleaming teeth. . . . Conscience gnaws with golden fangs!

No, in fact Conscience is represented by the giant squid in whose tentacles the poor sinner is emmeshed. A mighty octopus which, pressing its body against his, wrestles with the accused. A monster of skin and slime, indestructible, insuperable. . . . And yet, a magnificent squid, its skin patterned with spots like a leopard. The latest design of submarine leopard. . . . There is, indeed, a black humour about the whole thing. Unsuspected, it emerges from this fantasy of grimness and gravity like the golden snakes from the hair of the Gorgons. . . .

Only the day before yesterday, I saw *Jurisprudence* again. It was Friday, 13 November. A day of moody weather. . . . The bleak drizzle covered the streaming streets with its systematic blanket. Not until three o'clock in the afternoon did I get round to meeting Klimt in the Secession. He was still painting, although there was no longer any hope of finishing on time. I cast an eye at the picture as it hung there in the nave-like gloom, out of which golden phantoms glistened enticingly. The colours were all there . . . but a veil of dusk lay upon them. . . . And then it dawned upon me. Only four days previously, I had come back from Sicily. I was still intoxicated with the golden world of the mosaics, gleaming and glittering. . . . It came back to me as I stood there in front of Klimt's picture, with its shining gold. . . . A new style, after all the pictorial orgies of the previous centuries. More solemn, more religious in form and colour. . . . Observe its two pendants, *Philosophy* and *Medicine*. A mystical symphony in green, a mighty overture in red, both composed of a purely decorative play of colours. *Jurisprudence*, on the other hand, is dominated by gold and black—not in fact colours at all; in compensation, line and form are raised to a level of significance for which there is no other word than monumental. This picture must be regarded as the master's final step in this particular direction.[82]

Hevesi's account of what he considered the sources of Klimt's inspiration in *Jurisprudence* is extremely perceptive. His reference to the Symbolist painter Jan Toorop is certainly accurate; Klimt had been interested in Toorop's work at least since the seventh Secession exhibition, at which the Dutch artist's famous canvas *The Three Brides* (Plate 69) had been displayed. It is instructive to compare Toorop's female figures both with the 'three twentieth-century lemurs' in *Jurisprudence*, and with the standing, naked women in the 'Hostile Powers' panel of the *Beethoven-frieze*, although the latter, in particular, exhibit a certain mordancy of line and pose which seems closer to Beardsley, another contemporary artist greatly admired by the Secessionists. *Jurisprudence*, however, like the *Beethoven-frieze*, also marks the beginnings of a broadening of the artist's interests to include not only contemporary European painting, but also various kinds of exotica. Of these exotic influences which were to affect his work for the next decade, one of the most important was that of Byzantine art. Although Klimt had, unlike Hevesi, never been to Sicily, he had visited Ravenna, probably for the first time, in the spring of the same year 1903; he sent a postcard to his mother

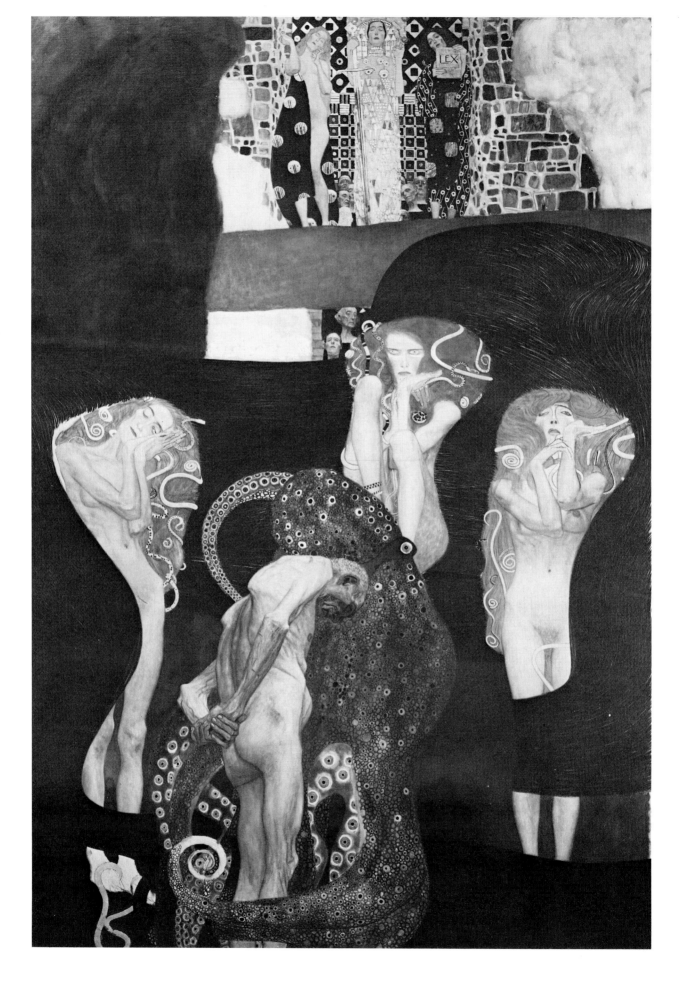

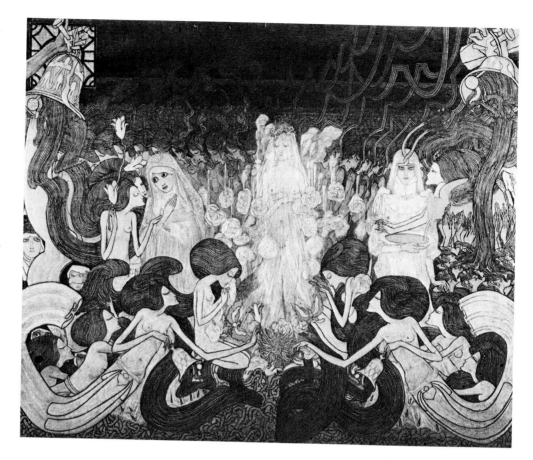

68. (*left*) Gustav Klimt:
Jurisprudence. Oil on canvas,
430 × 300 cm. Exhibited at
the eighteenth Secession
exhibition, 1903. Ceiling
painting for the Aula of
Vienna University.
Destroyed

69. (*right*) Jan Toorop:
The Three Brides, 1893.
78 × 98 cm. Otterlo,
Rijksmuseum Kröller-
Müller

with a picture of the interior of San Vitale on 9 May.[83] Alfred Roller, who had been there before him in order to study the technique of mosaic in connection with his work for the Breitenfelder-Kirche, may perhaps have incited Klimt to make the visit. The latter's enthusiasm for what he saw was sufficient to cause him to undertake a second trip to Italy the following winter in the company of the painter Max Lenz, who described Ravenna as the 'true goal' of the journey.[84] Lenz further recalled the enormous impact made on Klimt by the mosaics, an impact which is reflected not only in *Jurisprudence* and in the *Stoclet-frieze* (Klimt's only true mosaic), but also in his important later paintings *The Kiss* (1908) and his portraits of Fritza von Riedler (1905, Plate 151) and Adele Bloch-Bauer (1907, Plate 153). Hevesi later gave a more exhaustive account of the artist's 'mosaic' style in an article entitled 'Gustav Klimt und die Malmosaik'.[85]

The violent opposition originally provoked by the University Paintings had largely died down; of the critics of the eighteenth exhibition, only Karl Kraus seized the opportunity to launch a further, vitriolic attack against Klimt, and against *Jurisprudence* in particular:

For Herr Klimt, the concept of Jurisprudence is exhausted by the notions of crime and punishment. To him, the 'rule of law' means nothing more than 'hunt them down and wring their necks'. And to those who are more than content to have 'nothing to do with the law' he presents the terrifying image of the transgressor.[86]

The Split within the Secession

The eighteenth exhibition represented, from an artistic point of view, the high point of the early activity of the Secession. Of the shows which followed, only the nineteenth exhibition, which included works by Hodler, Amiet and Munch, and the twenty-third exhibition (Austrian art), at which Wagner's projects for the church 'am Steinhof' and for the ill-fated Stadtmuseum were shown, are worthy of mention. The other exhibitions of 1904–5 fail woefully to conceal the lack of enthusiasm, and the resulting decline in standards, which was the product of a growing rift between the members of the association. This rift derived partly from the predominance within the Secession of the artists of Klimt's circle which, while it included several other painters apart from Klimt himself, also embraced a significant number of architects and designers, among them Josef Hoffmann and Kolo Moser, the founding members of the influential Wiener Werkstätte. The other members of the association, for whom the applied arts were, at best, an incidental concern, reproached these *Raumkünstler* (decorative artists) with seeking to further the cause of architecture and design at the expense of easel painting. The origins of this jealousy may be traced back to the *débâcle* over the 1904 World's Fair at St Louis, at which the Secession had, somewhat belatedly, been invited to exhibit by the Austrian Ministry of Education. A special booklet published by the Secession in connection with this invitation indicates that the committee, faced with the choice of arranging an exhibition purely of paintings or creating some more 'monumental' kind of display, had decided in favour of a whole room designed by Hoffmann, where it was intended to show pictures by Klimt, among them *Philosophy* and *Jurisprudence*, and precious little else, apart from a few works by the sculptors Metzner and Luksch. The debate which this decision provoked, above all in the press, became so heated that the Secession was finally prevented from exhibiting at St Louis at all; but it is not difficult to recognize, in the attacks directed against Klimt and his party, the particular animus evoked by the continuing collaboration between Klimt and Hoffmann, and the indignation at the neglect of the other painters within the association. From this point onwards, the Secession polarized itself into two opposing groups: the *Klimt-gruppe*, which included the architect Otto Wagner, the designers Hoffmann and Moser, and the painter Carl Moll; and the *Nur-Maler* (pure painters), with Engelhart at their head.

The more immediate *casus belli* was, however, the question of the Galerie Miethke. Miethke's, the Durand-Ruel's of Vienna, had on the demise of its founder sought advice on matters of artistic policy from Moll, whose ambition appears to have been to run the gallery as a commercial outlet for the artists of the Secession. This ambition was, understandably, bitterly opposed by many of his colleagues. Engelhart recalled:

As president at that time, I had to intervene, and tell Moll that he must choose between the gallery and the Secession. The only circumstances under which a position such as his would have been tolerable would be if the gallery were to merge with the association.

At just this time, Liebermann had driven the Berlin Secession into the arms of the dealer Cassirer. Whether something similar was being planned in Vienna escapes my knowledge. . . . There was a short battle which ended in the withdrawal of twenty-four members of Moll's party. From then on, certain newspapers dubbed us the 'rump Secession'.[87]

In fact, the question of the Secession's involvement with Miethke's had been put to the jury of the association. The Klimt group lost by one vote. Klimt and most of the prominent members of the Secession then announced their resignation, leaving their opponents in possession of the most important asset—the building. The 'rump Secession' did not, however, succeed in maintaining the standard of the brilliant series of exhibitions which had distinguished the early years of the association's activity. The first 'eight years of the Secession', of which Hevesi wrote, had come to an end.

Regarding this first phase of the Secession's activity as a whole, one inevitably asks to what extent the original intentions which lay behind the founding of the association, its aims and ambitions, had been fulfilled. As concerns their desire to rescue Austria from its own provincialism, its artistic stagnation, by introducing to Vienna the work of the most significant contemporary artists from abroad, the Secessionists had certainly been largely successful. The early exhibitions had created a living monument to contemporary art. Quite apart from the Impressionist and Post-Impressionist painters and sculptors represented at the sixteenth exhibition, the names of the artists who participated in the other exhibitions of this early period read like a roll-call of the European *avant-garde*: Khnopff, Uhde, Rysselberghe, Meunier, Minne, Ashbee, Crane, Mackintosh and the Glasgow School, Beardsley, Segantini, Toorop, Hodler, Brangwyn, Somov, Hölzel, Leibl, Munch, Rops, Slevogt, and many others. The Secession had, moreover, through the participation of its members in exhibitions abroad, drawn Austria into the international art circle. The distinction awarded to Klimt at the Paris Exposition Universelle of 1900 was a mark of the respect which Austrian painting now enjoyed in the eyes of the world. The question as to the hoped-for rejuvenation of Austrian art itself, is, however, less easily answered. As far as painting is concerned, Engelhart's '*Nur-Maler*' were able to offer nothing more progressive than a rather watered-down version of French Impressionism; while the artists of Klimt's circle tended for the most part either towards graphics and small-scale works, or else towards monumental art, ceramics, mosaics and stained glass, rather than easel painting. Indeed, the only easel painter of really outstanding importance was Klimt himself. It was, rather, in the field of architecture and design that the Secession's most consistent contribution to the development of modern art was made. It is, therefore, to these areas of activity that we should now turn our attention.

AVSGESTALTVNG der QVAI
DES·DONAV·CANALES
NEVE·ASPERN·VND·FERDINANDBRVCKE
REGVLIERVNG·DES·STVBENVIERTELS
VON·OTTO·WAGNER·

III · ARCHITECTURE AND THE APPLIED ARTS

PROGRESS IN THE VISUAL ARTS in Vienna during the period 1898–1918 was in many ways bound up with developments in the fields of architecture and design. Both painting and architecture had as their goal the triumph of modernism, the rejuvenation of Austrian art; both involved a determined reaction against the recognized establishment; both moreover, seen in the context of twentieth-century art as a whole, manifest the same surprisingly conservative character. Nearly all the first generation of the Viennese *avant-garde* began their careers as members of that same establishment against which they subsequently rebelled; and if in later life artists such as Klimt and Wagner occupied increasingly controversial positions, they were nevertheless very far from eliminating from their work all traces of the tradition from which they sprang. This is particularly true of Otto Wagner, whose genuinely revolutionary buildings of the first years of the twentieth century still show the unmistakable imprint of his early training—and not only training. During the first twenty years of his long career, he executed a whole series of buildings and projects in a highly traditional, not to say fashionable manner —projects whose authorship he later tried to conceal or deny (it was surely Wagner whom Hevesi had in mind when he wrote: 'The historically-schooled architect throws his various styles overboard and tries to forget that he grew up in a "style-ful" epoch').[1] Nor did Wagner's followers altogether succeed in breaking with tradition—Hoffmann, or Olbrich, for example, whose work frequently invites comparison with the nineteenth-century Viennese school of design. Only in the buildings of Adolf Loos, with his disdain of elaborate ornament, his search for an astringent purity, does one find the beginnings of a wholly modern style in architecture. It is at least possible to regard the circle around Loos, Kraus and Trakl as the representatives of the true revolution in Austrian culture, by comparison with whom not only an artist such as Hoffmann, but also a writer such as Hofmannsthal seems far more the product of that same *fin de siècle* movement from which much of the pictorial art of the Secession also springs. Significantly, Loos, who for a few months allied himself with the newly founded Secession, rapidly became one of its severest critics, attacking what he saw as the irrelevance to contemporary life of the elegant aestheticism which characterized the work of Hoffmann and his circle. And yet even Loos never entirely freed himself from the reminiscence of the same architectural tradition upon which his opponents too were dependent. In the façade of his house on the Michaelerplatz (1910, Plate 144) one may still perceive, for all its apparent severity, the faint echo of that classical pomp which left so deep an imprint upon the face of nineteenth-century Vienna. Despite their differences of outlook, their personal feuds and alliances, one may plausibly interpret the work of the four principal representatives of early twentieth-century architecture in Vienna—Wagner, Olbrich, Hoffmann and Loos—in terms of varying reactions to a single phenomenon: that of Historicism.

70. Otto Wagner: *Drawing showing the projected regulation of the Stubenviertel, the quayside installations and the new canal bridges*, 1897. From *Einige Skizzen, Projekte und ausgeführte Bauwerke*, vol. 2, print 65

The Ringstrasse and the Architecture of Historicism

Historicism, as an architectural phenomenon, is not of course peculiar to Vienna. Virtually every European city which underwent any extensive programme of nineteenth-century re-planning will be found to display, especially in its public buildings, the same agglomeration of carefully and not so carefully imitated historical styles: Neo-Gothic, Neo-Classical, Neo-Baroque. But the mantle of Historicism lay perhaps more heavily upon the Austrian capital than elsewhere. Vienna, as an architectural conception, had come to maturity comparatively late, at the height of the Historicist epoch. Only in December 1857 did the Emperor Franz Joseph, in a famous directive to his Minister of the Interior, Freiherr von Bach, authorize the dissolution of the ramparts and fortifications separating the city centre from the new suburbs which had grown up to the north and west. A competition for designs for the 'regulation and adornment of the Imperial Capital and Residence . . . of Vienna'[2] was announced as early as January 1858; of the projects submitted, the most ambitious was that proposed by the architect Ludwig Förster. The competition specified the creation of a broad thoroughfare, the Ringstrasse, which should replace the existing ramparts; Förster's plan went further, turning the new street, with its parks, squares and tree-lined avenues, into a picturesque setting for parades, marches and ceremonial processions. The picturesque impression created by the Ring as we know it today is, however, as much the result of the buildings which adjoin it as of the pictorial elements, the parks and trees and monuments, foreseen by Förster's plan; and these buildings, one finds on closer examination, comprise an extraordinary variety of architectural styles. One has only to think of the Neo-Gothic Rathaus (Town Hall) by the Württemberger Friedrich Schmidt (1825–91), and Votivkirche by Heinrich von Ferstel (who also built the neighbouring edifice, the University of Vienna (Plate 71), in a quite different manner), the serenely classical Parliament Building by the philhellene Theophil Hansen (1813–91), or the richly ornate Opera House (1861–9) by August Siccard von Siccardsburg and Eduard van der Null, the leading Historicist architects of the day. The Opera House unites within the same design elements not only of French Renaissance and Gothic, but also of Florentine and even Venetian architecture—a pot pourri of styles truly amazing to modern eyes. The 'historically-schooled' architects of the day could, however, perceive no discrepancy in this juxtaposition of stylistically quite disparate motifs, nor any contradiction in utilizing the architectural vocabulary of a bygone age, or indeed several bygone ages, to meet the demands of contemporary society. Rudolf von Eitelberger, the first director of the Austrian Museum for Art and Industry, expressed the architectural sentiments of his generation when he wrote:

Ours does not appear to be an age given to the creation of new styles in architecture. The more attempts are made to invent a new style of building, the clearer it is that the vocation for such a creative activity is lacking. On the other hand, the more imaginatively, the more ingeniously one endeavours to unite given styles, the basic elements of already existing types of architecture, with the advances of modern technology, the more successful are the results.[3]

71. Heinrich von Ferstel:
Vienna University, 1873–84,
main façade

For Eitelberger and the representatives of Historicism, the Ring was the culminating achievement of the *Gründerzeit*, the apogee of modern architectural creation. For the following generation, it was to become a symbol having quite different connotations. Josef August Lux, in his biography of Wagner, wrote with scorn of an epoch which 'understood by architecture nothing more than an accumulation of orders, profiles and ornaments from two millennia, from which each individual selected what he thought best'.[4] Like van de Velde in Belgium, whose work and theories exerted a considerable influence upon the modern Austrian movement, the architects and designers—not to mention critics—who came to maturity during the last decades of the nineteenth century nurtured the ideal of a truly contemporary architecture, which would reflect not only modern developments in science and technology, but also the needs, the individual character of the society from which it sprang. 'Contemporary art', declared Wagner, 'must express the ability, the mode of existence, of modern man, by means of forms created by us'.[5] The notion of honesty, honesty to oneself, to one's materials, to the demands the architect was supposed to meet, occurs again and again. In an article on Wagner, Hermann Bahr, as so often the standard-bearer of the modern

movement, castigated in no uncertain terms what he called the 'artistic deceit' of the architecture of the Ringstrasse epoch:

If you walk across the Ring, you have the impression of being in the midst of a real carnival. Everything masked, everything disguised. . . . Life has become too serious for that sort of thing. We want to look life in the face. This is what we mean when we talk of 'realist architecture', that is, that the building must not only serve its intended purpose, but must also express, not conceal, that purpose. . . . To disguise it behind borrowed forms is both silly and ugly. Earlier, people used to require that a building should 'look like something'; we demand that it should 'be something'. We, the working people of today, should be ashamed to live in the style of the princes and patricians of yesterday. That we think of as a swindle. From the appearance of a house, we should be able to judge what is its purpose, who lives in it and how. We are not of the age of the Baroque, we don't live in the Renaissance, why should we act as if we did? Life has changed, costume has changed, our thoughts and feelings, our whole manner of living has changed, architecture must change too. . . . These demands have now become audible, and will no longer be stifled.[6]

Otto Wagner, 1841–1918

In the reaction against Historicism, Wagner has traditionally been accorded pride of place. He has been described as 'the antithesis of the Ringstrasse', 'the father of modern Viennese architecture', 'the educator of an entire generation'.[7] These are far from platitudes. His buildings of the early years of the twentieth century are the first outstanding examples of modern architecture in Vienna, and they gained Wagner a place in the international community of architects. They also profoundly influenced the younger generation who followed in his footsteps, and for whose education he was largely responsible. His impact both as a teacher and as a practising architect was enormous—and not only upon the artists of his immediate circle. Bahr, in an eloquent tribute, wrote of him:

But Otto Wagner is not only Austria's greatest architect since van der Null and Siccardsburg, not only Austria's most Austrian architect since Fischer von Erlach; he is also what d'Annunzio once called an *animatore*. In this, he may best be compared with Gottfried Semper, who also was never satisfied with influencing others solely through his works, but impressed his ideas upon the younger generation by means of the living word. So too Wagner, who exerts an enormous influence upon his pupils simply by his immediate presence. . . . He was fortunate enough to have from the very beginning the young Joseph Olbrich as a pupil, whom he watched over like a father to the very end. And Josef Hoffmann and Kolo Moser and all the best [artists] we now have owe what is best in them to him. And yet the influence of his invigorating, stimulating force has gone far beyond the boundaries of his own profession. What the circle around William Morris was for England, or in Germany Lichtwark, the younger Munich artists, van de Velde and so many others, all this has been achieved in Austria by a single

man. Without Otto Wagner there would be no Secession, no Klimt group, no applied art, no Alfred Roller, no Adolf Loos. For it was Wagner who created the atmosphere in which all this first became possible. And without Wagner's blazing audacity no one would have had the courage to believe once again in Austria's artistic future.[8]

Much that has been written about Wagner, the attempts to define his position within the development of twentieth-century architecture, must however be regarded with caution. Some commentators, like Lux, have been determined to see his entire *oeuvre* as challenging, revolutionary, unique. In doing so, they have ignored, or affected not to notice, the conservatism of much of his early work which, for all his avowed rejection of the accepted period styles, differs little from other examples of Viennese Historicism.[9] Attention has often been drawn to the 'visionary' quality of his writings, without much mention of the fact either that Wagner was, as a theorist, highly derivative (his call for 'contemporaneity', his demands for 'truth' and 'honesty to materials' are clearly indebted to the theories of Ruskin and Semper), or that these writings are, in places, undeniably self-contradictory—so much so that one might be surprised that they were capable of influencing anyone at all. Other architectural historians have concentrated their attention upon Wagner's buildings of the period *c*. 1898–1900, identifying the 'Wagner style' with that particular brand of *Jugendstil* which characterizes the houses on the Wienzeile (Plates 8 and 82), or some of the buildings for the Stadtbahn, without apparently realizing that this *Jugendstil*-influenced period was of short duration, and cannot be regarded as typical of the architect's work as a whole. On the other hand, there have been those who have recognized the revolutionary character of his work of the first years of this century, but who have for the most part failed to comment upon the most important factor: the continuity which runs through his work, the same classical spirit—and, above all, a classical sense of volume and proportion—which one recognizes as the hall-mark of his architectural conceptions. Only Hoffmann, more closely acquainted with Wagner's progress than subsequent critics, singled out this aspect of his teacher's practice when he wrote of him:

His development proceeds not by leaps and bounds, but rather by logical progression. His interest in the architecture of the Italian High Renaissance, and its echoes, is not a detour into an unfamiliar stylistic epoch, but, on the contrary, reflects a permanent aspect of his work which continues right up until today. On the other hand, he feels instinctively that it is not the use of a traditional formal vocabulary which determines the significance of a building, but simply and solely its individual, that is, its original character.[10]

The influence of classical architecture is hardly surprising if one considers Wagner's early training, or indeed his age. He was considerably older than the generation of Loos and Hoffmann—older in fact than most of the architects of the modern movement. From his youth, he would have been able to remember the legendary Vienna of the pre-Ringstrasse epoch; the impact of the Berlin of his student days made it virtually inevitable that he should tend for a time towards an almost Schinkelesque form of Classicism; while, in his early mature work,

the influence of the pervasive historicizing spirit of the Viennese *Gründerzeit*, of Hasenauer and Semper, Siccardsburg and van der Null, could scarcely have left him untouched. Lux wrote:

Three great epochs of architectural creation Otto Wagner has lived through. The spirit of Schinkel was still alive when he was for a period a student at the Royal Architectural School in Berlin. Like in a family album, a breath of that faded flower of the classical age is captured in the Berlin sketch-book of the young Wagner.

But immediately he returned to Vienna, the young artist and student of the Academy experienced a time of change: architects, and above all his teachers van der Null and Siccardsburg, follow a new leader of genius, Gottfried Semper. The spirit of Semper dominates the second half of the century, and naturally enough, Wagner too followed in his footsteps, although in an entirely independent and individual manner.

And now he experiences a third age, an age which he himself has created: the development of architecture in collaboration with the spirit of the engineer and the problems, undreamed-of until now, of the big city.

The artist himself has become a milestone in this development.[11]

The quintessential embodiment of the classical spirit is found in the villa which Wagner built in 1886–8 for himself and his family in the Viennese suburb of Hütteldorf, the 'First Villa Wagner', with its unashamedly Palladian allusions (Plate 72). Closer to the manner of the Baroque than of the Renaissance are a number of unexecuted early projects familiar to us as illustrations in the first of a series of folio volumes entitled *Sketches, Projects and Executed Buildings*,[12] which Wagner began publishing in 1892, and which trace the progress of his own architectural activity. The designs for the new Exchange Building in Amsterdam (1884, Plate 73), or for a Russian Embassy in Vienna (1886), with their ponderous ornamentation, must present at first sight a curious comparison with Wagner's later work in the fields of industrial architecture and town planning. A sub-species

72. Otto Wagner: *First Villa Wagner*, Hütteldorf, near Vienna, 1886–8

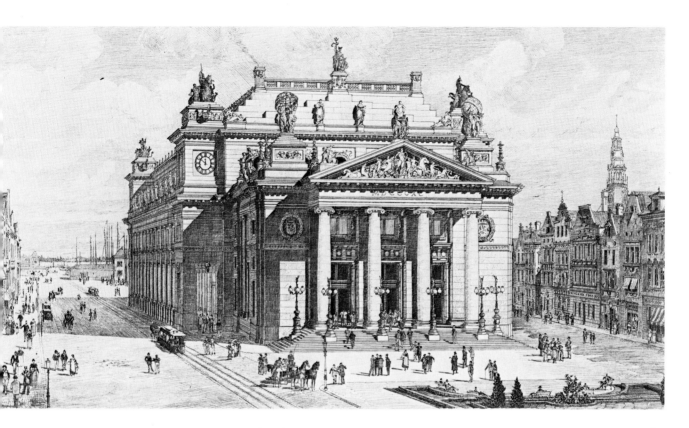

73. Otto Wagner: *Competition design for a new Exchange Building in Amsterdam*, 1884. From *Einige Skizzen, Projekte und ausgeführte Bauwerke*. Vol. I, print 28

in their own right are his numerous Viennese apartment blocks, of which an interesting early example is the house Stadiongasse 6–8 (1883). As far as the exterior is concerned, the building turns to the world the imposing Italianate façade typical of residential and business accommodation of this date, with certain reminiscences of the *casa di Rafaello* model characteristic of Roman Renaissance palace architecture. Even Lux, in general a staunch polemicist for the progressive character of virtually all Wagner's work, had to admit that this façade reminded him 'somewhat' of the Renaissance *palazzo* style.[13] The interest of the design lies, however, in the interior arrangement, especially the central vestibule, which offers a perfect example of Wagner's oft-remarked facility in juggling with spatial problems. Here, he compensates for the extremely shallow space available to him by making the massive paired columns approach more closely towards one another as they recede towards the back of the building, in such a way as to create the perspective illusion of an imposing depth of structure—a still essentially Renaissance device, but employed on this occasion with consummate artistry.

Other early buildings by Wagner manipulate space in equally ingenious ways. His masterpiece in this respect is the Oesterreichische Länderbank in the Hohenstaufengasse, built during the following year, 1883–4. This building is fascinating from a number of points of view, both spatial and practical. The disposition of the lighting anticipates in a more sophisticated way the arrangement which Wagner later adopted for the central hall of his famous Post Office Savings Bank: light filters down into the large counter hall of the Länderbank through a succession of glass roofs supported by iron beams, while on the upper floors, the semicircular corridors linking the various offices are illuminated from the same source by means of large windows, made of semi-opaque glass, which face inwards towards

the centre of the building. Even more remarkable is the overall plan of the edifice (Plate 74). Here, as on several later occasions, Wagner was faced with the problem of creating some kind of coherent, unified structure on an extremely asymmetrical site. Lux describes the architect's solution to this problem in the following extract from his biography:

If you want to go from the street to the large hall in which the customers' business is conducted, you walk first of all up several steps into a circular room, a kind of vestibule, in the middle of which stands a statue personifying Austria. From here you go straight into the main hall. You don't have to search or grope your way around, you can't go wrong, you have the feeling that you are walking in a straight line, you are going to the counters by the simplest and most straightforward route. You certainly don't notice that the main axis of the building has a kink in it, which could otherwise so easily disorientate the visitor, giving an impression of the crooked and repellant. How is this avoided? By means of the circular room, which momentarily distorts your sense of direction and completely prevents you from noticing that in its very centre the break in the main axis lies. One quick glance around the room and you are re-orientated in the direction of the main hall, without any sense of having turned a corner, thinking you have continued walking straight ahead. An amazingly simple and therefore ingenious solution.[14]

The structural solutions employed in the design for the Länderbank, Wagner's use of glass and exposed iron, appear in retrospect prophetic of his subsequent development. His significance as an architect lay above all in the emphasis which he placed not upon stylistic but upon practical and pragmatic considerations (he

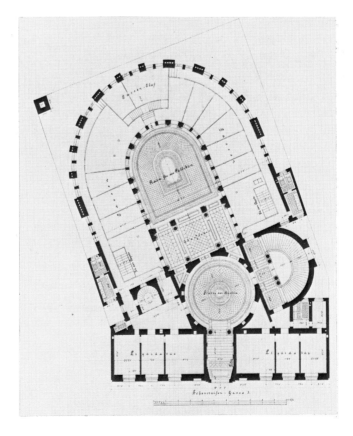

74. Otto Wagner: *Oesterreichische Länderbank*, Vienna, Hohenstaufengasse, 1883–4. Ground plan. From *Einige Skizzen, Projekte und ausgeführte Bauwerke*, vol. 1, print 54

referred to himself on one occasion as the 'representative of a certain practical tendency in architecture').[15] As early as 1891, in the preface to the first volume of his *Sketches, Projects etc.* (published the following year), he declared his faith in that 'pragmatic style of the future' towards which architects were heading under full sail, and pointed to the necessity of taking into account 'modern advances in materials and construction methods'. And in the first edition of his treatise *Moderne Architektur*, probably his most influential book, he devoted part of his text to an examination of the relationship between architecture and technology, announcing:

Modern forms must correspond to new materials, contemporary needs, if they are to be found suitable for mankind today. They must embody our own development, our democracy, our self-confidence, our idealism. They must take into account the colossal technical and scientific advances of our age, as well as the practical requirements of society—that is self-evident![16]

In this vision of the architect in his 'dual role as artist and engineer', Wagner was too modest not to acknowledge his debt to earlier prophets of the new architecture, especially in France. He was, however, by comparison with his French counterparts—Eiffel, for example—in a unique position, since he was one of the very few outstanding architects in a city whose rapid growth and new-found prosperity were beginning to pose unprecedented problems not only of housing, but also of transport and communications—subjects which were to occupy most of his energies for nearly a decade, from the 1890s to the early 1900s. In 1893, he was one of the successful entrants in a competition for designs for the 'general regulation of the city of Vienna'; his plan gave particular prominence to the question of the city's inter-urban communications, made clear the importance of long, straight roads to accommodate the growing volume of traffic,[17] and proposed the remodelling of certain sections of the old city, and the extension of the Gürtelstrasse, a further, semicircular road beyond and concentric with the Ring, so as to form a complete circle which would bypass the centre of Vienna altogether. Attention was also given to the regulation of the Danube Canal and the setting-up of all-weather harbours for grain and coal. There was even a section devoted to the transportation of the city's corpses, which were to be whisked away from specially pre-arranged pick-up points by the new underground railway.[18] Whether fortunately or unfortunately for the subsequent history of Vienna, the more grandiose aspects of his plan—his design for the regulation of the Stubenviertel, for example, the central area of the city next to the Danube Canal (Plate 70)—were doomed to remain as elaborate presentation drawings, although in their published form these drawings did much to enhance their author's fame in the realms of town-planning far beyond the borders of Austria. The trouble he had gone to in trying to rethink Vienna's acute traffic problems was, however, far from being entirely wasted. In particular, his appointment as professor of architecture at the Academy, a post to which he succeeded on the death of Hasenauer in 1894, coincided with his nomination by the Künstlerhaus to perhaps the most influential position the city had to offer in the field of communications: that of artistic adviser to the Viennese Transport Commission.

It was in his capacity as adviser to the Transport Commission that Wagner became involved in two of the most pressing technological projects of the day:

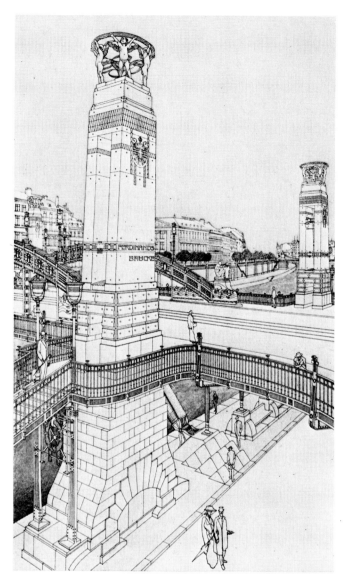

75. (*left*) Otto Wagner:
Drawing for the Ferdinands-
brücke, 1905. From *Einige*
Skizzen, Projekte und
ausgeführte Bauwerke,
vol. 3, print 62

the construction of the Stadtbahn, Vienna's metropolitan railway system, and of
the quayside installations and dams on the Danube Canal. These two schemes
were in fact closely related, since the Transport Bill of 1891 had stipulated that
the construction of the Stadtbahn and the regulation of the river Wien and the
Danube Canal should be undertaken simultaneously as part of a joint enterprise.
They were also by nature inextricably linked, since it was planned that low-lying
sections of the Stadtbahn should run alongside the canal; thus, one of the more
important functions of the dams was to protect these sections of track from the
danger of flooding. But the dams themselves were only part of a much more
ambitious programme for the regulation of the canal, which was to be enlarged
and made navigable whatever the state of the river. As it happened, only two of
the four dams originally envisaged were completed, and Wagner's magnificent
designs for bridges lower down the canal (Plate 75), which he proposed as part
of his reorganization of the Stubenviertel, never progressed beyond the drawing
board. But the two completed dams, at Nussdorf and at Kaiserbad (Plates 76–8),
were a revolution by themselves. The Nussdorf installation, the first to come

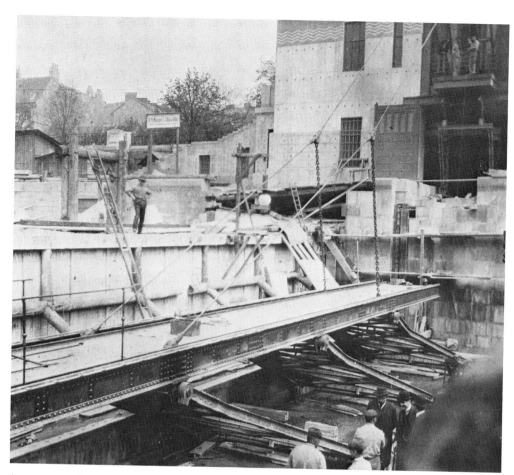

76 and 77. (*opposite right and right*) Otto Wagner: *Kaiserbad Dam.* Photographs *c.* 1904 showing construction in progress

into operation, was one of the technological sensations of its day, the mechanism accurate to within centimetres, the materials and methods employed in its construction often experimental, sometimes far in advance of their era (Wagner promised, for example, that the roofing material used for the control building and the large chain storehouse, a compound of iron, reinforced concrete, asphalt, gravel and hardcore, would last for ever).[19] Work on the foundations of the dam itself, which were sunk to a depth of twenty-seven yards, was carried out with extraordinary precision, and commanded the attention of the principal bridge-builders of Europe. Moreover, quite apart from the technological innovations, the aesthetic ensemble created by the installations reflects one of the most impressive of all the architect's designs, the dam surmounted by massive abutments, in keeping with the flanking pillars intended for the unrealized bridges lower down the canal. From these abutments great bronze lions, executed by Rudolf Weyr, gaze northwards towards the main stream of the Danube (Plate 78). Lux, commenting on the originality of Wagner's conception, wrote of the Nussdorf installation: 'There has been created a new beauty, arising out of purely technical objectivity, united with the artist's sense of form—a beauty which could never have been derived from the past.'[20]

An even greater technological challenge was offered by the project for the Stadtbahn, probably the most famous of all Wagner's executed works of this period. The very scope of this commission, which was to be completed within a space of only seven years, beggars description. The metropolitan railway network

embraces no less than forty stations, some of them quite extensive, with all the paraphernalia of platforms and staircases, signal boxes and booking offices, and some fifty miles of track, a mixture of subways, viaducts and open tunnel construction. When one considers that, despite the collaboration of a large team of assistants and the resources of a professional drawing-office, Wagner himself carried sole responsibility for the design and execution of the entire project, one can only wonder at the imaginative grasp and attention to detail revealed at every turn. Designs flowed from his pen not only for the station buildings, but also for bridges (Plate 79) and embankments, arcades and tunnels, right down to the minutiae of supporting arches and columns, abutments and tunnel entrances. Many of these designs still merit our attention on account of their clarity of vision, their logical employment of technological resources. Of particular interest is Wagner's use of exposed iron-framework construction, and the unfaced beams which, in certain of the station buildings, are used as window lintels; for some sections of the open tunnels which are a feature of outlying stretches of line, especially the Donaukanallinie (Danube Canal Line), he also employs a form of cast-iron supporting pillar with a reinforced concrete core. Confronted with parts of the Stadtbahn, even in its present neglected state, one is reminded irresistibly of the architect's own dictum: that by virtue of the technical innovations of modern times 'neither the Renaissance nor Antiquity had produced anything comparable to the architectural creations' of his own day.[21]

Of the six lines originally projected by Wagner, only four were actually built. The Donaukanallinie, the construction of which was only made possible by the completion of the dam at Nussdorf, was the last section of the network to come into service, in 1901. It is a tribute to Wagner's designs that those of his station buildings for the Stadtbahn which have been allowed to survive to the present

78. Otto Wagner: *Nussdorf Dam*, 1898. View from the observation post on the roof of the administration block

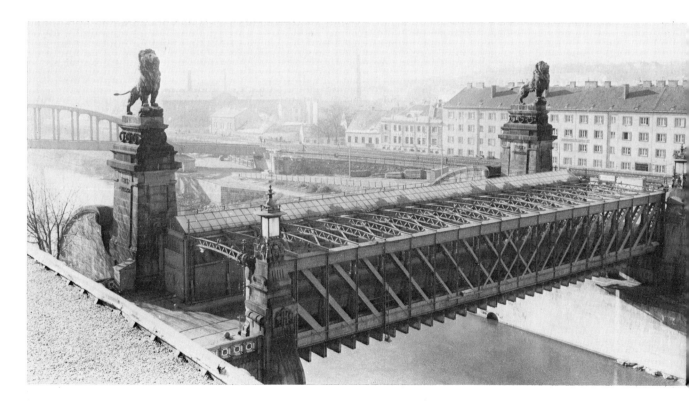

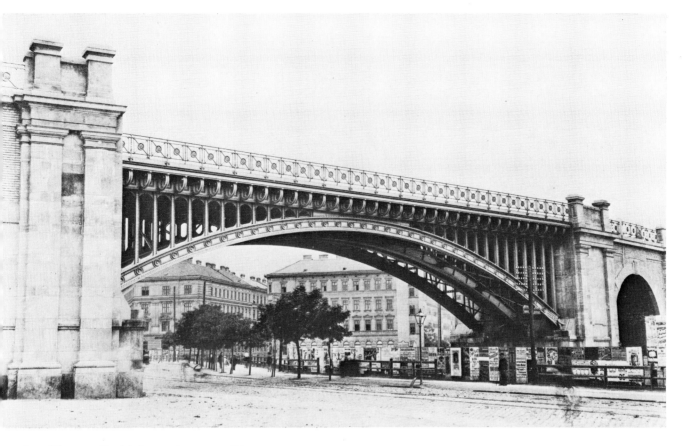

day are still able to cope with a vastly increased flow of traffic. As in the case of the Post Office Savings Bank, the architect envisaged, and provided for, the needs not only of the immediate present but also of the more distant future.

Stylistically, the Stadtbahn is a hybrid. It is, first of all, the offspring of that marriage of architecture and engineering which Wagner had demanded, and which remained the basis of all his subsequent work. This marriage is, however, not altogether a happy one. As in much of his later *oeuvre*, classical elements still survive in abundance, seeming particularly out of place when juxtaposed with

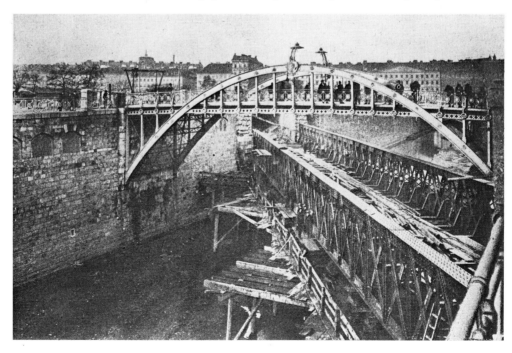

80. Photograph *c.* 1900
showing the *Zollamtsbrücke*
(Customs House Bridge)
and, below, part of the
Stadtbahn under construction

99

often sophisticated technological innovations. Lux himself pointed to this duality when he wrote:

In the Vienna Stadtbahn ... one can already see the revolutionary. He has reduced the demands of the day to the one radical formula: glass and iron! But at the same time, one would have to be blind not to see behind this apparent radicalism the classical pedigree of a genius reared on the works of the greatest masters of architecture of the past.[22]

But secondly, Wagner's designs for the Stadtbahn make manifest the importance of another, more immediate influence—that of *Jugendstil*. This influence was, it should be emphasized, only transitory, a kind of personal *fin de siècle*, although recognizably secessionistic elements continue to appear in a more muted fashion in some of the architect's later buildings, for example the church 'am Steinhof'. This response to, and subsequent rejection of contemporary tendencies in architecture is a further example of Wagner's essentially eclectic disposition; for him, *Jugendstil* was simply another style, equally interesting as the accepted period styles upon which he drew so heavily. Any examination of the problems posed by this apparently abrupt change in artistic direction must also take into account the important part played by Wagner's assistants in influencing this phase of his development. Their impact upon the architectural practice of their master, a mature, established artist in his mid-fifties, was in many ways as decisive as his effect upon them; it was undoubtedly this two-way relationship which Lux had in mind when he wrote of Wagner: 'The youthful enthusiasm which he has generated rebounds upon him; he himself becomes rejuvenated, transformed.'[23] It is more than coincidence that among his most brilliant helpmates were none other than Olbrich and Hoffmann; although the precise extent of their collaboration remains obscure, Olbrich, from quite an early date, bore a considerable part of the burden of the Stadtbahn project. His contributions, it has been shown, are in certain instances clearly documentable; in particular, it appears to have been he who was responsible for the singular, wholly individual flavour of the decoration of some of the most famous of the station buildings—decoration which at times even serves to obscure the fundamental message of Wagner's architectonic innovations.[24]

In the contemporary attacks which the Stadtbahn provoked, it is not difficult to recognize the disquiet occasioned not so much by the appearance of the buildings themselves as by the artistic affiliation which they demonstrated, the fact that yet another established artist was willing to ally himself with the Secessionists, who were evidently bent upon turning the development of Viennese art upside down. Equally widespread opposition was called forth by the two apartment blocks, Nos. 38 and 40 Linke Wienzeile, which Wagner built during 1898–9. Most famous, or notorious, was No. 40, the so-called Majolika Haus (Plate 8), with its elaborate, coloured ceramic decoration of the façade, the exterior crowned by four bronze half-length figures executed by the sculptor Othmar Schimkowitz, himself a member of the Secession. Even the faithful Lux seems to have found this façade difficult to accept; he describes what he calls the 'wildly secessionistic element' as a foreign body, insisting that it is necessary to look behind the façade 'in order to recognize the architect bent on the truly essential'.[25] Ironically, history has

reversed his judgement. The plan of the building can scarcely be described as progressive; in its conception, Wagner sticks closely to the type characteristic of the residential blocks of the early *Gründerzeit*. The ceramic patterns of the façade represent, on the other hand, an important step away from the kind of external sculptural decoration still found, for example, on the exterior of the Haus Zacherl (Plate 81, built in 1903–5 by Josef Plecnik, one of Wagner's pupils), towards an entirely flat, decorative, geometrical style of ornamentation. Even more interesting, as recent restorations have revealed, is Linke Wienzeile No. 38, the house on the corner of the Wienzeile and the Köstlergasse. Superficially, it too is highly

81. Josef Plecnik: *Haus Zacherl*, 1903–5. Vienna, Brandstätte 6

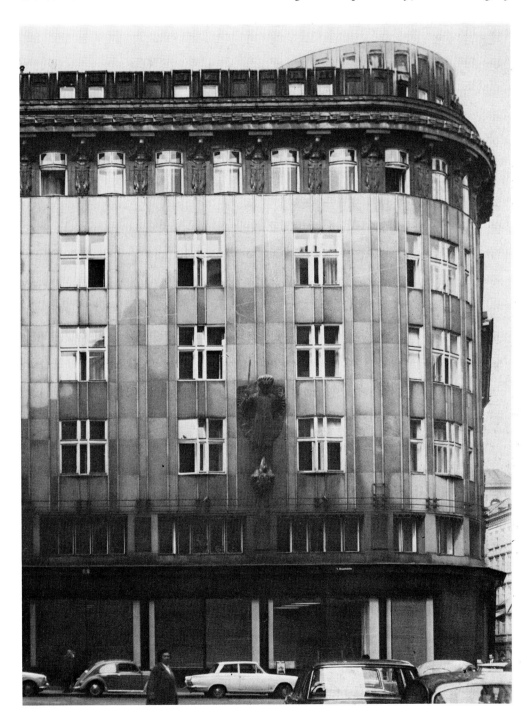

secessionistic in its decoration—secessionistic, here, in the strict sense, since its gleaming white-and-gold façades (Plate 82) closely resemble the original appearance of Olbrich's Secession building. But as important as this *Jugendstil*-influenced veneer is the overtly classical spirit which informs this building. The rustication of the ground floor is classical in derivation, as is the decoration beneath the sills of the upper windows, where triglyph-like supports occupy the position in which one might normally expect to find small consoles. Surmounting the façade, the massive cornice displays on its underside classical coffering, and even rosettes.

Wagner's alliance with the Secession (he actually joined the association in October 1899) coincided with the beginnings of that public opposition which was to dog him right up to his death; of the works of visual art produced by his friends and contemporaries, only Klimt's paintings gave rise to comparable dispute. For Wagner, however, this opposition must have been even more difficult to bear. Until now, he had been one of the most distinguished pillars of the establishment, the representative of everything that was officially acceptable; now, at the age of nearly sixty, he had to learn to be an *enfant terrible*. The attacks directed against him were on occasion such as to prevent some of his most ambitious projects from being realized—for the new Academy of Fine Arts, for example, or the Kaiser-Franz-Josef-Museum. On the other hand, he succeeded during the

82. Otto Wagner: *Apartment block*, 1899. Vienna, Linke Wienzeile 38

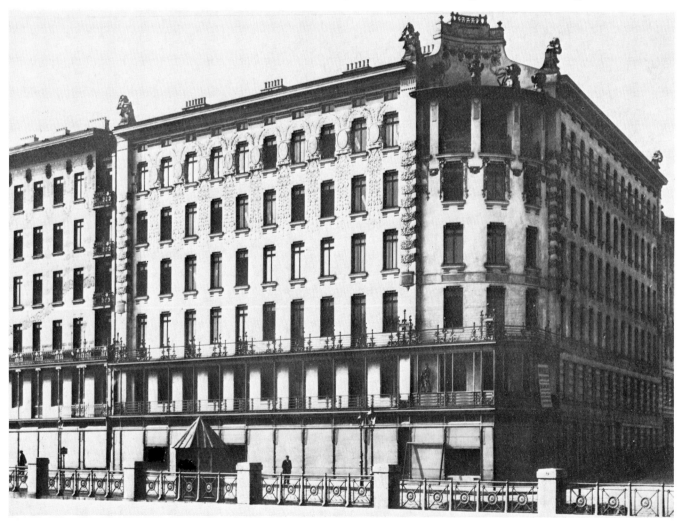

first years of the new century in winning two extremely important public commissions which, quite apart from any aesthetic considerations, demonstrate *par excellence* his incomparable technical virtuosity. These were the building of the Postsparkasse (Post Office Savings Bank, Plate 83) and the Church of St Leopold for the Lower Austrian Institution and Sanatorium 'am Steinhof' (Plate 88).

Wagner's competition design for the Postsparkasse, which triumphed over no less than thirty-six other entries, has some claim to be considered the most progressive of all his architectural projects. The construction was undertaken in two phases: the first (1904–6) saw the completion of the 'lungs and heart' of the design, the central, triple-naved counter hall (Plate 87); the second (1910–12) the rear section of the building (Plate 84), including the large pay office, which handled securities and bonds. The first phase of the building already incorporated the most revolutionary features of the finished project, among them the thin white panels of marble, secured by over 17,000 metal bolts, which clothe the exterior façades, and the extensive use of aluminium, out of which were constructed *inter alia* the famous hot air blowers (Plate 86), providing the temperature control for the counter hall. The external basement walls were faced with granite slabs held in place by aluminium-headed bolts, countersunk for greater emphasis (Plate 85)—an interesting modern variant of the kind of massive rustication

83. Otto Wagner: *Postsparkasse*, 1904–6. Vienna, Georg Koch Platz. Main façade

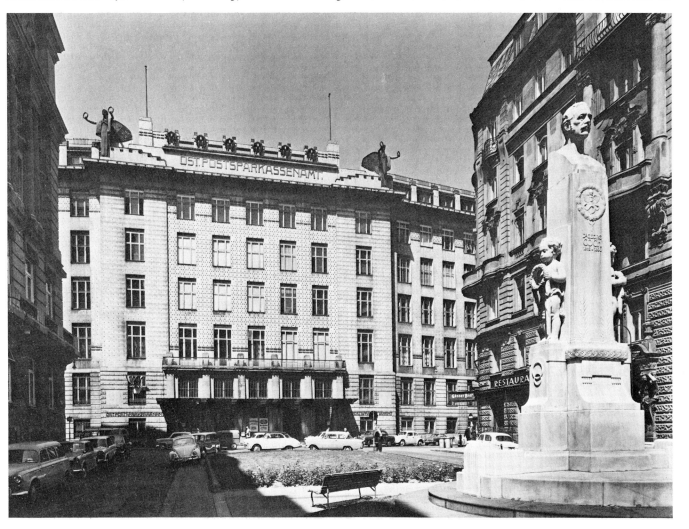

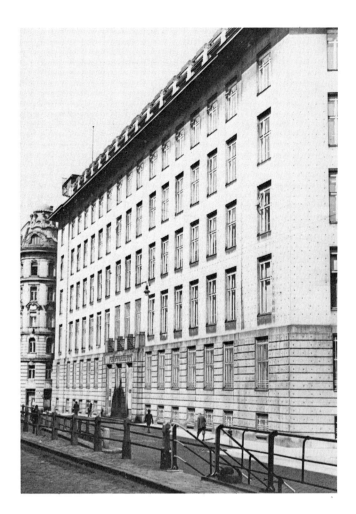

classically used for the ground-floor exteriors of banks and vaults (Wagner had employed a no less massive form of rustication in his earlier design for the Länderbank, where the overall appearance reflects in general a more traditional conception of public architecture). Another important feature of the first phase of the Postsparkasse is the use of a glass roof to light the central counter section—a device which also recalls the borrowed lights employed in the interior of the Länderbank. But although it is tempting to compare the ground-plans of the two buildings, or the logic and utility of their overall design, in their details, and especially in the use of materials which they embody, they are worlds apart. Lux wrote:

Nothing about the Postsparkasse reminds one of the 'free Renaissance'. No reminiscences of historical styles, no *palazzo* architecture, no false monumentality dug out from the treasure-house of tradition—everything *Nutzstil* [literally, 'usefulness-style']. Use of materials takes pride of place. Reinforced concrete, glass, marble, aluminium, ebonite etc.—these are the elements out of which the work is constructed. Pure new words! No architect would have thought of suchlike at the time when the Länderbank was being built. Otto Wagner discovered them. Even if he did not invent these materials, it is he, none the less, who has given them their up-to-date significance by revealing their practical application for architecture. . . .

84. (*left*) Otto Wagner: *Postsparkasse*, rear façade 1910–12. The glimpse of the adjacent building accentuates the contrast between Wagner's later work and Viennese Historicism

85. (*right*) Otto Wagner: *Postsparkasse*, detail of the rustication of the basement storey

86. Otto Wagner: *Postsparkasse*. One of the aluminium 'hot air blowers' which provided temperature control for the main counter hall

These new building materials, giving rise to new methods of construction, and the new decorative and monumental means of expression which follow from them—these are the external signs of a changing spirit of the age.[26]

Wagner's use of materials was, however, dictated not only by a new kind of aesthetic vision, but also by sheer practicality. Marble and glass obviated the necessity of cleaning and, in general, of repairs; aluminium, because it does not rust, needs to be neither cleaned nor replaced. The architect's attention to details, as in the case of the Stadtbahn, is astonishing—and supremely practical details at that, from the specially designed under-roof heating, intended to disperse accumulated snow in winter, right down to the unobtrusive, but effective, sheets of glass which covered the lower walls of the public rooms, to the frustration of habitual writers of graffiti. 'To scribble here', observed Hevesi, 'the public will have to use Grade A diamonds.'[27] Hevesi was one of a group of visitors who were shown round the building shortly after the completion of the first phase, guided by the director of the bank, Sektionschef von Schuster, and Wagner himself, and he left a fascinating description of the overwhelming impression which the whole made on him:

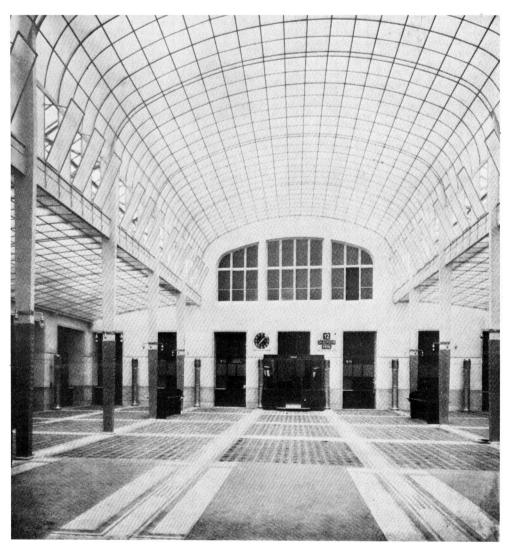

87. Otto Wagner: *Postsparkasse*, main counter hall

A monumental, purpose-designed building—something you notice already on your approach from the outside—has arisen in the midst of these crooked streets, which it exploits skilfully in order to present its central façade to the Ring. The two column-like figures on the roof (by Schimkowitz, fourteen feet high, cast in aluminium—a technique never before used on such a scale) look out over the Ring and the traffic. This is the way Otto Wagner wanted it; the main business quarters belong in the narrow streets, this dead region; the parts of the building intended for public access belong amidst the life of the broad thoroughfares. The forms of the new building are of course thoroughly modern. None of your exercise-book details, but at the same time, nothing of that curiosity style which the public calls 'secessionistic'. . . .

Led by our kindly guides, we wandered at leisure through all the rooms of this great building, with the exception of the vault, which had to remain closed to our obstinately heathen feet. . . . We went into the counter hall, in fact a glass-covered courtyard. Vienna's other glass roofs, which seem for the most part designed to let in the rain and store up the snow, could well learn some useful lessons from this one. It even has its own heating system, which is designed to melt snow and ice, allowing them to run away easily. In the counter hall itself there reigns the utmost simplicity. . . . Opposite the entrance, to left and right of the supervisors' boxes, one sees two rectangular objects: the clock and the calendar. They have great character and impress one far more than the somewhat mediocre effect which would be produced by two allegorical pictures. But the room itself, with its triple-naved rhythm, which is emphasized by the glass roof, is beautiful and imposing. To add a touch of the spice of high finance, it is worth remarking that of the thirty cash-desks placed along the walls, four are reserved for dealing with sums of over a million [crowns]. These are the romantic, indeed heroic touches which one finds in a modern Post Office Savings Bank. But in fact, everything is an attraction worth seeing. The interior of one of the cash-desks, with its own specially laid-out till, or even a simple iron door, consisting of one soft iron sheet between two hard steel ones, which has shown itself to be virtually impenetrable, but which is, of course, also provided with other security devices (alarm bells). The heating pipes run, as is taken for granted today, in full view along the walls. In the age of the false palaces, one would not have put up with them, today we experience them as, at the same time, a decorative, that is to say vitalizing detail of the organism as a whole, one which has its own elegance of line, and which itself helps to emphasize the dividing-up of space. In such an environment, modern man appears so much in his native habitat, so almost unexpectedly natural, that it is well-nigh impossible to comprehend how one could build otherwise. . . .

Looking attentively, we walked along the broad, well-lit corridors, behind whose rounded corners are concealed dustpans and vacuum-cleaners, and through the large offices. We had explained to us the structural innovations, the wonders of concrete, one might say, and imagined pillars which have to support a weight of 550 tons. We savoured figures and materials far from the run of everyday experience. One has ample opportunity to look around one on the way, as there is nothing to trip over. Even the linoleum, surely invented for the sole purpose of tripping one up, is here concealed, being countersunk its entire thickness in

the floor. And the parquet flooring of the halls is ideal. . . .

One can fill up a stimulating two hours with this visit. One hears and sees a multitude of novelties, and leaves this newest of public buildings with the conviction that modern architecture in Vienna has here enjoyed a resounding success in the practical sphere, and one which is indicative of the future.[28]

The foundation stone of Wagner's other most important building from the early years o the century, the church of St Leopold 'am Steinhof' (Plate 88), was laid on 27 September 1904 in the presence of the Emperor Franz Joseph. The church, completed in 1907, was built for the Lower Austrian Institution and Sanatorium, for the general layout of which Wagner also submitted a master plan, not in fact used. It is one of his few excursions into the realm of sacred architecture; it was also one of the works which contributed most to his international reputation:

88. Otto Wagner: *Church 'am Steinhof'*, 1905

This single-span church complied extremely well with Wagner's insistence on space. The pillars at the intersection of nave and transept, which support the

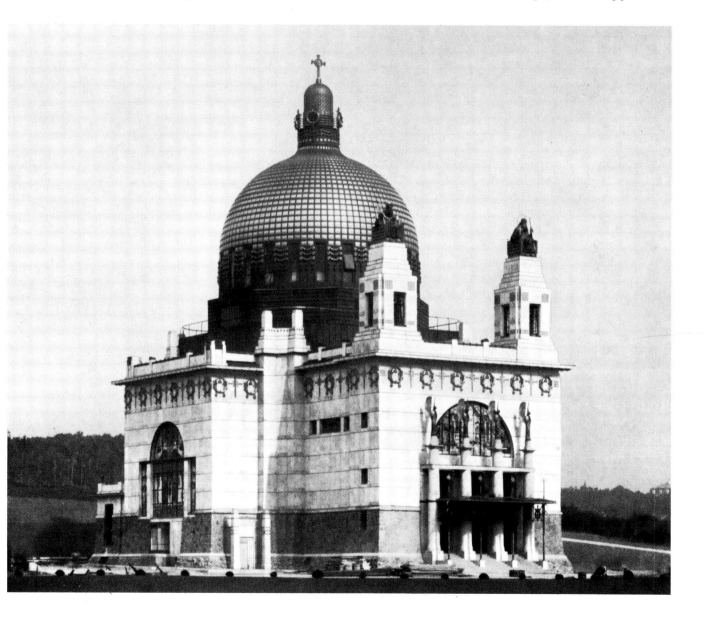

dome, are relatively narrow; they are made of plain brickwork and are entirely free from thrust. . . . Wagner, who hated canvases and 'the unreliable fresco technique which created so many difficulties', ensured that the picture above the high altar (by Remigius Geyling) and the two pictures above the side altars (by Rudolf Jettmar) were executed in a new and special kind of mosaic consisting of pottery, marble with different surface consistencies, vitrified enamel and glass. The pictures were not completed until 1913. To improve the congregation's view of the altar—which was already raised—the floor of the church was given an imperceptible slope, which ran from the vestibule down to the communion rail. Wagner indulged his aversion to 'abnormal height factors', and also sought to ensure good acoustics, by building a vaulted ornamental ceiling inside the dome, which considerably reduced its internal volume. This ceiling consists of Rabitz panels inserted into a framework of unfaced T-irons, whose visible lower faces were gilded. The space above the ornamental ceiling was divided into two separate sections by a concrete floor, which provided a working surface from which to operate the winches for the chandeliers and the cradle used for cleaning the ceiling. The outside brickwork was protected by sheets of marble two centimetres thick, which were held in position by stout marble bands and fixed to the wall with bolts fitted with screw-on copper caps. In fact, all the exposed metal parts were made of copper; even the iron windows were coated with copper. The lapped copper tiles on the roof of the dome were originally gilded, and the projecting lip at the top of each tile was meant to act as a screen against hailstones. The various flat roofs of the church were asphalted and covered with gravel.[29]

Work on the furnishings, sculptures and decoration of the church brought together many prominent artists of the Secession. Othmar Schimkowitz, who had designed the acroteria of the Post Office Savings Bank, created the four gilded copper angels above the main entrance (Plate 89). The sculptor Richard Luksch was responsible for the seated figures of Leopold and Severinus, patron saints of Lower Austria, which are enthroned upon the flanking towers, and the painter Rudolf Jettmar for the glass mosaics above the side altars. The design for a chalice was by Pater Desiderius Lenz, superior of the Beuron order of painter-monks. The windows above the side altars, in the organ loft and in the crossing of the vault, which were also glass mosaic and not, as is often stated, stained glass, were by Kolo Moser. Wagner had originally asked Moser to design the mosaics above the high and side altars, but this commission was subsequently taken away from him. One reason for this would appear to be a certain cooling of the relationship between Wagner and Moser after the latter's marriage to Editha Mautner-Markhof, and his subsequent conversion to Protestantism.[30] His studies for the side altars, which depict a guardian angel and the assumption of the Virgin, have however survived; they show not only Moser's typical delicacy of feeling but also, ironically, his perfect adaption to Wagner's architectural style of the period (Plate 90).

Like his project for the parish church at Währing (1898), the church 'am Steinhof' is eloquent of Wagner's disdain for what he called 'the traditional and—one is tempted to say—thoughtless impression of a church'.[31] Practical considerations—above all, the comfort, hygiene and participation of the congregation—

89. Othmar Schimkowitz: *One of four gilded copper angels above the main entrance of Wagner's church 'am Steinhof', c. 1905*

90. Kolo Moser: *Unrealized design for glass mosaic above side altar of Wagner's church 'am Steinhof'*, c. 1905. Vienna, Christian M. Nebehay

were for him of paramount importance. Particular attention was given to the demands of acoustics, of visibility from every viewpoint, of ventilation, heating and adequate lighting. 'Whoever believes', wrote Lux, 'that the mystical-religious impulse is nurtured in the semi-darkness of a poorly ventilated, cold, damp interior is brilliantly contradicted by Wagner's building'.[32] The special needs of the inmates of the sanatorium were also taken into account. The benches, which were made of dark oak, were purposely kept short, seating at most four or five people, so that, if any of the patients suffered an attack during a service, the staff could come to their aid with a minimum of disturbance. As far as hygiene was concerned, one of the most ingenious devices was the holy water stoop, in the shape of a small fountain which ran continuously during services; thus, the patients could pass their fingers under the stream of water instead of dipping them in a bowl in the traditional manner, avoiding any possible spread of infection. Among other practical provisions, the sacristy was intended to double as a treatment room in case of emergency, and the vestry as a confessional for the hard of hearing.

The unashamedly pragmatic view of sacred architecture which Wagner's designs embodied provoked spirited opposition both inside and outside the Catholic Church. Only the intervention of various highly placed personages, among them Dr Friedrich Piffl, Archbishop of Vienna, and Prince Liechtenstein, succeeded in quelling the architect's enemies. But Wagner was not without his supporters. In the course of the controversy over the church, Archbishop Piffl, in particular, became one of his staunchest advocates, and when the decoration of the interior was finally completed he seized the opportunity offered by the dedication of the altarpiece, on 26 July 1913, to deliver the following tribute to the artist whose work had been the focal point of such bitter discussion:

I am especially grateful for the opportunity of participating in this ceremony, since it gave me the chance of acquainting myself with this monumental work of sacred architecture, which I have so frequently heard discussed by those ill

equipped to do so. I can only say one thing: that I myself, when I entered the church, was literally seized by the monumental character of the building. I was overcome by the feeling: 'This is truly that holy place, of which it is written, Take off your shoes, leave all worldly thoughts behind you and turn to Him for whom this house of God was created!' Herr Hofrat [Wagner], I shall always remain a champion of this church, which produces so monumental an effect, which declares of itself that it is the house of God.[33]

Of course, the effect of the building cannot be explained solely in terms of the ingenuity of the architect's solutions to purely practical problems. Wagner's choice of materials, the use of white marble, the jewel-like effect upon which Hevesi commented, the church's commanding position on the ridge above the village of Baumgarten (which reminded Hevesi of the sixteenth-century cathedral of Kurtea de Arges in Rumania), all contributed to the overwhelming impression produced upon even the casual visitor. The location was particularly important, affecting Wagner's decision to gild the dome, which was visible like a beacon from many points among the surrounding hills, and also the use of what is in fact a double dome, the high exterior shell giving added visibility from the further environs of Vienna, the lower interior ceiling preserving the unity of the almost cubic internal spaces. Once again Lux:

The building rises amid the slopes of the Vienna woods, with an all-embracing view of Vienna. There, they have built a white city, the so-called 'Sanatorium and Institution', alas, without the guiding spirit of Wagner. . . . But the Church is by him—a new emblem of the city at its western approach from the Wiental, just as the dams provide an emblem on one's approach from the Danube.

From every high point about the city can be seen the golden cupola, flaming against its green setting. Of Palladian beauty, it is unmistakably informed by the spirit of modernity, held together by a steel ring, which thus obviates the necessity of supports and buttresses. It is a child of modern constructional methods. At

91. Otto Wagner: *First design for a university library.* From *Einige Skizzen, Projekte und ausgeführte Bauwerke*, vol. 4, print 16

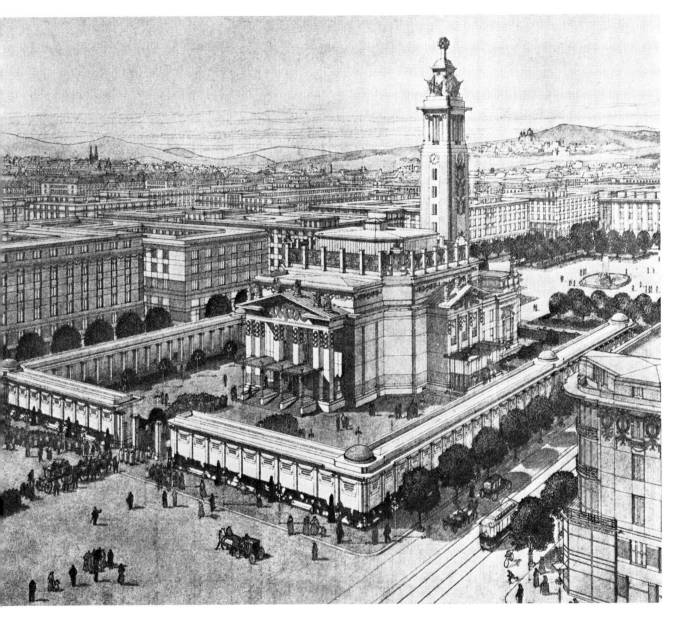

no other time than the present could it have been created in such a form.[34]

Wagner's *oeuvre*, both completed and merely projected, of the period after the completion of the church 'am Steinhof' manifests a certain duality. On the one hand, those buildings in which some technological or utilitarian concept prevails— his unrealized designs for a new university library, for example (Plate 91), or the apartment blocks in the Neustiftgasse and Döblergasse, which were actually built —are extremely progressive in character, with an emphasis on the reduction of ornament, on flat surface, above all a severely rectilinear geometry, which relates them more immediately than one might at first suppose to the 'nihilistic' architecture of Loos. On the other hand, some of Wagner's designs, even from his last years, adhere obstinately to the use of a highly traditional architectural vocabulary. A most striking example is his last design of all, entitled Victory Church or, more cautiously, Armistice Church, which utilizes a whole host of classical elements, including columns and pediments, as well as an extraordinary personal interpretation of the Renaissance type of campanile (Plate 92). Curiously, Wagner himself regarded it as potentially his masterpiece, although it is possible that, as

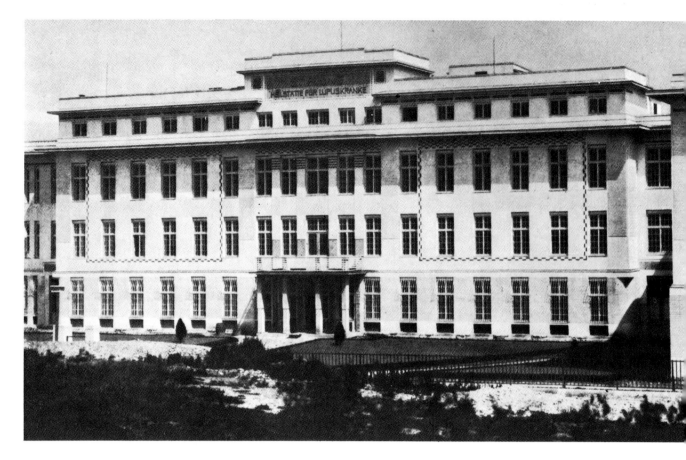

was the case with so many of his buildings, the final execution might well have differed from the *première pensée*. 'I have the feeling', he wrote, 'that the Frieden-skirche is the best thing I have ever done, and my sense of taste persuades me that no architect has ever created anything like it. . . . If I am successful with the church I shall be recognized as the foremost architect in Austria as well. If only I live to see it'.[35]

As it happened, the church 'am Steinhof' proved to be, apart from the Lupus Sanatorium (1910–13, Plate 93), the two apartment blocks, and the building of the second phase of the Postsparkasse, Wagner's last important public commission. His last years were increasingly embittered by official rejection of many of his most cherished ambitions, not only in the field of town planning, but also individual projects: for the new War Ministry Building (Plate 94), for an Academy of Fine Arts (Plate 95), for a 'Palace for Viennese Soceity'. Of these later projects, fate was particularly unkind to his designs for the Kaiser-Franz-Josef-Museum or Stadtmuseum (Plate 96), which Wagner had proposed as early as 1900, and which underwent innumerable revisions, including a change of location, before being finally abandoned. Originally, the museum was to have been built on a site almost identical with that of the present Historisches Museum der Stadt Wien, as part of a more general plan which Wagner had put forward for the regulation of the Karlsplatz. As in the case of the Oesterreichische Länderbank, the architect was here confronted with an asymmetrical area on which to build, and in the course of various revisions he developed a compact scheme which closed the eastern end, or 'museum end', of the square in a single unit. Wagner was especially anxious to avoid borrowing motifs from, or attempting to dominate, the Karlskirche, which would have been the adjacent building—the mistakes made by the conservative design for the museum submitted by Wagner's rival, the architect Friedrich

93. Otto Wagner: *Lupus Sanatorium*, 1912. Entrance block

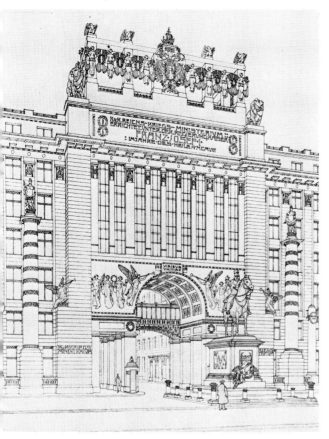

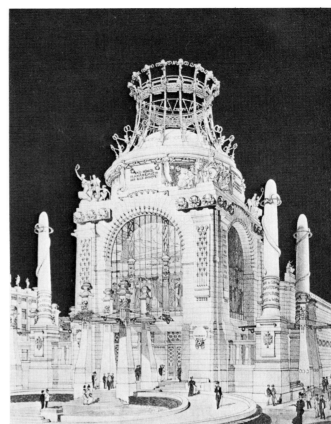

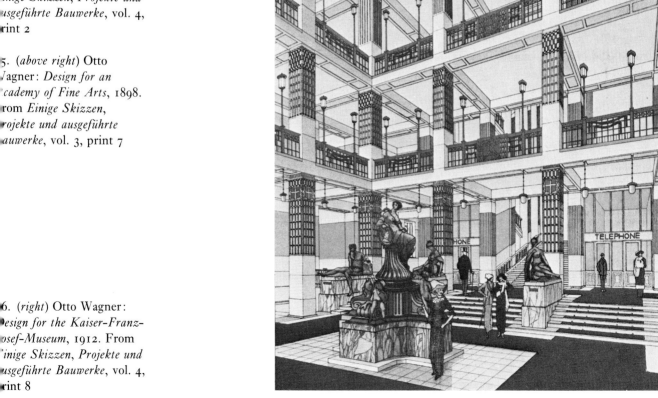

4. (*above left*) Otto Wagner:
*Competition design for a new
War Ministry building*, 1907.
Entrance section and
Radetzky monument. From
*Einige Skizzen, Projekte und
ausgeführte Bauwerke*, vol. 4,
print 2

5. (*above right*) Otto
Wagner: *Design for an
Academy of Fine Arts*, 1898.
From *Einige Skizzen,
Projekte und ausgeführte
Bauwerke*, vol. 3, print 7

6. (*right*) Otto Wagner:
*Design for the Kaiser-Franz-
Josef-Museum*, 1912. From
*Einige Skizzen, Projekte und
ausgeführte Bauwerke*, vol. 4,
print 8

Schachner. Controversy over the two competing projects continued long after Schachner's death; in 1909 Wagner drew up new plans which treated the square as a single entity (Plate 97), involving the construction of a department store on the southern side and, opposite it, a monumental fountain. In January 1910, he even went so far as to erect a full-size mock-up of part of the museum on the intended site to allow viewers to judge the effect produced by closing the museum end of the square. This move turned out to be his undoing. Despite the loyal support of many prominent members of the artistic fraternity, despite a whole evening of lectures in Wagner's defence organized by the Society of Austrian Architects, the public outcry which the erection of the model provoked signalled the death of the project, at least as far as the Karlsplatz location was concerned. Eduard Pötzl, the reactionary critic of the *Neues Wiener Tagblatt*, wrote:

This is the third time we have had to beat off Wagner's attacks on the Karlskirche. This time, with the setting up of the model, nobody who, with an open mind, walked across the square, could remain blind to the idiocy, the wilfulness of such a treatment of the church. Only artists, supporters of Wagner, saw in this act of vandalism a suitable 'closing of the eastern end of the square'. . . . Thus, prejudice blinds the otherwise clear-sighted, inciting them to heroic deeds for which posterity will revile us, just as we revile those evil-doers who did away with the Neuer Markt and other beauties of old Vienna.[36]

Dispute over the question of an alternative location for Wagner's museum dragged on for a time; the architect again drew up plans for a new site on the Schmelz, a large, somewhat desolate open space out beyond the Gürtel, which was also supposed to accommodate the projected Academy of Fine Arts, but in the end nothing came of it all. 'This Vienna', wrote Lux, 'possesses, in addition to other significant qualities, the extraordinary gift of banishing its most worthwhile talents, or of humiliating them'.[37] And Moser, recalling in 1916 the heroic period of the Secession and its associates, declared sadly:

The magnificent plan for the rebuilding of the Karlsplatz and the erection of the Stadtmuseum foundered due to the pettiness of the relevant authorities. Now we live once again in a desolate, silent age, and one longs for the stormy events of fifteen, twenty years ago. Certainly there is no shortage of discontent today— perhaps only a shortage of those youthful spirits to air their dissatisfaction with sufficient noise and violence.[38]

If Wagner's own later projects brought him little satisfaction, he could at least rejoice in the growing success of his pupils, and the increasing international reputation of the Special School for Architecture, over which he presided at the Academy. By 1907, Hevesi was able to report that no less than two hundred applicants from abroad had been refused places at the school, on account of the pressure from Austrian architectural students desiring acceptance on Wagner's courses.[39] The school albums produced during the early years of Wagner's professorship show clearly the development of a certain house style, and the influence which the master exerted upon his pupils. The volume *Wagner-Schule 01*, for example, reveals the impact of Wagner's secessionistic period upon younger architects such as Ungethüm or Flesch-Brunningen (although, as already noted,

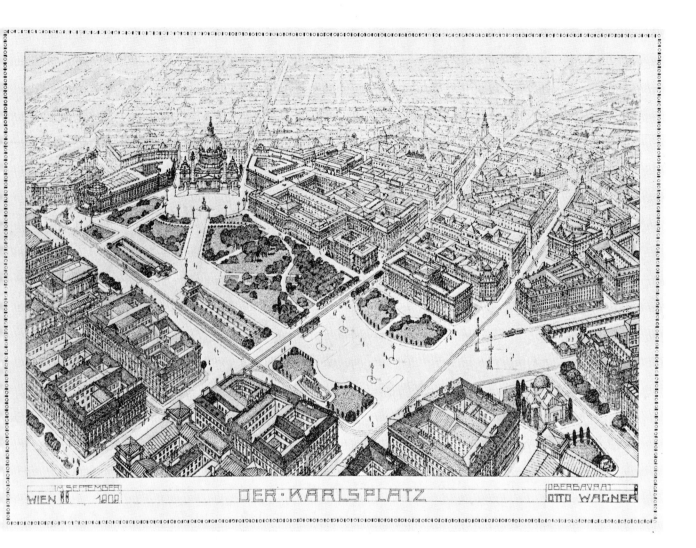

IM SEPTEMBER
WIEN II 1909 · DER · KARLSPLATZ · OBERBAVRAT
OTTO WAGNER

97. Otto Wagner: *Design for regulation of the Karlsplatz*, 1909. From *Einige Skizzen, Projekte und ausgeführte Bauwerke*, vol. 4, print 8

the influence of certain assistants, in particular Olbrich, upon the master's adoption and subsequent rejection of a secessionist manner must also be taken into account). However, apart from Olbrich and Hoffmann, the two most distinguished members of the *Wagner-Schule*, a number of other pupils rapidly developed an independent, recognizably individual style. Among them, Josef Plecnik (1872–1957) and Max Fabiani (1865–1962) are worth singling out for discussion. The former's Haus Zacherl (1903–5, Plate 81) and the latter's Haus Portois und Fix (1897, Plate 98) represent an important step away from the imposing Neo-Baroque façades of the Geschäftshaus Haas type of store (Siccardsburg and van der Nüll, 1865–7),[40] towards the more clear-cut division between residential and business accommodation which culminates in Loos' Haus Goldman und Salatsch (Haus on the Michaelerplatz, Plate 144) of 1910. Plecnik also built in 1910–12 the celebrated Heilig-Geist Kirche (Plate 100), which may be seen as a direct riposte to Wagner's church 'am Steinhof', but in which the pupil achieves a more consequential development of the master's own rationalization and unification of the interior spaces of the church. Of Wagner's other pupils, mention must also be made of Hubert Gessner, who built the Unfallsversicherungsanstalt (Accident Insurance Company Building) on the Linke Wienzeile, not far from the Majolika-

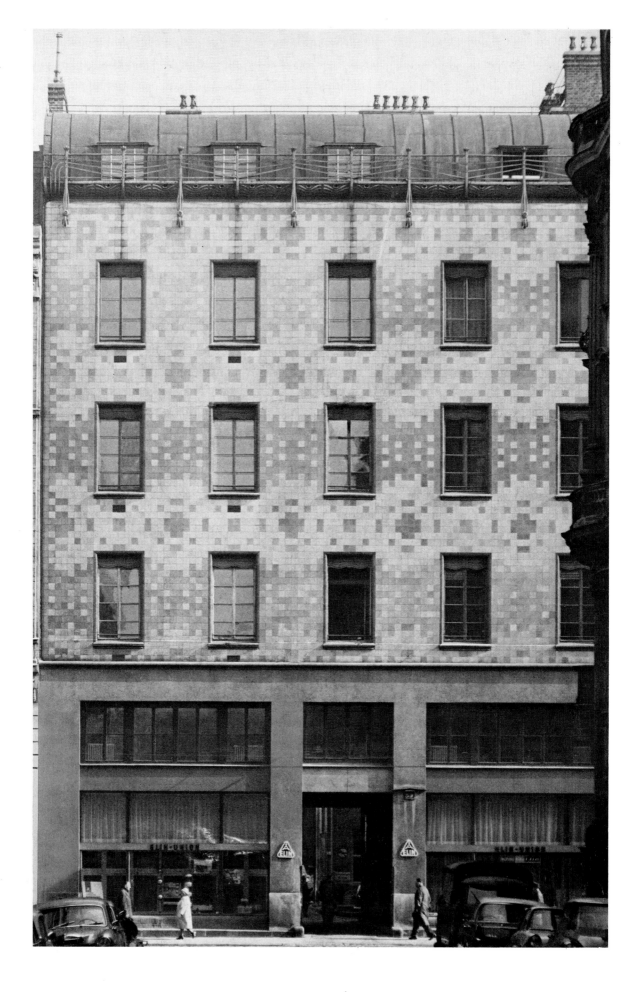

98. (*left*) Max Fabiani: *Haus Portois und Fix*, 1897. Vienna, Ungargasse 59

99. (*right*) Jan Kotera: *Villa Lemberger*, 1914. Vienna, Grinzingerallee 50

Haus, and the Czech architect Jan Kotera, whose only Viennese building, the Villa Lemberger of 1914 (Plate 99), demonstrates that combination of classical and expressive elements which is continued in the architecture of Czech Expressionism.

100. Josef Plecnik: *Heilig-Geist Kirche*, 1910–12. Vienna, Herbststrasse 82

Joseph Maria Olbrich, 1867–1908

Born in Troppau, Austrian Silesia (now Opava, Czechoslovakia), on 22 December 1867, Joseph Maria Philipp Olbrich first came to Vienna at the age of fourteen, where, at the building department of the Staatsgewerbeschule, he came into contact with the theories of the influential town-planner and passionate Wagnerian (Richard, not Otto, on this occasion) Camillo Sitte.[41] When he graduated from the school in 1886, Olbrich worked for a period in his home town as designer for a certain August Bartel, who was instrumental in persuading him to return to Vienna to complete his studies at the Academy. As a pupil of Hasenauer, Olbrich's natural fluency and outstanding draughtsmanship rapidly earned him not only virtually every prize the Academy had to offer, but also the notice of Wagner, soon to succeed Hasenauer as professor at the Special School for Architecture. (Much later, Wagner recalled that, as a draughtsman, he could think of only one other architect to compare with Olbrich, 'although scarcely as an equal . . . my own teacher, van der Null'.)[42] Wagner and his future aide first met on the occasion of one of the former's visits to the Academy exhibition of July 1893, where Olbrich had exhibited an elegantly Baroque theatre project. Concerning this meeting, Wagner related:

To my habit of visiting the annual exhibitions of the Academy, out of curiosity to see the level of achievement, was added the fact that in 1893 I was also looking for assistants to help with the architectural aspect of the Stadtbahn. Olbrich had worked up under Hasenauer a theatre project for this exhibition (highly traditional and still very much in Hasenauer's own style), but even so this project overshadowed all the others by the quality of its draughtsmanship. I enquired about this student, and learned that he was actually in the building. I met him in the vestibule, and he accepted with alacrity my offer of employment.[43]

Wagner's statement may occasion chronological misgivings, since it was not until 1894 that he was actually put in charge of the Stadtbahn project. By this time, Olbrich had returned from Italy, where he had gone as recipient of the Prix de Rome, and was working as chief draughtsman in Wagner's drawing-office. To what extent he contributed independently to the designs for the Stadtbahn has still to be clarified. Beyond doubt, he not only developed his employer's ideas but also, in a number of instances, can be shown to have elaborated his own highly individual conceptions in a series of studies which were then further modified by Wagner. The large-scale, elaborate drawings for stations, bridges etc. are usually in the anonymous, presentation style of Wagner's studio; certain of the smaller, preparatory drawings, on the other hand, such as that for the Hofpavillon station (Plate 102), may with some certainty be attributed to Olbrich himself.[44] A comparison of this drawing with Wagner's study, far more traditional in manner, for the Westbahnhof Underground station (Plate 103), which belongs early in the Stadtbahn series, also reveals the extent to which certain secessionistic elements in these designs may be traced back specifically to the younger architect's intervention.[45] Indeed, Olbrich may be said to have created out of his own personal brand of Art Nouveau fantasy that Secession style, as identified by critics and

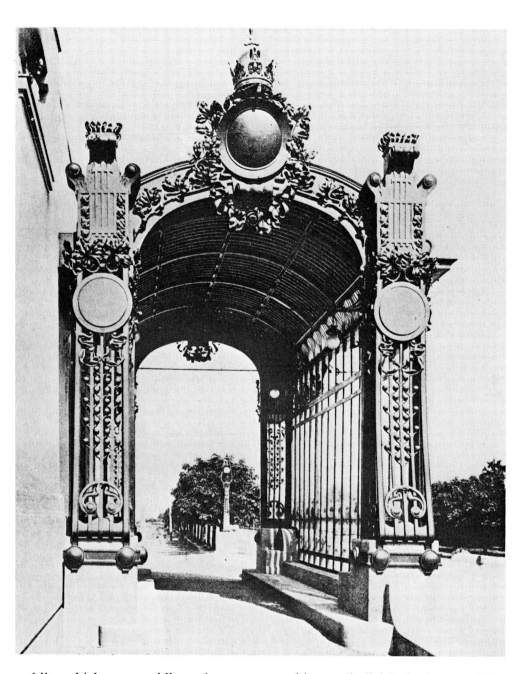

101. Otto Wagner:
Stadtbahn. Detail of station
'Hofpavillon Hietzing', 1898.

public, which was rapidly to become an architectural cliché. And not only in architecture. His elegant vignettes and decorative designs for the early numbers of *Ver Sacrum* created a model which significantly influenced the other early illustrators of the journal, among them Hoffmann, Böhm, and Moser.

Olbrich's links with the Secession have already been touched upon. Like Hoffmann a member of the exclusive Siebener-Club, he was one of only three architects among the founding members of the new *Vereinigung bildender Künstler Oesterreichs*, the others being Hoffmann and Mayreder (Wagner joined the Secession only later, in October 1899). Thus it was hardly surprising that he and Hoffmann should have been asked to design the setting for the first exhibition in the Horticultural Society building in March 1898. Olbrich's contribution to this enterprise was crucial. It appears from the account reprinted in Bahr's volume

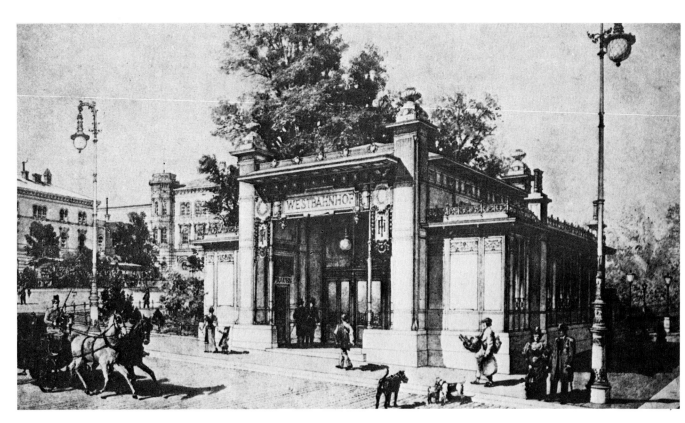

Secession that Olbrich was not only involved in the design aspect of the exhibition, but also shouldered much of the responsibility for the actual physical organization and hanging of this vital début before the Viennese public. Bahr, in the introductory essay, which is dedicated 'to *Meister* Olbrich in joyful admiration', describes that

gloomy place, with everyone sawing, hammering and nailing, almost despairing of ever being ready in time. Amidst all this bustle and confusion of shouting and suffering humanity I caught sight of you, with your hat on your head, twirling an elegant stick, or rather a light cane, in your hand. Your appearance was rather as of someone at a masked ball, in search of adventure. To every question you had an answer, for every request a word of advice, for every complaint a word of consolation, contentedly distributing instructions with the very best of humour. To those who maintained that the show would have to be postponed, you replied 'It'll open on time'. To the ones who despaired, you declared 'Everything will get done'. And to those who were panic-stricken, you said 'Don't get excited, children'. And all the while you had such a calm, mocking assurance in your amused eyes that people really believed you, and allowed themselves to be cheered up and encouraged. I, on the other hand, said to myself in admiration 'Just look at that: that's a real man. He'll be all right'. And so we introduced ourselves and chatted for a few moments, and then I took my leave, while you still stood calmly in the hall, twirling your cane.[46]

The difficulties encountered in trying to convert the rooms of the Gartenbaugesellschaft made clear the urgency of building an exhibition hall which the association could call its own. Apart from several sketches by Klimt, it appears to have been understood from the start that Olbrich was to be the architect of the new building. His first designs, for a modest structure with a rather self-consciously imposing portal, were intended for a site on the Wollzeile, on ground which actually came under the jurisdiction of the Austrian War Ministry (Plate 104).[47] The Secession's application for planning permission must have been determined, at least in part, by memories of previous temporary exhibitions held there. The city council, to whom application had to be made, were somewhat suspicious of Olbrich's drawings. 'The building strikes me as slightly crazy,' complained one member, made cautious, no doubt, by the prominence of the intended site, which gave directly on to the Ring. Further projects for this same site met with equally little favour (one of these, which should probably be placed late in the series of drawings for this particular location, shows one important feature of the final, executed design: the blind façades flanking the main entrance to the building which also appear in Klimt's early drawings inscribed *Ver Sacrum — Vereinigung bildender Künstler Oesterreichs*). However, the change of site to the corner of the Karlsplatz, where the building still stands — a decision taken in autumn 1897 and rapidly approved by the city council — altered matters radically. Olbrich, secure in the knowledge that he would be building less immediately under the searching gaze of the city fathers, drew up a series of new designs in a more consistently experimental spirit (Plate 105), in which the crowning motif of the dome, an evident allusion — albeit perhaps a subconscious one — to the Karlskirche on the other side of the square, appears for the first time. (Only in the drawings which immediately pre-

102. Joseph Maria Olbrich: *Drawing for the Stadtbahn station 'Hofpavillon Hietzing'*, c. 1896–7. This drawing, apparently from Olbrich's own hand, was done for the plate which appeared in the second volume of Wagner's *Einige Skizzen, Projekte und ausgeführte Bauwerke*, and differs in several respects from the building as executed. Vienna, Historisches Museum der Stadt Wien

103. Otto Wagner: *Drawing for the Stadtbahn station 'Westbahnhof'*. This design made for the plate which appeared in the second volume of *Einige Skizzen, Projekte und ausgeführte Bauwerke*, appears to have been conceived by Wagner but executed by Olbrich. Vienna, Historisches Museum der Stadt Wien.

104. (*left*) Joseph Maria Olbrich: *Design for an exhibition hall on the Wollzeile*, 1898. Berlin, Kunstbibliothek.

105. (*below*) Joseph Maria Olbrich: *Drawing for Secession building* (Karlsplatz site), 1898. Berlin, Kunstbibliothek

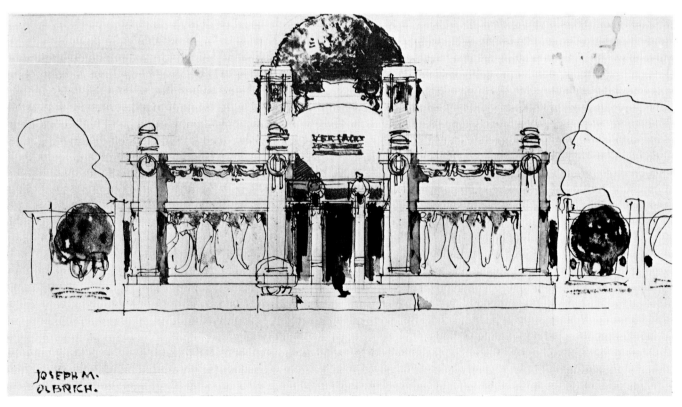

cede the start of construction does it become clear that the dome is to be foliated.) In these later drawings, increasing emphasis is put on the reduction of the masses of the building to fundamental relationships, 'the simple, primordial forms of all architecture', recalling the simplicity of the rural and vernacular buildings which Olbrich had seen and sketched on his trip to Italy and North Africa.

It is interesting to what extent the final design approximates to the preliminary studies made by Klimt in the spring of 1897. The public, who found the building 'somewhat Assyrian, with a bit of Egyptian and a touch of Indian',[48] were perhaps not so very wrong, since that combination of classical and exotic elements which is found in Klimt's pictorial work of this period is also reflected in the architectural conception of the *Haus der Secession*. Whether the blind façades shown in Klimt's original designs were intended to be filled with fresco or mosaic decoration, as the drawings seem to suggest, remains open to question. It is tempting to try to envisage the final appearance of the façade, had such an intention been carried out, especially if one recalls Klimt's own later essays in the field of mural art: the *Beethoven-frieze* of 1902, or the mosaic for the dining-room of Hoffmann's Palais Stoclet in Brussels. But if there were any such plans, nothing came of them. In the event, it is rather the simplicity, even severity, of the building as executed which appears the overriding feature of the design—the beginnings, perhaps, of a reaction on Olbrich's part against the occasional pomposity of Wagner's grand manner. It is, however, worth remembering that the somewhat severe impression the building makes is partly due to the eventual omission or simplification of much of the ornamental detail, which still played an important role even in the final drawings.

The Secession building is undoubtedly Olbrich's masterpiece of his Viennese period. It has frequently been seen as heralding the architecture of functionalism; even the editorial which appeared in the first issue of *Ver Sacrum* for 1899 described the arrangement of the building in terms of pure utility.[49] Indeed, as an exhibition space, its unusual flexibility demonstrates the advantages of custom building by an architect who was himself a designer of exhibitions. It was this flexibility, in particular, which captured the attention of many of the critics. The entire building was supported by no more than six permanent stanchions, and the interior partitions of the galleries themselves could be displaced at will, a system which Hevesi likened to the paper walls of Japanese houses. Hevesi marvelled: 'Even the mighty paired columns which separate the central room from the space at the rear can be removed!' and went on to assure his readers that 'this articulation of space' was 'so flexible' that it would allow for an entirely different exhibition layout every year for ten years.[50]

Richard Muther, who was equally well acquainted with the major galleries of Germany, commented: 'Only in Vienna does one have the opportunity of attuning the surroundings to the key of the works exhibited. This Protean character, the versatility of the building, has shown its worth again and again'.[51] And Bahr, in a further article devoted to Olbrich, gave a detailed account of what he saw as the underlying principle of the architect's design:

Here, everything is dictated by purpose. There is no superficial attempt to please, to dazzle, to blind. This is neither a temple nor a palace, but a space designed to

allow works of art to produce the greatest possible effect. The architect did not ask himself 'How can I make this look best?' but rather 'How can I make this best fulfil the demands posed by the new tasks ahead, our new needs?' It was created in the same way that one creates a high-quality wheel: with that precision which thinks only of the purpose, not of any prettifying intent; which seeks true beauty in the purest expression of the need which is to be met.[52]

This description is of some interest, particularly on account of the emphasis which it places upon the custom-built character of the building. It is, however, no less interesting in that it reveals the extent to which the judgements even of a critic as perceptive as Bahr may depart, if not from the artist's intentions, then at least from his own conception of what he has created. Bahr's emphasis upon purpose, his reference, in particular, to the 'high-quality wheel' is a far cry from the evident symbolism of cupola and façade of Olbrich's building; indeed, the architect's own account of the genesis of his design, couched in the language of purest poetry, makes clear the dangers inherent in any merely functionalistic interpretation:

The walls shall arise, shining white, sacred and chaste. A solemn, all-pervading dignity—that pure, sublime feeling which came upon me, overpowered me as I stood alone before the unfinished temple at Segesta. . . . I wanted to hear nothing other than the resounding echo of my own sensibility, to see my burning passions frozen in the icy stone. Everything which is subjective, my own conception of beauty, my house, as I had dreamed of it—this was what I wanted to, had to see.[53]

During the short period which remained between the completion of the Secession building, towards the end of 1898, and his departure from Vienna in the late summer of 1899, Olbrich's energies were mostly devoted to commissions for domestic architecture and interior design. Of these, particularly interesting is his completion of the Villa Friedmann at Hinterbrühl, which the owner, who had dismissed his original architect when the villa was already half-built, obviously intended to finish, as far as possible, *im Secessionsstil* (Plate 106). More significant than the secessionistic elements of the design was, however, Olbrich's dramatic simplification of the original conception, the attention paid to details of décor and furnishing, and in particular, the extent to which other members of the Secession contributed to the execution of the building, among them Adolf Böhm, who painted the apple trees on the walls of the garden façade, and Friedrich König; already at this date, it seems that Olbrich nurtured that ideal of the essential unity of architecture and design, that same collaborative principle which Hoffmann also inherited, and which may be traced back to the influence of the English Arts and Crafts movement. Olbrich, it may be noted, had spent the second part of his Prix de Rome tour, somewhat curiously, in England (the Prix de Rome was of course intended to provide primarily for study in Italy); he, above all, must be regarded as one of the most important links in the chain of transmission of English influences in Austria.

The same simplicity which is found in the completion of the Villa Friedmann also characterizes the two houses of this period, based on actual rural types, which

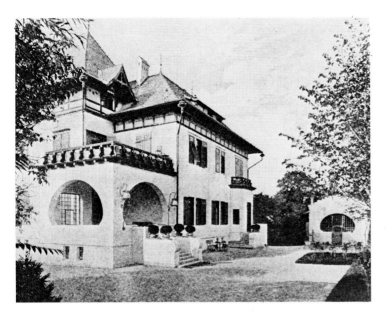

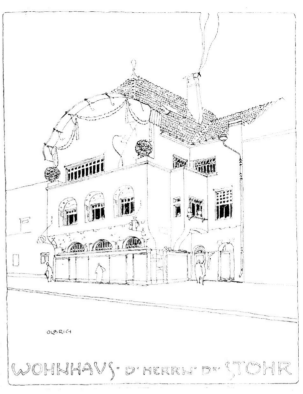

106. Joseph Maria Olbrich:
Villa Friedmann, Hinter-
brühl, near Vienna, 1898

107. Joseph Maria Olbrich:
*Design for Wohnhaus Dr
Stöhr*. From *Ver Sacrum, II*
(1899), i

Olbrich built 'from the ground up': the Wohnhaus Dr Stöhr at St Pölten (Plate
107), and the Villa Hermann Bahr (Plate 109) which was derived from a design
entitled '*ein kleines Haus*' (Plate 108) which the architect had probably made
the preceding year, 1898. In both of these buildings, the move away from the
ornate, inflated character of much of contemporary *Landhausarchitektur* is clearly
marked; Hevesi wrote of the Villa Bahr:

It is a real country cottage, built in the Viennese countryside, where the city and
the villages mingle. No trace of the carefully imitated Swiss chalet, the Italian
villa, or the gabled mansion from Meudon . . . least of all a German baronial
castle. . . . It really looks as if it has sprung up out of the living soil, like the
peasants' houses and the acacia trees.[54]

And Bahr himself, delighted with his new house, exclaimed:

Just come and look at my roof! How faithfully and imaginatively its shielding,
protective, motherly character has been captured, in a way that only the threatened
German peasant can comprehend![55]

It had been intended that Olbrich should go on to develop a whole succession of
residential houses on the fashionable Hohe Warte, the wooded ridge above Vienna,
with views across the surrounding countryside, which was at this time becoming
an increasingly desirable residential quarter for the capital's more well-to-do
bourgeoisie. In fact, this project was relinquished to Hoffmann. Olbrich had,
despite Wagner's intercession, failed to gain a professorship at the Kunstgewer-
beschule,[56] and an invitation from the Grand Duke Ernst Ludwig of Hesse to
go to Darmstadt, with a free hand in helping to create the new artists' colony, a
'modern Athens', as Bahr called it, proved too enticing to resist. Olbrich left

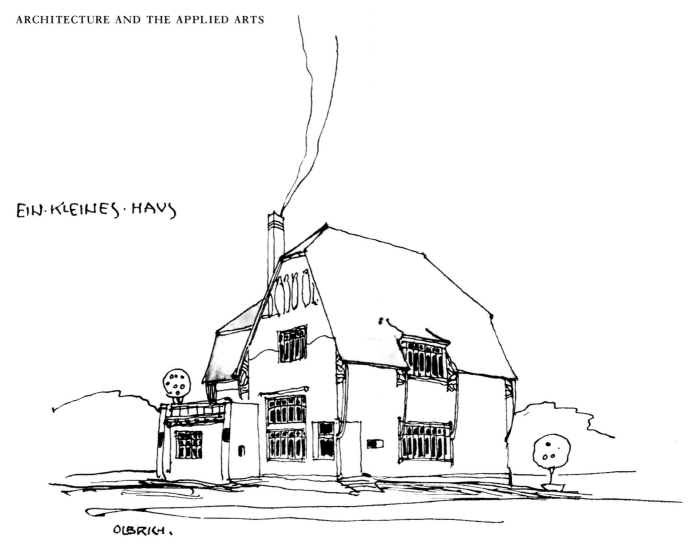

EIN·KLEINES·HAVS

OLBRICH.

108. Joseph Maria Olbrich: *Drawing inscribed 'ein kleines Haus'*. Berlin, Kunstbibliothek

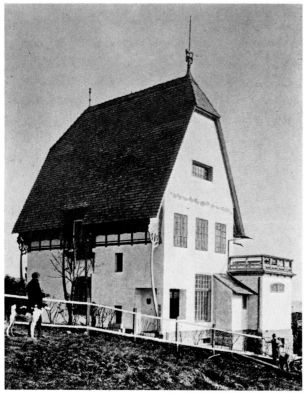

109. Joseph Maria Olbrich: *Villa Hermann Bahr*, 1899. Photograph *c.* 1900 showing the owner in the foreground. Destroyed

Vienna for good in September 1899. In a letter written from Darmstadt on 26 May 1900 to Carl Moll, he reassured his colleague about the Hohe Warte project: 'I'm sure Hoffmann will build you marvellous houses'[57]—houses which included those for the artists Moll and Moser, and for the friends of the Secession Friedrich Spitzer and Hugo Henneberg. The décor which Olbrich had designed for Spitzer's flat in the Schleifmühlgasse was later transferred intact to the new house on the Hohe Warte, where it created, according to Hevesi, a somewhat curious contrast with the severe logic of Hoffmann's architectural conception.[58]

Olbrich's later works go beyond the scope of the present account; they are, however, of the first importance for any study of the development of modern architecture on the Continent. As it happened, and was to happen so often in later years, Vienna had lost a major talent to the 'wide world beyond the Kahlenberg'.

Josef Hoffmann, 1870–1956

Hoffmann was born in Pirnitz, Moravia, on 15 February 1870. Having attended the Staatsgewerbeschule in Brno, he first came to Vienna in 1892 to study, like Olbrich, with Hasenauer at the Academy, and, when Hasenauer died two years later, he became in turn a pupil of Otto Wagner. The following year, 1895, he won the Prix de Rome with his diploma entry *Forum Orbis—Insula Pacis*, and his resulting trip to Italy brought him into contact not only with classical and Renaissance architecture, but also with the anonymous buildings of the Italian country-side which he recorded in numerous drawings, the farms and common dwellings whose whitewashed walls and simple proportions made a profound impression upon the young architect. In his autobiography, he wrote:

I found all these impressions at first overwhelming, especially the remaining monuments of antiquity, which produced a staggering effect upon me, young student of architecture that I was. But since Wagner's training had taught us not to give ourselves up to blind imitation, I did not want to get entirely carried away by these profound impressions, and it must have been of my own accord that I experienced the simple and yet wholly distinctive Italian method of building, such as one finds in the countryside and outside the realms of official architecture, as even more profoundly moving, in that it had far more to contribute to our own striving to build in conformity with the purpose and material at hand.

In my sketchbooks I found that I had involuntarily recorded precisely these buildings with their own particular, unique charm. In the spring, I set off as soon as possible for Pompeii and Sicily, becoming ever more enthusiastic about this kind of phenomenon. Nearly every little town *en route* was rich in examples of this natural, obvious manner of building, and was for me a revelation and confirmation of my own personal aims.[59]

For Hoffmann, as for Olbrich, the impact of the primitive buildings which he saw on his Prix de Rome tour combined with that of English design to influence the development of his early architectural style. He was, however, more heavily

indebted than Olbrich to contemporary English domestic architecture—the work of Voysey, for example, whose buildings were well known in Austria before the turn of the century (Hevesi specifically mentions Voysey's work in an article of 1898).[60] This influence can be seen most clearly of all in the group of houses and villas which he built between 1901 and 1905 on Vienna's Hohe Warte—commissions which, as we have seen, he inherited from Olbrich, who was by this time firmly entrenched in Darmstadt. These family houses, although small in scale, rank among his principal architectural achievements. The first group of villas (later additions were made to the Hohe Warte 'colony' in 1906–7 and again in 1909–11) includes the houses for the artists Kolo Moser and Carl Moll, for the doctors Friedrich Spitzer and Hugo Henneberg (the latter one of Mackintosh's Austrian patrons) and for the Brauner family. Hevesi, in a long article on the architect's work of the early 1900s, provided a detailed description of the last of these, the Haus Brauner (Plate 110), a building which may in many ways be regarded as typical of Hoffmann's suburban villa architecture of this period:

The Brauner house is a family house which, with its garden and décor, makes a wholly Hoffmannesque impression. The patron evidently feels a spiritual affinity with his architect, and knows that he is quite safe in his hands. His tastes and needs are cared for. Hoffmann, on the other hand, knows that the appearance of the house he is building for these people must be just so. . . . Above a mighty wall giving on to the street—the first of its kind permitted by the building authorities, instead of the obligatory small front garden—rises the unusually lofty roof, clad with old tiles which are already weathering most attractively. Above the roof, an old Viennese type of Belvedere, a kind of glass *salon* in the air, a proper *hohe Warte* [*die Warte*: watchtower or lookout], the incentive for which was the wonderful view which extends in every direction. From this lookout there shine forth at night electric lights, announcing to the world that here live people who are happy with their architect. The colours of the house are white and blue.

For the whitewash, ground marble has been used instead of sand, imparting its own chastity to the whiteness. Even the lime has been treated for two years before use, and goes on as pure as honey. That's the kind of whitewash that lasts! But because the house is so exposed to the weather—it actually has four weather sides—the whole of the upper storey, including the balcony and the round protruding bay of the living-room, is clad with a white wooden armour consisting of overlapping horizontal boards. The effect is the cosiest and most homely imaginable. . . .

The internal arrangement of the rooms can only be described as *liebevoll* [literally, 'loving' or 'affectionate']. I shall not describe every last room in detail, but a number of things are worth singling out for mention. For example the dining-room, which is transformed by sideboards in each of the four corners into a charming octagon. And then the living-room, its alcove with its sliding windows, divided into five parts—the windows don't open outward so as to obstruct the traffic, but slide up and down. Why should one have it easier in a railway compartment than at home? In all the rooms, special attention has been given to providing a unified source of light—part of that sense of logic which characterizes all Hoffmann's buildings. The doors are all wide and of the same height, although

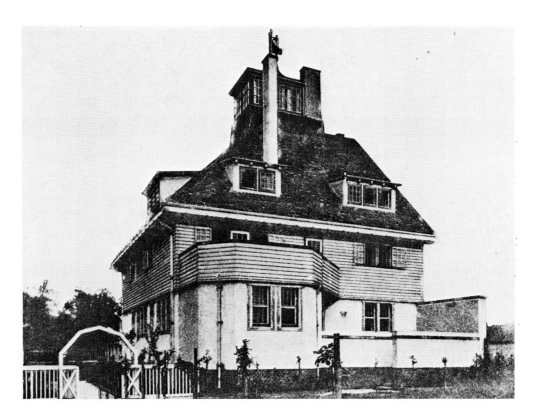

10. Josef Hoffmann: *Haus Brauner*, 1905. Vienna, Hohe Warte

not too high: no palace doors here, which only destroy the unity of the room, especially when they alternate with smaller doors. . . . The stairs have those pleasing twists and turns beloved by the English; the visitor should not be horrified by seeing all at once how high he still has to climb. Particularly attractive is the staircase which leads from the first floor up to the attic. Up there is a large playroom for the children. The whole structure of the roof being left exposed, there are as a result a host of secret crannies to suit the playful imaginations of the little ones. There is even a secret stairway leading to a little secret chamber at the top. And there is room for all the lathes, rock collections and other little hobbies of the younger generation. Anyone who has been a child, or even has only read Dickens, knows what an important role such spaces play in creating the unforgettable atmosphere of one's childhood. Behind the house is a large terrace with ivy and flowers. Hoffmann is a great connoisseur of plants and knows how best to utilize floral charms, as his gardens demonstrate. In fact, you can see into several of them from the garden of the Brauner house. Moll's has pleasant places for the family to sit; Moser's gives an important place to a kitchen-garden in which to grow vegetables; Dr Spitzer, a bachelor and dog-owner, has a garden in which his animals can run around and cavort at will. In each case, the garden presents a different face to suit the individual owner.[61]

Artistic developments in England also influenced Hoffmann's work in the applied arts. Particularly important in this connection was his appointment, at the age of only twenty-nine, as professor at the Kunstgewerbeschule, the school of arts and crafts attached to the Austrian Museum of Art and Industry (April 1899). Hoffmann's appointment was part of a dramatic programme of reform which had been initiated, with sublime disregard for the protests of members of the official

art world, by the new director of the museum, the orientalist and anglophile Hofrat Arthur von Scala. In November 1898, von Scala had brought no less a personage than Otto Wagner on to the curatorial board of the museum; in February 1899, the respected and conservative head of the Kunstgewerbeschule, Joseph Storck, was replaced by the Secessionist Felician von Myrbach. Further new appointments to teaching posts at the school included Arthur Strasser, Alfred Roller, and Kolo Moser. 'The Kunstgewerbeschule', wrote Hevesi, 'until a few months ago still considered the impregnable Bastille of Vienna, has been stormed overnight—or rather, it has surrendered, and is appointing itself a new commandant and a new garrison from the ranks of the previously despised Secession.'[62] No less important than the change in the teaching staff was the reorientation of the school curriculum. The Kunstgewerbeschule became, within a remarkably short time, a centre for the study of contemporary developments in the whole field of art and design, but especially developments in the English-speaking countries. Kokoschka, who was a student at the school during the early 1900s, described it as 'one of the most advanced teaching establishments in Europe', where one could not only find out, with the aid of the well-stocked library, 'what was being created in France, Holland, Belgium, Germany and England in the applied arts, and in the field of modern interior design', but also discuss 'in violent debate . . . the ideas of Ruskin and his spirited disciple William Morris, further developed in Scotland by the "Glasgow Boys" and the Mackintosh-Macdonalds'.[63] And Adolf Loos, who in 1898-9 was writing for the influential *Neue Freie Presse*, described in allegorical terms the introduction into the curriculum of the hitherto neglected study of English art:

There was once a school in which geography was taught, year in, year out. Europe, Asia, Africa, Australia and America. But the text book in use at this school had a gap. England was missing! Why? Well, because in that particular town the English did not enjoy the sympathies of the populace. And people thought they could do the English down by ignoring them. Then there came a new teacher. He saw with dismay that his pupils were equally at home in Tokyo and Venice, Samarkand and Paris, but that they had never even heard of Chippendale and Sheraton—I beg your pardon, London and Liverpool. He decided to put matters to rights.

The far-sighted, industrious students couldn't thank their new teacher enough for opening up before them a new world through the introduction of England into the curriculum. His opponents, however, found it all highly superfluous. But since gratitude is expressed quietly, whereas ill will is always associated with a good deal of noise, people outside the school believed that everyone was against the new reforms. Added to which, the industrious students had more than enough to do, what with their new course of study, and no time for demonstrations.[64]

Only in one respect was Scala still very much the heir of the nineteenth century, with its mania for imitation. In his famous winter exhibitions at the museum, he tended to display copies of antique English and American furniture, rather than the originals. Indeed, he is even supposed to have encouraged the designers and craftsmen for whose benefit the museum existed to make copies after antique models rather than to create original work. Loos, in his article 'Das Scala-Theater in Wien', makes his 'small craftsman' say: 'Rather copies, Herr Hofrat, rather

copies—I wouldn't trust myself to go making originals on my own!'[65] This insistence upon copying became a subsequent bone of contention between Hoffmann and the museum; it also provided perhaps the most important impetus for the eighth Secession exhibition, which was devoted to contemporary creative work in the applied arts.

Hoffmann, it appears, was already aware of English influences even before his appointment to the school—a fact which is hardly surprising if one considers the wide circulation enjoyed by the *Studio*, the vogue for English art in Germany, and the numerous works by British designers which appeared in German periodicals such as *Deutsche Kunst und Dekoration*. As early as 1897, he wrote: 'It is to be hoped that with us, too, the hour will strike when wallpaper and ceiling-painting, just like furniture and utensils, will be ordered from the artist, not from the dealer. England is far ahead of us in this respect.'[66] But his involvement with the teaching programme of the school caused him to become much more closely occupied with contemporary British developments in the applied arts. Of particular interest was Ashbee's Guild of Handicrafts, the workshop project which the English designer had started up, in accordance with socialist principles, at Essex House, in the poverty-stricken East End of London. In the spring of 1900, Hoffmann wrote to Myrbach, who was planning a trip to England, telling him specifically to go and see Ashbee, probably in connection with the projected eighth Secession exhibition, for which the organizers, Hoffmann and Moser, were determined to obtain original examples of modern British work. Hoffmann in fact confided in Myrbach: 'I think it would be worth while just for once to show in Vienna the real article as far as the English applied arts are concerned. It will deal a severe blow to the museum.'[67] The friendly contacts which were established between Austrian and British artists as a result of the eighth exhibition also led Hoffmann to visit England in December 1902, travelling to Glasgow, together with Myrbach, specially in order to see Mackintosh.

Hoffmann's interest in the aesthetic ideas of Ashbee and Mackintosh, and in the workings of Ashbee's Guild enterprise, was, however, far from being of a purely academic nature. During precisely this period, the increasing volume of his architectural work and commissions for interior design, and the attention lavished upon the details of the furnishings and interior arrangements of his villa projects, all emphasized what would be the advantages of a permanent team of designers and craftsmen working directly under the architect's supervision. The creation of some kind of 'craft guild' appeared, moreover, to offer the only solution to the problem of preserving a high level of individual skill, as exemplified by the works by British designers shown at the eighth Secession exhibition, in the face of that lowering of standards which seemed the inevitable consequence of mass production. From the end of 1900, if not earlier, it is clear that both Hoffmann and Moser were becoming increasingly interested in the possibility of forming a Viennese craft group along English workshop lines, a group dedicated to the revival and preservation of a 'true' standard of craftsmanship in the applied arts.

The Wiener Werkstätte

That this ideal became realizable was due to the intervention of a third, quite distinct personality, not an artist, but an amateur of the arts: the young businessman Fritz Wärndorfer. Wärndorfer, son of a wealthy family, 'a man of culture with a leaning towards modern art, and a capitalist to boot,'[68] was, like Hugo Henneberg, a patron of both Mackintosh and Hoffmann. Through his business connections with Britain, and his frequent trips abroad, he constituted the ideal link between the contemporary British and Austrian schools of design. As early as spring 1900 (i.e. even before the eighth exhibition of the Secession), he had visited Mackintosh in Glasgow, apparently at Hoffmann's instigation; he kept the Scottish artist *au courant* with Viennese aspirations concerning the formation of some kind of workshop association, and in March 1903 he conveyed to Hoffmann Mackintosh's enthusiasm for the Viennese project which was by then taking shape:

If one wants to achieve an artistic success with your programme ... every object which you pass from your hand must carry an outspoken mark of individuality, beauty and most exact execution. From the outset your aim must be that every object which you produce is made for a certain purpose and place. Later ... you can emerge boldly into the full light of the world, attack the factory trade on its own ground, and the greatest work that can be achieved in this century, you can achieve it: namely the production of objects of use in magnificent form and at such a price that they lie within buying range of the poorest. ... But till then years of hard, serious, honest work are still needed. ...

Yes—the plan which Hoffmann and Moser have designed is great and splendidly thought through, and if you have the means for it you are not taking any risk, and all I can say is: Begin today!—If I were in Vienna, I would assist with a great strong shovel![69]

Mackintosh also designed a signet embodying the letters 'WW', standing for Wiener Werkstätte, the name under which the new association was rapidly to become world-famous—a design which Wärndorfer also duly forwarded to Hoffmann in a letter of June 1903 (Plate 111).[70]

The 'programme' of the Wiener Werkstätte, to which Mackintosh refers, is itself deserving of some comment. Hoffmann summed up the aesthetic aims of the new association in an article entitled 'Das Arbeitsprogramm der Wiener Werkstätte':

That immeasurable damage caused on the one hand by inferior methods of mass production, on the other, by the mindless imitation of bygone styles, has become a mighty torrent of world-wide proportions. We have lost contact with the culture of our forefathers and are tossed hither and thither by a thousand different desires and considerations. For the most part, handiwork has been ousted by the machine, the manual worker by the businessman. ...

We want to establish an intimate connection between public, designer and craftsman, to create good, simple articles of household use. Our point of departure is purpose, utility is our prime consideration, our strength must lie in

111. Charles Rennie Mackintosh: *Part of a letter of June 1903 from Fritz Wärndorfer to Josef Hoffmann* Harvard, Prof. Eduard F. Sekler

good proportions and use of materials. . . . The value of artistic work and of the idea should once again be recognized and prized. The work of the craftsman must be measured by the same standard as that of the painter and the sculptor. . . .

It cannot possibly be sufficient to buy pictures, even the most beautiful. As long as our cities, our houses, our rooms, our cupboards, our utensils, our jewellery, as long as our speech and sentiments fail to express in an elegant, beautiful and simple fashion the spirit of our own times, we will continue to be immeasurably far behind our forefathers, and no amount of lies can deceive us about all these weaknesses.[71]

It is not difficult to recognize in this statement Hoffmann's debt to the English movement—not only to Mackintosh and Ashbee, but also to Ruskin and, above all, William Morris (interestingly, Hoffmann, in a lecture delivered as late as 1926 on the origins of the WW, described the foundation of the group as 'part of a continuous process of development leading from Ruskin and Morris' to the present day).[72] There are also, if one examines the 'Work Programme', many detailed points of comparison with Morris's theories. The ideal of a 'true' art, produced by a community of craftsmen out of a delight in manual labour, Hoffmann's description of that 'enthusiasm for the form which develops out of the materials and tools employed' immediately recalls Morris's definition of art as 'the expression by man of his pleasure in labour',[73] his conception of honesty to materials and techniques. Hoffmann also emphasized the educative aim of the Wiener Werkstätte, declaring as their purpose 'to awaken among the broad masses an interest in a cultivated, genuine, not imitative style of work'. Again, one is reminded of Morris's dictum, 'What business have we with art at all unless all can share it?' and his scornful references to artists' 'dreams of Greece and Italy'.[74] (Hoffmann, in the 'Arbeitsprogramm', emphatically rejected the imitation of preexisting historical styles in the applied arts; like Wagner, the WW advocated not a copying of the forms of Renaissance and Baroque, the styleful surrogates which could 'satisfy only the *parvenu*', but a true *naissance*, an art for contemporary society.) Morris's attitude towards machine methods, which he regarded as the ruin of true craftsmanship, is likewise reflected in Hoffmann's references to the 'facility' of mass production, which he saw as lulling artists into a 'diminished sense of responsibility'.[75] Of course, as in the case of Morris, this rejection of machine methods rapidly made nonsense of the notion of an art accessible to all. The insistence upon craftsmanship, the refined idealism of the Wiener Werkstätte brought with it an inevitable disdain of commercial considerations; indeed, it was considered 'not their purpose' to 'attempt to compete with the cheapness' of mass production. The proverbial costliness of the WW's designs, especially in later years, placed them effectively beyond the range of all but the wealthiest patrons and collectors of the *avant-garde*.

The Wiener Werkstätte was formally established in June 1903. The actual circumstances of its creation have become almost legendary. One day, so the story goes, Hoffmann, Moser and Wärndorfer were sitting in the Café Heinrichshof, talking about the latter's recent trip to England, and about the English workshop movement in general. Wärndorfer asked precisely how much, in financial terms, such an undertaking would cost. When Moser replied, 'For a start, one could

manage with five hundred crowns', Wärndorfer immediately put the money down on the table, and within twenty-four hours Moser had rented a small flat in the Heumühlgasse, and furnished it with the basic necessities.[76] Unfortunately, he was then faced with the prospect of going back to Wärndorfer and telling him that the money had all been used, and that more would be required in order to get the workshop project under way. Wärndorfer, characteristically, appeared quite undismayed, and agreed to discuss with his mother the possibility of financing the enterprise on a more generous scale, and within a few days he came back with the promise of no less than fifty thousand crowns, 'an absolutely unimaginable sum', as Hoffmann later recalled.[77] Already by October of the same year, a move to more spacious premises in the Neustiftgasse enabled the Werkstätte to broaden its areas of interest to include bookbinding and work in gold, silver and leather, as well as furniture and joinery. Moser, in his recollections, described the pro- grammatic arrangement of the various workshops and studios, each painted in its own particular colour, 'in the metal workshop everything red, in the book- binding department everything grey, in the carpenters' shop everything blue, and so on'.[78] Even the ledgers belonging to the various departments were bound

112. Josef Hoffmann: *Sanatorium Purkersdorf*, 1904–5. Entrance

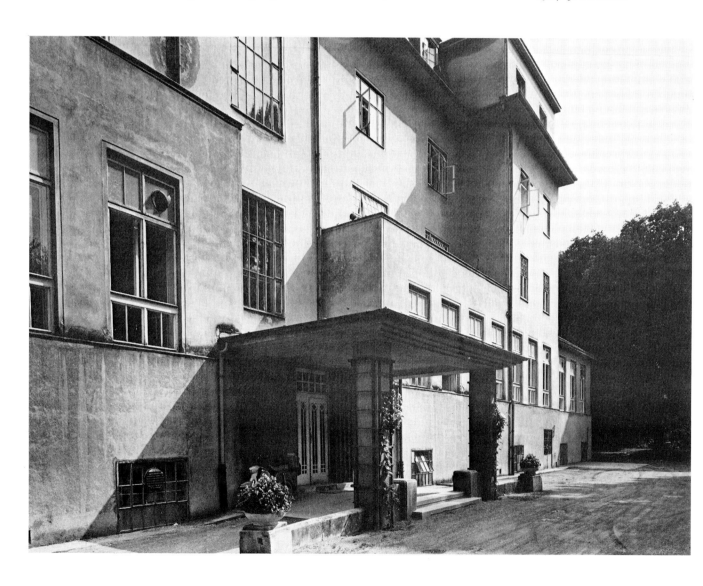

in the appropriate colour. Perhaps the most important of the new additions to the Werkstätte's range of activities during the autumn of 1903 was the institution of an architects' office for the purpose of co-ordinating the production of whole décors, and the building of houses as entire projects.

Of the actual buildings executed by Hoffmann and the Wiener Werkstätte, the earliest and one of the most important was the Sanatorium Purkersdorf (Plate 112), the first phase of which was built during 1904–5. The sanatorium, Hoffmann's most significant building apart from the Palais Stoclet in Brussels, has become famous among architectural historians as a building ahead of its time. Clear, simple, constructed of iron and concrete, it is difficult to believe that it dates from the early years of this century, especially when one takes into account the freedom from period influence, the lack of ornament, the essentially cubic design, the flat roof, windows without mouldings, and the particularly striking device of the tall, narrow staircase window, which we find again in the Palais Stoclet. 'There isn't a vaulted roof in the entire building', wondered Hevesi,[79] who had, in the enthusiasm engendered by his first visit to the newly built sanatorium, even gone so far as to subject himself to the various 'therapeutic' devices which the institution boasted. Hevesi described his visit in a lengthy article which is worth quoting *in extenso* not only for its account of Hoffmann's building, but also for its style:

From a structural point of view, the building is of great interest. . . . 'Hennebiq' [François Hennebique, the French designer and engineer who introduced the use of steel, rather than iron, for strengthening reinforced concrete] is the motto, which means construction out of iron and concrete, something which permits slender pillars and large, proper ceilings, without pretence, like that in the large dining-room, where you aren't palmed off with art-historical nonsense. Nor do the so-called public rooms suffer in this way. Thus, for example, the vestibule, in which this kind of slender pillar occurs, is in fact a large room of very attractive proportions. . . . The walls have, instead of panelling, white porcelain tiles. These tiles, and white paint, play an important role throughout the whole house. A white-painted or white-tiled 'washable' world. With the exception, of course, of the beautiful *salons* on the first floor, where colour appears in all its elegance, and even Kolo Moser has his say. . . .

But those rooms dedicated to purely practical purposes are themselves no less attractive. Here, one encounters everywhere the latest methods and apparatus. I will neither describe the kitchen nor glorify the washing-up machines. Nor shall I sing the praises of the bathrooms, in which special provision is made for the individual specialities of all the various doctors. But the 'mechano-therapy room' cannot go without a mention, this elegant white hall, full of artificial devices, with which I rapidly made closer acquaintance. A three-hour guided tour of the building had made my muscles flabby, here I had the chance of pumping them up again. Several ladies were standing at the electric massage machines—everything is electric—having their loins and stomach massaged. I was likewise kneaded, and it did me a great deal of good. I then sat myself on a bicycle which one can pedal without moving from the spot, and toned up my leg muscles. An elegant new type of gallows, meant to exercise one's arms, failed to tempt me, but I did

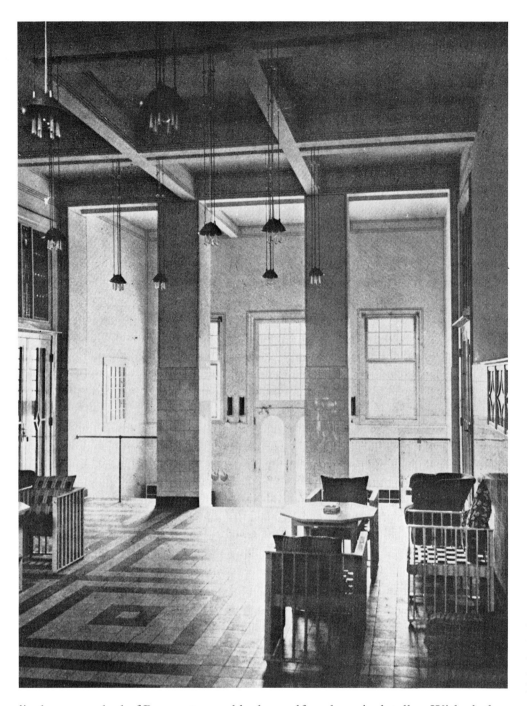

113. Josef Hoffmann:
Sanatorium Purkersdorf,
interior of hallway. From
*Deutsche Kunst und
Dekoration,* XVIII (1906),
p. 427

lie down on a bed of Procrustes, and had myself made an inch taller. With clothes much too short for me, I left this place of mechano-therapeutic healing. The guard on the local train didn't recognize me.[80]

The furnishings, decorations and appliances were designed entirely by Hoffmann, and executed by the Wiener Werkstätte. Here, as in his domestic interiors, one is immediately struck by the attention to detail which characterizes every aspect of the design. In this respect, Hoffmann was the true follower of Wagner. Hevesi commented:

To walk through the rooms of this house is extremely stimulating. Here, every-

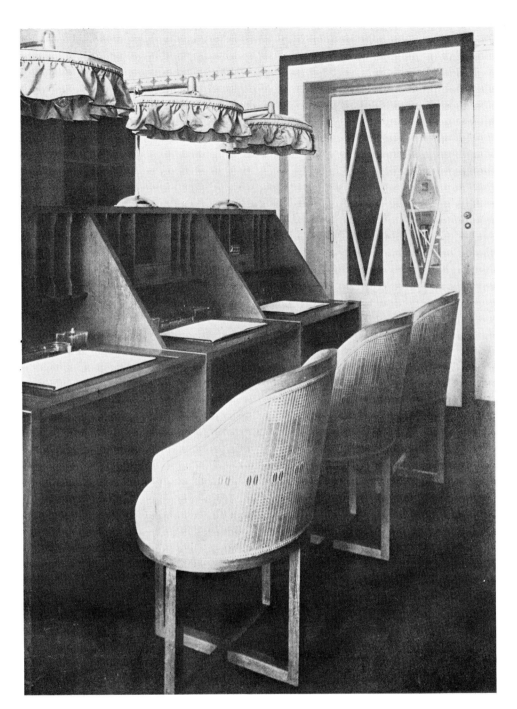

114. Josef Hoffmann: *Sanatorium Purkersdorf*, the writing room. From *Deutsche Kunst und Dekoration*, XVIII (1906), p. 428

thing is new, newer, newest. Hoffmann's bubbling inventiveness produces from up its sleeve every largest and smallest item of comfort and utility, and the slightest sketch by his hand is enough to enable the well-trained staff of the Wiener Werkstätte, this élite among Viennese craftsmen, to transform his ideas into reality. Not only 'every nail', as one says, but even the braid on the upholstery, made specially by Backhausen after his drawings, has been designed by him. He thinks of simply everything. In the Imperial Museum, some of the inscriptions on the doors are buried in everlasting darkness, so that you can only read them by striking a match; in Hoffmann's building, every door has its own electric button specially designed to illuminate the nameplate in the dark. The various types of

lamp alone constitute a pretty album—for imitators. The table lamps in the writing-room have even been designed so as not to come into conflict with the fashionable hats of the corresponding ladies. . . . And it goes without saying that there are no mirrors which are hung so high that they are only suitable for a Lady Goliath. What is more, every mirror is so shaped that it makes an elegant frame for the image of the person looking at their own reflection. His mirrors are in general very flattering for the user. When Gustav Klimt saw those in the dining-room of the Villa Wärndorfer, which reflect people and spaces in such a pictorial way, he cried, 'Well, and what is there left for us painters to do?'[81]

The objects of applied art produced during this early period of the Werkstätte's activity are remarkable for their geometric refinement, their elegant simplicity, contrasting with the *Jugendstil*-influenced exuberance of both Hoffmann's and Moser's work of the first years of the Secession. Hevesi wrote: 'The world has been given a new poetry, a kind of which no one has ever dreamed. A dry objectivity, after all the sweetness of the nineteenth century.'[82] This process of simplification displays clearly the influence which a more thorough knowledge of the work of the Scottish school of design, and of Ashbee, exerted; this influence is also reflected in the development of Hoffmann's architectural style during this period. This was the time of the closest artistic collaboration between the two master-designers, Hoffmann and Moser, to the execution of whose designs the energies of the WW were for the first three years exclusively devoted. The similarity of their styles, on occasion, makes it difficult to distinguish at first sight between their work, a fact which led Klimt to declare that the best way of telling which item was by which artist was to see who was most attracted by the objects: 'the women all crowd around Moser, the men make a bee-line for Hoffmann'.[83] There were, however, certain temperamental differences between the two artists. The strict purposiveness, the extreme simplicity of Hoffmann's table-ware were, for example, characteristics frequently commented upon. 'A ladle', exclaimed Hevesi, 'could serve as the theme for a whole lecture on logic'.[84] Not that this simplicity excluded attention to detail. The extreme delicacy of many of his silver designs, his use of costly materials—the coral decorations, for example, which adorn his tea-service (Plate 115)—are eloquent of that ideal of refinement which characterizes the finest of the Werkstätte's early products. Moser's designs, on the other hand, reveal an element of fantasy which distinguishes them from the often more severe appearance of Hoffmann's work of this period (Plate 116). 'His temperament', wrote the English critic A. S. Levetus, the Viennese correspondent of the *Studio*, 'is that of a true Viennese—joyous, earnest, rhythmical, and he is endowed with a developed sense of beauty'.[85] Of the two artists, Moser was also by far the greater virtuoso, a characteristic upon which Hoffmann himself commented.[86] His extraordinary ability in the most diverse fields of craftsmanship was due in part to the fact that his father had been one of the household managers at the Theresianum, the famous academy for the sons of aristocratic and bureaucratic families. In this 'little world of its own', the young Koloman not only had the run of the parks, swimming-pools and riding-stables, but also wormed his way into the workshops of the technical staff, with whom he soon made friends. Recalling this early period of his life, Moser wrote:

115. Josef Hoffmann: *Tea Pot*, *c.* 1905–6. Vienna, Museum für angewandte Kunst

116. Kolo Moser: *Vase and Sugar Bowl*. Vienna, Museum für angewandte Kunst

People have often wondered at my versatility in picking up the techniques of various kinds of handiwork and applied art, at the fact that I understood—indeed, to all intents and purposes had mastered—the arts of the carpenter, the book-binder and the locksmith. This is what I owe to my childhood and the staff of the Theresianum. . . . I avidly watched them at their jobs, and soon learned all their tricks. In this way I gradually began to practise, in my own childish fashion, the most varied crafts. I bound my own books, built my own rabbit-hutches, the tailor taught me how to sew, the joiner how to carve, and the gardener how to bind beautiful bouquets. What was then but a merry game later became of great and decisive significance, and only thus did I subsequently find my feet with ease amid the problems of the applied arts.[87]

Various aspects of Moser's early activity have been mentioned elsewhere: his first graphic works, his designs for Gerlach and for *Ver Sacrum* (Plate 117), his contributions to Olbrich's Secession building, including the great circular window in the vestibule (Plate 26). But, as in the case of Hoffmann, applied art itself played an extremely important role in his early career. As already noted, he was in a position to display items of furniture and decorative art at the eighth Secession exhibition in 1900, with considerable success; while the extent of his international reputation as a designer is revealed by an invitation of 1902—that is, even before the foundation of the WW—to participate in an exhibition of architecture and applied art held in Moscow in the winter of the same year under the august patronage of the Grand Duchess Elizaveta Fedorovna.[88] And in the exhibitions which the Werkstätte artists themselves organized, Moser displayed an amazing variety of objects designed by him: furniture and décor, hangings and patterned materials, table-settings and glassware. Hevesi, who followed the

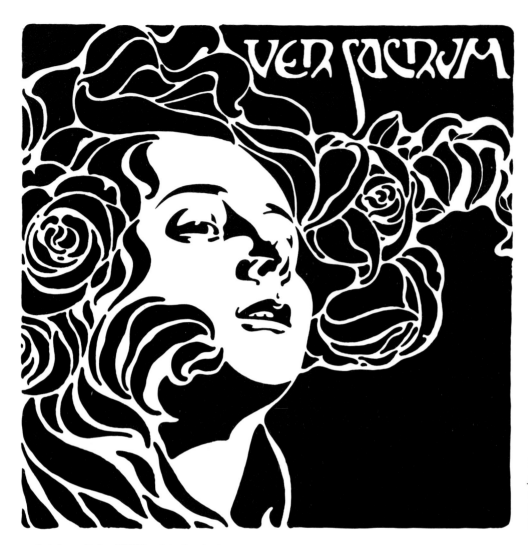

117. Kolo Moser: *Design for the cover of* Ver Sacrum, II (1899), iv. Vienna, Historisches Museum der Stadt Wien

activities of the WW with lively interest, commented:

For the table, Moser has even designed new forms of bread roll, and found an intelligent baker to bake them for him. Jokers will of course be sorry to hear that there aren't square champagne bottles in the square ice buckets, or rectangular apples in the rectangular fruit dishes. Let's hope that's still to come![89]

As early as 1904, a special exhibition at Hirschwald's Kunstgewerbehaus Hohenzollern, which became the Berlin outlet for the WW's products, drew the attention of the German public to the smaller and more costly items created by the new organization; after this exhibition, the silverware, in particular, became for a period a kind of craze in Germany. Other exhibitions, in London (summer 1906), Frankfurt and Dresden, also contributed to the fame of the workshops abroad, if not at home. But on the home front also, Hoffmann and Moser were far from idle. They did much to realize that original educative aim of the Werkstätte of forming the taste of the Austrian public by organizing a series of exhibitions and lectures devoted to special topics: in 1905 an exhibition of fine bindings; in 1906 a showing of the priceless silver box made by the WW for the Skoda factory in Pilsen to commemorate the visit of the Emperor Franz Joseph (Plate 118).[90] This box was designed by yet another member of the Secession, Carl Otto Czeschka,

who, as professor at the Kunstgewerbeschule, had the singular distinction of being the only member of staff prepared to accept Kokoschka as a pupil, and whom Hoffmann had recently won over as a third master-designer for the Wiener Werkstätte. Czeschka had, prior to joining the WW, been known, like Moser, principally as a graphic artist and designer, whose illustrations for Keim's *Nibelungen*[91] (Plate 119) and for the album celebrating the jubilee of the Imperial *Hof- und Staatsdruckerei* in 1904[92], rank among the finest examples of Viennese *Jugendstil*. He had also, through his drawing and graphics courses at the Kunstgewerbeschule, brought to maturity a whole generation of draughtsmen and printmakers. His early activity in the field of the applied arts, however, reveals that he was no less versatile a designer than Moser or Hoffmann. He produced for the early exhibitions of the WW not only silverware and metalwork, but also furniture and jewellery, as well as the sets and costumes for an unrealized production of Hebbel's *Nibelungen* intended for Vienna's Raimund-Theater.

Also in the same year 1906, a further exhibition entitled *Der Gedeckte Tisch* presented examples of table settings, Moser's glassware and Hoffmann's cutlery. For this exhibition, the WW took over additional space in the neighbouring building in the Neustiftgasse, decorating the rooms in the famous 'black and white' manner which is associated with the early Werkstätte style:

On this occasion, the public rooms give on to a whole large exhibition hall, with plenty of elbow-room. A black and white room, as people call it, I can't think why, perhaps because they find it easier to say. But in fact the room is not black and white at all, but rather white and black, which is something quite different.

118. Carl Otto Czeschka: *Silver box made by the Wiener Werkstätte for the Skoda factory in Pilsen to commemorate the visit of the Emperor Franz Joseph*, 1906. From *Deutsche Kunst und Dekoration*, XVIII (1906), p. 417

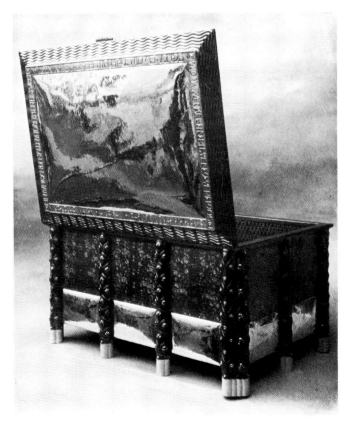

119. Carl Otto Czeschka: *Illustration for Keim's* Nibelungen, published in 1905 as volume 22 of Gerlach's *Jugendbücherei.* Vienna, Historisches Museum der Stadt Wien

A magnificent room, shining, shiny, decorated with flowers. Like a gentleman in an impeccable suit, with a flower in his button-hole. The white tiled stove is itself an object of study. Never has there been such a white stove. Of course, with black lines at the edges. . . . At one end of the room there is a raised gallery with a balustrade, which leads one into the neighbouring building, and from which one can survey the whole room. This, too, is worth looking at. These, too, are the 'Tales of Hoffmann', as J. A. Lux in an article once aptly dubbed Hoffmann's group of villas on the Hohe Warte. . . .

Dear God, every servant girl thinks she knows how to set a table. I have even got a book about this particular art, with numerous illustrations, for example, of how one folds napkins into various 'pretty', that is, absurd, patterns. And with tips on how to 'bestrew' the tablecloth with living flowers, presumably in order to conjure up the mood of a Roman orgy—specially for Grandma's birthday. . . . Hoffmann and Moser have quite different views. And other forms of inspiration. . . . Hoffmann's cutlery is as carefully designed as the precision instruments of the scientist, and a flower piece by him is so finely conceived, according to its form and purpose, that the same amount of mental energy would suffice to design a monument. On one of the tables, you can see Moser's sets of glasses. The usual, obligatory four types of glass. But normally, of course, one finds oneself confronted with four quite different designs of glass, of four different heights—nothing more disturbing, than a glance over the glassware of a 'correctly' laid table. Moser has set himself the problem of creating a set of glasses of the same height and of one single design. A problem which he solves in the simplest possible way: by differing lengths of stem and different volumes. So simple, that you smite your brow when confronted with this kind of novelty. . . .

And how many people are unacquainted with Hoffmann's silver cutlery? When they first turned up at the Secession exhibitions, a tremor ran through the eating world. People maintained it was quite impossible to eat with it, not eat properly, and certainly not in the 'English' manner! Herr Wärndorfer was the only person to buy it, and since then I myself have eaten with it, as English as an Englishman, and found it all extremely practical.[93]

Palais Stoclet—The Stoclet-frieze

In the last sentence of his 'Work Programme' Hoffmann had written: 'We stand with both feet firmly in reality, and wait only for commissions.' Not, however, in their wildest dreams had the founders of the Wiener Werkstätte envisaged a commission such as that which they received towards the end of 1904 from the Belgian millionaire Adolphe Stoclet for the design, execution and decoration of an entire mansion for himself and his family on the Avenue de Tervueren in Brussels. The circumstances in which this commission, the most ambitious ever undertaken by the WW, originated have been described by Adolphe Stoclet's son, M. Jacques Stoclet:

Hoffmann's talents were revealed to my parents, who were spending a year and a half in Austria during 1903–4, in the following manner. They were walking one day in the outskirts of Vienna when they were struck by the sight of a villa whose proportions, sober and harmonious at the same time, seemed to them completely new and filled them with admiration. Impelled by curiosity, they penetrated as far as the garden, where they were surprised by the owners [the painter Carl Moll and his wife] who, touched by their enthusiasm, invited them to look over the house, and introduced them to the architect, Professor Hoffmann.[94]

Adolphe Stoclet, it seems, originally intended to build a villa for himself and his wife on the Hohe Warte, on the site later used for the Haus Ast. The death of his father, however, not only necessitated his return to Belgium, but also meant that he was in a position to commission Hoffmann to build a house for him on a scale more appropriate to his new-found wealth. No one has ever discovered what the construction and decoration of the Palais Stoclet actually cost, but Hoffmann himself later recalled that Stoclet left him an entirely free hand as regards the design of the building, and also that, as far as financial considerations went, the sky was the limit.[95] Jacques Stoclet, in his speech delivered at the *séance académique* of October 1955 in memory of his father, commented:

To be able to give free flight to his imagination and his talent as regards the realization of this ensemble, in such a way as to create a perfect unity out of the smallest details of the architecture of the house and garden, the iron-work, the means of illumination, the furniture and flooring, the carpets and even the silver-ware, and, moreover, using the most costly materials, represents for an architect, even for a genius like Professor Hoffmann, an ideal, a dream which one cannot realize more than once in a lifetime.[96]

Application for planning permission, and preliminary designs for the Palais, were lodged in 1906;[97] Hevesi had, however, already seen and discussed in an article of November 1905[98] Hoffmann's model for the building, which differed from the final project in several important respects. One significant difference is the emphasis given to the tower of the building as actually executed; another is the use of the curved recess in the upper storey of the projecting central block of the garden façade, with its window in the middle, a somewhat curious device which does not occur in any of the preliminary designs, but which harks back

to an earlier drawing by Hoffmann of 1903 for an unspecified building (Plate 120). There are also other, quite specific references to Hoffmann's own earlier works. The tall staircase window of the street façade echoes the use of a similar motif which is found in the design for the Sanatorium Purkersdorf; while the projecting curved shape which indicates the position of the main hallway, and which marks almost the centre point of the main part of the street façade, recalls the projecting, semicircular bay of the living-room of the Haus Brauner. The use of projecting volumes serves, in general, to articulate the main façades of the building, which strike one not only by the clarity and logic of their disposition, but also by the sheer effect of extension they create—an impression which caused one critic to compare Hoffmann's Palais with the highest achievements of the Baroque.[99] The monumentality and elegance of the exterior were also matched by the internal arrangements. The principal materials employed were different colours of marble (which was also used as cladding for the exterior), rosewood, and parquet for the flooring. The rooms were of unusually grandiose proportions: the main bedroom measured 30 by 18 feet, Mme Stoclet's dressing-room 20 by 20 feet, and the kitchen 26 by 20 feet. Special emphasis was given to the public rooms of the house, with an eye to receptions, banquets and other festivities. Particularly magnificent are the main dining-room, with its immensely long buffet-sideboards and mosaic decoration, and the central hallway, clad in yellow and brown marble, with its chairs covered in a deep grey chamois (Plate 123). Other parts of the house reflected the hobbies and interests of the owner and his wife: the garage,

120. Josef Hoffmann: *Drawing for an unspecified building*, 1903. Illustration from the catalogue of the seventeenth Secession exhibition

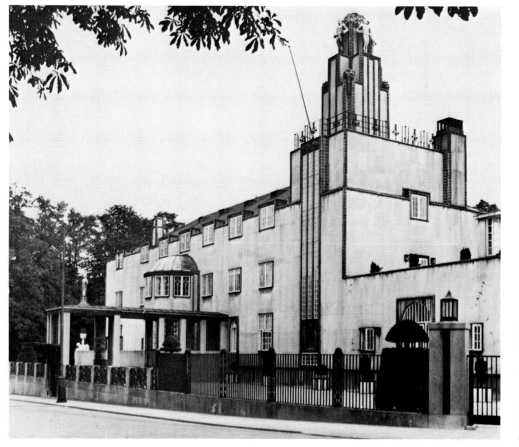

121. (*left*) Josef Hoffmann: *Palais Stoclet*, 1905–11. Brussels, Avenue de Tervueren. Street façade seen from the north-west

122. (*right*) Josef Hoffmann: *Palais Stoclet*, garage end of street façade

which embraced a repair shop, the small den with its faceted windows, 'so that the owner can observe without being seen everyone who enters his house',[100] and the sunken, marble music room with its semicircular stage. Much thought was also given to the housing and display of M. Stoclet's valuable collections of Oriental and European art.

The unique circumstances of the commission, the irrelevance of any kind of financial considerations, made possible the realization of that ideal for which the Wiener Werkstätte had been created, but which, apart from the Palais Stoclet, was rarely, if ever, achieved: the total integration of art, architecture and design, the creation of an almost musical unity, to which Hoffmann, somewhat misleadingly, referred by use of the term *Gesamtkunstwerk*—the total work of art. The utensils, furnishings and decoration were intended to be in complete harmony with the architectural conception, 'like the organs of a living being' (Plate 124); in fact, each room was assembled in its entirety in Vienna, in order to gauge the total effect, before being dismantled for shipment to Brussels. 'This', wrote Hevesi, 'is the new Viennese art—an art which exports whole houses!'[101] It is almost impossible to imagine the Palais Stoclet without its wallpapers and curtains, its chandeliers, its furniture and silverware, every smallest item designed and executed by the WW. Even the garden, with its terraces and pergolas, its summer-house and tennis courts, garden chairs and tables, was conceived and designed in the minutest detail by Hoffmann and his team.

In the event, the commission for the Palais Stoclet stretched even the Wiener

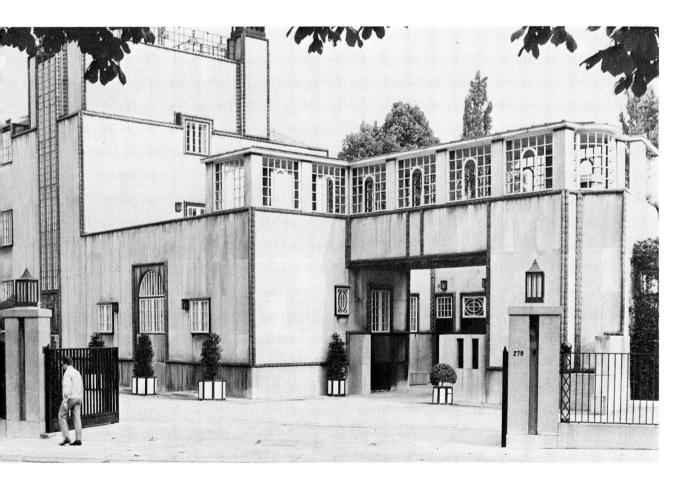

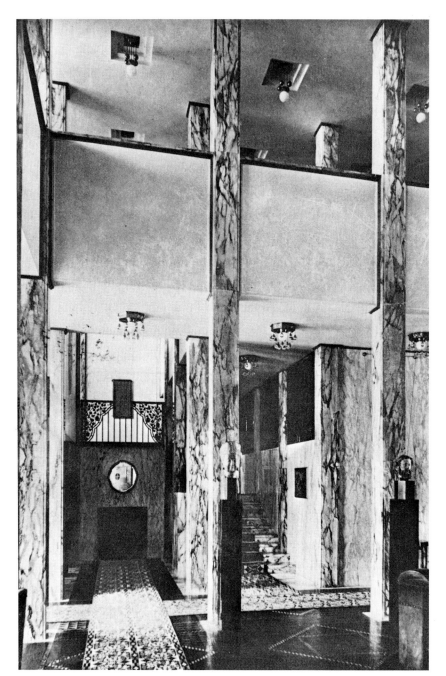

124. (*above*) Photograph (1955) showing the table of the breakfast room of the Palais Stoclet set with cutlery and glassware designed by the Wiener Werkstätte

Werkstätte's prodigious resources. By the time the decoration of the building was completed in 1924, many of the artists of the Klimt group within the original Secession, not themselves members of the WW, had become involved with producing designs for some aspect of the project. Kolo Moser, Carl Otto Czeschka and Leopold Forstner devoted their considerable talents to the details of the decoration, Ludwig Heinrich Jungnickel painted the walls of the children's room with a frieze of animals, Bertold Löffler and Michael Powolny, founders of the Wiener Keramik-Werkstätte, designed ceramic decorations and tiles. Of these 'outside' contributions, however, by far the most significant was the huge mosaic frieze which Klimt himself designed for the dining-room of the palace, now known simply as the *Stoclet-frieze*:

The upper walls of the dining-room, above the table-high sideboards running the whole length of the room, right up to the ceiling, were to be decorated throughout with a mosaic frieze. Gustav Klimt happily took on the task, which he fulfilled with consummate artistry. From a field of flowers sprang forth the highly stylized image of a tree with many branches, with golden foliage and details of birds, interrupted at the most important points by figural motifs. These, exceptionally beautiful and colourful in their effect, gave Klimt the opportunity of displaying his decorative gifts in a new and unique way.[102]

The frieze was executed in gold and silver, with enamel, coral and semi-precious stones, against a white marble background. The two long walls, which are separated by a narrow abstract panel at the entrance end of the room, depict the tree of life. Each long wall consists of seven sections; the corresponding panels on each wall are identical, save for the second panel on the left-hand wall, looking towards the entrance, where the standing figure of a young woman, seen in half profile, symbolizes Expectation, while the opposite panel on the right-hand wall depicts the embracing couple who symbolize Fulfilment. In the penultimate panel of each long wall, that is, towards the entrance, the spreading branches of the tree are interrupted by the motif of the magic bush, whose cascade of triangular emerald leaves counterbalances the figural components of the frieze at the window end of the dining-room. A handwritten note by Klimt on the working drawings for the frieze informs us of the artist's concern for texture: 'The tree is to be executed in mosaic, the scrolls as well as the leaves of the tree; the blossoms, on the other hand, are intended to be made out of some kind of material (enamel, or possibly coloured glass).' (Plate 126)

The *Stoclet-frieze* marks the culmination of that eclectic manner which is distinctive of Klimt's earlier work. Here, the sources upon which he draws— Mycenaean ornament, Byzantine mosaics, the art of Egypt and Japan—are fused into a unity which seems to defy precise art-historical scrutiny. In other ways, however, this work signifies not merely the end of a phase, the final, most grandiose statement of that ideal of purity and splendour which is symbolized by the 'gold and white' manner of the early Secession. The embracing figures representing Fulfilment, whose more naturalistically portrayed hands and faces emerge unexpectedly from among the abstract patterns of the branches of the tree of life and of their own garments, look not only backwards to the Flöge portrait and the final panel of the *Beethoven-frieze*, but also forwards to the inversion of the same motif in *The Kiss* (Plate 127), the most abstract and one of the most complex of all Klimt's later compositions. Technically, also, the *Stoclet-frieze* signals a new point of departure. Hevesi, in his description of the University Paintings, had already written of Klimt's 'painted mosaics'.[103] In fact, the commission for the decoration of the Stoclet dining-room provided the artist's only opportunity to experiment with the actual technique of mosaic; but the combination of materials employed, which is already prefigured in the use of gold and inlay for the *Beethoven-frieze*, anticipates the even more complex demonstrations of virtuosity, the mixed-media technique and intarsia-work effect which dominates Klimt's large-scale works of what may less than fancifully be termed his golden years.

Kabarett Fledermaus

The other project which best expresses the common aesthetic of the Wiener Werkstätte is that for the Kabarett Fledermaus, an intimate theatre and *Lokal* on Montmartre lines, which opened in Vienna at No. 33 Kärtnerstrasse in October 1907. Its purpose, according to its self-advertised programme, was 'to serve the cause of a true entertainment-culture by means of an organized, unified synthesis of all relevant artistic and hygienic elements'.[104] The Fledermaus soon became the regular haunt of the brilliant circle which had previously frequented the Café Central, and which included writers such as Bahr and the poet Peter Altenberg, who was a friend of Wärndorfer; indeed, according to Hoffmann, it was more for Altenberg's sake than for any other reason that Wärndorfer agreed to take on the running of the Cabaret.[105] The plays, poetry-readings and other spectacles which formed the staple diet of the theatre for the most part closely reflected Wärndorfer's own personal taste. Here, in the small semicircular auditorium, one could hear interpretations of Maeterlinck, poems by Wedekind, even dancing to 'themes' of Beardsley, as well as works by Altenberg, Egon Friedell, Hollitzer and other representatives of the Viennese *avant-garde*. Kokoschka's

125. (*left*) Photograph (*c*. 1907) showing the 'bar room' of the Kabarett Fledermaus

126. (*right*) Gustav Klimt: *Working drawing for the* Stoclet-frieze. Detail, 'Fulfilment'. 194 × 121 cm. Vienna, Museum für angewandte Kunst

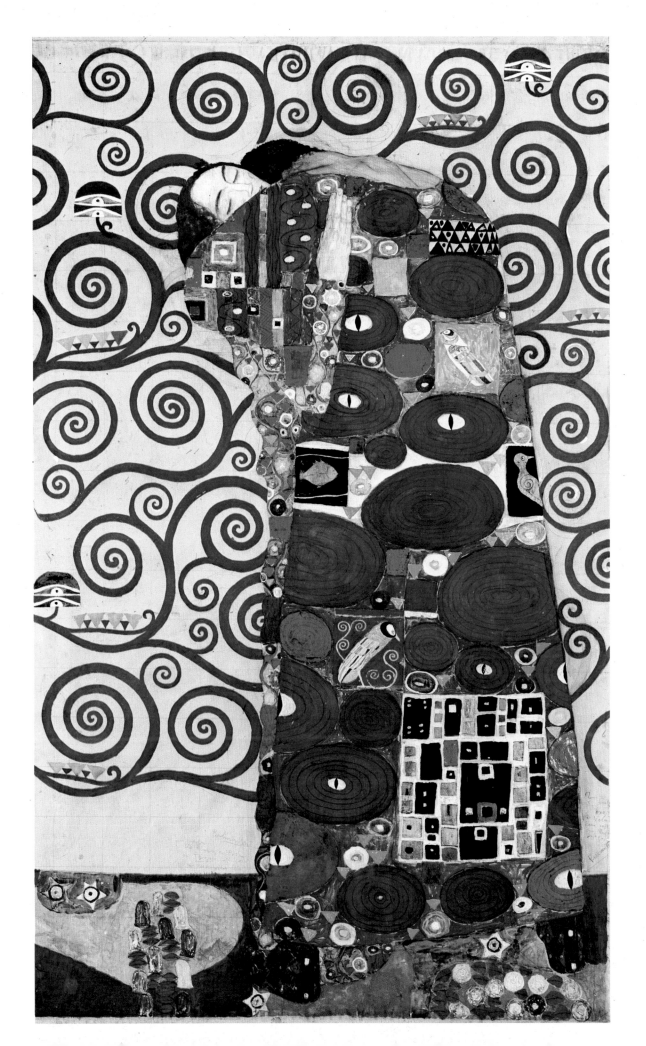

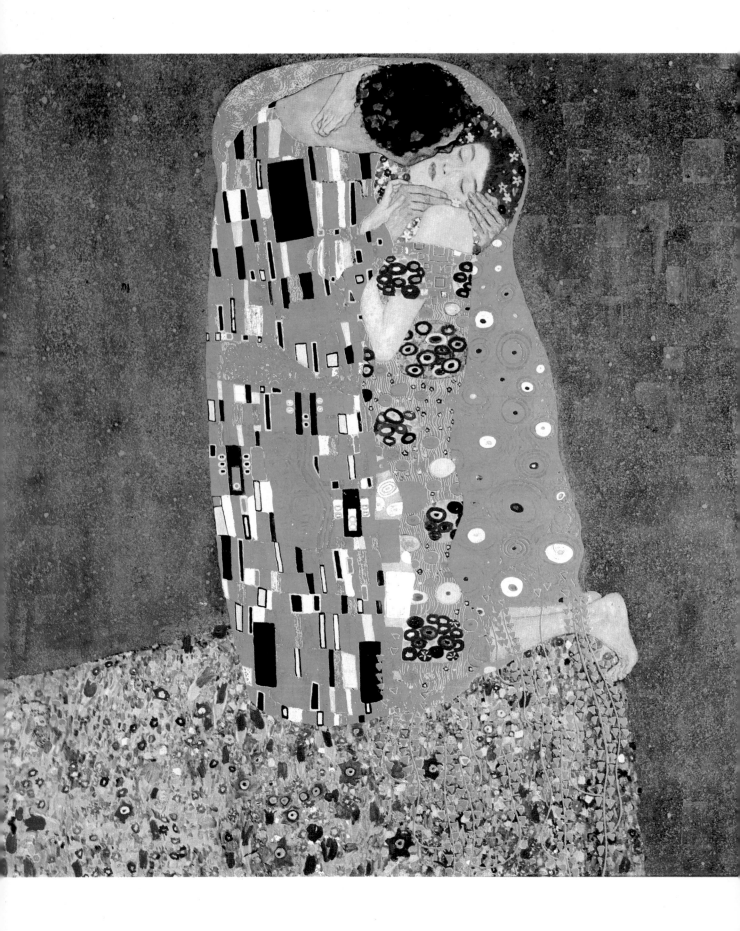

'shadow-drama' *The Speckled Egg*, a kind of proto-cinematographic allegory, was also first performed at the Fledermaus.[106]

A flight of stairs led down from the entrance in the Johannesgasse to the subterranean cavern which comprised the Cabaret itself. There were only two main rooms: the auditorium, and the famous 'bar-room' (Plate 125). The auditorium was tiny; in fact, the limited seating capacity caused endless financial problems. The walls were simply rendered in white plaster, and the only decoration was the repeated motif of a bunch of grapes, carved free-hand. In the middle of the auditorium stood a large pillar which, as Hoffmann remembered, could not be removed on account of the Viennese building regulations, and which made the organization of the available space even more difficult. In the antechamber were placed small chairs and tables, on every table a Hoffmann vase, with fresh flowers daily (the Werkstätte's exhibition *Der Gedeckte Tisch* had also emphasized the importance of flowers in table decoration). Most interesting of all was, however, the bar, which Hevesi described as a 'paperhanger's nightmare'. The entire wall surface was covered with rectangular, coloured tiles of irregular dimensions, the product of Löffler, Powolny and the other collaborators of the Keramik-Werkstätte. Hevesi wrote:

The bar-room is a room such as has never been seen before. Its décor is an original *coup* of decorative fantasy. . . . The walls, and the bar itself . . . are covered with an entirely unknown kind of mosaic. *Bunt wie die Buntheit, und phantastisch wie*

128. (*below*) Wiener Werkstätte postcard depicting the auditorium of the Kabarett Fledermaus, *c.* 1909

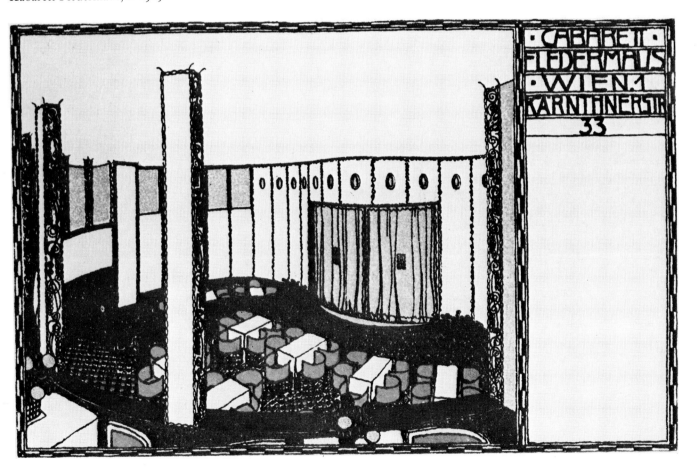

die Phantasie. An irregular, apparently random mosaic made out of large and small, rectangular ceramic tiles, each of a different colour. Of every possible size and shape, long, square, broad, narrow, all juxtaposed over a wide surface. Over seven thousand tiles, of every conceivable shade of colour, enormously effective, of which some thousand are adorned with pictures and drawings, vignettes, symbols, caricatures, modern emblems, portraits, lampoons, reptiles—in short, cartoons of every kind. . . . The most entertaining picture-book imaginable, always open, an entire *Orbis Pictus* with the products of the effervescent fantasy of the cabaret. One can amuse oneself for hours on end by rooting out from this endless *quodlibet* all the different jokes.[107]

The interior of the Cabaret was designed principally by Hoffmann and executed by the WW; but, as in the case of the Palais Stoclet, the project also involved the collaboration of many of those artists who had remained on friendly terms with Hoffmann after the split within the Secession. In addition to the actual decoration, much time and energy were expended on producing the necessary graphics connected with the theatre. Bertold Löffler, Moritz Jung and Carl Otto Czeschka were the principal artists involved in designing the posters and programmes for the early productions (Plate 129); the programme books in particular represent, together with Kokoschka's poetry and lithograph volume *Die Träumenden Knaben*, the highest achievement of the WW in the field of graphic design. Kokoschka, who made his Werkstätte debut with the Kabarett Fledermaus, also designed

129. Bertold Löffler: *Design for a brochure*, produced by the Kabarett Fledermaus, in honour of the poet Peter Altenberg's 50th birthday (1909). Vienna, Historisches Museum der Stadt Wien

several of the famous WW postcards, of which over nine hundred appeared during 1907–10. These postcards not only reproduced works by modern artists, but also depicted contemporary events such as the Imperial Jubilee Celebrations of 1908 (Plate 130), or the first flight of an aeroplane in Vienna (Blériot, 1909), as well as modern inventions like the automobile and the phonograph. One series was devoted to the Viennese coffee-houses and variety-shows of the period, including several views of the interior of the Kabarett Fledermaus in its original state (Plate 128). There were also greeting cards for numerous public and private occasions.

The year 1907 marks the end of the first phase of the Werkstätte's activity. Already in the summer of that year, Hevesi had been able to announce 'along with the usual toll of automobile accidents, another misfortune which has secretly overtaken us':[108] Czeschka's impending departure from Vienna. Like the sculptor Richard Luksch, Czeschka had been lured away by the promise of a professorship at the Kunstschule in Hamburg. 'Luksch', wrote Hevesi wryly, 'will no doubt be waiting for him on the platform'.[109] Czeschka's going meant the final dissolution of the original core of the Werkstätte's design department. Moser had resigned

130. Bertold Löffler: *Costume designs*, 1908. These were made for the Imperial Jubilee Celebrations of 1908. They represent the kind of costume worn by children at a harvest festival during the era of the Emperor Joseph II.

the previous year, and the advent of new designers such as Otto Prutscher and Eduard Josef Wimmer soon resulted in a watering-down of the strict geometrical style of the early Hoffmann-Moser period, as well as a further diversification of the WW's fields of interest. Moser in his reminiscences recalled:

Our sphere of activities became constantly greater. Apart from furniture and materials, we produced jewellery and toys, bindings and patterns. . . . In my view these undertakings were too diverse, and too dependent upon the taste of the customers. And yet, for the most part, the public had in fact no idea what it really wanted. The impossible demands of our clientele, and other differences of opinion, finally brought about my resignation from the Wiener Werkstätte.[110]

Moser's marriage, and his subsequent disappointment over the project for the decoration of Wagner's church 'am Steinhof', may also have contributed to his decision to devote himself principally to two fields of activity which had previously occupied only a small proportion of his energies: painting and stage design. His earliest work as a stage-designer would appear from his own recollections to have been for the writer Felix Salten's ill-fated cabaret Zum lieben Augustin; it was, however, only after his departure from the WW that he began to work for the more 'serious' stage, producing designs for Hebbel's *Genoveva*, and sets for productions at the Imperial Opera of works by the Austrian composer Julius Bittner, among them *Der Musikant* and *Der Bergsee* (1911). His statements on theatrical art are interesting in that they reflect the influence of one of the most revolutionary stage-designers of the day, Alfred Roller, with whose work Moser would have been well acquainted since the early days of the Secession:

131. Kolo Moser: *Self Portrait* (detail). Vienna, Oesterreichische Galerie

It is not that which is imitated from nature, but that which is necessary for the work itself which confers truth upon the stage setting. A certain naturalism can lend support to the plausibility of the design, but without true necessity it can only remain an accessory, mere décor, decoration. It is not the realization of the accidental forms of nature, but the embodiment of that world created by the author which must be the point of departure and the aim of creating the stage set. The space utilized must re-create in the most vivid way possible that mood demanded by the work, and at the same time offer the greatest possibilities of movement for the actors. Whether it is 'possible' in terms of the actuality of real life or 'correct' in terms of a particular epoch is a question of less importance. It must, above all, reflect the unity of the piece and, at the same time, create its own unity.—At the end of one performance, one of the young ladies present said to me 'I've just been told you designed the sets. I didn't think anything of the kind, I thought it must all have been in the play.' Dear young lady, exactly what I intended.[111]

Also attributable to this later period are the majority of his paintings in oil, although one of his finest female portraits, which depicts the cashier of the Secession (Plate 139), must on account of its subject-matter be ascribed to the early years of his association with the *Klimt-gruppe*. These later works reveal all too clearly the profound impact of Hodler's art, which Moser had known at least since the nineteenth Secession exhibition (see p. 84), for which he had designed the hanging. After 1907, Moser's personal relations with the Swiss artist appear

132. Kolo Moser: *Three Women*. Vienna, Museum des 20 Jahrhunderts

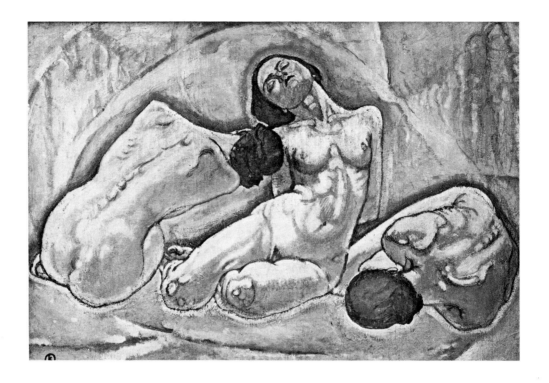

to have become closer; it is known, for example, that he visited Hodler in Switzerland in the spring of 1913. The uncompromising frontality of his *Three Women* (Plate 132), and the geometric monumentality of certain of his landscapes (Plate 133) recall precisely that aspect of Hodler's work which would have been familiar to him from the early Secession shows; many of his utterances concerning painting, for example 'Simplicity lies not in omission, but in synthesis', also demonstrate the influence of Hodler's aphoristic statements on the nature of art.

133. Kolo Moser: *Lake Garda*. Vienna, Oesterreichische Galerie

Alfred Roller, 1864–1935

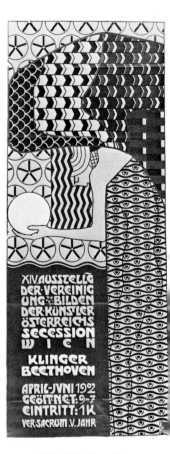

Mention must also be made of Roller's own career, which in its early stages closely resembles that of Moser. Roller, in common with several other members of the budding *avant-garde*, had as a student first enrolled in Griepenkerl's painting class at the Academy, although he soon decided he had little to learn in that environment. Together with Moser, Olbrich and Hoffmann, he was one of the founding members of the Secession, and in 1899 was appointed professor at the Kunstgewerbeschule, one of the rash of new appointments which accompanied Myrbach's reform of that institution. Here, he took over the preparatory drawing class, where he sought to combat the academic tradition of drawing from plaster casts by emphasizing the importance of studying nature and of being able to capture movement. One of his students during these early years at the Kunstgewerbeschule, the young Mileva Stoisavljevic, later became his wife.

Like Moser, Roller was during the first years of his career known principally as a draughtsman. He was for a time head of the editorial committee of *Ver Sacrum*, and had the distinction of creating the cover for the first number of the magazine (Plate 32), as well as innumerable vignettes and decorative designs for subsequent issues. He also designed the posters and catalogues for some of the most important Secession exhibitions: the fourth exhibition (Plate 39), at which his study for the mosaic *The Sermon on the Mount*, intended for the Breitenfelder-Kirche, was shown; the fourteenth exhibition, the poster for which (Plate 134) reproduces part of his mural *Falling Night* which adorned the rear wall of the main room of the Secession building, behind Klinger's statue of Beethoven; and the sixteenth exhibition, 'The Development of Impressionism in Painting and Sculpture'. His most important contributions to the Secession were however his exhibition settings, in particular his hanging of the ninth exhibition (Plate 135), which, by ruthlessly eliminating all conventional distractions, achieved for the first time that clarity of spatial organization which was to distinguish all the association's later shows.

134. Alfred Roller: *Poster for the fourteenth Secession exhibition*, 1902

We are told that when, as a young child, Roller was asked what he wanted to be, he replied: 'Someone who's allowed behind the scenes'.[112] But despite his gift, made manifest by his exhibition designs, for articulating space clearly and decisively, he had never been employed as a theatrical designer. By chance, the opening of the fourteenth exhibition, which took place under his presidency of the Secession, offered an unexpected opportunity which was to revolutionize the young artist's career. Carl Moll happened to introduce Roller to Gustav Mahler, who had married Moll's stepdaughter Alma Maria Schindler only a month before. At this first meeting, Roller showed Mahler the sketches he had made, more for his own satisfaction than with any hope of their realization, for Wagner's *Tristan und Isolde*. Mahler recognized even in these preliminary sketches a kindred spirit. *Tristan*, the first of many collaborations between Mahler and Roller, went into production in February 1903, and was acclaimed by the critics as aesthetically one of the high points of Mahler's directorship of the Imperial Opera:

The stage glowed with amazingly powerful colours: the first act yellow-red, orange

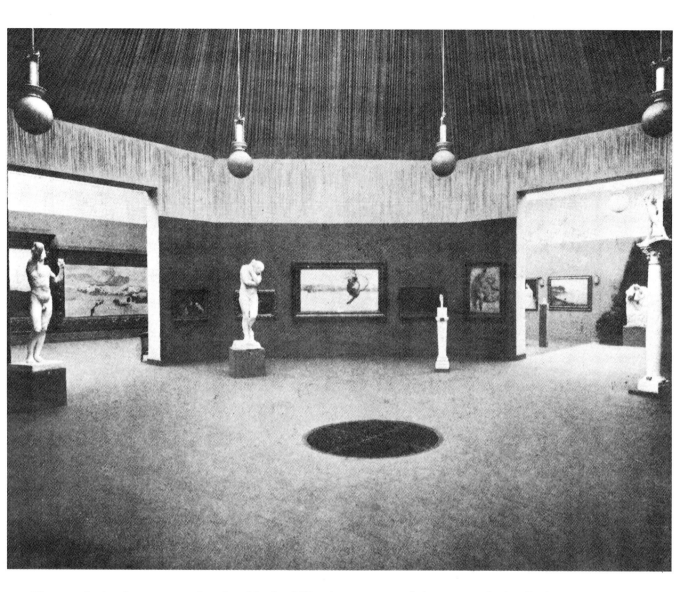

135. Photograph showing the interior of the ninth Secession exhibition, 1901. The setting was designed by Alfred Roller

and red, with the billowing canopy of the sun-soaked sail, the steps on the right leading to the deck hung with red; behind, the dark interior of the ship, lit by the crooked rectangle of the hatch. The centre of the stage was occupied by Isolde's couch, its posts decorated with heathen ornament and carvings, black and gold, the casket containing the deadly potions gleaming with gold, looking like a little shrine . . . set with great semi-precious stones and decorated, like the curtains and the couch, with Celtic ornament.[113]

Tristan was followed by a whole series of stage designs by Roller for Mahler's productions at the Hofoper: *Fidelio* (October 1904), *Don Giovanni* (December 1905), and an outstanding Mozart series to mark the 150th anniversary of the composer's birth (1906): *The Seraglio, The Magic Flute, Così fan Tutte*. In the one season 1905–6, Mahler directed no less than five entirely new Mozart productions. He also succeeded in winning Roller away from the Kunstgewerbeschule to become full-time head of design at the Opera, a post which the latter continued to hold until 1909.

The collaboration between these two artists embodied a—for Vienna—com-

pletely new conception of opera. Mahler's dedication to the Wagnerian ideal of the *Gesamtkunstwerk*, the production of opera as a unity which embraced not only the activity of the director and designer, but every aspect of the interpretation and staging, costumes and sets, lighting and choreography, is made clear by part of an interview which he gave to the *Illustriertes Extrablatt* in September 1903:

The whole of modern art has to serve the stage. Modern art, I don't just mean the Secession. It's a question of all the arts working together. Traditional methods are simply worn out; modern art must embrace costume, accessories, the whole revitalization of the work.[114]

It was Roller who first enabled Mahler fully to realize this ideal. To what extent his own conceptions of staging were a reflection of Mahler's expressed wishes remains unclear. Roller himself was exceedingly modest on the subject of his relations with Mahler, whom he revered as 'the greatest and purest man with whom my good fortune has brought me into contact'.[115] Looking however at his designs for *Tristan*, one can appreciate straight away what it was that Mahler saw in the work of his younger contemporary. The musician's overriding concern with clarity, his disdain for the accretions of theatrical tradition, which he identified with 'self-satisfaction and slovenliness',[116] are matched by Roller's disregard for the naturalistic conventions of the contemporary theatre, his desire that everything on the stage should 'mean something' rather than 'represent something':

I think *Bühnenbildner* [literally, 'stage painter'] is the wrong word: the stage isn't a picture [*Bild*]. The stage is a space. At least, that's how I see it. A space which is divided up, made meaningful by the movements of the actors. It means one thing when the actor smiles, and another, when the actor cries. For me the set must be constructed only out of *essentials*, which do not represent the setting, but which must above all be conditioned by the purpose, like the words or the tempo.[117]

There is also a significant resemblance between Roller's spare settings for *Tristan* or *Don Giovanni* and the work of the great Swiss designer Adolphe Appia who had, in his designs of precisely these years (and particularly in his sets for Wagner's operas), begun to reduce the means of theatrical representation to the barest minima.

The most ambitious project which Roller undertook for the Hofoper was a new production of the entire *Ring of the Nibelung*. Only two operas of the cycle, *Rheingold* (1905) and *Walküre* (1907), were performed under Mahler's direction. By mid-1907, the almost daily attacks in the press heralded the end of a reign which had stretched over a decade. Mahler's resignation was accepted on 5 October. In a letter of farewell to his colleagues he wrote:

The hour has come which brings to an end our collaboration. I take my leave of the theatre which has become dear to me, and bid you all farewell.

Instead of that perfect unity of which I had dreamed, I leave behind me a fragment, incomplete, as is the destiny of man.

It is not for me to judge the importance of my labours for those to whom they were dedicated. And yet I can say at this moment: my intentions were earnest, my

sights set high. Not always were my efforts crowned with success. No one is so much prey to the resistance of the material, the elusiveness of the object, as the performing artist. But always I gave of my all, subordinating my personal interests to the task in hand, my inclinations to my duty. I did not spare myself, and thus felt entitled to demand of others the expenditure of all their energies.

In the heat of battle, neither I nor you were spared wounds, errors. But when we succeeded, we forgot all our toil and tears, and felt ourselves amply rewarded— even without any of the external signs of success. We have all progressed, and with us the institute for which we have worked. Accept now my gratitude, all who have assisted me in my difficult, often thankless task. Accept my sincerest wishes for the success of your careers and of the Imperial Opera, whose fortunes I shall continue to follow with lively interest.[118]

Hoffmann's later work

Before turning to a consideration of the career of the fourth great architect of the *Wiener Moderne*, Adolf Loos, some attention should be given to Hoffmann's buildings of the period 1908–14, although for the most part these years are distinguished by his abandonment of his earlier, innovatory style in favour of a far more conservative, traditional manner of building. Only twice was he to recapture something of the simplicity and clarity of the Sanatorium Purkersdorf: in his design for the temporary structure on the site of the present Konzerthaus, which was built to accommodate the famous Kunstschau exhibitions of 1908 and 1909; and in the villa colony Kaasgraben of 1912 which, unlike the villas on the Hohe Warte, was conceived and built as a single entity. His other buildings of the immediately pre-war years, however, tend towards a rigid Neo-Classicism, and an excessive concern with surface ornament and external appearance. Particularly surprising is the Haus Ast (1909–11), which contrasts strangely with Hoffmann's earlier villas. Here, in the building as executed, the architect modified his originally rather simple design, emphasizing the cornice, and abandoning the 'long and short' treatment of the corners of the house in favour of a ponderous fluting (similar vertical forms separate the windows of the façade, giving the impression of a giant pilaster order). An interesting feature of the design is the continuation of the socle zone beyond the block of the main building to form a kind of secluded patio. Even more ponderous, with its similar pilaster-like treatment of the façade and heavy pediments, is the house which he built in the Gloriettegasse for Robert Primavesi, the cousin of Otto Primavesi, who later took over financial responsibility for the Wiener Werkstätte.[119] The same classicizing mood also informs the two exhibition buildings which Hoffmann designed to represent Austria abroad: the house which he built for the International Art Exhibition in Rome in 1911 (Plate 136), and the pavilion, designed in collaboration with the architect Oskar Strnad, for the German *Werkbund* exhibition in Cologne in 1914 (Plate 137). Of the latter building the critic Max Eisler wrote: 'No compromises, no trace of tradition can

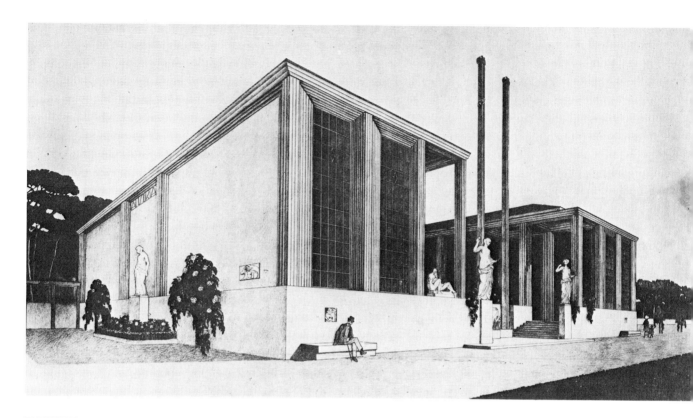

136. (*above*) Josef Hoffmann: *Austrian pavilion for the International Art Exhibition in Rome*, 1911

137. (*left*) Josef Hoffmann and Oskar Strnad: *Pavilion for the German* Werkbund *exhibition in Cologne*, 1914. From *Dekorative Kunst*, XVII (10 June 1914)

here be perceived, rather, simply the further development of Hoffmann's style to a new level of clarity'[120]—a judgement which art historians must view with some incredulity. The Austrian contribution to the *Werkbund* show consisted for the most part of a display of the products of the Wiener Werkstätte—the last important pre-war manifestation of the Werkstätte style.

Adolf Loos, 1870–1933

Loos, the most uncompromising architect of the *Wiener Moderne*, was born in Brno, the capital of Moravia, in 1870, the same year as Hoffmann. Only part of his active life was spent in Austria. The period after the First World War saw a series of attacks on his moral character in the Viennese press; in 1922 he emigrated to France, and during the years 1922–7 lived mainly in Paris. He was one of the outstanding polemicists of the modern movement; to the Viennese, no matter whether their standpoint was friendly or hostile, his name signified the ultimate in *avant-gardisme*, the last word in everything that was new, foreign, ultra-modern. An unswerving opponent of decadence, he initiated, as much through his writings as through his practical activity, a revolution which, although not entirely consistent in character, carried him to the forefront of the development of early twentieth-century architecture. Le Corbusier is reported as saying of him: 'Loos swept clear the path before us. It was a Homeric cleansing: precise, philosophical, logical. He has influenced the architectural destiny of us all.'

Having studied at the Dresden College of Technology from 1890 to 1893, Loos spent the next three years in America, where he supported himself by an extra-ordinary variety of occupations, including that of music critic.[121] He visited New York, Chicago, Philadelphia and St Louis, acquainting himself with American architecture of the nineteenth century. To this period can be dated his first encounter with the work of Louis H. Sullivan (1856–1924), which exerted a profound influence upon the young Austrian—an influence seen clearly in Loos's early designs for interior decoration. His experience of the United States left him a lifelong admirer of America and all things American; this admiration contrasts, to a marked degree, with the scorn Loos felt for Austria-Hungary, which he regarded, not altogether unjustly, as a still backward, predominantly Balkan state.

In 1896 he returned to Europe, this time to Vienna, where he embarked upon the dual career of architect and writer.[122] Loos was by far the most important artist of the period to devote a major proportion of his energies to literature and criticism. An admirer of Wedekind and the modern movement in poetry,[123] he was a close friend of both Altenberg and Kraus. Loos soon became a member of Kraus's circle which met at the famous Café Central, where he made the acquain-tance of the painter Oskar Kokoschka, the poet Georg Trakl, and the composer Arnold Schoenberg. This café-circle was an important forum for literary—and above all linguistic—discussion. Kokoschka later recalled: 'For Karl Kraus, correct mastery of the German language was proof that you belonged to the human race—his grammar book was his Bible. He tested his friends like an Apostle tests his disciples. Only I had the sort of freedom given to the court jester'.[124] Loos, on the other hand, was fully Kraus's equal as a writer: brilliant, pithy, urbane, perceptive. In a succession of articles published between 1897 and 1903, he subtly castigated the follies and fashions not only of contemporary art, but also of Viennese society. He viewed his own critical responsibility as, in the highest sense, cultural; the journal *Das Andere* (The Other), which he founded in 1903, was subtitled: 'A Newspaper to introduce Western Culture into Austria'—

much to the annoyance of the Nationalist party. To this journal, written—like the later numbers of Kraus's periodical *Die Fackel*—entirely by its founder, Loos contributed not only reviews of artistic events, but advice on morals and public behaviour, a correspondence column on what was or was not *bon ton*, even cookery hints. A whole column of the second issue of *Das Andere* was given over to an enthusiastic review of the aubergine.[125]

Loos's crusading spirit, hardly surprisingly, carried over into the realms of art criticism. Here, however, it is easier to recognize his intellectual debts and his theoretical allegiances. A statement such as 'It is entirely out of the question that anything which is not practical can be beautiful'[126] reveals the unmistakable influence of Wagner, whose importance for his own personal development Loos had the grace to acknowledge. He also vehemently attacked, in conformity with contemporary fashion, the pretentiousness which had disfigured the applied arts of the preceding decades, denouncing the accepted period styles as 'irrelevant to the age of the automobile and the telephone'. 'Down with the telephone', wrote Loos in one of his more sardonic moments. 'Let us encase it in Rococo ornament. Or Gothic. Or Baroque. All according to the wish of the customer.'[127] Another, almost inevitable stalking-horse was the architecture of the Ringstrasse era. As for Wagner, to say nothing of Bahr, the monumental façades which gave on to the Ring symbolized for Loos that architectural deceit inseparable from the whole practice of Historicism; ironically, his remarks on this subject almost exactly echo those of Bahr, with whom, otherwise, he had little enough in common. In an article entitled 'Die Potemkinsche Stadt' (Potemkin's Town), he wrote:

If I stroll along the Ring, I always have the impression that a modern Potemkin* has set himself the task of making someone believe Vienna to be a town inhabited by nothing but *nobili*.

Whatever the Italian Renaissance produced in the way of lordly palaces has been plundered, in order to conjure up before the eyes of His Majesty the Plebs a new Vienna, in which live only people in a position to own an entire palace from socle to cornice. . . . To possess such a palace must have pleased the landlord— to live in one pleased the tenant too. The simple man, who had simply rented a bedsitter on the top floor, would be overcome by feelings of feudal grandeur and noble majesty on observing his tenement from without. . . . What a deception![128]

'Die Potemkinsche Stadt', published in the July 1898 issue of *Ver Sacrum*, marked both the beginning and the end of Loos's association with the Secession. It is often related that he offered to design for Olbrich's building the room for which the least money had been allocated (according to some accounts, the board-room), and that this offer was turned down by Hoffmann. Loos, in later years, wrote in scornful terms of both Hoffmann and Olbrich. The latter he seems particularly to have disliked; in one article, he described a shop window which contained cutlery 'after the English model, for people who know how to eat, and after designs by Olbrich, for people who don't'.[129] But in any case, as an institution,

*The reference is to Count Potemkin, favourite of Catherine the Great of Russia, who erected dummy villages in the Ukraine for the occasion of the Empress' visit, giving the impression of a high level of prosperity among the impoverished population.

he rapidly came to regard the Secession as an object of hostility. In particular, he reproached the Secessionists, not altogether fairly, with having introduced merely another style, another form of artistic tyranny which, in the case of the applied arts, despite protestations of a return to 'true design' and 'honesty to materials', often failed to conceal a woeful lack of technical expertise. (Loos consistently placed 'craftsmen' higher in his scale of values than either 'artists' or 'architects'.) A kind of cautionary tale which he wrote for the second number of *Das Andere* told the story of a simple saddler:

There was once a saddler. A good, industrious craftsman. He made saddles of a kind which had nothing in common with the saddles of previous centuries. Nor with Turkish or Japanese saddles. In other words, modern saddles. Although he didn't know it. All he knew was that he made saddles. As best he was able.

Then one day a strange movement came to town. It was called 'Secession'. It demanded that objects of everyday use should only be produced in the *modern* manner.

When the saddler heard this, he took one of his best saddles and went along to one of the leading members of the Secession. And he said to him 'Herr Professor!'—for indeed he was, all the leaders of this movement had instantly been made Professors—'Herr Professor! I have heard about your demands. I too am a modern man. I too should like to work in the modern style. Tell me: is this saddle modern?'

The Professor examined the saddle, and then gave the craftsman a long lecture consisting, as far as he could hear, of words such as 'Arts and Crafts', 'individuality', 'modern', 'Hermann Bahr', 'Ruskin', 'applied art', etc. etc. The import was, however: No, this is not a modern saddle.

Filled with shame, the craftsman took his leave. Thought and toiled and thought again. But however much he tried to meet the lofty demands of the Professor, he could only succeed in producing the same old saddles.

In despair, he went back to the Professor and told his tale of woe. The Professor examined the man's attempts and spoke: 'My dear fellow, it's simply imagination you're lacking.' Yes, that was it! He hadn't got any! No imagination! In fact, he hadn't even known that one needed imagination when making saddles. If he had any, he would doubtless have become a painter or a sculptor. Or a poet or a composer.

But the Professor said: 'Come back again tomorrow. After all, that's what we're here for, to promote industry, implant new ideas. I'll see what we can do.

And he set his class the project: 'Design for a Saddle'. The next day, the saddler came again. The Professor showed him 49 designs for saddles. Actually, he only had 44 pupils, but 5 he had done himself. They contained a certain 'mood', which destined them for the *Studio*.

For a long time, the craftsman looked at the designs, and light gradually dawned in his eyes.

Then he said: 'Herr Professor! If I knew as little about riding, about horses, about leather and about craftsmanship as you, then I'd have your imagination!'

And lived happily ever after. Making saddles. Modern? He doesn't know. Saddles.[130]

Loos levelled the same accusation of artistic tyranny against the Secessionists on account of what he considered the rigid way they applied the concept of the unity of environment and design. Basically, he distrusted the whole *Jugendstil* aesthetic; in a note of 1910 he wrote, 'And I say unto you, the day will come when it will be considered an extra punishment to be put in cells decorated by Professor van de Velde'. [131] In his parable 'The Poor Rich Man', however, it was almost certainly Olbrich's 'through-designed' interiors he had in mind. The story tells of a rich man who decided to bring Art into his home. So he engaged an architect, whose first action was to throw out all the old furniture and design new. He also designed the wallpapers, the curtains, the carpets, the décor. Every smallest item of house-hold use had its own special place. Admittedly, once an object had been taken from that place, it was sometimes necessary to summon the architect and unroll the plans in order to remind oneself where it belonged. But the trouble only really started when the rich man celebrated his birthday:

His wife and children had lavished him with presents. The presents gave him great pleasure, a great deal of happiness. Then the architect came to put things right, to decide about difficult cases. He came into the room. The master of the house welcomed him eagerly, for he had much on his mind. But the architect observed nothing of the other's joy. He had caught sight of something quite different, and paled. 'What ever kind of slippers have you got on?' he managed to utter with difficulty.

The rich man looked at his embroidered slippers and breathed a sigh of relief. For this time he was entirely innocent. The slippers had been made after an original design by the architect himself. So he retorted: 'My dear architect! Surely you can't have forgotten? You designed these slippers yourself!'

'Certainly I did,' thundered the architect. 'But I designed them for the bed-room. In this room, you ruin the whole atmosphere with those two ghastly patches of colour. Can't you see?'

The rich man could indeed see. He quickly took the slippers off, and was overcome with relief to discover that the architect seemed to have no objection to his socks. They went into the bedroom, where the rich man was allowed to put his slippers on again.

'Yesterday', he began tentatively, 'I had my birthday. My family literally showered me with presents. I asked you to come, my dear architect, so that you could advise me where best to put them.'

The architect's jaw dropped visibly. Then he exploded: 'What! How can you have allowed yourself to be given presents? Haven't I designed *everything* for you? Haven't I thought of *everything*? You don't need anything else! You are complete!'. . .

The rich man was annihilated. And yet, he still didn't give up. An idea, yes, he had an idea!

'And what', he asked in triumph, 'if I buy myself a picture from the Secession?'

'Then just try and find somewhere to hang it. Can't you see, there's no room for anything else? Can't you see that I have designed a frame on the wall for every single picture here? You can't even *move* a picture! Just you try and find room for a new one!'

Then, a change came about within the rich man. He who had been so happy suddenly felt deeply, profoundly miserable. He contemplated his future life. No one would be allowed to give him any pleasure. Past the windows of the shops he must go, impervious to all desires. He could order nothing. His family couldn't even give him a picture. For him, there would be no more painters, no more artists, no more craftsmen. No more living and striving, achieving and desiring. He thought: this is what it means to learn to live with your own corpse. *Jawohl!* He is finished! *He is complete!*[132]

Loos's own attitudes to the question of interior design found practical expression in the large numbers of commissions for shops, cafés and apartments in Vienna which he executed between 1897 and 1914. He himself maintained that he regarded the decoration of domestic interiors merely as a sideline, an occupation he undertook simply because of the shortage of proper architectural employment. In a reply to an unknown correspondent he wrote:

You are kind enough to describe my activity to date as 'architectonic'. Unfortunately, it isn't. True, we live in an age in which even a designer of carpets calls himself an architect. Not that it matters. In America, even the people who install central heating call themselves engineers. But the decoration of apartments has nothing to do with architecture. It has provided me with a living, simply because it is something I know how to do. Just as, in America, I kept the wolf from the door for a time by washing dishes.[133]

This statement is rather too modest. Loos was in fact a decorator of genius. Many of the apartments he designed offer highly original solutions to acute spatial problems, as well as demonstrating the architect's extreme sensitivity to materials. In the Vienna flat which he created for himself and his wife, the intimate, homely character of the sitting-room is emphasized by the exposed wooden beams and the brickwork of the fireplace—characteristic Loos devices, which at the same time tell of the profound influence both of America and of Britain upon the formation of his early style (Plate 138). But even those interiors which he did no more than furnish reveal his unique sensitivity in creating a harmonious ensemble out of what are at first sight quite disparate—and often inexpensive—items of furniture. Paul Stefan recalled that, while the architects of the Secession would indulge in costly experiments at the client's expense, redecorating entire apartments every two or three years in order to keep abreast of the latest fashion, Loos would go with his clients to the street markets or the junk shops, buy Biedermeier furniture, which could then be had for a song, select the best pieces from among the discarded contents of refurbished dwellings, fine carpets and so on, and create out of these elements the most comfortable and elegant, although sparsely ornamented, interiors.[134] Where it was a case of designing or ordering new furniture or fittings, Loos demanded first and foremost simplicity and a high level of craftsmanship—prerequisites which, in his view, made all considerations as to 'style' irrelevant. Not for him the elaborate, hand-carved ornament, the artificially stained woods beloved of the Secessionists. Loos was one of the few architects to recognize the merits of natural softwood, simply painting it white, rather than trying to imitate the appearance of the more expensive hardwood,

138. (*left*) Adolf Loos: *Interior of his own flat in Vienna, c.* 1903

as was then the custom. His advice on the manufacture of a writing-desk is also interesting:

Smooth brown linoleum, without pattern, has much to recommend it. The linoleum is affixed to the whole surface of the writing-desk, which must first be planed level at the edges. You then screw on a strip of polished brass, two millimetres thick and as wide as the thickness of the wood plus the thickness of the linoleum, which thus forms the surround. The brass screws should be countersunk in such a way that their heads are on a level with the surface of this strip.[135]

Brass, linoleum, marble and glass were also the materials most frequently employed in Loos's designs for the decoration of shops and business premises. His interior for the Steiner plume and feather shop in the Kärntnerstrasse (Plate 141) was described by Hevesi in a review of 1907:

The panes of the window curved round to meet the doorway. Glass set in brass frames. Inside, white rendering, including the ceiling with its exposed beams veneered in blond satinwood. The counters, too, with their glass tops, are of the same wood, with lighter or darker triangular patterns of inlay. The cupboards mounted in brass. Everything rectangular, strictly linear, without a trace of ornament. . . . An interior of geometric elegance and clinical precision. The whole thing might be a steel safe.[136]

Interestingly, the wording of this article closely resembles that of Hevesi's review of Ashbee's furniture designs shown at the Secession seven years previously:

139. (*right*) Kolo Moser: *Female Portrait*, Vienna, Christian M. Nebehay

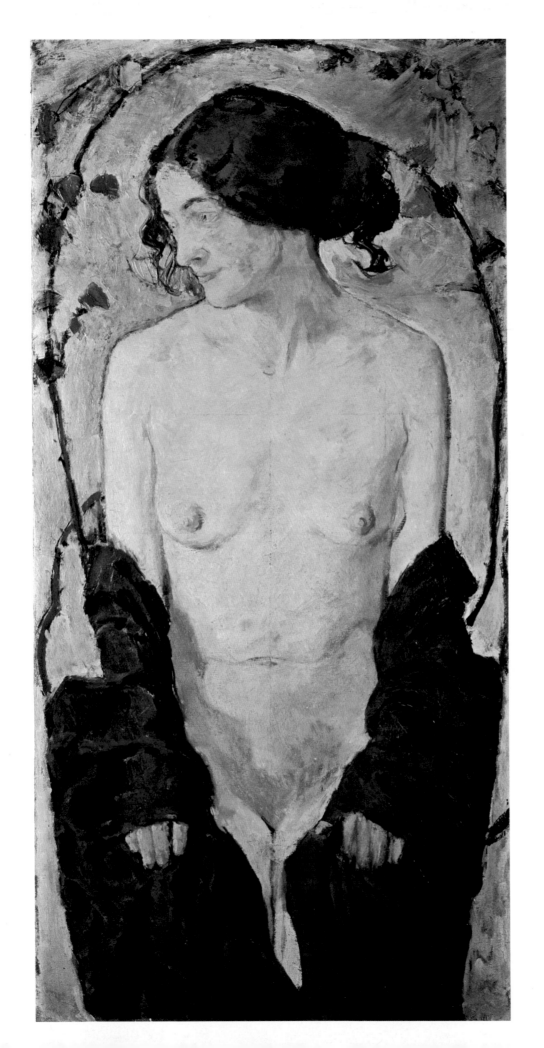

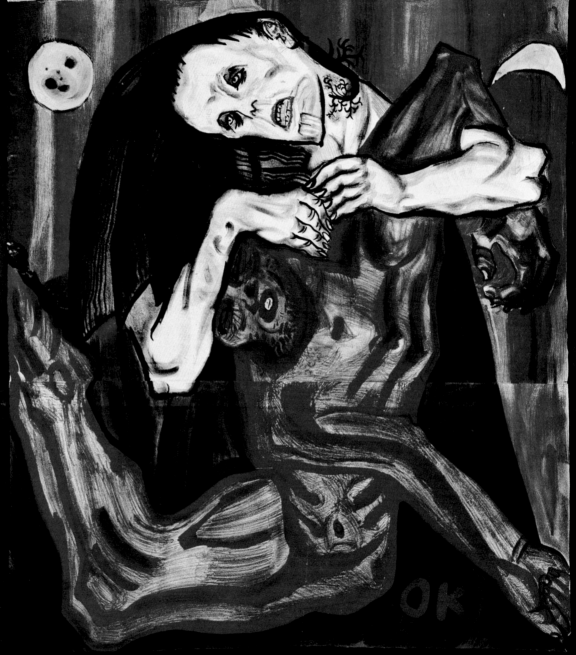

140. (*left*) Oskar Kokoschka: *Poster, called 'Pietà', advertising the open-air theatre of the Kunstschau.* In its iconography, this poster is clearly connected with Kokoschka's own drama *Murderer, Hope of Women,* which received its première at the Kunstschau on 4 July 1909

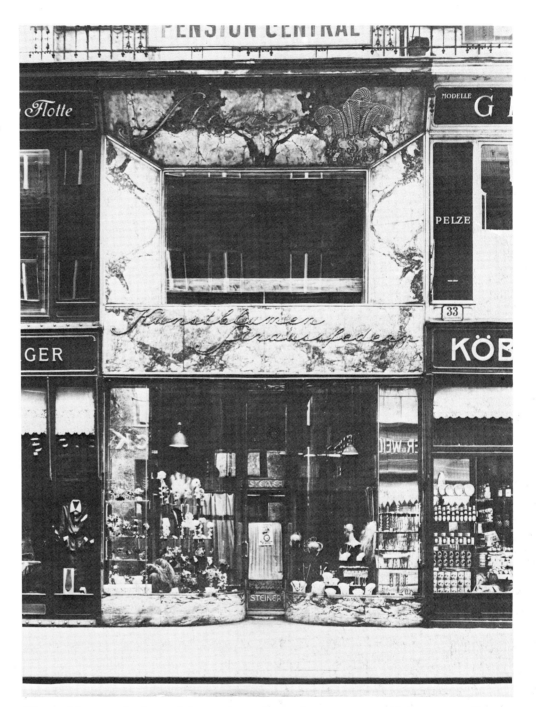

141. (*right*) Adolf Loos: *Steiner Plume and Feather Shop,* Vienna, 1907

'Everything vertical, at right angles, ninety degrees . . . as if they came from a rectangular planet'. The beams which the reviewer mentions serve in this instance a somewhat different purpose to that which they fulfil in Loos's domestic interiors. Here, as in several of his designs for shop premises, space was at a premium. The beams were one of the devices employed to make the tiny ground floor of the Steiner establishment seem more spacious than it really was. To the same end, Loos used full-length mirrors, which not only enabled customers to see their reflection, but also apparently doubled the width of the interior—a trick which he utilized again for the inside of the famous 'American Bar' in the Kärntnerstrasse (Plate 142). The original entrance to the bar, with its garish *sopraporta* imitating

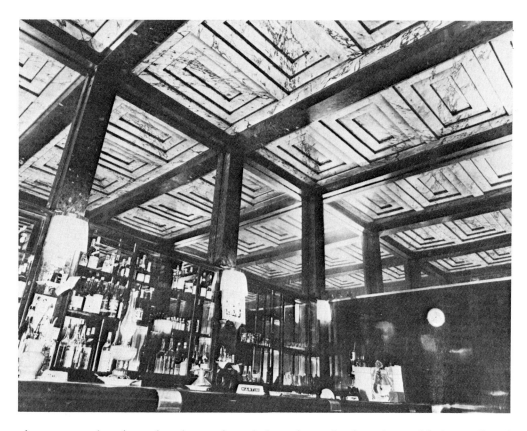

the stars and stripes, has been altered, but the quiet interior, with its coffered marble ceiling, its mirror-walls and Jagerspacher's portrait of Peter Altenberg, has been restored to its former appearance. Not so an earlier café interior by Loos, the Café Museum (1899), which, owing to the spareness, even severity of its decoration, became famous under the sobriquet 'Café Nihilismus'. The long,

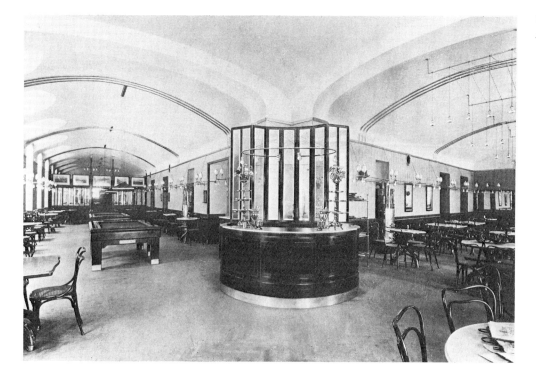

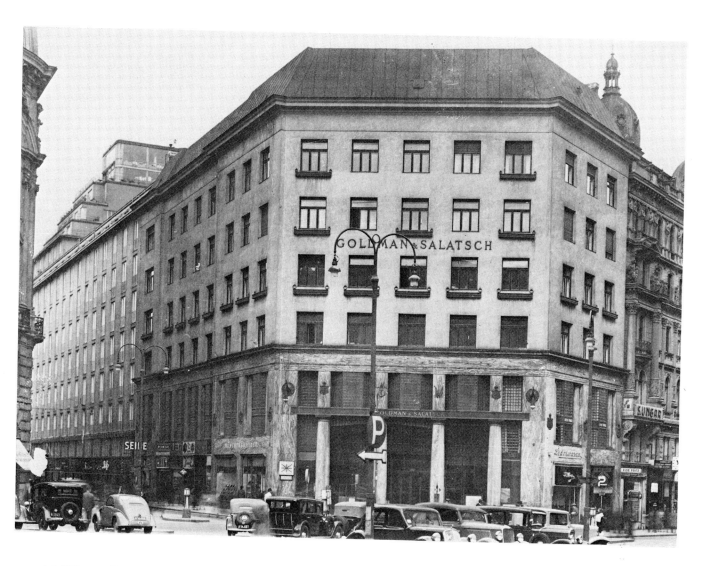

144. Adolf Loos: *House on the Michaelerplatz*, Vienna (Haus Goldman und Salatsch), 1910–12

shallow, vaulted arms of the building, the beauty of which Loos emphasized by his use of lighting (the side walls were pierced by unusually large windows in order to keep the interior as light as possible), have since been divided up by partitions which entirely destroy the sense of proportion. An old photograph (Plate 143) still gives some idea of the original appearance.

The number of Loos's architectural commissions during these years was extremely small. An early project for a theatre to seat 4,000 must, presumably, have been a fantasy design, although a resourceful and imaginative one. In 1907, Loos, like Wagner, entered the competition for designs for the enormous new War Ministry building on the Ring, on a site opposite Wagner's Postsparkasse, but without success. His most important executed building of this pre-war period was the apartment block and store commissioned by the firm of Goldman und Salatsch (for whom Loos had already designed one of several interiors on the Kärntnerstrasse), known as the House on the Michaelerplatz (Plate 144). It created a furore. Loos's opponents were particularly incensed by the prominent position which the new building occupied, in the very centre of the old city, opposite the entrance to the Imperial Residence. The anonymous feuilletonist of the *Neue Freie Presse*, Loos's old newspaper, wrote:

Choose a point on the Michaelerplatz from which to observe the new building which has been put up in place of the Dreilauferhaus, and immediately some passer-by will latch on to you, repeating out loud what you had been thinking to yourself, cursing the revolting edifice to its face, and pass on his way, muttering imprecations. Seldom has a work of architecture called forth such universal opposition, not even the 'cabbage dome' of the Secession. What is more, from the lowest point of the threshold to the bridge tiles on the roof, there isn't a trace of anything Viennese about the new house. The ground floor and mezzanine of proud marble, massive columns hewn from a single block, the lofty street façades, which fill the spaces between the huge panes of glass, all made of the noblest material, costly marble, and above it all, a bare plaster wall, without the shadow of an ornament, pierced by tasteless window-openings, a desolate poverty above all this marble splendour. . . . How can anyone have thought it possible to harmonize this blatantly dissonant modernism with its timeless, historic surroundings?[137]

Most criticisms of the new building adopted a similar tone. The blank window openings, without mouldings, came in for particularly frequent attack, as did the total lack of ornament on the upper part of the façade. Loos had become famous as a passionate opponent of decoration, largely on account of his essay 'Ornament and Crime' of 1908. It is at least partly true that many of the objections later directed against his *Ornamentlosigkeit* arose from misunderstandings of this essay. At the most elementary level, critics have often failed to notice that Loos is, in 'Ornament and Crime', far from being entirely serious. A statement such as 'In certain prisons, as many as eighty per cent of the prisoners are tattooed. People who wear tattoos and are not in prison are merely latent criminals or degenerate aristocrats. When someone with a tattoo dies a free man, it is simply the case that he passed away several years before committing a murder' is surely humorous in intent.[138] But Loos's more earnest intentions have also been frequently misinterpreted. His attack is not upon ornament as such, but upon meaningless ornament, employed simply because of fashion, which may even obscure the true function and purpose of the building. Here, Loos is following not only in the footsteps of Wagner, who had himself advocated the abandonment of unnecessary ornament, but also of the American nineteenth-century theorists of design, especially Sullivan. (Sullivan had, as early as 1892, advised that architects should 'refrain entirely from the use of ornament for a period of years, in order that our thought might concentrate . . . upon the production of buildings well-formed and comely in the nude'.)[139] As far as the bare plaster surfaces of the upper storeys of the House on the Michaelerplatz were concerned, Loos could also point to the precedent of older Viennese urban architecture. In a reply published in the *Neue Freie Presse* two days after the above-quoted review, he vigorously defended his position:

Every word written in praise of our ancient city, in defence of its rapidly disappearing past, certainly evokes a far stronger echo in me than in many others. But that I, I above all, should have committed a crime against this heritage of ours—such an accusation hits me harder than many people might believe. For I did indeed design the building so that it might harmonize as far as possible with the square

on which it stands. The style of the church, which forms the pendant to my building, acted as my point of departure. . . . I chose real marble because any form of imitation is distasteful to me. I kept the plaster surfaces as simple as possible, because the burghers of Vienna also built in a simple style. . . . My object was to make the strongest possible separation between store and apartments, and I always imagined that I had resolved this problem in the spirit of the antique Viennese masters, an illusion fostered by another modern artist who was heard to exclaim: 'What! He calls himself a modern architect and designs a building that looks like the medieval Viennese houses!'[140]

Loos's mention of the 'antique Viennese masters' serves to draw our attention to a number of undeniably traditional references which may be discerned in his building, in particular the imposing main entrance, set into the oblique central façade of the store, which gives directly on to the Michaelerplatz (Hoffmann, not exactly firm friends with Loos, also refers in his autobiography to the curious impression created by the 'antique columns and details of the fenestration, which did not altogether correspond to our own conceptions').[141] One detail of the main entrance, however, has its origin in purely practical, rather than stylistic considerations: the recessed portico, which encourages the casual window-shopper by providing a haven not only from the elements, but also from the bustle of the street. Sadly, many of the most original features of the interior layout have now been altered or removed altogether, including the magnificent mahogany staircase which dominated the centre of the ground floor, so that one is today able to gain little impression of the architect's intentions regarding this aspect of the design.

Loos's other commissions of the years 1910–14 were mostly for domestic buildings, of which the most important were the Haus Steiner (Plates 145–6), the Haus Scheu (Plate 147), and the Haus in der Nothartgasse (Plate 148). In the case of both the Haus Steiner and the Haus in der Nothartgasse, practical considerations also played an important role in determining the forms employed by the architect. The Haus Steiner has become justly famous in the history of twentieth-century architecture as one of the first wholly modern buildings in Vienna, with its rejection of external ornament, its radically simplified fenestration and emphasis upon the predominantly cubic forms of the main structure. Equally interesting, however, is the solution which it proposes in trying to conform with the city's highly restrictive building regulations. The by-laws governing suburban domestic architecture limited the street façade of any building to basement storey and one main storey plus attic; thus, for the front of the Haus Steiner, Loos brings the roof forward in a downward-sweeping curve pierced by a single attic window in strict conformity with the letter of the law. At the rear of the house, on the other hand, he utilizes the whole height of the building to provide three main storeys plus basement; while, giving on to the garden, the roof of the elevated basement storey became a pleasantly secluded terrace, directly accessible from the main living and dining area. In the case of the Haus in der Nothartgasse, the same building regulations posed almost insuperable difficulties, since the building occupied a corner plot, thus having two street façades—a problem which Loos solved, not altogether satisfactorily, by using a semicircular metal roof. The

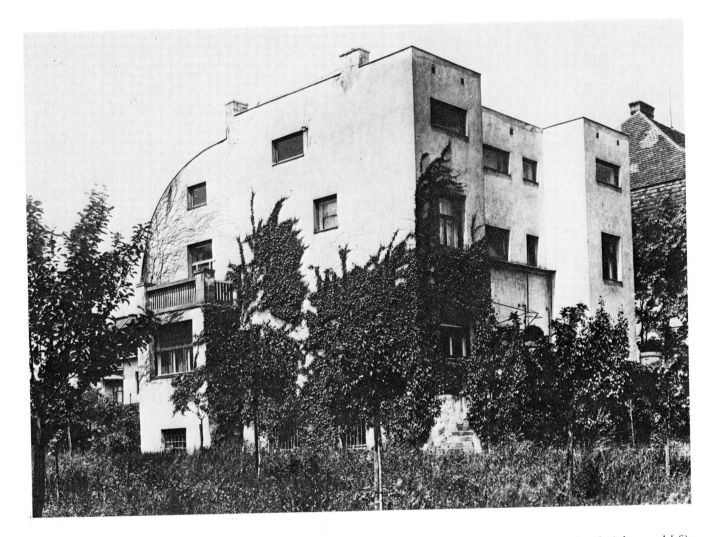

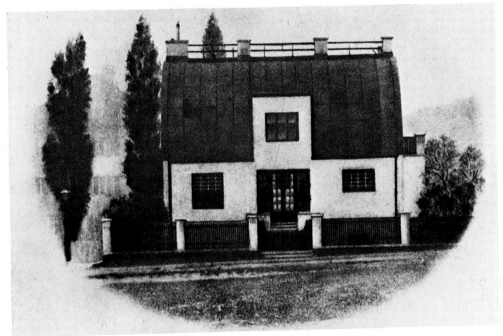

145 and 146. (*above and left*)
Adolf Loos: *Haus Steiner*,
Vienna, 1910

interior arrangement of the Haus Steiner also merits attention. Of particular significance is the large living-cum-dining area, which occupies the greater part of the ground floor—spatially an extremely logical expression of that 'one room' principle which is also to be found in the work of Frank Lloyd Wright, and which may be traced back via Loos's earlier designs for the Villa Karma and for the Wohnung Hirsch in Pilsen (1907). Concerning the disposition of space, Loos himself explained: 'The plan of a room nowadays, under Japanese influence, is centrifugal. Furniture is placed in the corners of the room (not at angles, however, but straight). The centre is empty (circulation space). Artificial light should be placed where needed. There is no stress on the centre.'[142]

Of all Loos's pre-war buildings, the most forward-looking was, however, the Haus Scheu. This suburban residential building, the first 'terraced' house in Central Europe, differed from the two other houses discussed above in that the topmost storey was designed as rented accommodation; it was perhaps this factor which influenced Loos in his choice of the stepped-back terraces, which gave each floor of the building individual access to a small patio. Loos had already

147. Adolf Loos: *Haus Scheu*, Vienna, 1912

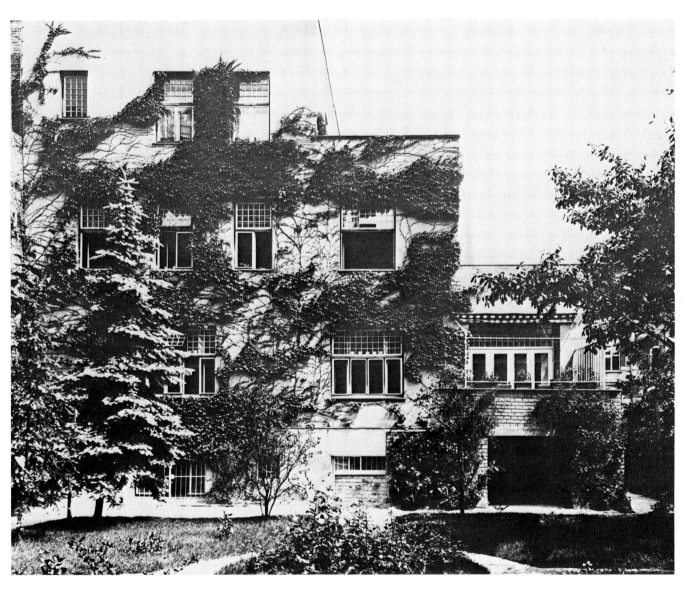

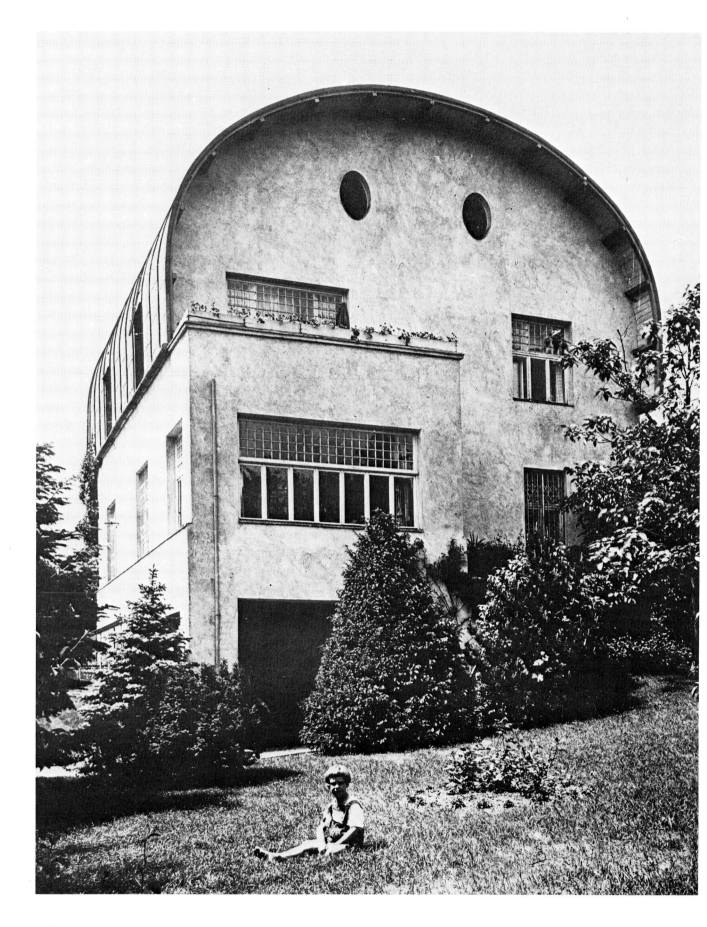

experimented with stepped terrace construction in his design for a large store in Alexandria (1910); it is possible that the Oriental setting may in this particular instance have fired his imagination. Certainly the perspective view of the building depicted by one of Loos's pupils, R. Wels, in a watercolour which the master retained until his death has a markedly Egyptian flavour, which derives not only from the terracing of the upper storeys, but also from the use of a massive order of pillars capped with a small Ionic capital. The architect himself, on the other hand, denied any influence of Mediterranean architecture upon the form taken by the Haus Scheu. Over ten years later, he wrote about his first terraced building:

Years ago I built the villa for Dr Gustav Scheu in Hietzing, Vienna. It occasioned general head-shaking. It was thought that this type of building might be all right in Algiers but not in Vienna. I had not even thought of the Orient in designing this house. I only thought that it would be most agreeable if one could go out on to a large common terrace from the bedrooms, which were situated on the first floor. Anywhere, in Algiers as well as Vienna. So this terrace, which was repeated on the second floor, a rented apartment, was the unusual, the extraordinary. Someone got up in the city council and demanded that this type of building should be forbidden by law.[143]

The Haus Scheu, with its terraced profile, its windows cut straight into the rendering, its insistence upon the use of the flat roof, remains the most advanced of all the architect's pre-war buildings. By the time the lines quoted above were written, the current of modernism, of which Loos had been one of the foremost representatives, had swept past him into the open sea of the International Style— a style to which, enigmatically, he found like Hoffmann or Perret he could no longer subscribe. Of all the personalities considered in this book, Loos demonstrates most clearly that duality inherent in the work of the Viennese *avant-garde*, that tension between radicalism and conservatism which, ultimately, limited the impact of the revolution they had initiated. This revolution had, none the less, decisive repercussions upon the development of twentieth-century art as a whole.

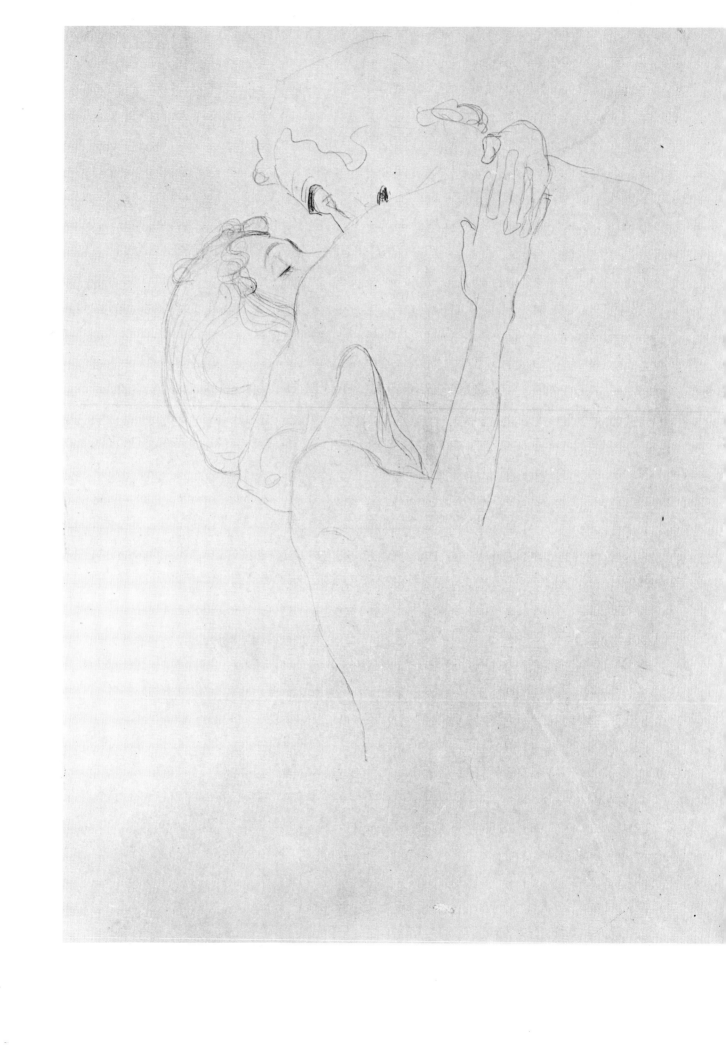

IV · KUNSTSCHAU 1908~9

THE EARLY WORK OF KOKOSCHKA AND SCHIELE

Kunstschau 1908

The resignation of Klimt and the 'stylists' (see p. 85) marked the end of the heroic period of the Secession. Olbrich's temple, which had for so long borne aloft the standard of modernism, was now in the hands of the conservatives—an important factor in the artistic life of the capital. Neither the brilliant series of exhibitions which the Wiener Werkstätte was able to arrange in its own premises in the Neustiftgasse, nor the existence of Miethke's, where the University Paintings were again exhibited in 1907, was able to compensate for the fact that the halls of their own exhibition building were now closed to the artists of Klimt's circle, who had, by their manoeuvrings, deprived themselves of an essential focus for their activity. There were, it is true, thoughts of founding a new association; as early as 1906, an organization calling itself the *Oesterreichischer Künstlerbund* (Union of Austrian Artists) appears in the city records as a registered society—presumably the same *Bund Oesterreichischer Künstler* which Klimt later invited Schiele to join, and which, under the former's presidency, participated in the exhibition of the Berlin Secession of 1916. But the problem was still the same— the lack of any suitable exhibition building. One can, therefore, understand the enthusiasm with which the artists of the Viennese *avant-garde* seized the unexpected opportunity offered by the lease of an area of land just off Vienna's Lothringerstrasse—an area occupied today by the Konzerthaus, but which before 1913 was still open ground, and which provided the perfect location for the staging of temporary exhibitions. A prefabricated building, designed by Hoffmann with the collaboration of the architects Otto Schönthal, Karl Breuer and Paul Roller, was rapidly erected; it embraced terraces, courtyards, gardens, even a café, as well as a total of fifty-four exhibition rooms. There was also a small open-air theatre, in which short plays were performed during the warm, light evenings. Here, during the summers of 1908 and 1909, the considerable energies of Klimt and his friends were again united in forcing upon the consciousness of the Viennese public everything that was new, revolutionary, shocking in contemporary art. That these two exhibitions, which went under the title 'Kunstschau', were, unlike the early exhibitions of the Secession, to prove financially disastrous, no one could have foretold.

The first exhibition, which opened at the beginning of May 1908, was devoted entirely to Austrian art. At the opening ceremony, Gustav Klimt, as president, delivered the following speech:

We do not, obviously, regard an exhibition as the ideal way of establishing contact between artist and public. For instance, the execution of large-scale public commissions would be infinitely preferable for this purpose. But as long as public

149. Gustav Klimt: *Embrace.* Drawing. Vienna, Historisches Museum der Stadt Wien

life continues to occupy itself predominantly with political and economic matters, exhibitions are the only means which remain open to us. We must, therefore, be grateful for that public and private support which has enabled us, on this occasion, to make use of this means and demonstrate that we have not been idle during these exhibitionless years, that on the contrary—perhaps because we have been free from the cares of arranging exhibitions—we have been working all the more industriously, inwardly, on the development of our ideas.

We do not belong to any association, any society, any union, we are united, not in any compulsory manner, simply for the purpose of this exhibition—united in the conviction that no aspect of human life is so trifling, so insignificant as not to offer scope for artistic endeavour. In the words of Morris, even the most insignificant object, if perfectly made, helps to increase the sum total of beauty on this earth. It is only upon the continuing penetration of life by art that the progress of the artist is able to be grounded. . . .

No less broadly conceived than the term 'art' is the term 'artist'. Not only he who creates, but also he who enjoys merits this title, if he is capable of judging and experiencing the work of art in emotional terms. . . .

Thus it is in vain that our opponents attempt to combat the modern movement in art, to declare it dead. For theirs is a struggle against growth, against becoming— against life itself. True, we who have toiled for weeks on end in preparing this exhibition will, once it is opened, separate and go our own individual ways. But perhaps in the foreseeable future we shall find ourselves united again in some quite different association. Whatever the case, our trust is in each other, and I wish to thank all concerned for their efforts, their cheerful self-sacrifice, their devotion. I thank too all our patrons and supporters who have enabled us to carry through this exhibition, and while inviting you, honoured guests, to undertake a tour of the building, I declare the Kunstschau Vienna 1908 open.[1]

Above the main entrance stood the inscription *Der Zeit ihre Kunst, der Kunst ihre Freiheit*. 'Hmm', pondered Hevesi, 'that sounds familiar. Haven't I read that somewhere before?'[2] On entering the building, the visitor was greeted by a whole room full of children's art; the two rooms immediately following were allotted to the work of the sculptor Franz Metzner, the largest space given to a single artist. Three rooms contained examples of art in the service of the theatre; here, one could see a number of Roller's designs for Mahler's productions at the Imperial Opera, including *Das Rheingold*, and Czeschka's sets for Hebbel's *Nibelungen*. Almost as if intended as a slap in the face of the 'rump Secession', considerable emphasis was laid upon the applied arts; the whole of room 50, in particular, was given over to the products of the Wiener Werkstätte. Room 10 was devoted to the art of the poster; together with examples of *Jugendstil* design, and posters from the early Secession exhibitions, one could see the three placards advertising the Kunstschau itself. Löffler, the designer of one of these placards (Plate 150), also created the admission ticket for the exhibition. Under the heading 'sacred art' one could see Moser's designs for the windows of Wagner's church 'am Steinhof'; in room 24 were displayed Wagner's own competition projects for the new War Ministry building. Of the architectural contributions, one of the most interesting was an entire two-storey cottage, the work of Hoffmann; in

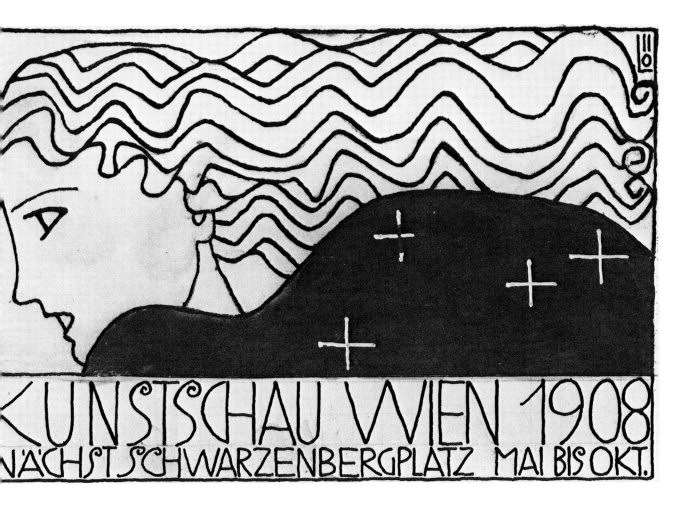

o. Bertold Löffler: *Poster advertising the Kunstschau, o8*

contrast to the costliness of the majority of the Wiener Werkstätte's designs, this *kleines Landhaus*, as it was described in the catalogue, was offered complete at the astonishingly low price of 7,000 crowns.

Room 22 was reserved for Klimt. There were three outstanding female portraits: of Fritza von Riedler, Margaret Stonborough-Wittgenstein, and Adele Bloch-Bauer (Plates 151–3). The Wittgenstein portrait of 1905 is a transitional work; in it, one can see the artist's development from the Impressionism of *Sonja Knips* to the decorative manner of his work after the commission for the *Stoclet-frieze*. This decorative tendency is, however, far more pronounced in the portrait of Fritza von Riedler, especially in the repeated 'eye' motif of the sofa upon which the privy councillor's wife is seated, and the amazing, semicircular mosaic panel in the background, which not only gives the illusion of a kind of hieratic head-dress worn by the sitter, but also flattens the already shallow pictorial space still further. Even more amazing is the *Adele Bloch-Bauer* of 1907, a portrait which at first sight appears as much a tribute to the art of the goldsmith and the jeweller as to the charms of the sitter. The gold decoration which dominated the Bloch-Bauer portrait inspired Eduard Pötzl, the critic of the *Neues Wiener Tagblatt* and one of Klimt's principal opponents, to coin one of his best puns: '*Mehr Blech als Bloch!*'[3] (More tin than Bloch; *Blech*, however, in slang means rubbish). Klimt, we are told, was highly amused by this. Pötzl, in his review, also describes the technique of the *Bloch-Bauer* in a passage which, but for its hostile tone,

181

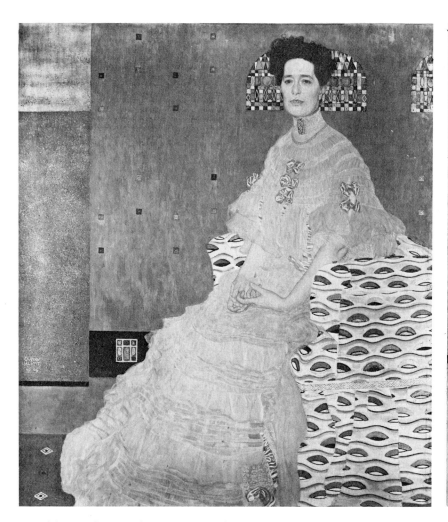

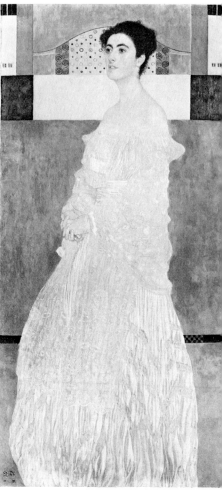

provides an interesting account of the decorative effect produced by the curious mixture of which Klimt here employs:

> ... master extraordinarily developed technique. And what does he use it for? In order paint a mixture of peacocks' tails, mother of pearl, silver scabs, tinsel and sn... ...' paths ... which recurs in nearly all his pictures. Sometimes there is a bit of human face or body thrown in, sometimes not, sometimes ... rather too much.[4]

Klimt's large painting *The Kiss* (Plate 127) was also shown for the first time at this exhibition—the culmination of his 'mosaic' manner of these years, the transformation of the chaste influence of Ravenna into a sumptuous gesture of transfigured eroticism. *The Kiss* is in every respect a crucial work. The different media, the combination of oil paint and golden ornament, are here employed in the attainment of a *ne plus ultra* of decorative splendour. The stylization of the garments in which the figures are arrayed—a tendency already noticeable in embryonic form in the portrait of Emilie Flöge and in the figural panels of the *Stoclet-frieze*—is so intensified that there is in the end nothing but surface pattern, save for the heads and hands of the two figures, which are united in one single form in a way which seems reminiscent of certain Persian miniatures. As far as its subject is concerned, this painting also stands as the most elaborate, the most grandiose

151. (*left*) Gustav Klimt: *Fritza von Riedler*, 1907. O on canvas, 153 × 133 cm. Vienna, Oesterreichische Galerie

152. (*right*) Gustav Klimt: *Margaret Stonborough-Wittgenstein*, 1905. Oil on canvas, 180 × 90 cm. Munic Bayerische Staats-gemäldesammlungen

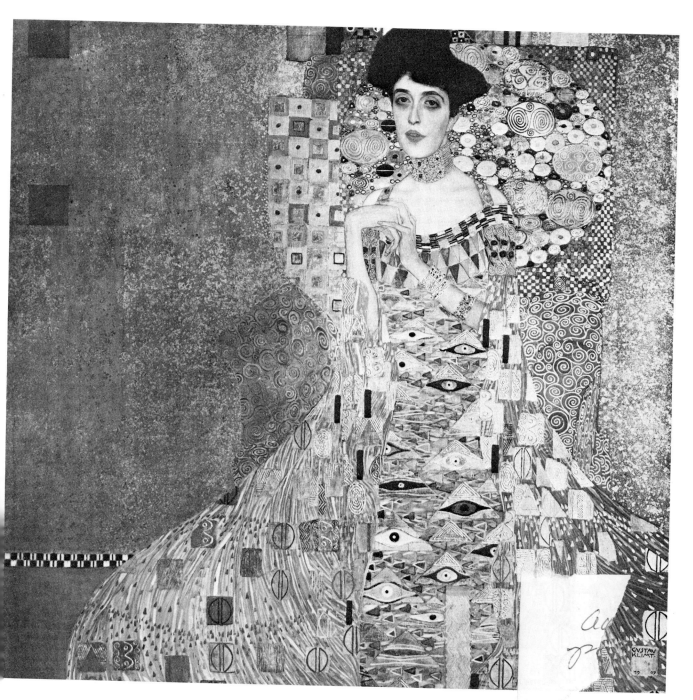

153. Gustav Klimt: *Adele Bloch-Bauer I*, 1907. Oil on canvas, 138 × 138 cm. Vienna, Oesterreichische Galerie

statement of the theme of embrace which may be traced back through various stages to some of the earliest of Klimt's independent works such as the Symbolist-influenced *Love* (Plate I) of 1895, published as a colour reproduction in the new series of Martin Gerlach's *Allegorien*. The important position which *The Kiss* occupied within Klimt's *oeuvre* was, for once, recognized even at the time of the exhibition. In an extraordinary gesture of official acclaim, the painting was purchased for the Austrian nation even before the closure of the Kunstschau, at about the same time as the portrait of Emilie Flöge was acquired by the city of Vienna. These purchases, little enough in all conscience, represent the highest honour done to the prophet in his own country.

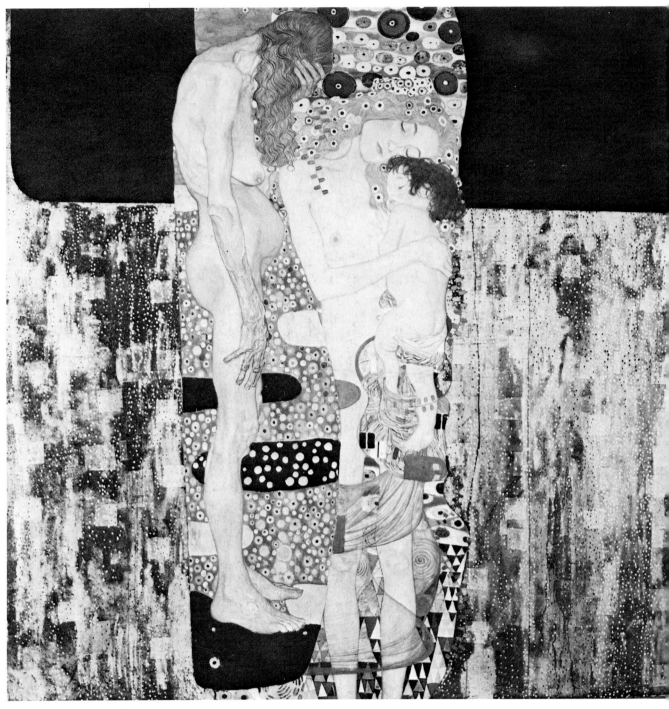

Of the other paintings by Klimt shown at the first Kunstschau, one may single out *The Three Ages of Man* (Plate 154), a reaffirmation of the artist's preoccupation with the theme of decay and mortality which is also dominant in the University Paintings, and the famous *Danaë* (Plate 157), one of several treatments of classical subjects which occur during Klimt's later period, among them the *Leda* of 1917 (Plate 158). The *Three Ages* inspired Peter Altenberg to write its creator a moving letter, which began 'Dearest, dearest Gustav Klimt,' and which contained the words:

154. (*left*) Gustav Klimt: *The Three Ages of Man*, 1905. Oil on canvas, 180 × 180 cm. Rome, Galleria Nazionale d'Arte Moderna

155. (*right*) Oskar Kokoschka: *Auguste Forel*, 1910. Oil on canvas, 71 × 58 cm. Mannheim, Kunsthalle

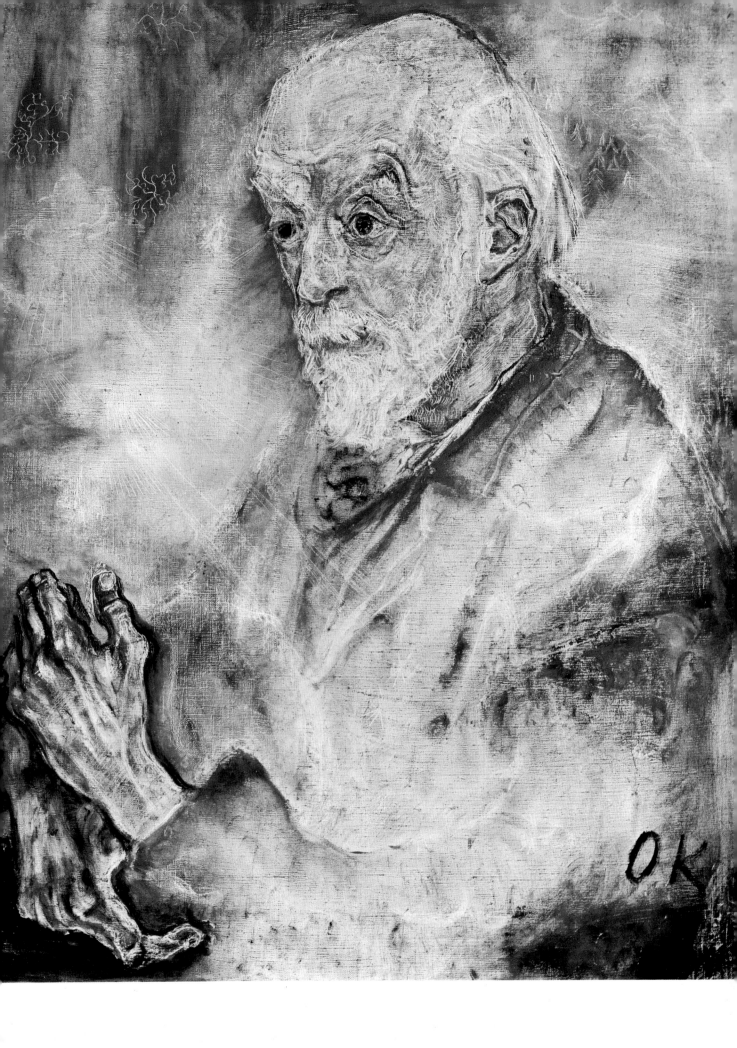

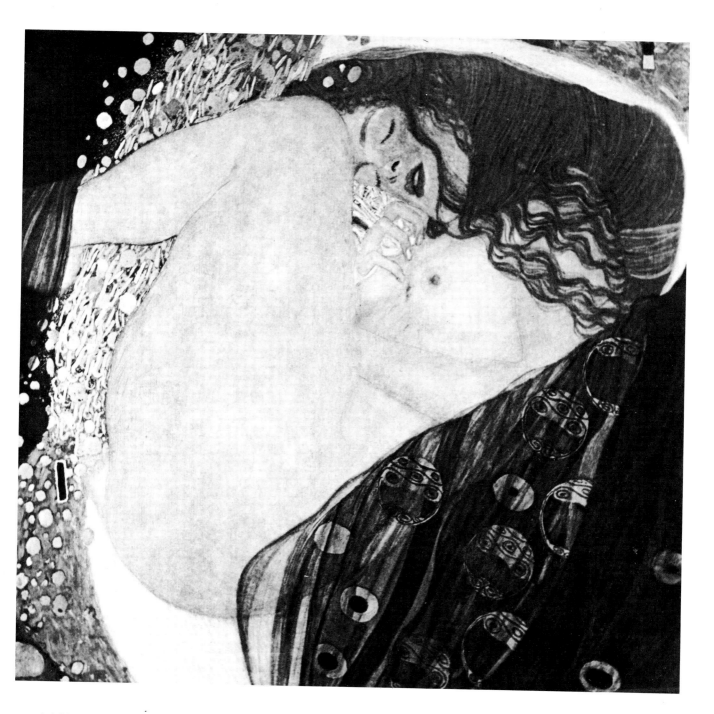

157. (*right*) Gustav Klimt:
Danaë, 1907-8. Oil on
canvas, 77 × 83 cm. Graz,
Private Collection

156. (*left*) Oskar Kokoschka:
Dent du Midi, 1909-10. Oil
on canvas, 76 × 116 cm.
Zurich, Marianne
Feilchenfeldt

If I knew nothing by you save the two *Bauerngärten*, the portrait of the young
Wittgenstein, and your picture *Die Drei Lebensalter*, I should still have a pro-
found, lifelong respect for you. . . . You draw all this from an unimagined source
of strength, sublimated in the work of art into the tenderest blossom.[5]

Concerning the *Danaë*, Eduard Pötzl again indulged himself at Klimt's expense:

This time, it is Danaë who displays her charms; yet not standing, nor sitting,
nor lying. No. Much too ordinary. This Danaë is rolled up like a bundle of old
washing, and in this position, which no woman in the world has ever assumed of
her own free will, she permits us to admire her thigh and half her bosom. The

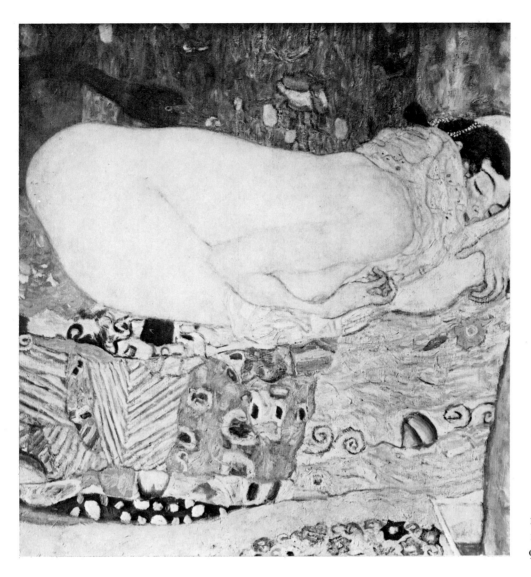

158. Gustav Klimt: *Leda*, 1917. Oil on canvas, 99 × 99 cm. Destroyed

rest is, as usual, filled in with mother of pearl and peacocks' fans. I can't help it, I think it's unhealthy.[6]

Pötzl was by no means the only critic to adopt a hostile attitude towards the first Kunstschau. The writer and friend of the *Klimt-gruppe*, Bertha Zuckerkandl, recorded how she, Muther and Hevesi sat day after day in the café at the exhibition, discussing how best to counter the outrageous and often libellous attacks which appeared in the popular press. 'It's no use', she remembered Hevesi saying. 'But in twenty years, people will see we were right'.[7] Many of the attacks were directed against the ultra-modernistic character of the whole show. The critic of the *Wiener Sonn- und Montagszeitung* wrote of the participants: 'All sing in barbaric sequence the well-worn song: "The collapse of the old is irrevocable. The old has vanished."'[8] Most heated of all, however, were the attacks provoked by the work of a young artist who, at the time of the Kunstschau, was still a student at Vienna's Kunstgewerbeschule. His name, soon to become familiar not only to the Viennese press, was Oskar Kokoschka.

Oskar Kokoschka, born 1886

Kokoschka was a pupil of Bertold Löffler and Carl Otto Czeschka. The latter was one of the few established artists to recognize the young man's talent straight away, and did everything he could to help him. The fleeting studies of bodies in motion which Kokoschka, while still a student at the Kunstgewerbeschule, had made off his own bat so aroused Czeschka's enthusiasm that he entrusted his protégé with the running of one of the preparatory drawing classes. It was also Czeschka who invited Kokoschka to participate in the Kunstschau, where he was given a small corner to himself—a corner which Hevesi, on account of the reaction of the public, dubbed the 'chamber of horrors'.[9] Here were displayed four large tapestry designs which the artist had intended for the decoration of a ballroom, and which were entitled *Die Traumtragenden* (The Bearers of Dreams). There was also a skull-like portrait head, with gruesome blue wash, visible nerve endings and wide-open mouth—one of a succession of allegorized self portraits from this period, which also included the poster *Pietà* (Plate 140),[10] and the illustrations for Kokoschka's own drama *Mörder Hoffnung der Frauen* (Plate 161). Concerning the portrait head, Kokoschka recalled:

Apart from my tapestry designs, I had also shown, standing on a pedestal, a painted plaster bust which I had entitled *Warrior*. In fact, it was a self portrait with open mouth, the expression of a wild cry. . . . In the mouth were daily to be found bits of chocolate or whatever; in this way, presumably, the ladies of Vienna expressed their scorn at the work of this 'super-Fauve', as the critic Ludwig Hevesi called me.

None the less, as a mere débutant, I had the consolation that several of the sketches which I had made during my rapid drawing courses were bought by well-known artists, among them Kolo Moser and Emil Orlik. These were my first 'public' successes. My much disputed bust was acquired by Adolf Loos, whom I got to know on this occasion, and who retained it until his death.[11]

Also to be seen were the drawings for *Die Träumenden Knaben* (The Dreaming Youths), a children's fairy-tale book written and illustrated by Kokoschka, as well as the completed volume with its beautiful colour·lithographs, which had been published earlier the same year by the presses of the Wiener Werkstätte (Plate 159). *Die Träumenden Knaben* merits our attention on a number of counts. Kokoschka, in the best William Morris tradition, had become extremely interested in every aspect of book-production—design, layout, decoration, binding; he even gave lectures on the subject after the scandals caused by the Kunstschau had deprived him of his job at the Kunstgewerbeschule. The illustrations for this volume, however, have little in common with the other graphic work published by the WW, and even less with the English Arts and Crafts movement. An immediate source, which has on several occasions been pointed out, is an illustration by Wilhelm Laage (Plate 160)[12] which appeared in one of the later issues of *Ver Sacrum*; a more far-reaching influence upon Kokoschka's graphic style is undoubtedly the vertically conceived space and flat areas of colour of Japanese woodcuts, which he had studied as a pupil. As regards its subject, *Die Träumenden*

Knaben held an important autobiographical significance for the artist:

The original commission was to create an illustrated children's book with coloured lithographs. But only the first plate was really true to this commission. The other plates came into existence, like my poems, as a kind of free versification in pictures. I gave the book its title because it was a kind of account in words and pictures of my spiritual state at that time. The heroine of the poem, the girl Li 'from the lost, bird-inhabited forests of the North', was a young Swedish girl called Lilith. She, too, attended the Kunstgewerbeschule, and used to wear a red coat of peasant design of a kind unknown in Vienna. Red is my favourite colour. The book was my first love-letter; but she had already vanished from my life by the time the book came out.[13]

But the most astonishing contribution to *Die Träumenden Knaben* is undoubtedly Kokoschka's own verses. In their mock naïvety, the curious succession of images ('My body like a tongue-damp tree') the accompanying poems foretell, in a remarkable way, the imaginative world of much of Expressionist poetry; there is also a nostalgic glance backwards to the traditional verse forms, the simple style of the *Knaben Wunderhorn*, the German 'folk-poems' which underwent a widespread revival during the early 1900s, spiced with a certain brutally observed naturalism:

> rot fischlein
> fischlein rot
> stech dich mit dem dreischneidigen messer tot
> reiss dich mit meinen fingern entzwei
> dass dem stummen kreisen ein ende sei
>
> rot fischlein
> fischlein rot
> mein messerlein ist rot
> meine fingerlein sind rot
> in der schale sinkt ein fischlein tot

159. (*left*) Oskar Kokoschka: *Illustration from his book* Die Träumenden Knaben, published by the Wiener Werkstätte in 1908.

160. (*right*) Wilhelm Laage: *Fairy Tale*. Lithograph. From *Ver Sacrum*, IV (1901) p. 262

little red fish
red little fish
let me stab you to death with my three-pronged knife
tear you apart with my fingers
and put an end to your mute gyrations

little red fish
red little fish
my little knife is red
my little fingers are red
in my dish a little fish sinks down dead

161. Oskar Kokoschka:
Illustration for his drama
Murderer, Hope of Women.
This drawing was reproduced
on the front page of
Herwarth Walden's periodical
Der Sturm, 14 July 1910

Kokoschka's relationship with literary Expressionism may likewise be discerned both in his own *Reminiscences* and in his two early dramas *Sphinx und Strohmann* (later revised under the title *Job*), first performed in 1907, and *Mörder Hoffnung der Frauen* (*Murderer Hope of Women*). The latter work, in particular, with its rejection of the trappings of the conventional theatre, its anonymous characters ('Man', 'Woman'), its unfathomable plot, if plot it can be called, not only brings to mind the stage works of Strindberg (*To Damascus*, 1898), but also looks forward to such outstanding manifestations of Expressionist theatre as Schoenberg's *Die Glückliche Hand* of 1911. (Egon Wellesz, in an account of Schoenberg's mysterious music-drama, compares it to Strindberg's chamber-plays, in which 'the miraculous can happen without any external motivation, because everything that happens comes from within';[14] the same remark could be equally well applied to Kokoschka's stage works.) Kokoschka himself, however, asserted in definite terms that *Mörder . . .* had, as far as his own intentions were concerned, 'nothing to do with that rejection of society or plans for the improvement of the world such as characterize the literary breakthrough and change in style which is called Expressionism'.[15] The theme of the play was woman, who holds man prisoner in a cage; man overcomes his bondage, frees himself, and kills her—a savage allegory of the author's own view of the eternal opposition of the sexes. The production of *Murderer Hope of Women*, which received its première in the open-air theatre of the Internationale Kunstchau in July 1909, marked the beginning of a lifelong acquaintance between the artist and one of the most brilliant pre-war German actor-producers, Ernst Reinhold.[16]

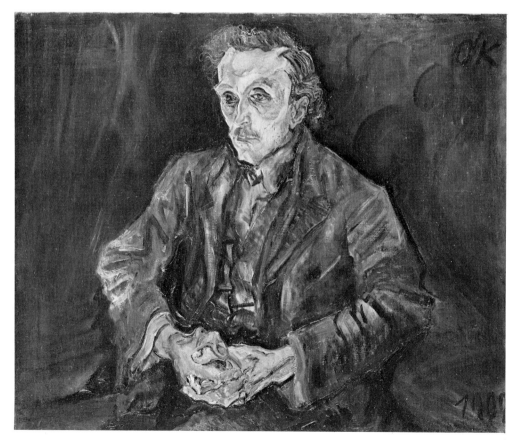

162. Oskar Kokoschka: *Portrait of Adolf Loos*, 1909. Oil on canvas, 74 × 93 cm. Berlin, Staatliche Museen (Nationalgalerie)

One has only to consider the titles chosen by Kokoschka—*The Dreaming Youths*, *The Bearers of Dreams*—in order to realize the important role which nightmare, dream and fantasy play in his works of this time. For Kokoschka, as for Freud, the dream represented not only release, but also an intimation of the inner life of man, his secret desires and strivings. It is this inner element, removed from the everyday, the merely external world, which constitutes the life of the work of art. In his essay 'On the Nature of Visions' of 1912, one of his most important theoretical statements on art, Kokoschka wrote:

Consciousness is the source of all things and all ideas. It is a sea with visions as its only horizon.

Consciousness is a tomb for all things, where they cease to be, the hereafter in which they perish. And thus it would seem that things end up with no existence beyond my inner vision of them. Their spirit is sucked up by that vision as oil in a lamp is drawn up by the wick in order to nourish the flame.[17]

His incessant search for inner life confers an extraordinary visionary quality upon his works—especially his numerous portraits, which rank among the masterpieces of early Expressionist painting. Kokoschka painted and drew some of the most important literary and artistic figures of the Viennese *avant-garde*, among them Karl Kraus (Plate 164), Anton von Webern, the painter Carl Moll (Plate 163), and of course Loos (Plate 162), the proud possessor of the portrait bust *The Warrior*. Loos was his guardian angel. Having made Kokoschka's acquaintance at the Kunstschau, he at once became a fervent admirer and firm friend of the young artist. Kokoschka later remembered that Loos 'sold the carpets out of his own home' in order to raise the money to send him to Switzerland (Kokoschka made two trips to Switzerland, in the winter of 1909 and again in 1910). The profound impression which the natural grandeur of the Alps made upon him is expressed in the infinite space, the sense of overwhelming majesty of one of his earliest landscapes, the *Dent du Midi* (Plate 156). In Switzerland, he continued for some time to eke out a meagre existence by executing further portrait commissions, including the pictures of the Marquise de Rohan-Montesquieu (Plate 165), who reminded Kokoschka of 'those aristocratic women who sought consolation in religion, at a time when only mystics still believed in a private heaven of their own',[18] and (at Loos's instigation) of the famous scientist Auguste Forel (Plate 155). The artist himself described his own feelings on painting the latter portrait:

He was not in the least interested in painting—hardly uttered a word the whole time, and made no effort to help me at all. Only loyalty to Loos kept me working. Every evening Forel carefully weighed out nuts and apple-peel, which he solemnly ate. At last he finished and sat down. 'Can you see all right?' or 'Does it matter if I go to sleep?' was all he ever said to me. And sometimes he did indeed nod off. Then I could really study the way he sat in his chair, and see how the wrinkles on the face increased and deepened. Suddenly he seemed ancient. Myriads of small wrinkles appeared, like the documents of a man's life, and I felt that I must record them all, decipher them like old parchment and hand them on to

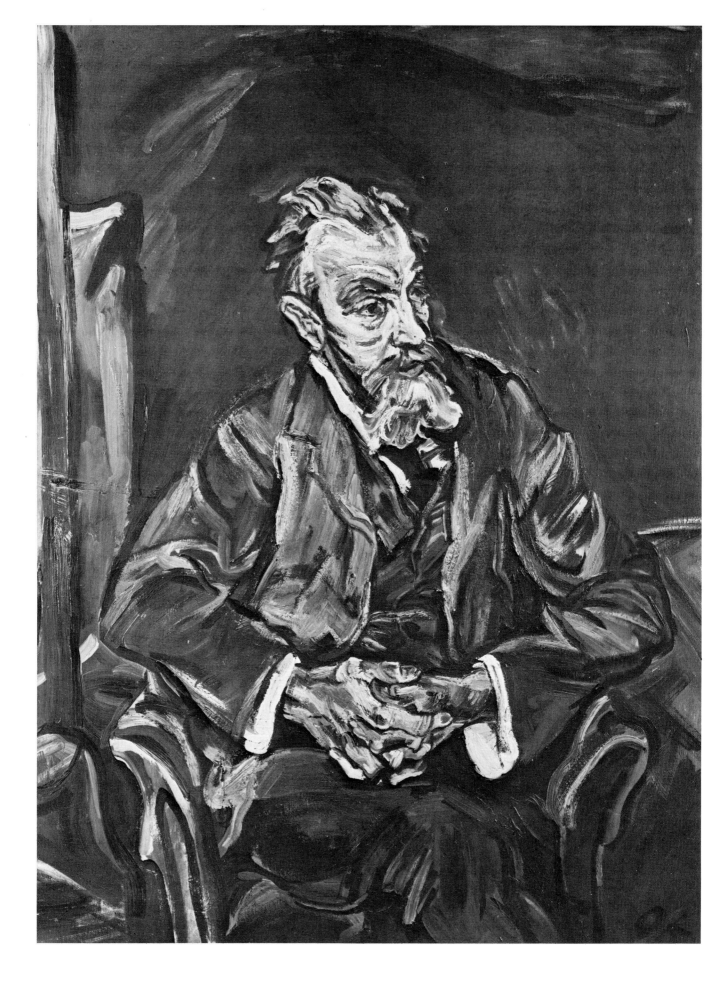

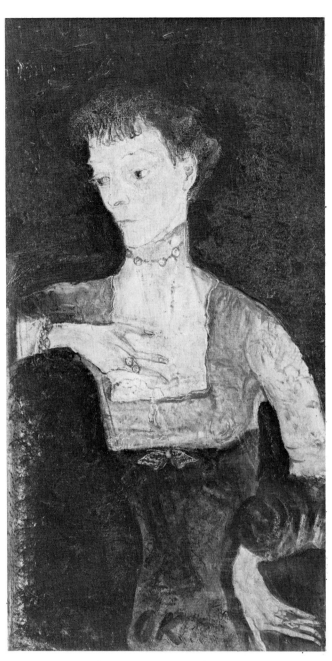

164. (*above*) Oskar Kokoschka: *Karl Kraus*, 1909. Drawing. Zurich, Walter M. Feilchenfeldt

165. (*right*) Oskar Kokoschka: *Marquise de Rohan-Montesquieu*, 1909–10: Oil on canvas, 95 × 50 cm. Rome, Mr and Mrs Paul E. Geier

163. (*opposite*) Oskar Kokoschka: *Carl Moll*, *c*. 1913. Vienna, Oesterreichische Galerie.

posterity. His face, and especially his hands, fascinated me. His fame meant nothing to me, but the task set by Loos filled my mind. . . .

The eye grew clearer. I searched it profoundly, for it was the eye of a seeker wont to see beyond the appearance of things. It was the window of a brain whose intelligence I was trying to portray. My biggest problem was how to reproduce the scholar's knowledge when I myself was so ignorant. How to depict it for posterity? I had never read any of his work, and therefore had no idea what his interests were. His wife, who was an old lady, and his daughter were often present at these sittings, and they would talk while I painted. . . .

I gradually realized that these people were discussing family affairs before me, a stranger, and were gossiping about relations. . . . I was the unwilling witness of secrets of family life that I did not want to know. Strange problems of marriage

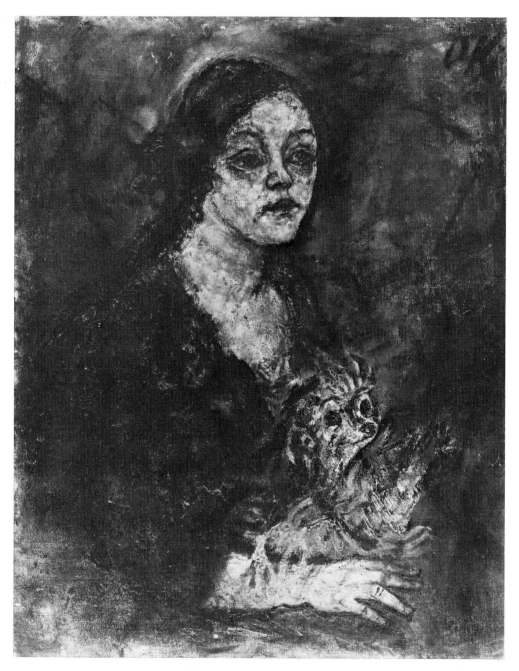

166. Oskar Kokoschka: *Else Kupfer*, *c*. 1911. Oil on canvas, 90 × 71 cm. Zurich, Kunsthaus

and procreation were unrolled before my eyes. It was only at the very end of my stay, when the picture was finished, that I realized . . . that all three were biologists . . . that they had been discussing ants.[19]

Kokoschka probed the interior of those he portrayed in such a way that the finished portrait became not merely a physical likeness, but a psychological document. J. P. Hodin wrote of him: 'Kokoschka had an inner link with all his sitters. If he found them uncongenial, they always had some quality which disturbed and therefore excited him. In the portrait of Ludwig Ritter von Janikowsky he perceived the resignation of a man caught in the grip of a mental sickness; in the Count of Verona, the ghostly presence of tuberculosis feeding on its victim . . . the self-denying shell of Ernst Reinhold, who was always changing his

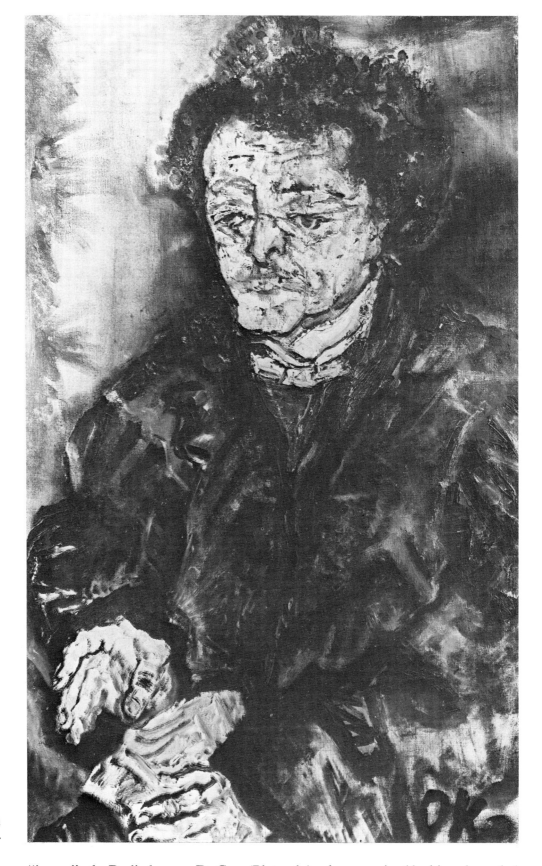

167. Oskar Kokoschka:
Dr Hugo Caro, 1910. Oil on
canvas, 89 × 55 cm. Winter-
thur, Kunstmuseum

"image"; the Berlin lawyer, Dr Caro (Plate 167), who was ruined by his unbounded love for mankind and pity for the poor. He saw the mortal sickness which ravaged the features of the actress, Else Kupfer (Plate 166), and perceived the meaning of loss of sight in the *Blind Mother and Her Child*'.[20] He even probed beneath the

197

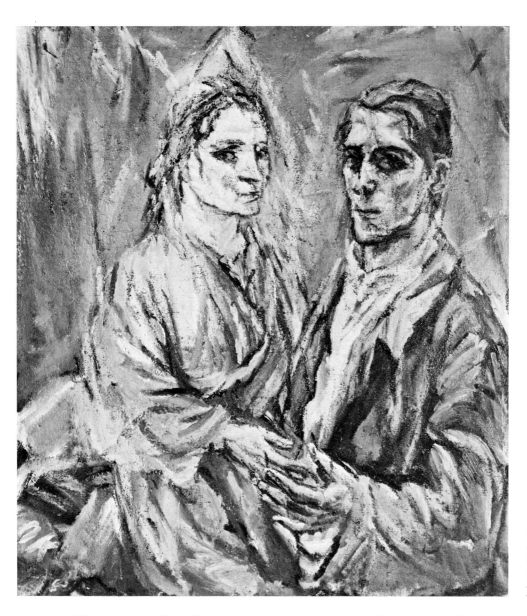

168. Oskar Kokoschka: *Self Portrait with Alma Mahler*, *c*. 1913. Oil on canvas, 100 × 90 cm. Hamburg, Professor Edgar Horstmann

surface of his own relationship with one of the most beautiful women of the day in his paintings and drawings of the bewitching Alma Mahler, especially in his double portrait of himself with the composer's widow (Plate 168). This relationship also found symbolic expression in the most famous of all his early paintings, *Die Windsbraut* (*The Tempest*) of 1914 (Plate 169). Here, Kokoschka's constant self-allegory and his gift of vision are united in a swirling vortex of cloud and wind in which the figures of the lovers, who bear the features of himself and Alma, are carried along in oblivion.

It has often been asserted that the financial loss which the first Kunstschau suffered must be largely ascribed to the widespread opposition provoked by Kokoschka's work. Certain members of the public even thought they discerned in his contributions signs of a rather bad practical joke. The critics were almost unanimously hostile, in an unpleasantly personal way. (This was not the only time Kokoschka was exposed to venomous attack over the showing of his work. On one famous occasion, the Archduke Franz-Ferdinand, heir to the Austrian

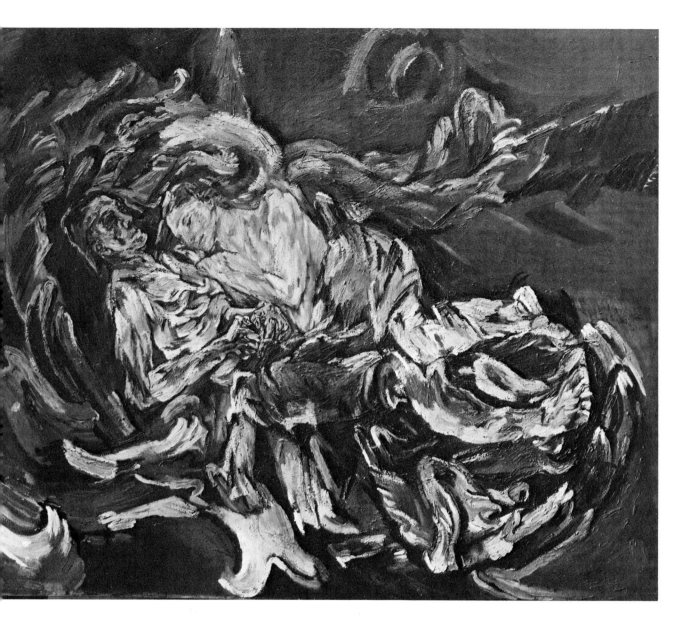

69. Oskar Kokoschka: *The Tempest*, 1914. Oil on canvas, 81 × 221 cm. Basle, Kunstmuseum

throne and a dedicated opponent of modern art—Otto Wagner also fell foul of him at the ceremonial opening of the church 'am Steinhof'—was heard to remark that he would like to break every bone in the young man's body.) Even Richard Muther, one of the champions of the modern, viewed his art with a mixture of admiration and horror. In a review which appeared in the newspaper *Die Zeit* he wrote:

Well, Herr Kokoschka, your tapestry designs are revolting. A mixture of fairground images, primitive Indian painting, ethnographic museum, Gauguin gone mad—I don't know. And yet there's nothing for it: I have to admit that I have not witnessed such an interesting début for years. This *enfant terrible* is indeed a child, not an imposter at all, no, a worthy lad.[21]

Klimt, on the other hand, was unequivocal in his defence of the young artist's work. According to Zuckerkandl, when the question of Kokoschka's participation in the show was raised by anxious members of the jury, he declared: 'Our duty is

to give an artist of outstanding talent the opportunity of expressing himself. Oskar Kokoschka is the greatest talent among the younger generation. Even if we run the risk of sinking our own exhibition, then it will just have to sink. But we shall have done our duty'.[22] In private, however, he was less sanguine about his own relationship with the new *avant-garde*. On one occasion, he is supposed to have remarked:

The young painters don't understand me any more. I'm not even sure whether I count for anything in their eyes. A bit early for it to happen to me, although it has always been the fate of the artist. Anyway, the young always want to tear down what already exists at the first assault. But there's no point in being sour about it.[23]

Kokoschka, despite the fact that his own art was rapidly developing in a completely different direction from that of his older colleague, none the less dedicated the first edition of *Die Träumenden Knaben* to Klimt 'in deepest reverence'.

Richard Gerstl, 1883–1908

Kokoschka's departure for Berlin, in 1910, marks the end of an epoch in Viennese painting. His art, expressive and distorted, already richly Baroque in conception and use of colour, profound and visionary in its content, was quite unlike any-

170. Richard Gerstl: *Portrait of Arnold Schoenberg and Family*. Oil on canvas, 89 × 109 cm. Vienna, Oesterreichische Galerie

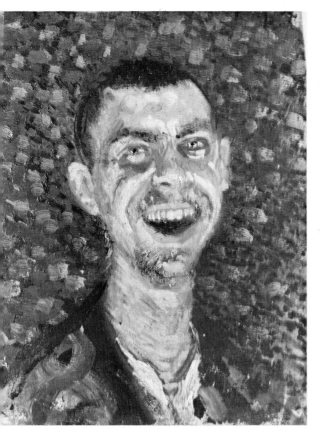

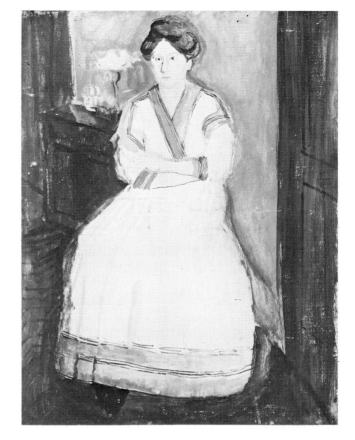

71. (*left*) Richard Gerstl: *Laughing Self Portrait*. Oil on canvas, 40 × 30 cm. Vienna, Oesterreichische Galerie

72. (*right*) Richard Gerstl: *Seated Woman*. Oil on canvas, 95 × 75 cm. Vienna, Oesterreichische Galerie

thing else being produced in Vienna at this time. The only remotely comparable phenomenon was the young Austrian artist Richard Gerstl, whose early suicide in 1908 robbed Expressionist painting of one of its potentially outstanding talents. Gerstl worked wholly in isolation, shunning formal association with other artists or groups; in fact, he sought contact with musicians rather than with painters. He lodged for a time with Schoenberg and his family, whose portraits he painted (Plate 170); his art, savage in character, with a tinge of mania and an amazing impasto technique, certainly influenced the composer's experiments with the medium of oil paint. Of formative influences upon Gerstl's own style it is difficult to speak in any meaningful sense. He had studied under Griepenkerl at the Academy of Fine Arts, and with the Hungarian painter Holosy at Nagy-Banya; his art is, however, largely independent of any influence of his teachers, and, apart from a certain formal and colouristic connection with the work of Klimt and, more especially, Edvard Munch, appears wholly original in conception and development. In 1906, the painter Heinrich Lefler, impressed by the young artist's work, invited him to attend his special painting class at the Academy; for the last two years of his life, Gerstl worked largely under Lefler's eye. The latter even wanted to arrange an exhibition of his pupil's work in Vienna, an idea which he eventually gave up 'in order to avoid provoking a public scandal'. The Viennese, who were shocked enough by Kokoschka, would doubtless have been even more horrified by Gerstl. His work shares, however, something of the visionary quality of Kokoschka's paintings. His portraits, in particular, attain a comparable depth of psychological penetration (Plate 172), although his work is characterized by even more violent abbreviations of form than Kokoschka, the 'super-Fauve', ever permitted himself. In his *Laughing Self Portrait* (Plate 171), one of his last paintings, Gerstl created one of the most striking, even haunting images of early Expressionist art.

Kunstschau 1909—Vienna before the War

The Internationale Kunstschau 1909 offers, by comparison with its predecessor, a less unified picture of contemporary Austrian art; on the other hand, like the sixteenth exhibition of the Secession, it sought to bring to Vienna a comprehensive review of *avant-garde* painting in Europe, especially in France. Three of the founding fathers of modern painting, van Gogh, Gauguin and Munch, were again represented, as well as the Nabis Bonnard, Vuillard and Denis, the Fauves Vlaminck and Matisse, the Swiss painter Cuno Amiet and the German sculptor Ernst Barlach. Klimt showed a new collection of his most recent paintings, including his *Judith II* (Salome), and also an earlier work, here exhibited publicly for the first time: *Hope I* (Plates 176 and 177). The latter painting came from the private collection of Fritz Wärndorfer, who kept it behind locked doors in a specially constructed shrine; one of the most individual, personal of all Klimt's works, it presents an astonishing, immediately striking, and at the same time overtly erotic, image of pregnancy. The *Judith*, on the other hand, is, in its decorative intent and mordant use of line, the epitome of the artist's *Jugendstil* manner. Interestingly, the composer Richard Strauss saw in the 'world of this painter of fantasy much of my own music, especially *Salome*'[24]—a reference to Strauss's opera, which Mahler had in 1905 been prevented by the Viennese censor from performing at the Imperial Opera.[25]

The financial disappointments which accompanied the two Kunstschau exhibitions left no resources available for further experiments of this kind. No other major exhibitions of *avant-garde* painting took place in Vienna after 1909; strictly speaking, it is impossible not to regard the period between the closure of the second Kunstschau and the outbreak of the First World War as a culturally barren epoch. On virtually every front, one could observe the empty victory of what the writer Paul Stefan termed 'the everyday', the forces of pettiness, mediocrity and philistinism which, in Vienna perhaps more than elsewhere, did so much to limit artistic freedom, hamper progress. As early as 1901, pointing to the recalcitrance not only of the critics, but also of the official patrons and protectors of the arts, Bahr had warned what the eventual consequences would be. In his speech in defence of Klimt's University Paintings, he declared in emphatic words:

We owe our present artistic success to a small number of men, no more than ten or fifteen in all. None of them is obliged to stay here, none bound by material interests; any one of them could leave tomorrow, which would delight no one more than the young Grand Duke of Hesse, who has set himself the fine ambition of turning his little capital of Darmstadt into an Athens of modern art. If these few choose to remain here, it is as a consequence of a strong sense of duty, a fine, exalted species of patriotism. But at that moment at which they realize that they are deprived of any opportunity of pursuing their artistic aims by the lack of any kind of sympathy or protection on the part of the educated, then any such sense of duty will become meaningless. In which case, they will be entitled to leave in search of a better homeland elsewhere. And then?[26]

173. Egon Schiele: *Winter Trees*, 1912. Oil on canvas, 80.5 × 80.5 cm. Vienna, Private Collection

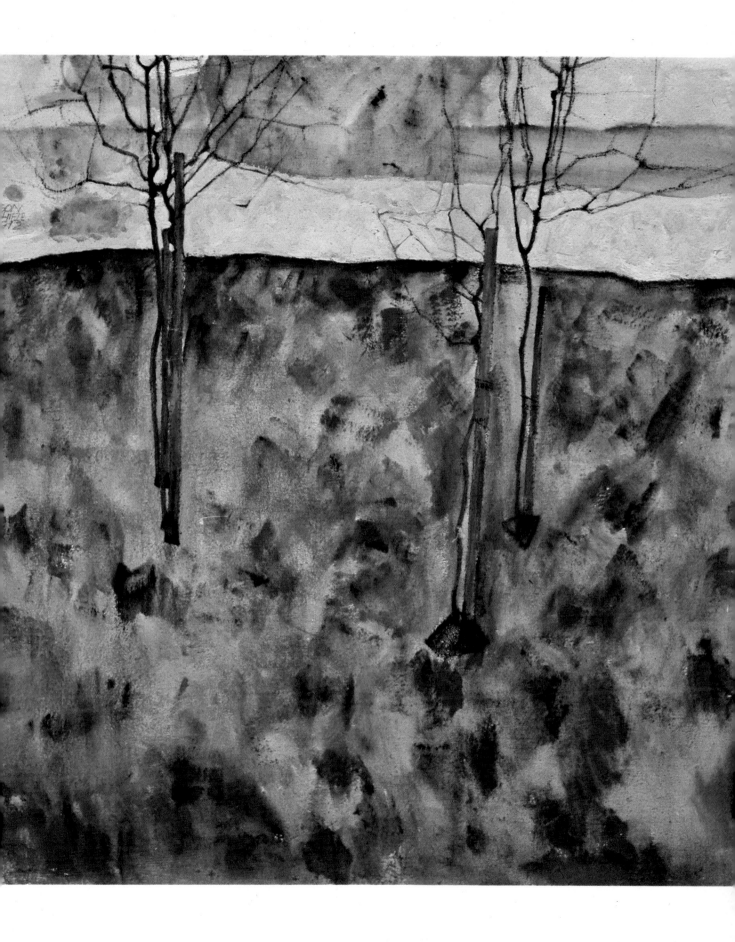

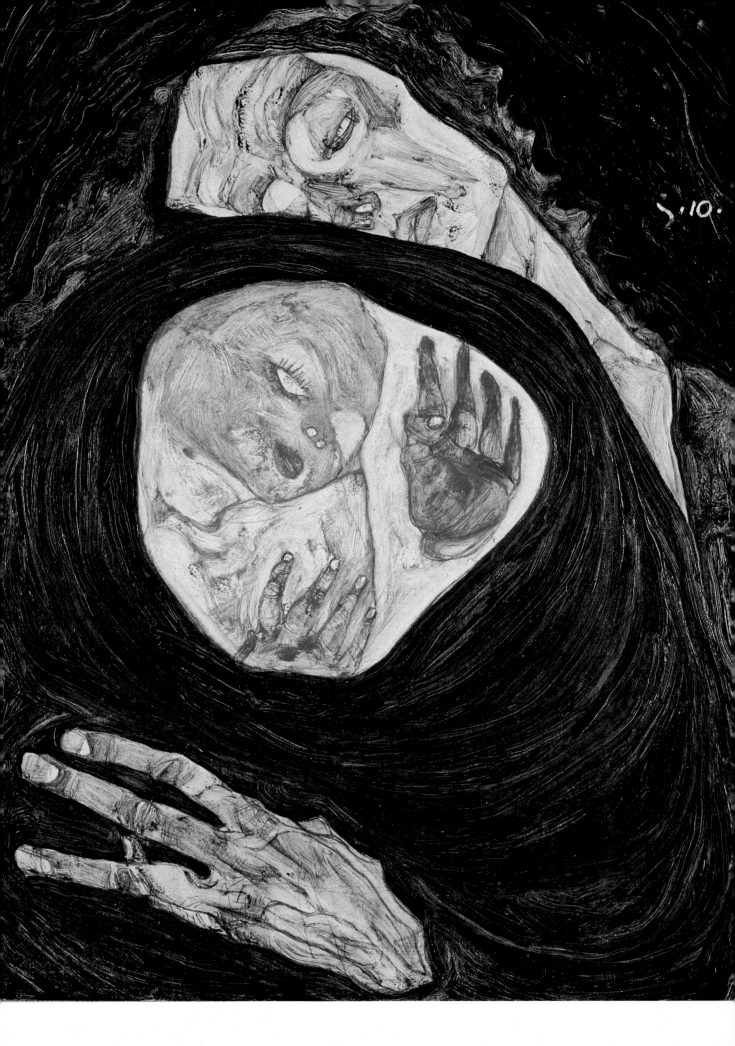

Now his prophecy had come to pass. Klimt, it is true, had remained in Vienna, but after the financial failure of the second Kunstschau he withdrew into increasing isolation. The incessant attacks on his art had finally taken their toll not only of his patience, but also of his habitual good humour. Zuckerkandl records that when the artist finally completed the mosaic panels intended for the decoration of the dining-room of the Palais Stoclet, and the question arose of exhibiting them in Vienna prior to their shipment to Brussels, Klimt retorted:

When you all thought to yourselves I had simply swallowed the insults offered me, I swore, then, that I would never again exhibit in Vienna. This frieze, upon which I have expended years of effort, would become yet again the object of the crudest kind of attack. It's not that I object to criticism. But *that* kind of criticism, which does not refrain from impugning an artist's honour, it is this which has forced me to resolve: 'Away from Vienna', if I am to exhibit at all. This is for me the only dignified way of defending myself.[27]

175. Oskar Kokoschka:
Herwarth Walden (detail).
Stuttgart, Staatsgalerie

174. (*opposite*) Egon Schiele:
Dead Mother, 1910. Pencil
and oil on wood, 32 × 25.7
cm. Vienna, Dr
Rudolf Leopold

Many of the others had, however, already gone. Myrbach had resigned his post as head of the Kunstgewerbeschule and returned to France; Luksch and Czeschka had gone to Hamburg, Klimt's friend and collaborator Jungnickel to Frankfurt. Berlin, that same Berlin which the Viennese affected to despise, and which was soon to eclipse the Austrian capital as a cultural centre, claimed many of the leading Viennese artists of the day. Orlik went to take up a post as professor at the school attached to the Museum of Applied Arts, Kokoschka to join Herwarth Walden, editor of the magazine *Der Sturm*, whom he had already met in Vienna through Karl Kraus. Kokoschka assisted Walden with the publication of *Der Sturm*, illustrating many of the issues for 1910–11; his drama *Mörder Hoffnung der Frauen*, accompanied by his own drawings, was published in the issue dated 14 July 1910. Schoenberg, no less disillusioned with Vienna than Kokoschka, also deserted his native city for the more pleasing prospects offered by the Prussian capital. For years he had lived in abject poverty; only the intercession of such prominent personalities as Mahler and Goldmark had secured for him a teaching post at the Conservatory, and even then his courses in harmony and composition were designated as 'optional' and 'extra-curricular'. Now, ironically, the director of the Conservatory, Karl von Wiener, wrote to Schoenberg offering him a professorship. Schoenberg refused. His reply is characteristic:

My main reason is that I have still not forgotten, cannot reconcile myself to things which have been done to me there. I can no longer live in Vienna. . . . If now you hold this refusal against me, just as I hold these things against Vienna, perhaps in time you will come to think less harshly of me, and perhaps in time I shall feel more strongly than at present that love for my native land; perhaps then you will think of me again, in which case it is certain that I shall want to return. But not now.[28]

Unthinkably, some of the key figures of the Austrian art revival were already dead. Olbrich had died in 1908; one of the first Viennese artists to desert to the German side, his brilliant career in the service of the Grand Duke of Hesse had been abruptly cut short at its peak. Gustav Mahler, who had contributed so much to the final flowering of Austrian culture, of a musical tradition reaching back

over two hundred years, was dead. As early as 1907, he had resigned his post as director of the Imperial Opera, and left the old world to seek his fortune in the new. On that December day, a small group of friends and admirers had gathered on the platform of the Westbahnhof to catch a last glimpse of the man whose life had been the centre of such bitter controversy. And he, who was normally so terse, so distant, had been moved beyond measure by this spontaneous demonstration, had shaken his well-wishers by the hand, had found a friendly word for everyone. As, finally, the train steamed out of the station, it was Klimt who uttered the word which was in everybody's mind: 'Finished!'[29] In the spring of 1911, he was brought back to Europe a dying man. Unremitting work on the ninth and tenth symphonies, on *Das Lied von der Erde*, Mahler's farewell to life, and the ceaseless performing in America had taken their toll. He died in Vienna on 18 May; his grave, according to his own wishes, bore nothing but his name. 'Those who seek me', Mahler had said, 'know who I was; the others have no need to know.'

Hevesi, too, was dead. In 1910, he had embraced the same fate which was to claim so many of his friends and contemporaries: suicide. An extraordinarily large number of the intellectual and artistic élite of Vienna ended by taking their own life: Gerstl, Otto Mahler (Mahler's brother, and a composer in his own right), Weininger, Kurzweil. It was not for nothing that Kraus, one of the most far-sighted of the prophets who foretold the eventual dissolution of the Habsburg empire, described Vienna as an 'experimental station for the collapse of mankind'. And Hermann Bahr, whose literary work is close to the apocalyptic spirit of those Russian Symbolist writers and poets who also glimpsed the imminent holocaust, wrote of the last years of that world whose self-appointed chronicler he had become:

Our epoch is shot through with a wild torment, and the pain has become no longer bearable. The cry for salvation is universal; the crucified are everywhere. Is this, then, the great death which has come upon the world?

It may be that this is the end, the extinguishing of exhausted humanity, and these are but the death-throes. It may be that this is the beginning, the birth of a new mankind, and that these are the avalanches of spring. We ascend to the Divine or collapse, collapse into darkness and annihilation. But there is no standing still.[30]

Such rays of light as illuminated the artistic scene originated mostly from abroad: the completion of the Palais Stoclet, which, with its countless details of decoration and furnishings, occupied the energies of many of the former Secessionists; the honour done to Klimt at the International Art Exhibition in Rome in 1911, where many of his most important works, including *The Kiss*, *Jurisprudence* and the *Portrait of Emilie Flöge*, were shown before an international audience; and the impressive Austrian contribution to the German Werkbund exhibition in Cologne in 1914. There was also, especially in Germany, growing recognition for the work of a young artist who was soon to emerge as the leading talent of his generation, dominating Austrian painting up to the end of the First World War: Egon Schiele.

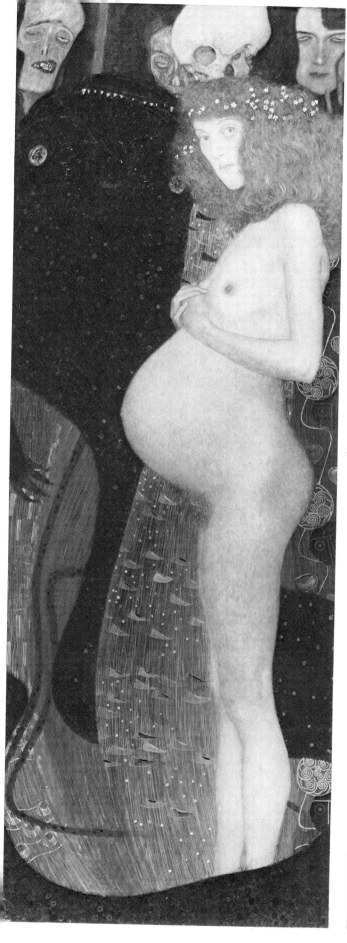

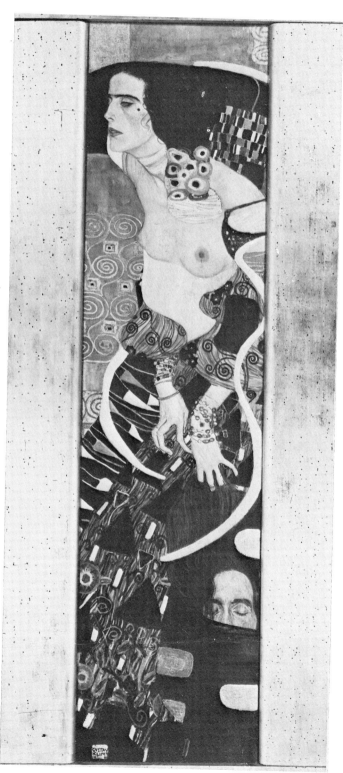

176. (*left*) Gustav Klimt:
Hope I, 1903. Oil on canvas,
181 × 67 cm. Ottawa,
National Gallery of Canada

177. (*below*) Gustav Klimt:
Judith II (*Salome*), 1909.
Oil on canvas, 178 × 46 cm.
Venice, Galleria d'Arte
Moderna

Egon Schiele, 1890–1918

Egon Leo Adolf Schiele was born on 12 June 1890 at Tulln, Lower Austria, the son of a railway official. He was educated at the local primary school, then at the grammar school at Krems; from 1902 onwards, he attended the Landes-Real- und Obergymnasium at Klosterneuburg, the church and convent of which can be recognized in some of his earliest paintings. He did not take kindly to formal education, which he resented as an intrusion upon his freedom:

On such days, I felt as if I could already smell and hear the magic of the flowers, the mute gardens, the birds in whose gleaming eyes I could see my own rose-tinted reflection. Often, I would half-weep when autumn came; and when it was spring again, I would dream of the music of life. . . .

Until that time, I had lived a life sometimes happy, sometimes sad, but at all events free from care. But now began my time of toil, the lifeless schools. . . . My brutal teachers were from the start my enemies.[31]

In 1905, Schiele's father died, and his uncle Leopold Czihaczek became his guardian (Plate 178). Czihaczek, in accordance with his brother-in-law's wishes, intended that the young Egon should go on to study at Vienna's Technische Hochschule, but his nephew was clearly more interested in an artistic than in an academic career. In 1906, he passed the entrance examination for the Academy of Fine Arts, and was accepted into Griepenkerl's painting class. He got on no better with Griepenkerl than with his other teachers; the story goes that on one occasion he so infuriated the old academician that the latter lost his temper and bellowed at him: 'You! You! The Devil sent you into my class!' By this date, Schiele was already seeking to associate himself with the Viennese *avant-garde*. As early as 1907, he met Klimt for the first time; in the same year, he journeyed to Trieste in the company of his younger sister Gertrude, recording his visit in a series of paintings which, above all in their use of line, tell of the influence of *Jugendstil* upon the young and still highly impressionable artist (Plate 179).

In 1908, he made his first public appearance, in an exhibition held in May/June in the convent at Klosterneuburg. It was on this occasion that he met Heinrich Benesch, whose son, the art historian Otto Benesch, later became director of the Albertina; Schiele subsequently depicted father and son in one of the strongest of his double portraits (Plate 180). Benesch senior, who was immediately impressed by Schiele, became one of the first collectors of his watercolours and drawings; years later, he could still recall the pictures shown at this first exhibition:

In 1908, at an exhibition of Klosterneuburg painters . . . I encountered the works of a young artist who at once excited my attention. They were small oil-studies, landscapes for the most part, painted with a certain fluency and confidence. That was Egon Schiele.[32]

His début before the Viennese public came the following year at the Internationale Kunstschau of 1909. He was represented by four paintings, two of which were portraits of the painter Hans Massmann, a fellow-student at the Academy (Plate 182), and of Anton Peschka (Plate 183), who was to marry Schiele's sister. These

178. Egon Schiele: *Portrait of Leopold Czihaczek I*, 1907. Oil on canvas, 150 × 50.5 cm. Vienna, Dr Kurt Stockert

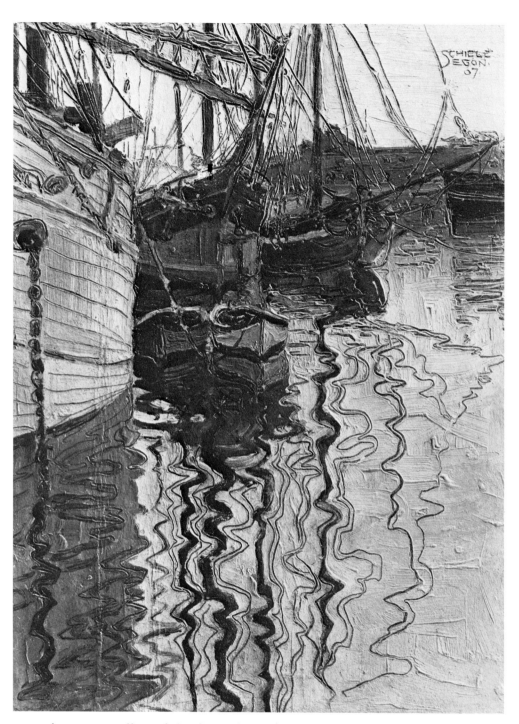

179. Egon Schiele: *Harbour at Trieste*, 1907. Oil and pencil on cardboard, 18 × 25 cm. Graz, Landesmuseum Joanneum

portraits are revealing of the formative influences upon his early work. That of Massmann, in particular, with its grain-like texture and use of a decorative border, has certain affinities with the work of the Norwegian Munch, whose world of feeling and choice of subject-matter in his paintings of the turn of the century are closely related to the themes Schiele selected in his works of his early, expressionistic period. The most striking influence at this time was, however, undoubtedly that of Klimt—an influence which was almost inevitable for the younger painters of the Viennese school. Schiele paid unconcealed homage to Klimt in the two versions of his composition *Watersprites* (Plate 181), which take

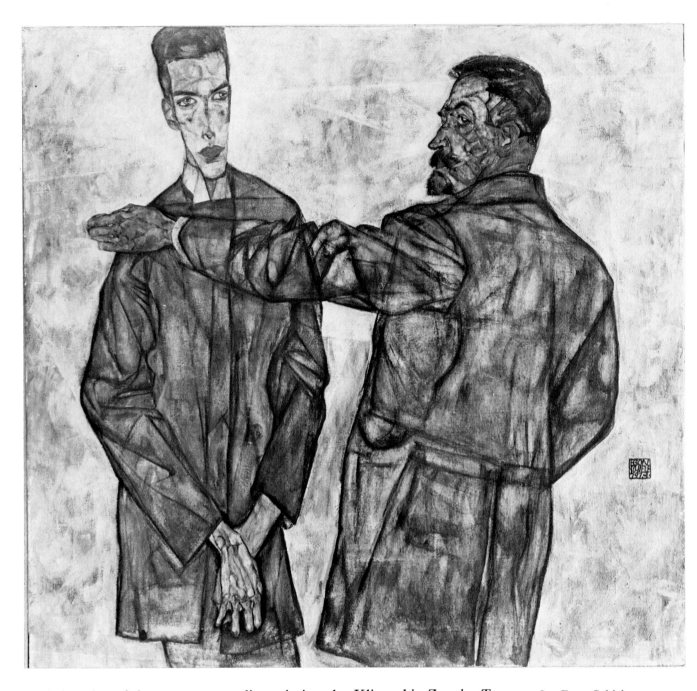

as their point of departure two earlier paintings by Klimt: his *Zug der Toten* (Procession of the Dead) of 1903, and *Watersprites II* of 1904; he also appears to have been profoundly affected by one of Klimt's paintings shown at the first Kunstschau, the *Danaë*, even going so far as to make his own version of the same subject. This picture by Schiele, strangely, seems in its turn to have influenced Klimt himself, who much later adopted an almost identical pose for the female figure in his *Leda* of 1917 (Plate 158).

Klimt's influence upon Schiele's work soon receded; the latter, however, never wavered in his admiration of his older colleague. He was particularly enthused by Klimt's monumental works, especially the *Beethoven-frieze*; according to Roessler, he described the frescoes as 'the high point of Klimt's art . . . the whole

180. Egon Schiele: *Heinrich and Otto Benesch*, 1913. Oil on canvas, 121 × 131 cm. Linz, Neue Galerie, Wolfgang Gurlitt Museum

181. (*above*) Egon Schiele:
Watersprites I, 1907.
Gouache, crayon, gold and
silver paint on paper,
c. 24 × 48 cm. Switzerland,
Private Collection

183. (*below right*) Egon
Schiele: *Anton Peschka*,
1909. Oil on canvas,
110 × 100 cm. Private
Collection

182. (*below left*) Egon
Schiele: *Hans Massmann*,
1908–9. Oil on canvas,
120 × 110 cm. Switzerland,
Private Collection

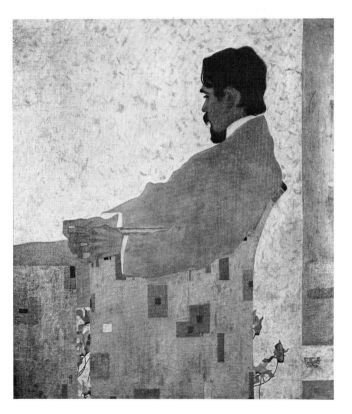

Klimt-faith expressed on six 6½ by 20 feet panels'.[33] The admiration appears to have been mutual. One anecdote is indicative of the relation between the two artists. Schiele, who greatly envied Klimt's drawings, suggested an exchange, by which he meant he would gladly give several of his own drawings for one by Klimt; Klimt's reaction, characteristically, was: 'Why on earth do you want to swap drawings with me? You draw better than I do!'[34] Nevertheless, he agreed to the exchange, and bought several more drawings by Schiele into the bargain. Klimt also tried to assist Schiele, at a moment when the young artist's finances were more than usually precarious, by introducing him to August Lederer, by far the most important of his patrons; as a result, Schiele was commissioned to paint a portrait of Lederer's son Erich (Plate 185), who also later took drawing lessons from the artist.

As Klimt had prophesied, many of the artists who participated in the two Kunstschau exhibitions were to regroup themselves into yet other organizations and societies. One such was the Neukunstgruppe, which came into being in the same year as the second Kunstschau, 1909, and which brought together the young painters Anton Faistauer, Franz Wiegele, Paris von Gütersloh, and Hans Böhler, as well as Peschka and Schiele. The society's first exhibition was held at the Salon Pisko on the Schwarzenbergplatz in December of the same year, an exhibition for which Faistauer, to whom we also owe one of the first general accounts of *avant-garde* painting in Austria,[35] designed the poster, in a manner strongly reminiscent of certain of Schiele's self-portrait drawings and watercolours of this period. At this exhibition, Schiele broadened his circle of useful acquaintances by getting himself introduced to the collectors Carl Reininghaus and Oskar Reichel, the publisher Eduard Kosmack (whose portrait Schiele painted, Plate 184), and, perhaps most important of all, the critic Arthur Roessler, who became the artist's first official champion, as well as the originator of countless anecdotes and reminiscences about him, some apparently accurate, others pure fabrication. Among his more useful reminiscences, Roessler has left us the following vivid picture of the impression Schiele made upon him at this time:

One felt one had before one a personality extraordinary in every respect, so extraordinary, in fact, that by no means everyone can have felt comfortable in its presence, sometimes not even its owner himself. To the sensitive, Schiele must have seemed like a sendling from an unknown land, like one who has come back from the dead and now, filled with a painful confusion, carries among mankind a secret message, without quite knowing to whom to deliver it.

Even amidst celebrated men of impressive appearance, Schiele struck one as an extraordinary phenomenon, as I later had frequent opportunity of observing. Of tall, slender, supple figure, with narrow shoulders, long arms, bony hands with long fingers, his beardless, sun-tanned face, surrounded by a shock of long, unruly dark hair, with a broad, obliquely furrowed, slanting forehead—a face whose eloquent features mostly bore a serious, almost mournful expression, as of someone inwardly in pain—with his large dark eyes, from which, when spoken to, he had always to banish a dream, he impressed you immediately you confronted him. If his behaviour was violent, it was never from lack of upbringing; even when carried away by passion, he was never uncontrolled. The undeniable grandeur

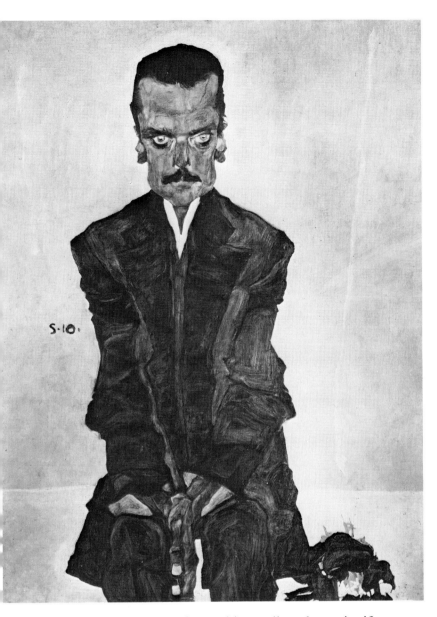

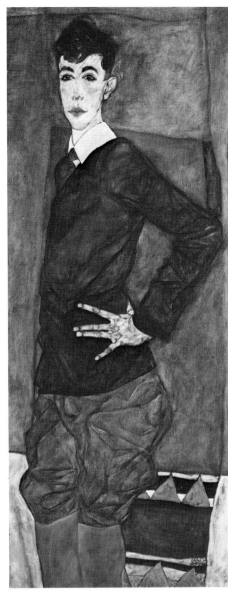

184. (*left*) Egon Schiele: *Eduard Kosmack*, 1910. Oil on canvas, 100 × 100 cm. Vienna, Oesterreichische Galerie

185. (*right*) Egon Schiele: *Erich Lederer*, 1912. Private Collection

of even his smallest, least significant gestures, his economical, aphoristic way of speaking, produced, in harmony with his external appearance, an impression of inner nobility, which was all the more profound in that it clearly corresponded to his very nature, and was in no sense contrived.[36]

The Pisko show coincided with the first detailed reviews of Schiele's work to appear in the Viennese press. One of these, written by A. F. Seligmann, the critic of the *Neue Freie Presse*, merits our attention for its prophetic qualities:

A quite different impression is produced by the Neukunstgruppe, who are exhibiting at Pisko's on the Schwarzenbergplatz. They are mostly young academicians, or such as would like to be as much, imitators of Klimt, Kokoschka and the French Neo-Impressionists. Some of them indeed have talent, as far as one can judge from what one is offered here, but nearly all tend in a direction which leads only to a dead end: they are preoccupied with purely ornamental problems, problems which are, in essence, those of the applied arts; the representational aspect is

kept purposely primitive, ugly, or else remains unintentionally dilettantish. . . .

That these younger artists, under the pretext of seeking for a certain decorative effect, prefer to select obscene things and actions for their subject-matter can, in the end, scarcely be held against them, for they are simply following in the steps of those they imitate, some of whom are already 'grand old men'. Since they have at their disposal not merely walls and fences, but canvas and paper, they have, understandably, seized upon the idea of going through the crisis of puberty before an invited audience. . . .

Schiele, too, is certainly gifted. One can see here a whole series of drawings and paintings by him—that is, the ones which don't offend our already much-blunted 'public morals'. How far his artistic talent will take him, it's too early to say. But, if I'm not much mistaken, he might easily find himself presented with a nice little summons.[37]

Seligmann's remarks touch upon one of the most important aspects of the artist's early work. Accusations of pornography dogged him almost from the beginning of his career—not always without justification. Schiele at times made a living from the sale of his more explicit drawings. There were even plans to publish a folder of erotic subjects by him in a limited edition of one hundred copies, but nothing came of this project.[38] His preoccupation with sexual subject-matter goes, however, far beyond merely business interests. As it was for Klimt, sexuality was for him a vital source of inspiration, although his treatment of erotic subjects is nearly always more unabashed; at times, his nude studies, especially of the period 1909–11, have an anatomical, almost gruesome character. This is seen particularly clearly in certain of his famous nude self portraits (Plate 186), variations upon the themes of suffering and crucifixion. As in the case of Kokoschka, an important thread of self-allegory runs through his early work; his own body, no less than those of his models, was an object of intense fascination for him. Infantile sexuality was another important source of inspiration. Schiele, as is well known, frequently employed children as models for his early nude studies, a practice which, as with Loos some years later, soon aroused the suspicions of the guardians of that same public morality to which Seligmann refers. To what extent his interest in his younger models was anything other than purely artistic will probably never be answered; once, when reproached with the eroticism of his drawings, he replied with some bitterness: 'I certainly didn't *feel* erotic when I made them!'[39] Roessler, perhaps in order to shield his protégé from the charges levelled against him, records for posterity a remark supposedly made by the artist on one occasion, when he greeted him with the words:

The twisted faces which tormented me, and which I could not obliterate from my retina, however hard I tried, are gone, gone! Why so suddenly? Because I have seen the faces of young girls which bear no sign of passion and suffering, no trace of the knowledge of any man!—I tell you—you must believe me—there is something sacred about the pure face of a chaste, beautiful girl![40]

But if one takes an unpartisan view of Schiele's drawings of this period, it is, rather, the tension between the innocence of the scarcely formed bodies of his sitters and the emphasis he places upon details of genitalia, the frequently lascivious

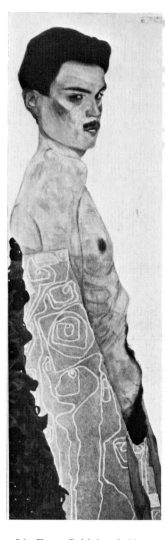

186. Egon Schiele: *Self Portrait with Decorated Drapes*, 1909. Oil on canvas, 110 × 35.5 cm. London, Marlborough Fine Art

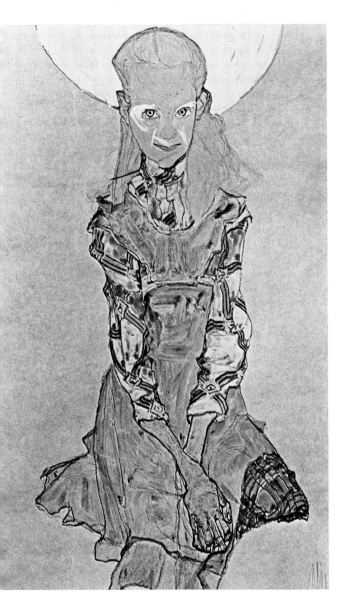

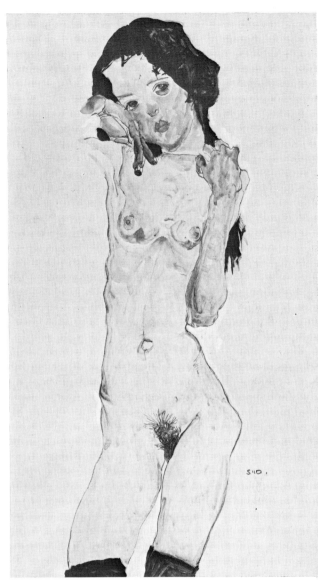

187. (*above*) Egon Schiele:
Sketch for Poldi Lodzinski,
1910. Gouache and water-
colour, 45 × 28.5 cm.
London, Fischer Fine Art

188. (*right*) Egon Schiele:
Nude black-haired girl.
Watercolour. Vienna,
Albertina

poses he utilizes, above all a certain knowing quality in the eyes and faces of the children portrayed, which instils in these works their vital, eerie, unique character (Plate 188). A whole world of obsession lies behind the seductive smile on the face of the young Poldi Lodzinski, between whose angular expressive hands the secret meaning of the picture is contained (Plate 187).

In 1911, Schiele, together with his mistress Wally Neuzil, moved to Böhmisch Krumau (now Cesky Krumlov, Czechoslovakia), his mother's birthplace. He was fond of Krumau, a picturesque old town situated on a sharp bend of the Moldau; he may even have intended to take up permanent residence there. Its steep gables, its towers and spires appear as identifiable motifs in many of his pictures, which, despite Schiele's use of an often improbable-seeming viewpoint, preserve a high degree of topographical accuracy. His paintings of Krumau are among the first important works of his early maturity. Here, the artist has moved beyond the influence of *Jugendstil*, adopting a far more complex geometrical structure than is evident in his earlier works, although the majority of these

215

paintings, such as *Houses and Roofs in Krumau* (Plate 189), still display the same shallow space and essentially vertical composition. This emphasis upon geometry is also characteristic of Schiele's later work, especially his numerous tree studies, where the use of line is reduced to the merest indication of the supports upon which the composition is to be built (Plate 173)—an almost mathematical manner of composing, which it is tempting to describe as a kind of 'stripped Expressionism'. In other respects, however, it is doubtful to what extent the term 'expressionist' may properly be applied to his work. In his choice of subject-matter, his portrayal of ugliness, misery and death, it is true that he displays a certain affinity with literary Expressionism. There is also his relationship with Munch to be considered. One of the most important of Schiele's early paintings, the *Dead Mother* of 1910 (Plate 174), looks back directly to the work of the Norwegian artist, whose treatment of similar subjects, for example his *Puberty* or *The Sick Mother*,[41] constituted one of the most telling influences upon the Expressionist movement in painting, especially upon the *Brücke* group (Kirchner, Heckel, Schmidt-Rottluff and others), who may be termed the first generation of Expressionists in the visual arts. But Schiele's art is, stylistically speaking, far removed from the pictorial manner of the *Brücke* artists. Far more complex structurally, his works seek to realize subtle, delicate effects of colour and tone; the influence of the Fauve painters, which, together with that of van Gogh, provided the other most important formative impetus for the art of Kirchner and his circle, remained essentially foreign to him. Significantly, many of Schiele's most individual artistic statements are couched in the medium of watercolour or drawing—works which, independently conceived, have little or nothing to do with the graphic deliberations which preceded his oil compositions.

The opposition provoked by Schiele's Bohemian style of living and, especially, by his liaison with Wally made Krumau too hot to hold him, and in the late summer of 1911 the artist and his mistress moved to Neulengbach. His financial situation was, as usual, precarious. Schiele was hopelessly impractical with money; indeed, he resisted any attempt to bring order into his chaotic personal affairs. On one occasion, when his mother reproached him with his free and easy ways, he retorted: 'I mean to savour the joy I have of the world, that is why I am able to create. . . . I have no money put by, I live from hand to mouth, therein lies my pleasure . . . yet you do me an enduring injustice because you do not understand that I absolutely need all this in order to produce.'[42] Earlier, however, he had written in less confident tones to Roessler: 'Can it go on like this? Won't anybody help me? . . . I have no money to buy canvas. I want to paint, but I have no colours.'[43] The occasional sale of a few drawings, or even a painting, did little to alleviate his distress; at home, at least, his chances of recognition seemed more and more remote. 'Neither the bourgeoisie, nor the aristocracy', wrote Roessler, 'is capable of being moved by Schiele's pictures—neither their hearts nor, indeed, their heads . . . scarcely even their senses.'[44] The artist's spirits, already at a low ebb, failed completely when, in the spring of 1912, he was arrested on the charge of seducing a minor. There was almost certainly no foundation in the charge, and he was eventually acquitted; he was, however, sentenced on a lesser charge—that of disseminating indecent drawings. One of his nude studies, which had been found pinned up on the wall of his lodgings, was burnt before

189. Egon Schiele: *Houses and Roofs in Krumau*, 1911. Gouache and oil on wood, 37.2 × 29.3 cm. Prague, Narodny Galerie

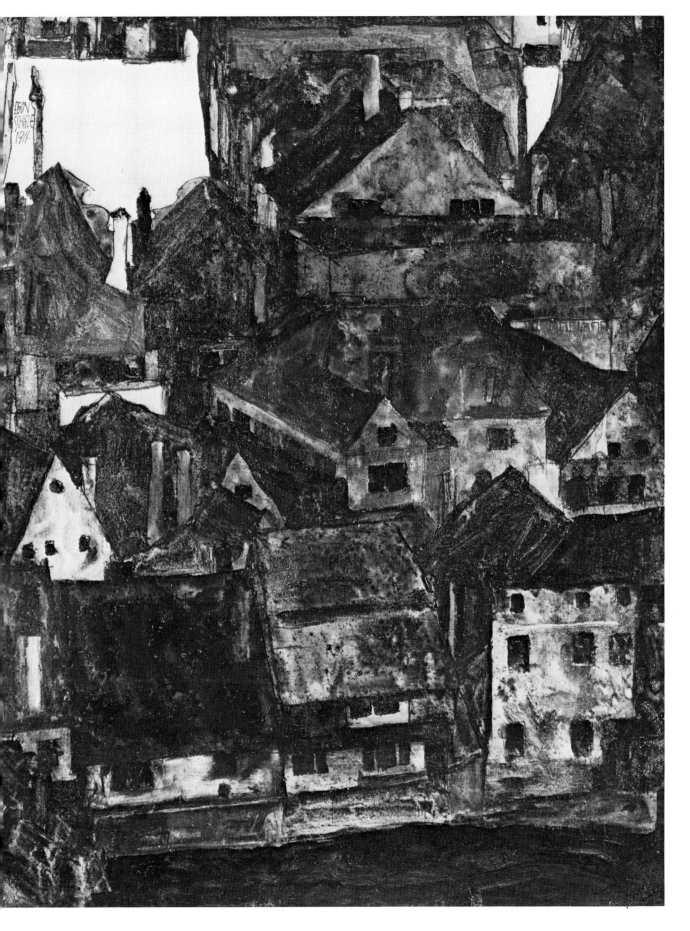

his eyes at the hearing. He also spent a total of twenty-four days in prison, at Neulengbach and at St Pölten, during March and April 1912—an experience which left an indelible scar on his consciousness. 'I am wretched, I tell you, I am inwardly so wretched', he wrote to Roessler on 9 May; and, as late as 19 September: 'I must live day after day with the evil thought that I work at nothing and just wait and wait. From March until now, I have just not been able to paint or, above all, to think.'[45]

Ironically, this period of poverty and distress, his release from prison and his restless wanderings during the remainder of the summer and early autumn of 1912, coincided with the first indications of an upward turn in events, especially as far as the recognition of his art abroad was concerned. In the spring and autumn of that year, he exhibited at the Munich Secession and at the great *Sonderbund* exhibition in Cologne. During June and July 1913, the Munich art dealer Hans Goltz, with whom Schiele had been in touch for some time, organized a collected show of his work; in Vienna, the artist was represented by six works at the forty-third exhibition of the Secession (January–February 1913), was elected a member of the *Bund Oesterreichischer Künstler*, and participated in the society's exhibition held in Budapest in March of the same year. The following year, 1914, marked the high point of Schiele's early reputation in Germany, with participation in exhibitions in Dresden, Hamburg and Munich, as well as the German *Werkbund* exhibition, held in Cologne during the summer of that year. The friendly reception accorded to his art continued even during the war years; in 1916, Franz Pfemfert's periodical *Die Aktion*, which from 1913 onwards had included prose poems and reproductions of drawings by Schiele, brought out an Egon Schiele issue, with six drawings, including a self portrait on the title-page.

The year 1914 also marked the beginning of a more settled period in his personal affairs. Two years previously, he had rented a large studio in Vienna's Hietzinger Hauptstrasse, which he was to retain until his death; it was here, in all probability towards the beginning of 1914, that he first made the acquaintance of the sisters Edith and Adele Harms, daughters of the master locksmith Johann Harms. By the spring of the following year, it was settled that Edith was to become Schiele's wife. During this same period, Schiele embarked on a new group of pictures remarkable for their intricacy of composition and power of imagery: *Sunflowers*, *Young Mother*, *Man and Woman*, as well as the portrait of the beautiful Friederike Maria Beer, friend of the artist Hans Böhler, whom Klimt also depicted (at Böhler's expense) in one of the finest of his late portraits (Plate 196). It was also in the Hietzinger Hauptstrasse studio, at the end of July 1914, that Schiele learned of the event which was to disrupt the newly settled pattern of his existence: the outbreak of the Great War.

V · EPILOGUE : VIENNA 1914~18

THE LATER WORK OF KLIMT AND SCHIELE

THE SUMMER OF 1914, and the outbreak of war. The shots which rang out at Sarajevo signalled the end of far more than just the Danube Monarchy. Karl Kraus, aghast at the tragedy he had himself predicted, wrote in the last issue of *Die Fackel* for 1914:

IN THIS GREAT EPOCH

which I knew already, while it was still of insignificant proportions, which could become insignificant again, if only there were time; for which we have greater respect than for prosperous times, or even difficult times; an epoch in which the unthinkable has come to pass ... this earnest epoch, which laughed itself to death at the thought that it might one day be in earnest; overcome by tragedy, headed for dissolution, catching itself red-handed, seeking for words; this tumultuous era which resounds with the gruesome symphony of those deeds which newspaper reports seek to justify; at such a time you can expect no word from me ... I have nothing new to say; in the room in which I am writing, the noise is so great, it is impossible to distinguish whether it comes from animals, from children or merely from the mortar-fire.... Those who have nothing to say, because deeds speak for themselves, continue their harangue; step forward, all those who have something to say, and keep silent! My words could drown the roar of the printing presses, and the fact that the presses are still turning does not disprove my word. Mightier machines have not succeeded either, and the ear of the public, already attuned to the sound of the last trumpet, is still far from deaf to the daily Heralds.[1]

Kraus, whom we have already encountered as one of the most vocal of Klimt's critics from the early days of the Secession, was, like Zweig, a passionate opponent of the war faction in Austrian politics, a Jew who managed to combine a profound sense of alienation, of rootlessness, with an empassioned adherence to the more permanent values of the society of which he was a member. He was the scourge of everything arrogant, self-inflated, chauvinistic—in particular, the contemporary press, which he flayed with systematic regularity in his own numerous articles and editorials, denouncing not only their corruption and rooted prejudice, but also their linguistic degeneracy, their disdain for the finer points of grammar and syntax, their violation of the German language. Kraus, the 'white high priest of truth', as Trakl called him, held an inalienably moralistic view of language; for him, depravity began with a wrongly used subjunctive, the dissolution of the world with a badly constructed sentence, mass murder with a misplaced hyphen. Kokoschka, who belonged to that exclusive circle which also included Loos, Altenberg and Trakl, recalled how the appearance of each new number of *Die Fackel*, the periodical of which Kraus wrote and edited every word, was accompanied by interminable discussions, during which the author would tax his disciples with their understanding of each sentence, down to the finest nuance

of meaning, the last comma. Kraus had a heartfelt disdain for most of his contemporaries, especially the Secessionists and their champion Bahr, whom he castigated in a series of articles, including the famous essay 'Das Café Griensteidl und der Herr aus Linz'. He was, however, an eloquent advocate of the few artists whom he admired. It was he who was responsible for publishing an early sketch by Altenberg, 'Lokale Chronik', in the periodical *Liebelei*; he also persuaded the publishing house of S. Fischer to accept Altenberg's first book, *Wie ich es sehe*.

There was an eerie sense of duality about the first months of the war. The flower of Austrian manhood was being annihilated on the battlefields of Eastern Europe; while at home, the balls, café-life and society gossip continued as if nothing untoward were taking place. 'I have become a simple newspaper reader', wrote Kraus, overcome with bitterness, in an editorial entitled 'Ein Tag aus der Grossen Zeit' (published in *Die Fackel* on 23 February 1915), and juxtaposed without further comment two articles which had appeared on the same day in the Viennese press, one a report from the front, the other an account of the opening of a new café:

At six o'clock we went into battle, in silence, no one speaking. The comrades who stood near each other shook one another's hand. . . . He sprang forward, was however at once thrown back . . . his whole chin, his mouth all shot away; while being bandaged, half his tongue fell out of his mouth. He was wounded in the arm too. Then all hell broke loose; the enemy machine-guns opened fire, it was terrible. Our comrades were falling left and right, our lieutenant cried 'I'm done for!' His arm and leg were shot away. . . . I saw dead men with their heads blown off. But if the tempest of the battle was terrible, the icy silence afterwards was more terrible still. . . . Next to me lay men and horses piled on top of one another. . . . Then came Morast. . . . My platoon consisted of two men, all that remained. The trenches around the guns, in particular, were full to the brim. The company re-assembled. The captain, the lieutenants and forty-one men were missing. . . . The colonel greeted us with the words:

It was really one of those social events, one of those pretty, typically Viennese 'happenings' at which one so likes to be 'on the scene'. In a pleasant and informal manner, the great Kaiser Wilhelm Café yesterday afternoon celebrated its opening. . . . The well-ventilated rooms, which take up the whole of the ground floor and mezzanine storey, are particularly beautiful, with their imposing, subtly toned architecture, which is brought to life by the magnificent effects of lighting produced by the chandeliers. And the seats, the cosy corners are so warm, so intimate, after the wide, brightly lit spaces of the main rooms—a truly German spirit of homely comfort. One is greeted by the painted portraits of our own Monarch and of the German Kaiser, decked with flowers. Even in these earnest times, this concern holds high the banner of commercial enterprise. On every side, lively activity. People point out to one another 'who's who': the actresses, with their circle of admirers, up above in the delightful balcony-salon; the artists, the civil servants, representatives of the diplomatic corps, officers and business-

190. Gustav Klimt: *Baroness Elizabeth Bachofen-Echt*, 1914. Oil on canvas, 180 × 128 cm. Private Collection

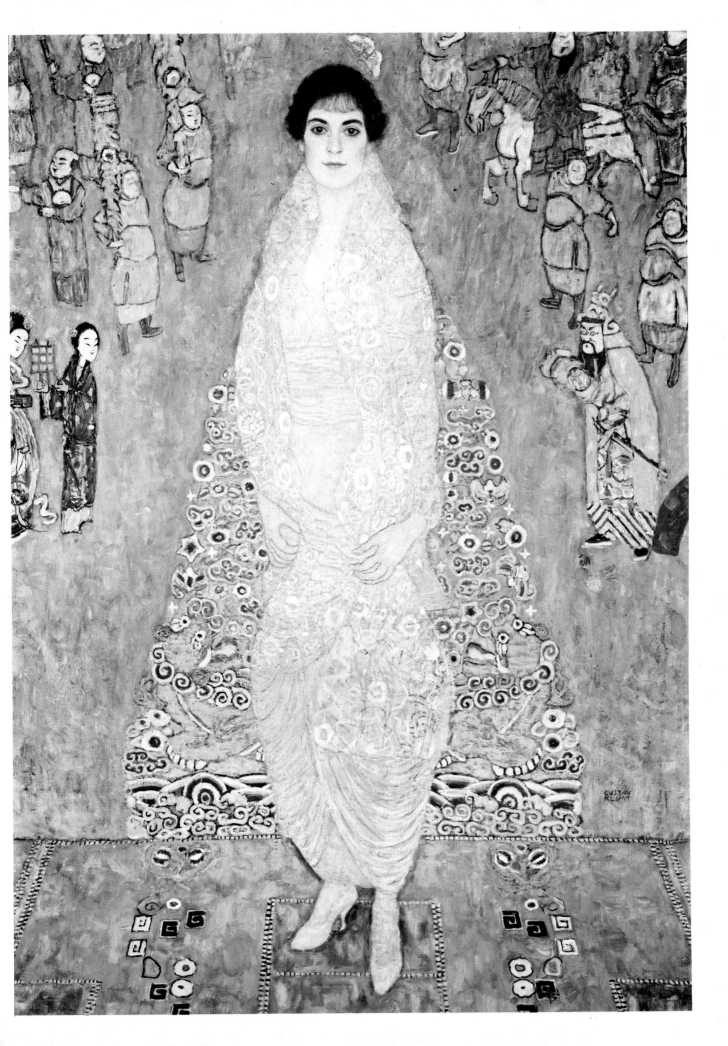

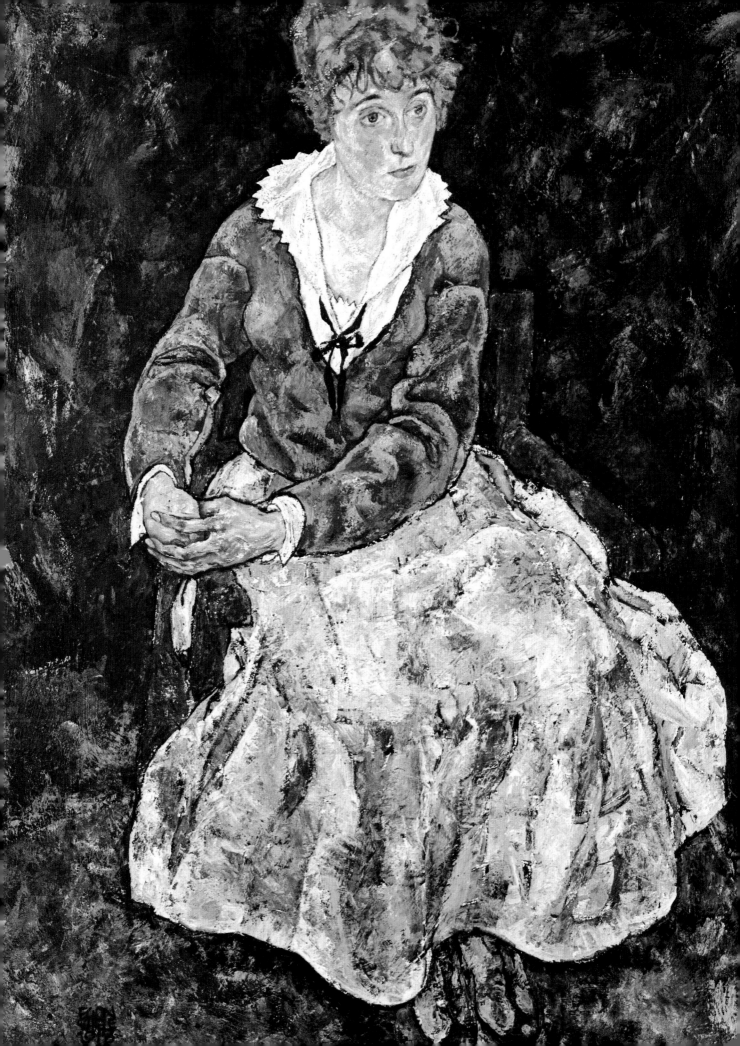

'Good morning, Number One Battalion!' Then he tried to continue, but could only stutter for tears. Then the General spoke. He said we had virtually annihilated an enemy eight times our strength, that our battalion would go down in history. Then he cheered us, and the whole regiment stood and wept. . . . Then we withdrew and were given rations, but nobody had any appetite. At half past three we buried the dead, and at seven we retired to the batteries, where we still are.

men. People crowd into the writing room and the buffet, which makes a speciality of light, delicious snacks; the ladies tickle their palettes in the *confiserie*; while smaller groups of light-hearted gentlemen settle themselves down comfortably in the bar. This magnificent café has brought a breath of modernity into the Viennese café-life. Business continues until late at night, and when you leave the Kaiser-Wilhelm Café, you know that you will come back again tomorrow, and the next day, and again, and again.[2]

This duality extended likewise to the realms of art. On the one hand, at least some of the leading Austrian artists continued not only to devote themselves to their work, but also to participate in exhibitions abroad—in those countries, that is, which were still prepared to welcome their participation, in the main Germany, Switzerland and the neutral states. On the other hand, artistic activity within Austria was severely curtailed. There was no longer any possible contact with the majority of the prominent figures of the European *avant-garde*, and any serious interchange of ideas, or even group manifestations of modern art, came to a standstill. Moreover, the artists themselves, like everybody else, had to face up to the grim realities of war. Wagner, who at one time in his career was accustomed to the aid of literally dozens of assistants, complained bitterly that he was having the utmost difficulties in finding drawing-office staff at all. There were soon all kinds of privations, increasing hardship. Worst of all, as it became only too clear that the war would not be over by Christmas 1914, nor Christmas 1915, nor even 1916, the artists too—Berg, Schoenberg, Kokoschka, Schiele—began to be called up.

Of those artists who were able to continue working during these years, Klimt was least of all affected by the war. He had become more isolated after the completion of the *Stoclet-frieze*, more set in his ways. The pattern of his life was unvarying. The summer months were spent at Attersee, a picturesque lake which was a favourite resort of the Viennese bourgeoisie. It was to Attersee that Klimt and the Flöge sisters had gone nearly every year for over a decade, living first of all in Litzlberg, then at Kammer, finally, from 1914 to 1916, in Weissenbach, at the more mountainous end of the lake. (The only exceptions were the summer of 1913, which Klimt spent on Lake Garda, and 1917, in Mayrhofen.) Klimt, a great sportsman, swam and rowed; he was also, apparently, one of the first to own a motor-boat, an enthusiasm comparable to Mahler's passion for motoring. Much of the time was, predictably, dedicated to painting. 'Here', wrote Moll, 'in the hot summer months, Klimt rested . . . by working, in the company of his lifelong companion, his "Kathi Fröhlich" and her family.'[3] It was also at Attersee, in all probability during the summer of 1905, that the greater part of the working

191. Egon Schiele: *Portrait of Edith seated*, 1917–18. Oil on canvas, 140 × 110.5 cm. Vienna, Oesterreichische Galerie

drawings for the *Stoclet-frieze* were executed. The rest of the year was spent in Vienna. Here, the artist's day was organized according to a strict routine. An early riser, he would walk from his flat in the Westbahnstrasse to the Café Tivoli for breakfast, an elaborate affair, which invariably included a sizeable portion of whipped cream. Over breakfast, his friends would seek him out, knowing that once immured in his studio, the master was not to be disturbed. Breakfast finished, Klimt would walk back across Schönbrunn park (in earlier years, his studio was located in Vienna's eighth district, after 1914 in Hietzing), and spent the rest of the day working without interruption; at the studio, there were always several models at hand, and, between painting, Klimt would make rapid life sketches, or more elaborate composition studies. Only in the late evening would he repair once more to the café to replenish his energies, seeking relaxation in the company of his friends: Hoffmann, Moser, Moll. In their circle, he was dubbed *König* (king)—a mark not only of their unbounded affection for him, but also of the fact that they, too, considered him the best painter of them all.

Apart from his habitual journey to Bad Gastein to take the waters, the only event which Klimt would permit, albeit somewhat reluctantly, to disrupt the

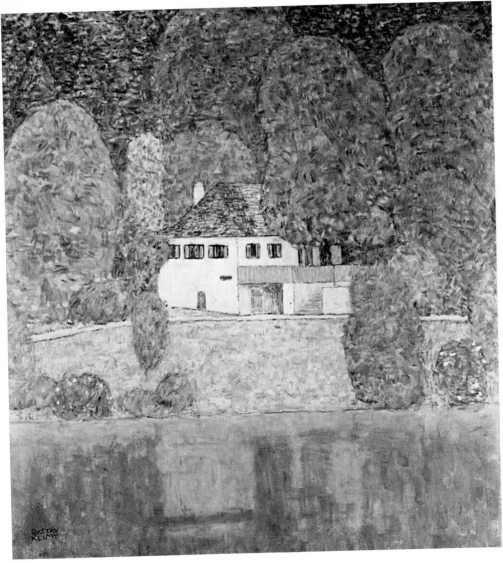

192. Gustav Klimt: *Litzlbergkeller am Attersee*, 1915. Vienna, Private Collection

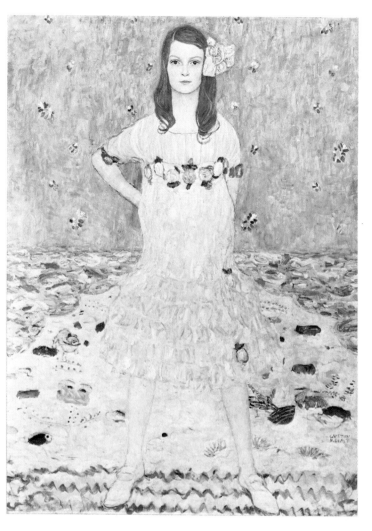

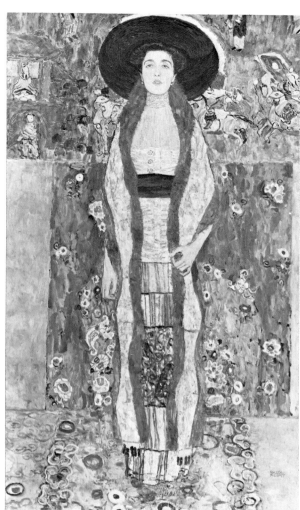

193. (*above*) Gustav Klimt:
Mäda Primavesi, 1912. Oil
on canvas, 150 × 110 cm.
Westport, Connecticut,
A. Mertens

194. (*right*) Gustav Klimt:
Adele Bloch-Bauer II, 1912.
Oil on canvas, 190 × 120 cm.
Vienna, Oesterreichische
Galerie, on loan to Museum
des 20 Jahrhunderts

fixed pattern of his existence was his annual, or even twice-yearly visit to the home of the Primavesi family near Olmütz in Moravia. This visit had become something of an institution, started perhaps by Hoffmann, whose patrons they originally were. Otto Primavesi, a banker and financier, had taken over the financial burden of the Wiener Werkstätte after Wärndorfer, who had seen his own far from inconsiderable resources vanish in the enterprise, had left to seek new fortunes in the United States. Every year, Otto Primavesi and his wife would celebrate what was called the *Schweindlfest*, a kind of elaborate barbecue, at which the guests included a varying circle of friends, but nearly always Klimt, Hoffmann, and the sculptor Anton Hanak.[4] This traditional festival took on an added significance during the dark days of the war, when food was more plentiful in Moravia than within the boundaries of present-day Austria. In 1917 and 1918 Klimt appears to have spent New Year in Olmütz. The Primavesis, perhaps at Hoffmann's instigation, purchased several important examples of Klimt's work, including the landscape *Litzlbergkeller am Attersee* (Plate 192), and a sculpted head (Klimt's experiments as a sculptor, although mentioned by his contemporaries, have until recent years gone virtually unremarked in the secondary literature). They also commissioned two family portraits—of the daughter of the house, the young Mäda Primavesi (Plate 193), and of Mäda's mother Eugenia. The portrait of Eugenia Primavesi is now lost; that of Mäda, however, remains among the most highly personal of the artist's works, in which he has captured not only much of the

effervescent personality of his youthful sitter, but also the shyness, the awkwardness of childhood.

Portraiture occupied an important place within Klimt's *oeuvre* of the war years. After the second Kunstschau and the completion of the *Stoclet-frieze*, he had moved away from the lavishly ornamented, golden manner exemplified by the *Portrait of Adele Bloch-Bauer I*, towards a more painterly style. It is illuminating to compare the *Bloch-Bauer I* with his later version of the same subject, done in 1912 (Plate 194), where the decorative effect of the composition is achieved entirely by the use of colour and line. The simplicity of the pose of the standing figure, which is seen frontally, reminds the viewer irresistibly of Watteau's *Portrait of Gilles*, albeit in a somewhat Whistlerian interpretation. The *Bloch-Bauer II* is also remarkable as one of the earliest examples of the artist's use of specifically Oriental motifs. Klimt was, as we have seen, deeply interested in the art of the East. Over the years, he had built up an extensive collection of Oriental and primitive art, a considerable part of which he was able to display in the large studio in the Feldmühlgasse in Hietzing, which he took over when the house in the Josefstädterstrasse was demolished in 1914. Several descriptions of this last studio tell of the Chinese and Japanese screens and wall-paintings, Oriental vases and figurines which were to be seen there,[5] and which are depicted in some of the artist's most important works of his last period. In the late portraits, especially, he often makes use of the Oriental wall-paintings and hangings, as well as other objects, in order to create a colourful backdrop to the figure of the sitter— not only in the *Bloch-Bauer II*, but also in the portraits of the Baroness Bachofen-Echt (Plate 190), daughter of August and Serena Lederer (Plate 195), and Friederike Beer (Plate 196). The latter work is particularly interesting as regards its background since, according to the sitter herself, the Oriental figures were taken from a Korean vase in Klimt's collection, which the artist had, so to speak, unrolled so as to create a lively, almost abstract pattern. This decorative use of Oriental motifs parallels the role played in Klimt's earlier work by his employment of inlay and mosaic; it also, inevitably, recalls certain of van Gogh's paintings— in fact, van Gogh certainly inspired Klimt, who had become familiar with the Dutch artist's work through the sixteenth exhibition of the Secession, and through the large van Gogh exhibition held at Miethke's in 1907. The lapse in time between these exhibitions and the first trace of their impact appearing in his work need not surprise us; it often took Klimt years to assimilate influences upon his own art, slowly digesting and absorbing them until they finally re-emerge in an altogether individual, although still identifiable, form in his later paintings. The influence of the Ravenna mosaics, which, as already noted, Klimt had seen as early as 1903, upon his later works such as *Adele Bloch-Bauer I* and *The Kiss*, provides another example of this gradual process of maturation.

Of Klimt's other works of this period, his landscapes, their subjects taken for the most part from the locality of the Attersee, are perhaps the most important. In some of these paintings, the influence of French Post-Impressionism is still perceptible—his views of the park of Schloss Kammer, for example, where the (for Klimt) heavier impasto and the twisted forms of the trees remind one again of his debt to van Gogh. On the other hand, in his marvellously atmospheric *Island on the Attersee* (Plate 198), it is the work of Monet, rather than any of the

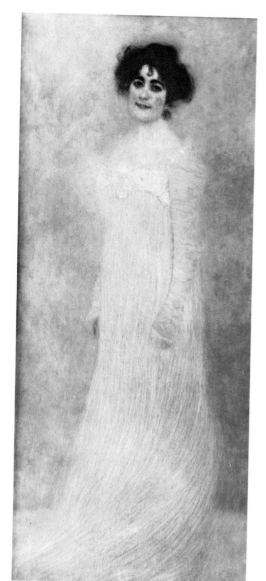

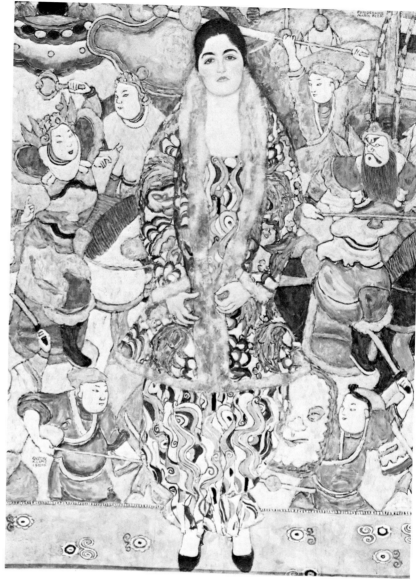

195. (*left*) Gustav Klimt: *Serena Lederer*, 1899. Oil on canvas, 188 × 83 cm. Private Collection

196. (*right*) Gustav Klimt: *Friederike Maria Beer*, 1916. Oil on canvas, 168 × 130 cm. New York, Mrs F. Beer-Monti

Post-Impressionists, which would appear the dominant influence. Kammer and its surroundings provided Klimt with a variety of subjects which he treated in a whole series of paintings, some of them variants seen from closely related viewpoints. He painted numerous versions of the Schloss itself, departing, on occasion, quite radically from topographical fact, altering the proportions of the house, combining different viewpoints, and, in his *Avenue in the Park of Schloss Kammer* (Plate 197), noticeably abbreviating the perspective. Other views of the house were almost certainly painted from a boat on the lake, perhaps with the aid of binoculars. Strangely, Klimt, who as we know made innumerable studies for his portraits and allegorical compositions, appears to have painted these landscapes without any recourse to preparatory drawings or sketches, although one cannot be certain, since his notebooks of this period, which he always carried with him and which might have provided some insight into the sources of his inspiration, have since been destroyed. By habit a studio-painter, he would on occasion set up his easel in the open air and paint from nature, even leaving the half-finished

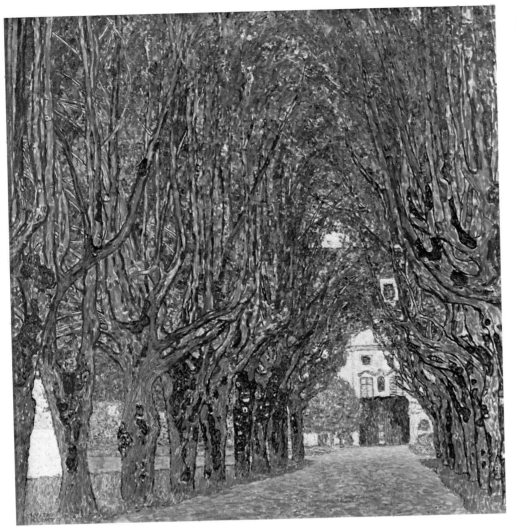

198. (*opposite left*) Gustav Klimt: *Island on the Attersee*, 1910. Oil on canvas, 100 × 100 cm. New York, Dr and Mrs Otto Kallir

199. (*opposite right*) Gustav Klimt: *Church in Unterach*, 1916. Oil on canvas, 110 × 110 cm. Graz, Private Collection

197. Gustav Klimt: *Avenue in the Park of Schloss Kammer*, 1912. Oil on canvas, 110 × 110 cm. Vienna, Oesterreichische Galerie

picture concealed in the undergrowth in order to avoid having to drag it to and fro.[6] He was, however, extraordinarily sensitive to any disturbance, and would only paint *en plein air* when completely secure from interruption. Thus, not a single landscape resulted from his stay in Mayrhofen in the summer of 1917, where he was unable to obtain that seclusion necessary for him to be able to paint at all. Only at Attersee could he find the essential isolation and repose. Here, far removed from the horrors of war, he painted works untouched by any trace of external events: *Forester's house in Weissenbach*, *Church in Unterach* (Plate 199), and the already mentioned *Litzlbergkeller am Attersee*, which was bought by the Primavesi family.

For five years, from 1912 to 1917, Klimt's art remained to all appearances static, incapable of further development. Then, in his paintings produced during the very last months of his life—that is, from about the beginning of 1917 until his death in February 1918—one can detect, astonishingly, what seem to be the beginnings of yet another important change in style. The emphasis upon pattern, decoration, the feeling for line, the delicacy of the colouristic effect the artist strives to achieve—all these remain; but in addition, there is a heightened awareness of the compositional element, a more lively concern with geometric structure.

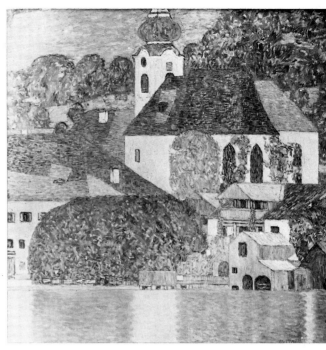

200. (*below left*) Gustav Klimt: *The Bride*, detail, 1917–18. Oil on canvas, 166 × 190 cm. Private Collection

201 (*below right*) Gustav Klimt: *The Baby*, 1917. Oil on canvas, 110 × 110 cm. New York, Galerie St Etienne

Works such as *The Bride* and *The Baby* (Plates 200–1) are immediately striking on account of their more intricate working-out of the relationship between individual motifs within the picture. This preoccupation with problems of structure appears indicative of the influence exerted upon Klimt's work at this time by that of Schiele. We have already seen how, in his *Leda* of 1917, Klimt is indebted for the overall conception of the picture and, in particular, for the pose of the central figure, to Schiele's *Danaë* of 1908; now, in *The Baby* (also called *The Cradle*), Klimt's use of a receding triangular form as the structural basis of the composition suggests a comparison with Schiele's paintings of the years

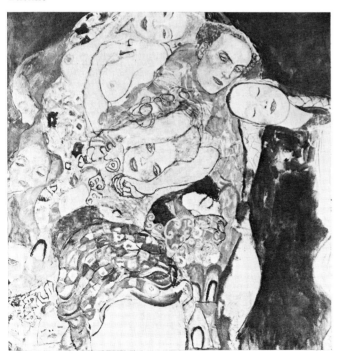

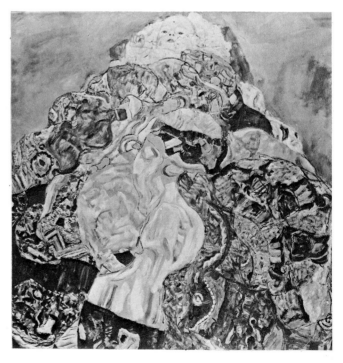

1915-16, such as *Death and the Maiden* (Plate 215) and *The Embrace*. (There is also an instructive parallel to be drawn between the head of the baby in Klimt's painting and that of the unborn child in Schiele's earlier painting *The Dead Mother*.) The importance given to the abstract element of the composition, which takes precedence over not only representational, but also spatial concerns, likewise suggests the beginning of a new and radical development. This period of experimentation was, however, too abruptly cut short for it to be possible to make any detailed prognosis of the direction Klimt's art might subsequently have taken. The canvases which were left unfinished in his studio when he died in 1918 remain too incomplete, too enigmatic, to enable one to assess their full implications—mute witnesses of a new, synthetic phase, the complete expression of which Klimt did not live long enough to achieve.

For the first nine months of the war, Schiele, too, was able to continue working undisturbed. At two preliminary medical examinations, he had been found unfit for military service, and could concentrate all his energies upon the important collective exhibition of his work held at the Galerie Arnot in Vienna from December 1914 to January 1915, for which Heinrich Benesch wrote the introduction to the catalogue. In May 1915 he married Edith; at the end of the same month, he was finally declared fit and ordered to report for duty in Prague on 21 June, where he was followed by his bride of a few weeks. After a fortnight of what Schiele called 'hanging about', he was assigned to guard duties at Neuhaus; by the late summer of 1915, he was back in Vienna, still on guard duties. One of his tasks was escorting Russian prisoners of war, and here, as later at Mühling, Schiele recorded the features of a number of his charges in a series of superb drawings (Plate 202).

His transfer to Liesing, in the spring of 1916, represented a marked improvement, since he was able to spend his free time working in his studio in the Hietzinger Hauptstrasse. Here he completed a townscape of Mödling, and embarked upon a portrait of his father-in-law, Johann Harms (Plate 203). In May, he was posted to the prison camp for Russian officers at Mühling, 'a place Egon actually likes', as Edith described it.[7] Apart from the beauty of the surroundings, Mühling had the added advantage that a kindly superior, one Lieutenant Herrmann, put a temporary studio at Schiele's disposal; it was probably for Herrmann that Schiele painted the now-vanished *Vision of St Hubert*. The frustrations of life at Mühling, however, and the long hours of duty prevented him from getting much serious work done, and it was not until the beginning of 1917, with yet another transfer to the offices of the Imperial Supply Department, that he was able to begin again on any important pictures. At the Supply Department, Schiele was fortunate enough to fall in once more with superiors willing to ease his misfortunes. The officer-in-charge, Hans Rosé, and his deputy, Karl Grünwald, employed Schiele whenever there was any 'artistic' job to be undertaken: the printing of new forms, or the design of an oval signboard with the title of the unit and the coat-of-arms of Austria-Hungary (Plate 204). Better still, Rosé decided to make a pictorial record of the work of his department, with a view to eventual publication, and sent Schiele and Grünwald off on a tour of the provincial headquarters in order to draw the stores, the offices, and anything else which caught the artist's eye. The

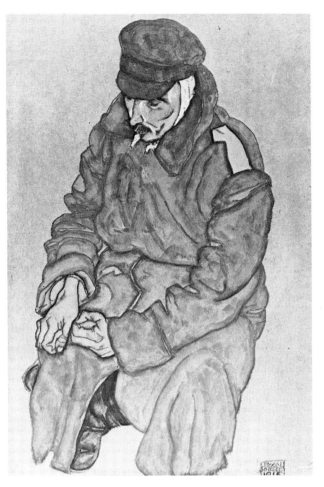

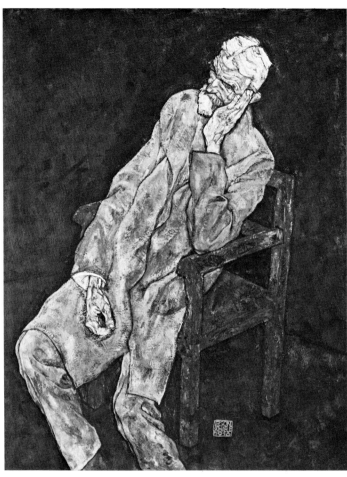

202. (*left*) Egon Schiele: *Russian Prisoner of War*, 1916. Pencil and water-colour, 39 × 27 cm. London, Marlborough Fine Art

203. (*right*) Egon Schiele: *Johann Harms*, 1916. Oil on canvas, 140 × 110.5 cm. New York, Solomon R. Guggenheim Museum

work was never in fact published, but Schiele's drawings are preserved, as well as a fine sketch of Rosé's office at headquarters, and of Grünwald's desk (Plate 205).

The short period 1916–18 is distinguished by a whole series of outstanding portraits by Schiele—not only of Grünwald, his companion on his travels to the Tirol and Southern Austria, but also of numerous friends and relatives, colleagues and contemporaries. In his portrait of his father-in-law, Johann Harms, begun in 1916, he created a moving image of old age, the old man, the coat in which he is wrapped failing to conceal the emaciated condition of the body beneath, perched precariously on the edge of his chair, his head supported in his hand. The economy of means which Schiele here employs looks forward to his work of the following two years; the shallow, imperfectly defined space, for example, relates this picture to his later composition *The Family* (Plate 209), in which the figures are likewise set against a dark, loosely brushed background of indeterminate depth. The artist paid tribute to two of his colleagues in his portraits of the dealer Guido Arnot, who had organized the first important collective show of Schiele's work in Vienna, and of the painter Paris von Gütersloh (Plates 207–8); in the latter work, the emphasis given to the hands, the instruments through which the painter expresses himself, calls to mind Kokoschka's portraits of the period just before the outbreak of war. Like Kokoschka, Schiele possessed an uncanny insight into the inner life of his subjects—their personality, their strengths and

204. Egon Schiele: *Design for an oval signboard, bearing the Austro-Hungarian coat of arms and the title of the supply unit to which the artist was attached.* London, Marlborough Fine Art

205. (*above*) Egon Schiele: *Grünwald's Desk.* Black chalk, 29.5 × 46 cm. London, Marlborough Fine Art

weaknesses, the marks left by sorrow or sickness. One senses the creeping onset of illness in his portrait of Franz Martin Haberditzl, director of the Oesterreichische Galerie (Plate 206), whose stiffening hands can barely hold the study (by Schiele) which he has taken from the folder at his feet. By including one of his own works in this picture, Schiele has indicated the nature of his relationship with the sitter, one of the first official admirers of his art. It was Haberditzl who was responsible for the acquisition by the gallery of one of the finest of the artist's paintings, the *Portrait of Edith Seated* (Plate 191), although, strangely, he seems not to have appreciated the brightly chequered skirt in which Edith Schiele had originally been portrayed, and asked Schiele to overpaint this part of the picture in the more sombre colour with which we are familiar today. Edith, together with her

206. (*right*) Egon Schiele: *Dr Franz Martin Haberditzl,* 1918. Oil on canvas, 140.5 × 110 cm. Vienna, Private Collection

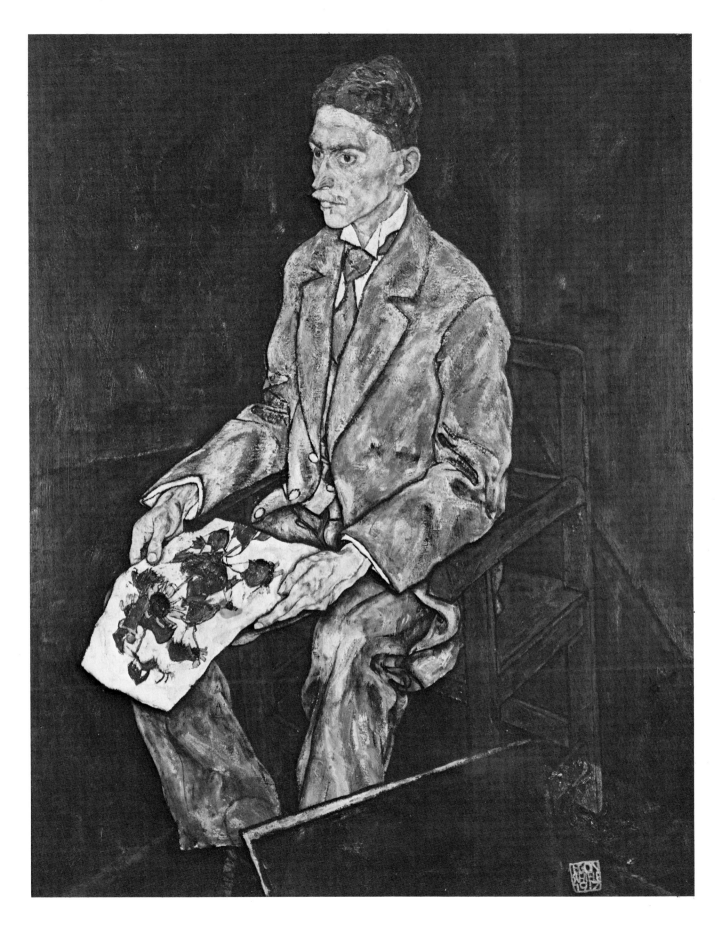

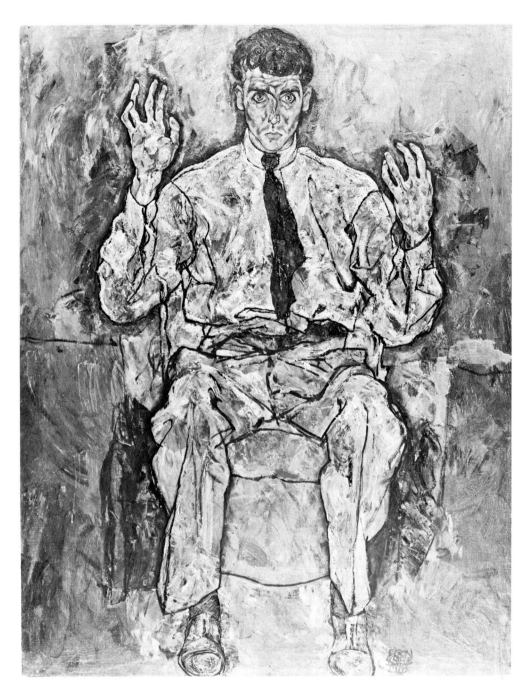

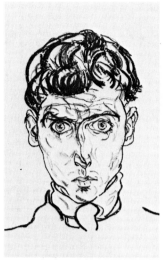

208. (*above*) Egon Schiele: *Study for the Portrait of Paris von Gütersloh*. Lithograph. Vienna, Historisches Museum der Stadt Wien

207. (*left*) Egon Schiele: *Paris von Gütersloh*, 1918. Oil on canvas, 140.5 × 110 cm. Minneapolis, Institute of Arts

sister Adele, also became the subject of a number of the most beautiful of all her husband's portrait drawings (Plate 210), to which, on occasion, an air of haunting melancholy attaches—perhaps, ironically, even a sense of impending loss.

It is tempting to infer some causal connection between the happiness and stability of Schiele's private life and the nature of his art during this last period. Marriage gave Schiele, the most lonely of men, something which had been lacking during all his earlier incessant wanderings: a sense of security, a feeling of belonging. This feeling is expressed with particular poignancy in one of his last paintings, *The Family* (Plate 209), in which, subordinated to a complex compositional schema, Schiele has portrayed himself, his wife, and—an extraordinary intimation

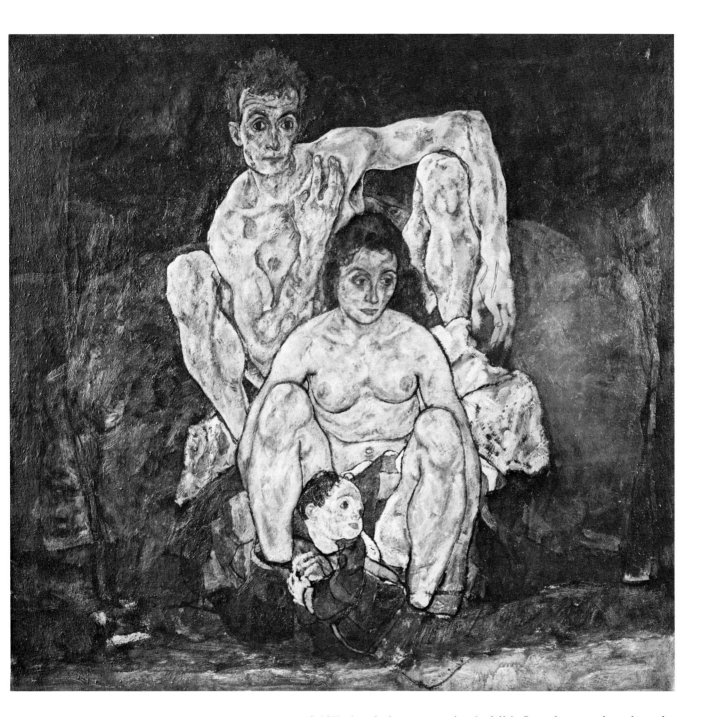

209. Egon Schiele: *The Family*, 1918. Oil on canvas, 152.5 × 162.5 cm. Vienna, Oesterreichische Galerie

of desires as yet unfulfilled—their unconceived child. In other works, also, the treatment of subject-matter is interesting. Gone are the tortured, emaciated nudes, the blues and reds of their bodies reminiscent of flayed carcases. The absorbing interest in sexuality, on the other hand, remains, sometimes expressed in a more muted fashion, as in certain of Schiele's studies of himself embracing his wife (Plate 211), sometimes flaring up again with the original intensity. Edith herself, Schiele's 'good angel', appears as the model in one of the most unashamedly erotic of all his later paintings, the *Recumbent Woman* of 1917 (Plate 212), her legs spread wide, her genitals exposed. The obviousness of the sexual imagery cannot, however, conceal the carefully constructed symmetry of the

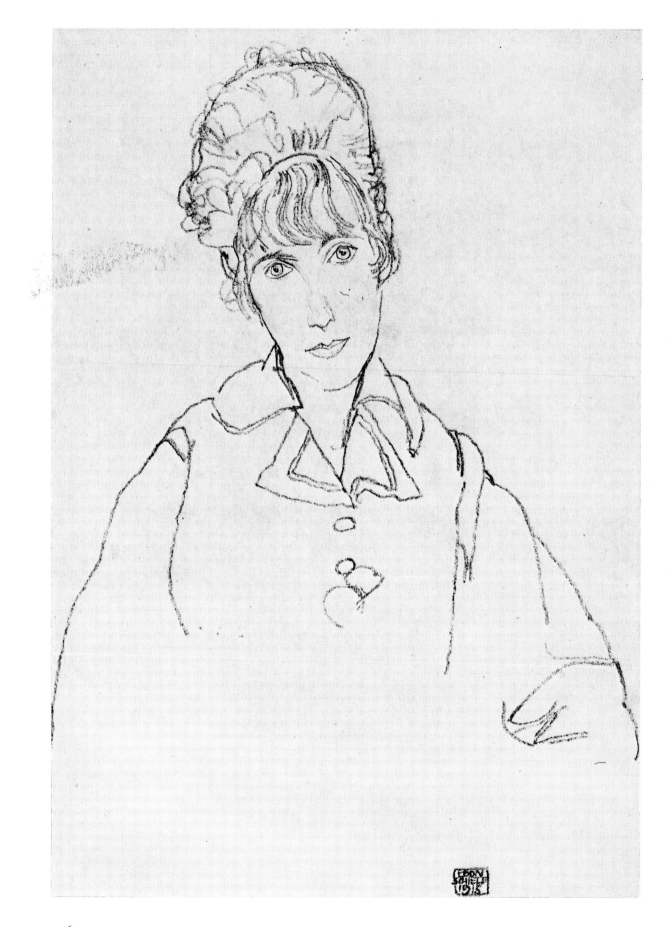

composition. In this respect, the *Recumbent Woman* is characteristic of much of Schiele's later work. This search for balance and symmetry, an even greater emphasis upon geometry, and a far more structural use of colour and brush-stroke, contrast with the nervousness and intensity of line, the angular distortions which mark out his paintings of the pre-war period, although these characteristics, too, were never entirely to disappear from his art.

The more congenial circumstances of Schiele's employment after the beginning of 1917 enabled him once again to devote his energies to working for exhibitions, and to plans aimed at resuscitating the artistic life of war-bound Vienna. In the course of 1917, he exhibited, as in previous years, at the Munich Secession, and sent contributions to shows as far afield as Copenhagen, Stockholm, and Amsterdam. There were also plans for a new organization, called 'Kunsthalle', whose aim was 'to unite young, independent people with the intention of gathering together those forces from all realms of art which have been scattered by the war . . . to give visual artists, poets and musicians the opportunity of reaching a public which, like themselves, is prepared to fight against the ever-growing cultural dissolution'.[8] Schiele appears to have been active in trying to drum up support for this new venture, and in fact succeeded in enlisting quite a collection of notables, among them Klimt, Hoffmann, Hanak, Altenberg and Schoenberg. The increasing gravity of Austria's military situation, however, prevented anything from coming of all these plans. The war, in fact, cast a blight upon all activity, and the artists of the Austrian *avant-garde* were, for the most part, incapable of breaking out of the circle of isolation which surrounded them.

Towards the end of the same year, 1917, came the first rumours of an end to the fighting. On a page of his notebook, datable to the end of September, Klimt scrawled the single word '*Friede?*'—'peace?'[9] The rumours were false. Christmas came and went, with Klimt's customary visit to the Primavesi family in Olmütz, and the New Year dawned with the armed forces of Europe still locked more in exhaustion than in combat. The peace, when it came, was to be for Klimt too late.

Nineteen-eighteen, that *annus terribilis* which at last saw an end to the war, but also death for hundreds of thousands of victims of starvation and disease, reaped a terrible harvest among the leading artists of the modern Viennese movement. At the beginning of the year, Klimt died from the after-effects of a stroke. Wagner died in April, from erisypelas, Moser in October, from cancer of the jaw. Schiele died in the same month from Spanish influenza. It was the end of an era.

Klimt, who had always dreaded being struck down by an early heart attack like that which had killed his father, suffered a thrombosis on the morning of 11 January, while he was dressing. Still reeling, he managed to gasp the words: 'Call Emilie!' Paralysed in his right side, he was taken to a clinic in Vienna's ninth district. A lung infection, the consequence of that same 'flu epidemic which claimed so many whose resistance was shattered by the privations of war, hastened his end. He died on 6 February. On that day, Otto Wagner, who still wrote letters to the dead wife whom he so deeply missed, had already closed his epistle with an account of the latest events. When he heard the news, he reopened the letter and began afresh: 'I must write again. Something terrible has happened.

211. (*above*) Egon Schiele: *Study of himself embracing his Wife*, 1915

210. (*left*) Egon Schiele: *Portrait drawing of Edith Schiele*, 1915. Vienna, Albertina

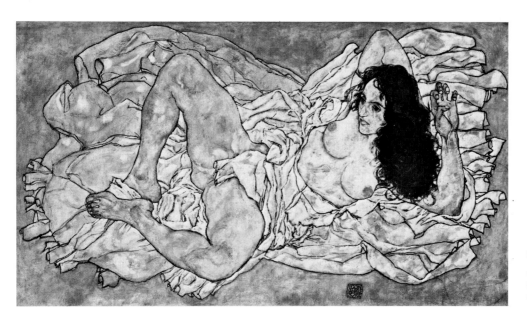

212 (*left*) Egon Schiele:
Recumbent Woman, 1917.
Oil on canvas, 96 × 171 cm.
Vienna, Dr Rudolf Leopold

Klimt is dead! If only this stupid world knew what it has lost today!'[10] And Hoffmann, one of Klimt's closest friends, wrote in dismay to Primavesi:

I don't think I shall ever get over Klimt's death. I must confess, I am really beside myself. It has happened once already that I lost one of my friends, Olbrich, just as unexpectedly, and I still experience that loss even today. For me, the world is out of joint. I feel as if I am left hanging in the air, as if the ground has been taken away from under my feet.[11]

The following month, at the forty-ninth exhibition of the Secession, Schiele at last enjoyed the triumph he had so long been denied. The exhibition was devoted entirely to the work of himself and his friends:[12] Faistauer, Jungnickel, Merkel, Gütersloh, Melzer, Kubin, Peschka. Schiele himself showed nineteen paintings and a number of watercolours and drawings. The paintings included nearly all his important large-scale works of the immediately preceding years: *The Family*, *Recumbent Woman*, *Mother with Two Children* (Plate 213), *Death and the Maiden* (Plate 215), and the portrait of Edith, seated. Other portraits included those of Karl Grünwald, Johann Harms, and Ritter von Bauer, the industrialist and land-owner. There were also several townscapes, among them a number of later views of Krumau, which are distinguished from Schiele's earlier treatments of the same subject by their even greater complexity, and the pronounced emphasis on line (Plate 214). The exhibition was the artist's first major public success in Vienna. Roessler wrote in the *Arbeiter-Zeitung* on 23 March 1918: 'Fate has decreed that he should become famous, not merely notorious, in his own lifetime. For Vienna, an unthinkable occurrence.'[13]

Other shows followed. In May, Schiele sent paintings and studies to the large exhibition 'A Century of Viennese Painting', held at the Kunsthaus in Zürich. The Secession invited him to participate in their exhibition of portraits, which was scheduled for the autumn; there were also plans for exhibitions in Prague and Wiesbaden. In June, Schiele once again showed a collection of drawings at the Galerie Arnot, his last appearance in Vienna before his death. The extent to

213. (*right*) Egon Schiele:
Mother with Two Children,
1915–17. Oil on canvas,
150 × 159 cm. Vienna,
Oesterreichische Galerie

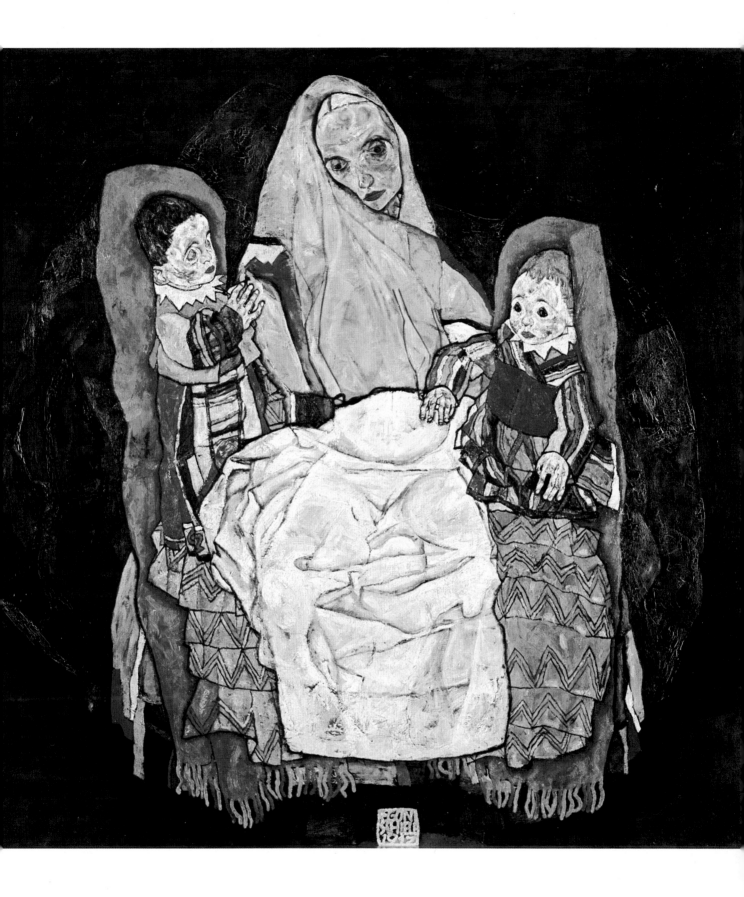

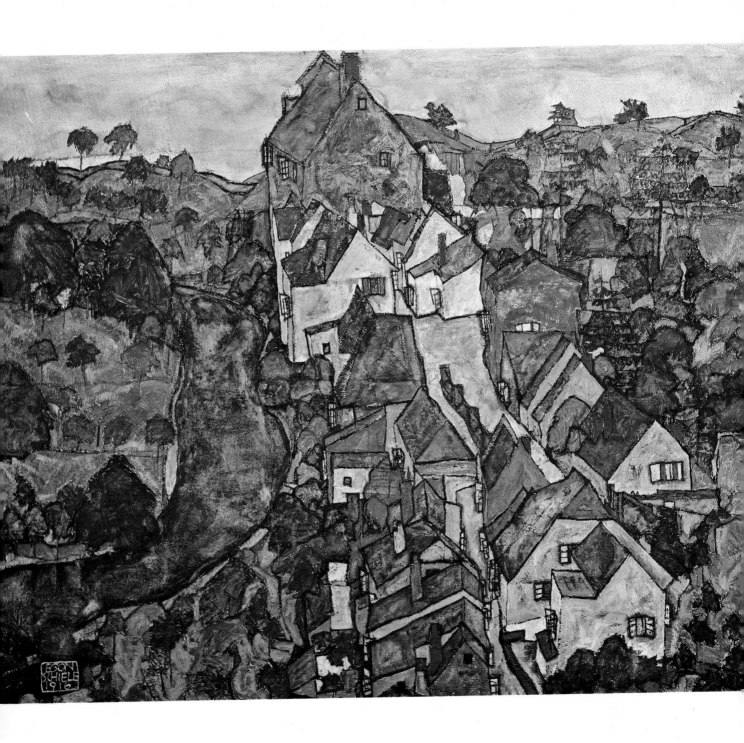

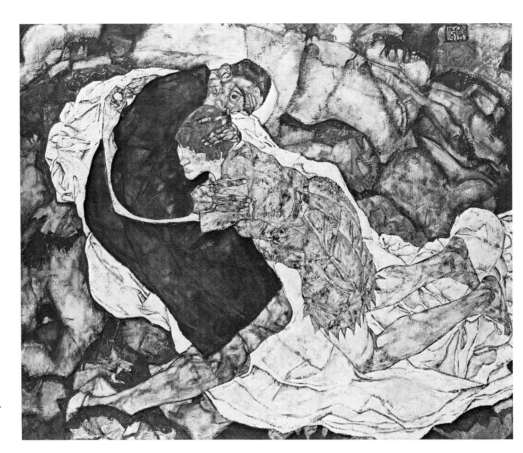

215. (right) Egon Schiele:
Death and the Maiden, 1915.
Oil on canvas, 150.5 × 180 cm.
Vienna, Oesterreichische
Galerie

which he had arrived may be judged from the review written by the usually conservative Seligmann in the *Neue Freie Presse*:

It is always a pleasure to look at drawings by Egon Schiele. Superb how, while completely renouncing light and shade, tone and colour, the entire life, the whole expression of the subject appears captured in the contour alone.[14]

Schiele had all too little time to savour the belated recognition of his art. On 19 October, his wife was laid low with Spanish influenza. Her condition worsened. As she lay racked with fever, she managed to write a few lines on a sheet of paper: 'I love you so much . . . my love for you is beyond all bounds, beyond all measure.'[15] The following day, Schiele telephoned Hans Rosé in a state of utter despair. Edith was dead.[16] Three days later, he himself succumbed to the same epidemic. Roessler, his constant biographer, recorded what purport to be his last words:

On earth . . . perhaps mankind will now be free. I must leave. Dying is both sad and difficult. And yet no more difficult than life, my life, attacked by so many people. Sooner or later, when I am dead, they will revere me, and admire my art. Will they do so in the same measure as they formerly reviled me, scorned and rejected my work? Such misunderstandings will always happen, with me and with others. What does it matter?[17]

214. (left) Egon Schiele:
Landscape at Krumau,
1916. Oil on canvas,
110 × 140.5 cm. Linz, Neue
Galerie, Wolfgang Gurlitt
Museum

NOTES

Every effort has been made to ensure the accuracy of the notes, but unfortunately it has not always proved possible to verify the source of certain quotations. In particular, a number of the manuscripts and newspaper cuttings preserved among the Ankwicz-Kleehoven papers, one of the richest collections of documentary material relating to this period, are either in a fragmentary state or else, in the case of some of the cuttings, are filed without any indication as to their date. The author would welcome any information which would supplement these incomplete references, and any corrections; all such contributions will be gratefully acknowledged in any future edition of this book.

All translations are by the author unless otherwise noted.

Chapter I

1. Robert Musil, *Der Mann ohne Eigenschaften*. English translation, *The Man without Qualities*, London 1953, p. 32.
2. On the political history of this period, see further Carl E. Schorske, 'Politics in a New Key: An Austrian Triptych', *Journal of Modern History*, XXXIV, No. 4 (December 1967), p. 343f.
3. Stefan Zweig, *Die Welt von Gestern*, Frankfurt (Fischer Verlag) 1970, p. 15.
4. Gerhard Fritsch, 'Die Wirbel der Sprache führen ins Bodenlose', in G. Fritsch and O. Breicha, *Finale und Auftakt: Wien, 1898–1914*, Salzburg 1964, p. 9.
5. Zweig, p. 14.
6. Hermann Bahr, 'Die Moderne' in *Die Überwindung des Naturalismus (Studien zur Kritik der Moderne, zweite Reihe)*, Dresden 1891, pp. 3–4.
7. *Man without Qualities*, p. 8.
8. Those who have written about Vienna at this time have, for the most part, agreed as to the important role played by the coffee-house as a forum for discussion. Thus Bruno Walter, for example, recalled: 'Events of cultural or historic importance, serious political and scientific discussions

took place there . . . they were a hive of endless intrigue and gossip. . . . I think it would not be wrong to say that the period after the turn of the century until the outbreak of the Great War in Austria was a time when conversation was on a very high cultural level. . . . The period of fine letter writing, of sensitive and spirited literary confession was over, but conversation flowered. When I think of the satirist Karl Kraus and his circle, of which the poet Alfred Polgar was an outstanding member, and of the exceptional poet Peter Altenberg and his friends in the Café Central, I have to admit the part played by the Viennese coffee-house in the stimulation of conversational genius'. (Bruno Walter, *Theme and Variations*, London/New York 1947; quoted after J. P. Hodin, *Kokoschka, the Artist and his Time*, London 1966, p. 77.)
9. Otto Friedländer, *Letzter Glanz der Märchenstadt*, Vienna 1969, p. 69.
10. Zweig, p. 70
11. ibid. p. 62.
12. Friedländer, p. 329.
13. ibid. p. 32.
14. Ch. M. Nebehay, *Gustav Klimt, Dokumentation*, Vienna 1969, p. 224, n. 14.
15. 'Otto Wagner zum 70. Geburtstag', reprinted in H. Bahr, *Kulturprofil der Jahrhundertwende: Essays*, ed. H. Kindermann, Vienna 1962, p. 283f.
16. Hodin, op. cit. p. 78.
17. Alma Mahler, *Gustav Mahler, Memories and Letters*, ed. Donald Mitchell, enlarged edition London 1973, pp. 111–12.
18. Willi Reich, *Schönberg, oder, Der konservative Revolutionär*, Vienna 1968, p. 101
19. 'Otto Wagner zum 70. Geburtstag', *Essays*, p. 284.
20. Mahler to Mengelberg, August 1906.

Chapter II

1. Griepenkerl, Christian (1839–1916), from 1874 professor, after 1877 head of the Special School for History Painting at the Academy.

2. For the history of the *Genossenschaft* see Rudolf Schmidt, *Das Wiener Künstlerhaus 1861–1951*, Vienna 1951.

3. See further Hans Ankwicz von Kleehoven, 'Die Anfänge der Wiener Secession', *Alte und Moderne Kunst*, V (1960), June–July, p. 6f; also Walter Maria Neuwirth, 'Die sieben heroischen Jahre der Wiener Moderne', ibid. IX (1964), May–June, p. 28f. The *Hagenbund* which, under the leadership of Heinrich Lefler and Joseph Urban, withdrew from the Künstlerhaus on 29 November 1900, later organized a series of exhibitions in Vienna's Zedlitzhalle, of which the first took place in January 1902.

4. Neuwirth, op. cit.

5. Reprinted in the volume *Secession*, Vienna 1900, p. 11f.

6. The name 'Secession' derives from the *secessio plebis* of Roman antiquity. During the 1890s the term was used, at least in the German-speaking countries, to refer to an independent, autonomous association of artists, usually an exhibiting society. There were three principal organizations of this name: in Vienna, Munich and Berlin. The Munich Secession, under the presidency of Franz von Stuck, was the oldest, and generally speaking the most conservative. The Berlin Secession later produced two mutually-hostile offshoots which styled themselves the 'neue Secession' and the 'freie Secession'.

7. This letter is reprinted in full by Nebehay, op. cit. p. 135.

8. Hevesi, 'Weiteres zur Klimt-Ausstellung', reprinted in the volume *Acht Jahre Secession*, Vienna 1906, p. 450.

9. Moll's stepdaughter, Alma Maria Schindler, married Gustav Mahler on 9 March 1902. Moll himself was a many-sided personality. One of the most active founder-members of the Secession, he later became artistic director of the Galerie Miethke; he also owned an extensive collection of Renaissance and pre-Renaissance art, part of which was auctioned by the art-dealer Cassirer in March 1917. As an Impressionist painter, the critic Arthur Roessler wrote of him: 'Carl Moll is neither a mystic nor a psychologist, neither an epic painter nor a romantic. He seeks not a beauty which lies beyond the reality of this world, but one which he espies and feels in the sensory perception of natural appearances. Imagination in painting is for him something suspect; not only the chaotic, misty cosmology of the romantics, but also the cerebral constructions of the painter-mathematicians is completely foreign to him, although he knows well that experience and its representation are two fundamentally different things.' (A. Roessler, 'Carl Moll', *Oesterreichische Kunst*, 4 (1931), p. 11f.)

10. *Ver Sacrum*, I (1898), i, p. 6.

11. ibid. p. 27.

12. Josef Engelhart, *Ein Wiener Maler Erzählt*, Vienna 1943, pp. 79–80.

13. ibid. pp. 80–1.

14. Bahr, *Secession*, p. 25.

15. *Ver Sacrum*, I (1898), viii, p. 24.

16. *Secession*, p. 15.

17. Engelhart, p. 80.

18. See Robert J. Clark, 'Olbrich and Vienna', *Kunst in Hessen und am Mittelrhein*, Heft 7 (1967), pp. 38–9.

19. *Ver Sacrum*, I (1898), i, under *Mitteilungen*.

20. Arthur Roessler, *Der Malkasten—Künstleranekdoten*, Vienna 1924, pp. 132–3.

21. Bahr, 'Meister Olbrich', *Secession*, Vienna 1900, p. 60.

22. Hevesi, *Acht Jahre Secession*, pp. 63–72.

23. *Vereinigung bildender Künstler Oesterreichs, Katalog . . .* (of the second exhibition), November–December 1898.

24. *Secession*, p. 83.

25. ibid. p. 34.

26. 'Weshalb wir eine Zeitschrift herausgeben?', *Ver Sacrum*, I (1898), i, p. 7.

27. Hevesi, 'Zwei Jahre Secession', *Ver Sacrum*, II (1899), vii, p. 3.

28. 'Otto Wagner', *Secession*, pp. 110–11.

29. 'Mein Werdegang', *Velhagen und Klasings Monatshefte*, 31, ii (Oct 1916), p. 17.

30. The first number of *Ver Sacrum* appeared in January 1898; the journal ceased publication at the end of 1903. The first editor was Wilhelm Schölermann, the second Roller; later, *Ver Sacrum* was edited by a committee of four or five members of the Secession. Klimt was a member of the editorial committee during 1900.

31. An article by Schölermann on graphic design and book illustration appeared in the September issue of *Ver Sacrum*, 1898. Of particular interest is his account of the relationship between textual and illustra-

tive material; the author describes for example the use of the decorative border as 'at once ornament, decoration, and yet at the same time a sensible, profound allegory in line and colour, which surrounds the actual work, distinguishing it from its environment.... The illustrative artist must follow the poet as the harp-player accompanies the singer. He can strike the introductory chord in major or minor with a tastefully chosen headpiece; accompanying him then in a pleasingly flattering manner, up and down the scale of feeling, creating a web of arabesque, at times more obtrusive, at other times silent, finally to die away questioningly, nostalgically in the full, bright, final chord, or in a gentle unison. This is the essence of book illustration in the modern sense. Or better: in an artistic sense in general'. (W. Sch., 'Buchschmuck', *Ver Sacrum*, I, ix, p. 25f.)

32. From an article by Paul Kühn, printed in the catalogue of the third exhibition.

33. Engelhart, pp. 82–3.

34. Strasser's *Mark Antony* was one of the few important works of Austrian sculpture from the early years of the Secession. Only a handful of the Secessionists themselves were exclusively sculptors by profession, and although sculpture was shown at many of the early exhibitions, it was more often works by corresponding members from abroad—Rodin, Klinger, Minne—which predominated. The lack of any considerable body of sculptural work which might rival the productions of the painters and applied artists is one of the curious features of Viennese *Art Nouveau* generally, although mention might be made of the famous *Mozart-Brunnen* (1905) by Karl Wollek, or the monument to the Empress Elizabeth (1907) by Bitterlich and Ohmann. Also worthy of note is the sculptor Richard Luksch, who created the monumental seated figures which surmount the façade of Wagner's church 'am Steinhof'; and the acroteria which are the crowning motif of Wagner's Post Office Savings Bank, designed by the Secessionist Othmar Schimkowitz, who also collaborated on the decoration of the *Majolika-Haus* (see p. 100).

35. Engelhart, 'Ein Bericht an den Arbeits-ausschuss', *Ver Sacrum*, III (1900), i.

36. An important contribution to the catalogue was the accompanying note by Adolf Fischer, *Der japanische Holzfarbendruck, Geleitswort zur Ausstellung der Vereinigung bildender Künstler Oesterreichs (Secession)*, Vienna 1900.

37. See below, chapter v, p. 226 and n. 5.

38. For the complete history of the commission see the essay by Alice Strobl, 'Zu den Fakultätsbildern von Gustav Klimt', *Albertina Studien*, II (1964), Heft 4, pp. 138–69.

39. R. Muther, *Studien und Kritiken*, I, Vienna 1900, p. 57.

40. Strobl, loc cit, p. 144f.

41. *Acht Jahre Secession*, pp. 233–4.

42. *Die Kunst für Alle*, XV (1900), p. 500.

43. H. Bahr, *Gegen Klimt*, Vienna 1903.

44. *Die Fackel*, 1900, No. 36.

45. *Studien und Kritiken*, p. 58.

46. *Ver Sacrum*, III (1900), x.

47. H. Bahr, *Rede über Klimt*, Vienna 1901, pp. 3–4.

48. Felix Salten, 'Gustav Klimt', in *Geister der Zeit—Erlebnisse*, Vienna 1924, pp. 42–3.

49. 'All the same, we are somewhat nervous. Will he be able to remain on the same level, to equal the earlier picture? He has not only equalled it, he has surpassed it. *Medicine* is still greater, purer, more free. And what happens? The same witch-hunt begins again, only this time even wilder, more vicious, more shameful.' (Bahr, *Rede über Klimt*, p. 5.)

50. *Ver Sacrum*, IV (1901), p. 158f.

51. Bahr, *Gegen Klimt*.

52. Reprinted in Fritz Karpfen, *Oesterreichische Kunst*, Leipzig—Vienna 1923, p. 25.

53. Undated typescript in the Bibliothek der Stadt Wien, Inv. Nr. 152980; reprinted by Nebehay, op. cit. p. 32.

54. 'Kunst und Kultur—Erinnerungen an Klimt' (fragment); Oesterreichische Galerie Vienna, Nachlass Hofrat Ankwicz von Kleehoven.

55. Strobl, p. 162.

56. Secession, *Hausarchiv*.

57. *Ver Sacrum*, III (1900), p. 343.

58. Secession, *Hausarchiv*.

59. *Acht Jahre Secession*, p. 288.

60. See Eduard F. Sekler, 'Mackintosh and Vienna', *Architectural Review*, CXLIV (December 1968), pp. 455–6.

61. *Vereinigung bildender Künstler Oesterreichs, Katalog ...* (of the tenth exhibition), Vienna 1901.

62. *Studio*, XXV (1902), p. 267.
63. ibid. p. 268.
64. *Vereinigung bildender Künstler Oesterreichs, Katalog . . .* (of the fourteenth exhibition), *Katalogvorwort von E. Stöhr*, Vienna 1902.
65. 'Klingers Beethoven und die moderne Raum-kunst', *Deutsche Kunst und Dekoration*, X (1902), p. 477.
66. Felix Salten, 'Erinnerungen an Klimt', *Neue Freie Presse*, 18 October 1936, p. 1.
67. 'Klingers Beethoven und die moderne Raum-Kunst', loc. cit. p. 476.
68. ibid. p. 479.
69. *Acht Jahre Secession*, p. 391f.
70. Nebehay, pp. 299–300, nn. 8a and 8d.
71. *Kurier*, 10 May 1972; P. Vergo, 'Gustav Klimt's Beethoven Frieze', *Burlington Magazine*, No. 839, vol. CXV (Feb 1973), pp. 109–13.
72. *Vereinigung bildender Künstler Oesterreichs, Katalog . . .* (of the fourteenth exhibition), Vienna 1902.
73. *Acht Jahre Secession*, p. 283.
74. R. Wagner, *Beethoven* (1870), quoted by Johannes Dobai, 'Zu Gustav Klimts Gemälde "Der Kuss"', *Mitteilungen der Oesterreichischen Galerie*, XII, No. 56 (1968), p. 108 and n. 131.
75. Hevesi, loc. cit.
76. See Jaroslav Leshko, 'Klimt, Kokoschka und die Mykenischen Funde', *Mitteilungen der Oesterreichischen Galerie*, XIII (1969), p. 16f.
77. Ferdinand Hodler, interview with Else Spiegel, 1905, reprinted in Hans Ankwicz von Kleehoven, 'Ferdinand Hodler und Wien', *Neujahrsblatt der Zürcher Kunstgesellschaft*, 1950, p. 15.
78. *Vereinigung bildender Künstler Oesterreichs, Katalog . . .* (of the sixteenth exhibition), Vienna 1903.
79. 'Address', dated 12 September 1917, for the volume *Das Werk Gustav Klimts*, Leipzig—Vienna 1918, with contributions by Hermann Bahr and Peter Altenberg.
80. *Vereinigung bildender Künstler Oesterreichs, Katalog . . .* (of the eighteenth exhibition), Vienna 1903.
81. This study was burnt in the Schloss Immendorf in 1945; it is known to us from an old photograph from Klimt's studio, reproduced by Nebehay, op. cit. fig. 441.
82. 'Zur Klimt-Ausstellung', *Acht Jahre Secession*, pp. 444–8.
83. Nebehay, p. 495.
84. 'Gustav Klimts Winterreise nach Italien . . . von W. Dessauer', *Oesterreichische Kunst*, IV (1933), pp. 11–12.
85. Reprinted in *Altkunst—Neukunst*, p. 210f.
86. *Die Fackel*, 21 September 1903.
87. Engelhart, p. 124.

Chapter III

1. Hevesi, 'Zwei Jahre Secession', loc. cit.
2. *Wiener Zeitung*, Friday, 25 December 1857.
3. Quoted after W. Mrazek and R. Feuchtmüller, *Kunst in Oesterreich, 1860–1918*, Vienna 1964, p. 6.
4. J. A. Lux, *Otto Wagner*, Munich 1914, p. 53.
5. O. Wagner, *Moderne Architektur*, Vienna 1896, p. 31.
6. *Secession*, p. 109.
7. 'Otto Wagner zum 70. Geburtstag', reprinted in *Essays*, loc. cit. pp. 283, 285.
8. ibid. pp. 284–5.
9. Thus, for example, H. Fischel in *Bildende Künstler*, 1911, Heft 7: 'If we look at his *oeuvre* as a whole, we realize that at every stage his work was advanced, epoch-making, and that many of the things which today appear to us outmoded then produced a new and startling effect' (p. 299).
10. Josef Hoffmann, 'Rede über Otto Wagner', *Jahrbuch der Gesellschaft österreichischer Architekten*, 1910; this speech was delivered by Hoffmann on 4 January 1910 as part of the campaign in support of Wagner's design for the Kaiser-Franz-Josef-Museum on the Karlsplatz (see below, pp. 112–14).
11. Lux, pp. 9–10.
12. O. Wagner, *Einige Skizzen, Projekte und ausgeführte Bauwerke*, Vienna 1892 and subsequent volumes.
13. Lux, p. 56. Hans Tietze, in an article 'Otto Wagner zum 70. Geburtstag' (*Fremdenblatt*, 13 August 1911) remarked: 'Wagner may have declared that these stylistic experiments left him virtually untouched, but his buildings show what in 1899 one understood by "virtually untouched". For his designs for a Russian Embassy in Vienna, for an apartment block in the Stadiongasse (1879) . . . and the house Stadiongasse 6–8 show, in their handling of the exterior, a wealth of indications of their dependence

upon the architecture of the High and Late Renaissance.'

14. Lux, pp. 57–8.

15. ibid. p. 137.

16. *Moderne Architektur*, p. 37.

17. O. Wagner, *Erläuterungsbericht zum Entwurfe für den Generalregulierungsplan über das gesammte Gemeindegebiet von Wien*, Vienna (2nd edition) 1894, p. 14f.

18. ibid. p. 66f.

19. H. Geretsegger and M. Peintner, *Otto Wagner*, English edition London 1970, p. 82.

20. Lux, *Otto Wagner*, Munich 1914, p. 65.

21. For a detailed description of the Stadtbahn project, see Geretsegger & Peintner, op. cit. pp. 47–78.

22. Lux, p. 11.

23. ibid. p. 61.

24. On the relation between Olbrich and Wagner see Robert J. Clark, 'Olbrich and Vienna', *Kunst in Hessen und am Mittelrhein*, Heft 7, 1967; also the same author's unpublished dissertation, 'Joseph Maria Olbrich and Vienna', University of Princeton, 1973.

25. Lux, p. 67.

26. ibid. pp. 70–1.

27. Hevesi, *Altkunst—Neukunst*, Vienna 1909, p. 246.

28. 'Der Neubau der Postsparkasse', *Altkunst—Neukunst*, Vienna 1909, pp. 245–8.

29. Geretsegger—Peintner, p. 207.

30. According to Christian M. Nebehay, in the catalogue *Kolo Moser . . . im Verlag Ch. M. Nebehay*, Vienna, June—July 1971, note following entry 82.

31. Geretsegger—Peintner, p. 206.

32. Lux, p. 76.

33. ibid. p. 78.

34. ibid. pp. 76–7.

35. Geretsegger—Peintner, p. 18.

36. *Neues Wiener Tagblatt*, ? i. 1910 (Oesterreichische Galerie, Vienna, Nachlass Hofrat Ankwicz von Kleehoven).

37. Lux, p. 8.

38. 'Mein Werdegang', *Velhagen und Klasings Monatshefte*, 31, ii (October 1916), p. 262.

39. 'Otto Wagners moderne Kirche', *Altkunst—Neukunst*, p. 251.

40. The Geschäftshaus Philipp Haas, now destroyed, was built on Vienna's Stock-im-Eisen Platz by the architects Siccardsburg and van der Null. It was interesting for its day in that, behind its historicizing façade, the building was supported upon a cast-iron framework.

41. On Olbrich's early career see Clark, 'Olbrich and Vienna', loc. cit. and dissertation.

42. O. Wagner, 'Nachruf auf Joseph M. Olbrich', *Hohe Warte*, IV (1908), Heft 17, pp. 257–8.

43. *idem*.

44. Clark, 'Olbrich and Vienna', p. 32 and n. 43.

45. Professor Clark, with whom I have discussed the drawing for the Westbahnhof station, informs me that in his opinion it was undoubtedly executed by Olbrich, although it clearly reflects Wagner's own conception; in which case, this drawing may with some certainty be attributed to the first months of Olbrich's collaboration on the Stadtbahn project. The contrast with Olbrich's later drawings for a number of station buildings in which he was able to give free rein to his own fantasy is thus all the more striking.

46. *Secession*, pp. v–vi.

47. Clark, pp. 37–8.

48. Carl Schreder, 'Zweite Kunstausstellung der Secession', *Deutsches Volksblatt*, 19 November 1898, p. 1.

49. 'Das Haus der Secession', *Ver Sacrum*, II (1899), i, p. 6f.

50. *Acht Jahre Secession*, p. 63f.

51. R. Muther, *Studien und Kritiken*, I, Vienna 1900, p. 9.

52. *Secession*, p. 61.

53. J. M. Olbrich, 'Das Haus der Secession', *Der Architect*, V (January 1899), p. 5.

54. *Acht Jahre Secession*, p. 512f.

55. Quoted after Clark, op. cit. p. 48.

56. O. Wagner, 'Nachruf auf Joseph M. Olbrich', loc. cit. p. 258.

57. Clark, p. 48.

58. *Altkunst—Neukunst*, pp. 217–18.

59. Josef Hoffmann, 'Selbstbiographie', *Ver Sacrum (Neue Folge)*, Jg. 1972, p. 110.

60. 'Das Haus der Secession', *Fremdenblatt*, 11 November 1898, pp. 13–14.

61. 'Neubauten von Josef Hoffmann, *Altkunst—Neukunst*, pp. 218–20.

62. 'Zwei Jahre Secession', *Ver Sacrum*, II (1899), vii, p. 3f.

63. Oskar Kokoschka, *Mein Leben*, Munich 1971, p. 49.

64. Adolf Loos, 'Wanderungen im Oester-

reichischen Museum', *Neue Freie Presse*, 27 November 1898.

65. 'Das Scala-theater in Wien', *Die Wage*, 1898, Heft 45, p. 749.

66. *Der Architekt*, III (1897), p. 13.

67. Quoted after Mrazek und Feuchtmüller, *Kunst in Oesterreich, 1860–1918*, Vienna 1964, p. 110.

68. A. S. Levetus, 'The Wiener Werkstätte', *Studio*, LII (1911), p. 187.

69. Published by E. Sekler, 'Mackintosh and Vienna', *Architectural Review*, CXLIV (December 1968), p. 456, n. 12.

70. ibid.

71. 'Das Arbeitsprogramm der Wiener Werkstätte', *Hohe Warte*, I (1904–5), No. 15, p. 267.

72. MS. of a lecture delivered in Vienna, 27 June 1926; Oesterreichische Galerie, Vienna, Nachlass Hofrat Ankwicz von Kleehoven.

73. Quoted after N. Pevsner, *Pioneers of Modern Design*, Harmondsworth 1960, p. 23.

74. *The Collected Works of William Morris*, London 1915, XXIII, p. 147.

75. 'Arbeitsprogramm . . .', loc. cit.

76. I have followed the account given by Ankwicz von Kleehoven in an unpublished lecture, preserved in the archives of the Oesterreichische Galerie.

77. Hoffmann, 'Selbstbiographie', p. 111.

78. 'Mein Werdegang', loc. cit. p. 259.

79. 'Neubauten von Josef Hoffmann', *Altkunst—Neukunst*, p. 216.

80. ibid. pp. 216–17.

81. ibid. pp. 215–16.

82. 'Haus Wärndorfer', *Altkunst—Neukunst*, p. 223.

83. 'Vom gedeckten Tisch', ibid. p. 227.

84. 'Haus Wärndorfer', ibid. p. 222.

85. 'The Wiener Werkstätte', *Studio*, LII (1911), p. 195.

86. 'Selbstbiographie', p. 112.

87. 'Mein Werdegang', loc. cit. p. 254.

88. The invitation is preserved among the Ankwicz-Kleehoven papers. The Grand Duchess Elizaveta Fedorovna, wife of the Grand Duke Sergius and a princess of Darmstadt-Hesse, was a well-known protectress of the arts in Russia. Both Olbrich and Mackintosh participated in this exhibition.

89. *Altkunst—Neukunst*, p. 229.

90. On 9 September 1905.

91. Published in 1905 as vol. 22 of *Gerlachs Jugendbücherei*.

92. *Zur Feier des einhundertjährigen Bestandes der k.k. Hof- und Staatsdruckerei*, Vienna 1904.

93. *Altkunst—Neukunst*, pp. 228–9.

94. *Allocution de M. Jacques Stoclet, séance académique . . . en hommage au professeur Hoffmann et à la mémoire de Monsieur Stoclet*, given at the Palais Stoclet, Brussels, 4 October 1955.

95. 'Selbstbiographie', p. 116.

96. *Allocution de M. Jacques Stoclet*

97. On the design and building history of the Stoclet House, see Eduard F. Sekler, 'The Stoclet House by Josef Hoffmann', *Essays in the History of Architecture presented to Rudolf Wittkower*, London 1967, pp. 228–44.

98. 'Neubauten von Josef Hoffmann', *Altkunst—Neukunst*, p. 221.

99. Sekler, p. 228.

100. 'Neubauten von Josef Hoffmann', *Altkunst—Neukunst*, p. 221.

101. 'Haus Wärndorfer', ibid. p. 227.

102. 'Selbstbiographie', p. 116.

103. 'Gustav Klimt und die Malmosaik', *Altkunst—Neukunst*, p. 210f.

104. *Kunst in Oesterreich, 1860–1918*, p. 114.

105. 'Selbstbiographie', p. 118.

106. Wolfgang Fischer, 'Kokoschka's early work', *Studio International*, CLXXXI, No. 929 (January 1971), p. 4.

107. 'Kabarett Fledermaus', *Altkunst—Neukunst*, pp. 242–3.

108. 'C. O. Czeschka', ibid. p. 236.

109. ibid. p. 239.

110. 'Mein Werdegang', loc. cit. p. 260.

111. ibid. pp. 260–1.

112. Max Mell, *Alfred Roller*, Vienna 1922, p. 20.

113. ibid. p. 22.

114. Quoted after Kurt Blaukopf, *Gustav Mahler, oder, Der Zeitgenosse der Zukunft*, Vienna 1969, p. 208.

115. Mell, p. 26.

116. Blaukopf, p. 202.

117. 'Theater und Kunst', *Neues Wiener Tagblatt*, 5 October 1934.

118. Blaukopf, pp. 259–60.

119. On the Primavesi family and their relations with Hoffmann, Hanak, and the artists of the Secession, see Hedwig Steiner, *Anton*

Hanak, Munich 1969, and also the same author's article 'Gustav Klimts Bindung an Familie Primavesi in Olmütz, *Mährisch-Schlesische Heimat*, Jahrgang 1968, pp. 242–52.

120. 'Das Oesterreichische Haus auf der Deutschen Werkbund-Ausstellung in Köln', *Dekorative Kunst*, XVIII, 10 July 1914.

121. 'Mein Auftreten mit der Melba', *Neues Wiener Tagblatt*, 20 January 1900.

122. Loos's articles and essays were collected in two volumes, *Ins Leere Gesprochen* (best translated, perhaps, as *Upon Deaf Ears*), Zürich–Paris 1921, and *Trotzdem* (*Nevertheless*), Innsbruck 1931. For a modern edition see Adolf Loos, *Sämtliche Schriften*, *Bd. 1*, ed. F. Glück, Vienna-Munich 1962.

123. An enthusiastic review of Wedekind's *Spring Awakening*, which Loos recommended to 'every father, every mother, every teacher', appeared in *Das Andere*, No. 2 (15 October 1903).

124. 'Kokoschka's early work', *Studio International*, January 1971, p. 5.

125. *Das Andere*, No. 2, p. 4.

126. 'Das Sitzmöbel', 19 June 1898; *Sämtliche Schriften*, p. 48.

127. 'Die Englischen Schulen im Oesterreichischen Museum', ibid. p. 171.

128. 'Die Potemkinsche Stadt', *Ver Sacrum*, I (1898), vii, p. 15f.

129. 'Kleines Intermezzo', published in *Trotzdem*, Innsbruck, 1931, reprinted in Adolf Loos, *Sämtliche Schriften*, vol. I, Vienna–Munich 1962, p. 289.

130. *Das Andere*, No. 2, pp. 1–2.

131. 'An den Ulk', *Sämtliche Schriften*, p. 288.

132. 'Vom armen reichen Manne', *Neues Wiener Tagblatt*, 26 April 1900, reprinted under the title 'Von einem armen reichen Manne' in *Sämtliche Schriften*, pp. 201–7.

133. *Das Andere*, No. 2, pp. 8–9.

134. Paul Stefan, '*Zwei Architekten*', 1930, Oesterreichische Galerie, Vienna, Nachlass Hofrat Ankwicz von Kleehoven.

135. *Das Andere*, No. 2, p. 11.

136. 'Adolf Loos', *Altkunst—Neukunst*, p. 284f.

137. 'Das Haus gegenüber der Burg', *Neue Freie Presse*, 4 December 1910.

138. 'Ornament und Verbrechen', *Sämtliche Schriften*, p. 276.

139. 'Ornament in Architecture', quoted after Pevsner, *Pioneers of Modern Design*, p. 28.

140. *Neue Freie Presse*, 6 December 1910.

141. 'Selbstbiographie', p. 116.

142. Quoted after H. Kulka, *Adolf Loos*, Vienna 1931, p. 28.

143. Quoted after Ludwig Münz and Gustav Künstler, *Adolf Loos*, English translation London 1966, p. 131.

Chapter IV

1. Reprinted in the catalogue, *Ausstellung der 'Kunstschau'*, Vienna 1908.

2. 'Kunstschau 1908', *Altkunst—Neukunst*, p. 312.

3. Nebehay, p. 425, n. 13.

4. 'Kunstschau', fragment of a newspaper review, Oesterreichische Galerie, Vienna, Nachlass Hofrat Ankwicz von Kleehoven.

5. Nebehay, p. 424, n. 12.

6. See n. 4 above.

7. 'Als die Klimtgruppe sich selbständig machte', *Neues Wiener Journal*, 10 April 1927.

8. 'Die Kunstschau 1908', *Wiener Sonn- u. Montagszeitung*, 22 June 1908.

9. 'Kunstschau 1908', *Altkunst—Neukunst*, p. 313.

10. It has been suggested, erroneously, that Kokoschka's poster *Pietà* relates either to the *first* Kunstschau (for which the artist did in fact design another poster), or to his play *Schauspiel* of 1911 (published in the volume *Oskar Kokoschka, Dramen und Bilder*, with an introduction by Paul Stefan, Leipzig 1913). In fact, the reference to the *Sommertheater der Kunstschau*, and the iconography itself, clearly connect this poster with the première of Kokoschka's drama *Murderer Hope of Women* in July 1909 (see p. 192).

11. Oskar Kokoschka, *Mein Leben*, Munich 1971, p. 55.

12. *Ver Sacrum*, IV (1901), p. 262, reproduced in Nebehay, p. 399, fig. 504.

13. *Mein Leben*, p. 52.

14. Quoted after K. H. Wörner, 'Die Glückliche Hand', *Schweizerische Musikzeitung*, Sept/Oct 1964, p. 274.

15. *Mein Leben*, p. 67.

16. Kokoschka himself related in his autobiography that the première of *Mörder* ended in a pitched battle between actors and audience, that police and troops from a certain Bosnian regiment were involved in the mêlée, and that he himself was nearly

arrested for causing a breach of the peace; he also refers to being 'torn to pieces' in the review which appeared in the *Neue Freie Presse* the following day, 5 July 1909. This story is also related by Hodin, and virtually all subsequent commentators; it does not, however, appear to be true. There is no mention of any disturbance in any of the morning papers; moreover, the review which appeared in the *Neue Freie Presse* adopted no more than a faintly patronising tone towards Kokoschka's literary début. The same review also states that the public 'greeted this drama, meant no doubt as a piece of fun, with sympathetic good-humour'. It is possible that the artist was confusing this première with some other occasion.

17. Quoted after Victor H. Miesel, *Voices of German Expressionism*, Englewood Cliffs 1970, p. 100.
18. *Mein Leben*, p. 97.
19. Quoted after J. P. Hodin, *Kokoschka, the Artist and his Time*, London 1966, p. 96f.
20. ibid. p. 114.
21. 'Die Kunstschau', *Die Zeit*, 6 June 1908.
22. Zuckerkandl, loc. cit.
23. Zuckerkandl, 'Einiges über Klimt', *Volkszeitung*, 6 February 1936.
24. Quoted after the catalogue of the Richard Strauss centenary exhibition held by the Oesterreichische Nationalbibliothek, Vienna 1964.
25. The first Austrian performance of *Salome* was given at Graz on 16 May 1906 under the composer's direction.
26. *Rede über Klimt*, Vienna 1901, pp. 12–13.
27. Zuckerkandl, 'Erinnerungen an Gustav Klimt', *Neues Wiener Journal*, 4 February 1934.
28. Quoted after W. Reich, *Arnold Schönberg*, Vienna 1968, p. 85.
29. The circumstances of Mahler's departure from Vienna have frequently been narrated, with minor variations; I have followed the account given by Kurt Blaukopf, *Gustav Mahler*, Vienna 1969, p. 259.
30. Bahr, *Essays*, Vienna 1962, p. 129.
31. Grete Helfgott, 'Egon Schiele, zu seinem 30. Todestag', *Arbeiter-Zeitung*, 31 October 1948.
32. Heinrich Benesch, *Mein Weg mit Egon Schiele*, New York 1965, p. 9.
33. Fritz Karpfen, ed., *Das Egon Schiele Buch*, Vienna 1921, p. 90.
34. ibid. pp. 85–6.
35. Anton Faistauer, *Neue Malerei in Oesterreich*, Vienna 1923.
36. *Das Egon Schiele Buch*, pp. 30–2.
37. *Neue Freie Presse*, 1 December 1909.
38. See Rudolf Leopold, *Egon Schiele—Paintings, Watercolours, Drawings*, English edition London 1973, p. 666.
39. Helfgott, loc. cit.
40. *Das Egon Schiele Buch*, p. 45.
41. Schiele's *Die Tote Mutter*, which depicts the unborn child in the mother's womb, might perhaps be regarded as prophetic of the fate of the artist's own wife, in the same ironic sense as Mahler's *Kindertotenlieder* of 1905 'foretell' the death of the composer's eldest daughter Maria Anna, on 5 July 1907.
42. Leopold, p. 15.
43. Letter to Arthur Roessler, 10 January 1911.
44. Helfgott, loc. cit.
45. Leopold, p. 15.

Chapter V

1. *Die Fackel*, XVI, No. 404 (5 December 1914), pp. 1–2.
2. *Die Fackel*, XVI, No. 405 (23 February 1915), pp. 1–2.
3. 'Meine Erinnerungen an Gustav Klimt', *Neues Wiener Tagblatt*, 24 January 1943. Kathi Fröhlich was Grillparzer's 'eternal fiancée'.
4. See Hedwig Steiner, 'Gustav Klimts Bindung an Familie Primavesi in Olmütz', *Mährisch-Schlesische Heimat*, 1968, Heft 4, pp. 242–52.
5. Perhaps the most interesting description is that left by Schiele, related by Ida Foges in her article 'Gustav Klimt, persönliche Erinnerungen von Egon Schiele': 'On entering one found oneself first of all in a vestibule, from which the left-hand door led into his reception room. In the middle stood a square table, and around the walls hung next to one another Japanese woodcuts and two rather larger Chinese paintings. Standing on the floor were a number of Negro sculptures, and in the corner beside the window a suit of Japanese armour in red and black.' (*Wiener Journal*, 4 March 1918).
6. Nebehay, p. 452.

7. Leopold, p. 16.
8. From a fragment preserved among the Ankwicz-Kleehoven papers.
9. Nebehay, p. 479.
10. Geretsegger and Peintner, *Otto Wagner*, London 1970, p. 18.
11. Steiner, 'Gustav Klimts Bindung an Familie Primavesi in Olmütz', loc. cit.
12. Not, as repeatedly stated by Kallir and others, a one-man show of Schiele's work.
13. *Arbeiter-Zeitung*, 23 March 1918.
14. Oesterreichische Galerie, Vienna, Nachlass Hofrat Ankwicz von Kleehoven.
15. This letter is reproduced in facsimile in Otto Kallir, *Egon Schiele, Oeuvre-Katalog der Gemälde*, Vienna 1966, p. 75.
16. *Egon Schiele, Drawings and Watercolours: 1909–1918*, London (Marlborough Fine Art) 1969, p. 11.
17. Leopold has, probably correctly, cast doubt on the authenticity of Schiele's 'last words' as transmitted by Roessler, which, as he points out, closely reflect Roessler's own style. According to Leopold, Adele Harms heard her brother-in-law say, just before he died, 'The war is over and I must go. My paintings shall be shown in all museums of the world!'

SELECT BIBLIOGRAPHY

BAHR, HERMANN, *Secession*, Vienna 1900
—*Rede über Klimt*, Vienna 1901
—*Gegen Klimt*, Vienna 1903

BLAUKOPF, KURT, *Gustav Mahler, oder, Der Zeitgenosse der Zukunft*, Vienna 1968

CLARK, ROBERT JUDSON, 'Olbrich and Vienna', *Kunst in Hessen und am Mittelrhein*, 1967, Heft 7, pp. 27–51

DOBAI, JOHANNES, 'Zu Gustav Klimts Gemälde "Der Kuss" ', *Mitteilungen der Oesterreichischen Galerie*, XII, Nr. 56 (1968)

ENGELHART, JOSEF, *Ein Wiener Maler Erzählt*, Vienna 1943

FISCHER, WOLFGANG, 'Kokoschka's early work', *Studio International*, CLXXXI, No. 929 (January 1971), pp. 4–5

FRIEDLÄNDER, OTTO, *Letzter Glanz der Märchenstadt*, Vienna 1969

FRITSCH, G. and BREICHA, O., *Finale und Auftakt: Wien 1898–1914*, Salzburg 1964

GERETSEGGER, H. and PEINTNER, M., *Otto Wagner*, London 1970

HEVESI, L , *Acht Jahre Secession*, Vienna 1906
—*Altkunst—Neukunst*, Vienna 1909

HODIN, J. P., *Kokoschka, the Artist and his Time*, London 1966

HOFFMANN, JOSEF, 'Selbstbiographie', *Ver Sacrum, Neue Folge*, Jg. 1972, pp. 105–23

Hohe Warte, Halbmonatsschrift zur Pflege der künstlerischen Bildung . . . herausgegeben von Joseph August Lux, Vienna—Leipzig, 1904–7.

JANIK, N. and TOULMIN, S., *Wittgenstein's Vienna*, London 1973

KALLIR, OTTO, *Egon Schiele, Oeuvre-Katalog der Gemälde*, Vienna 1966

KARPFEN, FRITZ, ed., *Das Egon Schiele Buch*, Vienna—Leipzig 1921

KLEEHOVEN, HANS ANKWICZ VON, 'Die Anfänge der Wiener Secession', *Alte und Moderne Kunst*, V (1960), June—July, p. 6f

KOKOSCHKA, OSKAR, *Mein Leben*, Munich 1971

KULKA, H., *Adolf Loos, das Werk des Architekten*, Vienna 1931

LEOPOLD, RUDOLF, *Egon Schiele, Paintings, Watercolours, Drawings*, London 1973

LESHKO, JAROSLAV, 'Klimt, Kokoschka und die mykenischen Funde', *Mitteilungen der Oesterreichischen Galerie*, XIII (1969), p. 16f.

LUX, J. A., *Otto Wagner*, Munich 1914

LOOS, ADOLF, *Sämtliche Schriften, Bd I*, ed. F. Glück, Vienna—Munich 1962

MAHLER, ALMA, *Gustav Mahler, Memories and Letters*, enlarged edition ed. D. Mitchell, London 1973

MELL, MAX, *Alfred Roller*, Vienna 1922

MOSER, KOLO, 'Mein Werdegang', *Velhagen*

und Klasings Monatschefte, XXXI, ii (October 1916), p. 254f.

MRAZEK, W. and FEUCHTMÜLLER, R., *Kunst in Oesterreich, 1860–1918*, Vienna 1964

MÜNZ, L. and KÜNSTLER, G., *Adolf Loos*, London 1966

MUTHER, RICHARD, *Studien und Kritiken*, I–II, Vienna 1900–1

NEBEHAY, CH. M., *Gustav Klimt— Dokumentation*, Vienna 1969

NEUWIRTH, WALTER MARIA, 'Die sieben heroischen Jahre der Wiener Moderne', *Alte und Moderne Kunst*, IX (1964), May–June, p. 28f.

NOVOTNY, F. and DOBAI, J., *Gustav Klimt— Oeuvre-Katalog*, Salzburg 1967

Joseph Maria Olbrich, das Werk des Architekten, Darmstadt (Hessisches Landesmuseum), 1967

REICH, WILLI, *Schönberg, oder, Der konservative Revolutionär*, Vienna 1968

ROESSLER, A., *Im Memoriam Egon Schiele*, Vienna 1921

—*Der Malkasten, Künstleranekdoten*, Vienna 1924

ROESSLER, A. ed., *Briefe und Prosa von Egon Schiele*, Vienna 1921

Egon Schiele, Drawings and Watercolours: 1909–1918, London (Marlborough Fine Art) 1969

Egon Schiele, the Third London Exhibition, organized and introduced by Wolfgang Fischer, London (Fischer Fine Art) 1972

SCHMIDT, RUDOLF, *Das Wiener Künstlerhaus, 1861–1951*, Vienna 1951

SCHORSKE, CARL, 'Transformation of the Garden', *American Historical Review*, LXXII (July 1967)

—'Politics in a New Key: An Austrian Triptych', *Journal of Modern History*, XXXIV, No. 4 (December 1967)

SEKLER, EDUARD F., 'The Stoclet House by Josef Hoffmann', *Essays in the History of Architecture presented to Rudolf Wittkower*, London 1967, pp. 228–44

—'Mackintosh and Vienna', *Architectural Review*, CXLIV (December 1968), pp. 455–6

STEINER, HEDWIG, *Anton Hanak*, Munich 1969

—'Gustav Klimts Bindung an Familie Primavesi in Olmütz', *Mährisch-Schlesische Heimat*, Jg. 1968, pp. 242–52

STROBL, ALICE, 'Zu den Fakultätsbildern von Gustav Klimt', *Albertina Studien*, II (1964), Heft 4.

UHL, OTTOKAR, *Moderne Architektur in Wien*, Vienna 1966

Ver Sacrum, Organ der Vereinigung bildender Künstler Oesterreichs, Vienna 1898–1903

WAGNER, OTTO, *Einige Skizzen, Projekte und ausgeführte Bauwerke*, Vienna 1892 and subsequent volumes

—*Moderne Architektur*, Vienna 1896

WAGNER-RIEGER, RENATE, *Wiens Architektur im 19. Jahrhundert*, Vienna 1970

WAISSENBERGER, ROBERT, *Die Wiener Secession*, Vienna 1971

Wien um 1900, Ausstellung veranstaltet vom Kulturamt der Stadt Wien, Vienna 1964

Wiener Werkstätte—modernes Kunsthandwerk von 1903–1932, Vienna (Oesterreichisches Museum für angewandte Kunst) 1967

Addenda, 1981

BILLCLIFFE, ROGER and VERGO, PETER, 'Charles Rennie Mackintosh and the Austrian Art Revival', *Burlington Magazine*, No. 896, Vol. CXIX (November 1977), pp. 739–744

BISANZ-PRAKKEN, MARIAN, *Gustav Klimt. Der Beethovenfries. Geschichte, Funktion und Bedeutung*, Salzburg 1977

COMINI, A., *Schiele in Prison*, London 1973

—*Egon Schiele's Portraits*, Berkeley/Los Angeles 1974

FENJÖ, IVAN, *Oskar Kokoschka. Die frühe Graphik*, Vienna 1976

FENZ, WERNER, *Kolo Moser*, Salzburg 1976

JOHNSTON, W. M., *The Austrian Mind*, Berkeley 1972

Klimt-Studien. Mitteilungen der

Oesterreichischen Galerie, Jg. 22/23 (1978/ 1979) No. 66/67, Salzburg 1978

MITSCH, ERWIN, *The Art of Egon Schiele*, London 1975

Koloman Moser 1868–1918, Vienna, Oesterreichisches Museum für angewandte Kunst, 1979

NEBEHAY, CH. M., *Ver Sacrum 1898–1903*, Vienna 1975

—*Egon Schiele 1890–1918. Leben, Briefe, Gedichte*, Salzburg 1979

POWELL, NICOLAS, *The Sacred Spring*, London 1974

SCHORSKE, CARL, *Fin-de-Siècle Vienna*, New York 1980

VERGO, PETER, 'Gustav Klimt's Beethoven Frieze', *Burlington Magazine*, No. 839, Vol. CXV (February 1973), pp. 109ff.

ACKNOWLEDGEMENTS

Photographs have been kindly supplied by the owners credited in the captions, except where listed below.

Albertina, Vienna: 19, 25, 39, 42, 43, 134, 138, 140, 141, 142, 143, 145, 146, 147, 148

The Art Museum, Princeton: 165

Bildarchiv der Oesterreichischen National-bibliothek, Vienna: 2, 4, 5, 6, 23, 24, 48, 49, 60, 61, 62, 71, 72, 76, 77, 80, 82, 84, 125, 128, 144

Brüder Rosenbaum, Vienna: 173, 174, 214

Bundesdenkmalamt, Vienna: 100

Robert J. Clark, Princeton: 102, 106, 109

Colorphoto Hans Hinz, Basle: 190

Joanna Fiegl, Vienna: 83, 112

Galerie Welz, Salzburg: 7, 16, 40, 41, 54, 68, 126, 151, 157, 158, 192, 193, 196, 198, 199, 200, 201

Historisches Museum der Stadt Wien: 130, 150, 159

Kunstmuseum, Basle: 185, 195

Dr Rudolf Leopold, Vienna: 178, 181, 183, 206

Manchester Public Libraries: 113, 114

Marlborough Fine Art (London) Ltd: 175

Christian M. Nebehay, Vienna: 21, 90

Oesterreichische Galerie, Vienna: 9, 56, 110, 124, 136, 137

Otto Müller Verlag, Salzburg: 120

Phaidon Press archives, London: 22, 26, 32, 46, 51, 55, 57, 65, 79, 87, 88, 93, 118, 135, 160

Residenz Verlag, Vienna: 8, 78, 85, 86, 89, 211

Royal Institute of British Architects, London: 70, 73, 74, 75, 91, 92, 94, 95, 96, 97

Royal Academy, London: 115, 212

Anton Schroll, Vienna: 81, 98, 99

Eduard F. Sekler, Harvard University: 121, 122, 123

Staatsbibliothek, Berlin: 161

Peter Vergo, Essex: 18, 31, 33, 34, 35, 36, 45, 101, 107

The publishers would like to thank Mrs Gertrude Peschka-Schiele and the late Mrs Melanie Schuster-Schiele for permission to reproduce works by Egon Schiele; Galerie Welz, Salzburg, for permission to reproduce works by Gustav Klimt; Herold Verlag, Vienna, for permission to quote from *Adolf Loos* and Bruckmann, Munich, for permission to quote from Oskar Kokoschka, *Mein Leben*. All works by Oskar Kokoschka are © by S.P.A.D.E.M., Paris, 1975

INDEX

Numbers in italics refer to illustrations

Akademie der bildenden Künste, 18, 33
Albert, Eugen Francis Charles d', 43; *37*
Alt, Rudolf von, 34; *23*
Altenberg, Peter, 79, 148, 161, 170, 184, 219, 220, 237; *129*
Amiet, Cuno, 84, 202
Ansorge, Conrad, 43
Anzengruber, 17
Appia, Adolphe, 158
Arnot, Guido, 231
Arts and Crafts Movement, 124, 189
Ashbee, Charles Robert, 62, 63–4, 85, 131, 133, 138, 166
Attersee, 223, 226, 227
Auchentaller, 47

Bach, Freiherr von, 88
Bacher, Rudolf, 18, 23, 25; *Franz Josef at the first Secession Exhibition, 23*
Bachofen-Echt, Baroness Elizabeth, 226; *190*
Backhausen, 137
Bahr, Hermann, 11–12, 16, 17, 23, 24, 30, 31, 34, 37, 39, 46, 55, 57, 88–90, 119–21, 123–4, 125, 148, 162, 202, 206, 220; *3, 31*
Barlach, Ernst, 202
Bartel, August, 118
Bartholomé, 27
Bauer, 43
Beardsley, Aubrey, 85, 148
Beer, Frederike Maria, 218, 226; *190, 196*
Beethoven, Ludwig van, 16, 67–77; *55*
Benesch, Heinrich, 208, 230; *180*
Benesch, Otto, 208; *180*
Berg, Alban, 223
Berger, Julius, 49
Bernatzik, Wilhelm, 23, 25, 78; *The Vision of St Bernard, 25; 15*
Besnard, 27
Biedermeier, 165
Bierbaum, Otto Julius, 42
Bing, Samuel, 78
Bittner, Julius, 154
Bloch-Bauer, Adele, 83, 181, 226; *153, 194*
Böcklin, Arnold, 28, 65, 77; *Sea Idyll, 65; 53*
Böhler, Hans, 212, 218
Böhm, Adolf, 18, 25, 43, 47, 119, 124; *Dawning Day, 69; 57; River of Tears, 40; 33*
Boldini, 27
Bonnard, Pierre, 78, 202
Bonnat, Léon, 25
Brangwyn, Frank, 27, 28, 85
Breuer, Karl, 179

Brücke group, 216
Bruckner, Anton, 16
Burckhard, Max, 16
Burgtheater, 25; *16*

Café Griensteidl, 12
Café Sperl, 18
Canon, Hans, *The Circle of Life, 50; 47*
Caro, Hugo, 197; *167*
Carrière, Eugène, 27, 46
Cassirer, 85
Cézanne, Paul, 78
Charcot, 14
Church 'am Steinhof', 100, 103, 107–11, 115, 154, 199; *88–90*
Claude Lorrain, 58
Crane, Walter, 28, 37, 44, 85; *Pegasus, 18; The Skeleton in Armour, 44*
Czeschka, Carl Otto, 140–1, 146, 152, 153, 189, 205; *Illustrations for* Nibelungen, 141; *119; Sets and costumes for* Nibelungen, 141, 180; *Silver Box, 140; 118; Wine and Dance, 11*
Czihaczek, Leopold, 208; *178*

Dagnan-Bouveret, 27
Darmstadt, 125–7
Daumier, Honoré, 78
Degas, Edgar, 78
Dehmel, Richard, 42
Delacroix, Eugène, 78
Denis, Maurice, 78, 202
Dill, 27
Dresden, 140
Dumba, Nikolaus von, 46, 77
Duncan, Isadora, 15
Durand-Ruel, 78
Dürer, Albrecht, 75

Eiffel, Gustave, 95
Eisler, Max, 159–60
Eissler, Gottfried, 78
Eissler, Hermann, 78
Eitelberger, Rudolf von, 88–9
El Greco, 78
Elisabeth, Empress, 12
Elizaveta Fedorovna, Grand Duchess, 139
Engelhart, Josef, 18, 23, 25, 27, 28, 33, 45, 46, 84, 85; *Self Portrait with Top Hat, 12*
Erlach, Fischer von, 90
Ernst Ludwig, Grand Duke of Hesse, 125

Fabiani, Max, 115
Faistauer, Anton, 212, 238
Felix, 23, 31–2
Ferstel, Heinrich von, 49, 88; *Vienna University, 88; 71*

Fischer, S., 220
Flaubert, Gustave, 15
Flesch-Brunningen, 114
Flöge, Emilie, 79; *67*
Forel, August, 193; *155*
Förster, Ludwig, 88
Forstner, Leopold, 146
Frankfurt, 140
Franz-Ferdinand, Archduke, 198–9
Franz Joseph, Emperor, 9, 10, 12, 80, 140; *23*
Freud, Sigmund, 13, 14, 15; *6*
Friedell, Egon, 148
Friedländer, Otto, 15
Friedrich, 43

Gauguin, Paul, 78, 202
George, Stefan, 17
Gerlach, Martin, 183
Gerstl, Richard, 200–1, 206; *Arnold Schoenberg and Family, 201; 170; Laughing Self Portrait, 201; 171; Seated Woman, 172*
Gessner, Hubert, Unfallversicherungsanstalt, 115
Geyling, Remigius, 108
Glasgow School, 62–3, 64, 85, 130, 138
Goethe, 15
Goldmark, Carl, 205
Goltz, Hans, 218
Goya, 78
Grasset, Eugène, 44
Griepenkerl, Christian, 18, 201, 208
Grillparzer, 16, 17
Grünwald, Karl, 230–1
Guild of Handicrafts, 131
Gütersloh, Paris von, 212, 231, 238; *207–8*

Haberditzl, Franz Martin, 232
Hagengesellschaft, 18
Hamsun, Knut, 42
Hanak, Anton, 225, 237
Hancke, Franz, 62
Hansen, Theophil, 88
Harms, Adele, 218
Harms, Johann, 218, 230, 231; *203*
Hartel, Wilhelm von, 55, 61, 64
Hasenauer, 92, 95, 118, 127
Haus Ast, 159
Haus Brauner, 128–9, 144; *110*
Haus Goldman und Salatsch, 43, 115, 171
Haus in der Nothartgasse, 173; *148*
Haus Portois und Fix, 115; *98*
Haus Scheu, 173, 175–7; *147*
Haus Steiner, 173–5; *145–6*
Haus Zacherl, 101, 115; *81*
Hebbel, 16, 17, 141, 154, 180

Heckel, 216
Hellmer, Edmund von, 23
Henneberg, Hugo, 64, 127, 128, 132
Herterich, 27
Hevesi, Ludwig, 24, 34, 39, 50, 63, 70, 80, 81–3, 85, 87, 105–6, 110, 114, 123, 125, 128, 130, 135, 136–7, 138, 139–40, 143, 147, 151, 153, 166, 180, 188, 189, 206
Hietzing, 47
Hirschwald, 140
Hodin, Paul, 196
Hodler, Ferdinand, 74–5, 84, 85, 154–5; *The Chosen One*, 75; *63*
Hoffmann, Josef, 18, 23, 25, 30, 37, 39, 40, 43, 47, 61, 62, 63, 64, 68, 69, 79, 84, 87, 90, 91, 100, 115, 119, 124, 127–31, 132, 133, 138, 140, 148, 156, 159–60, 162, 177, 180–1, 224, 225, 237; *31, 34, 56, 120*; Cutlery, 141–2; Haus Ast, 159; Haus Brauner, 128–9, 144; *110*; Hohe Warte, 127, 128, 142, 159; International Art Exhibition Pavilion, Rome, 159; *136*; Kaasgraben, 159; Kabarett Fledermaus, 151, 152; Kleinstadt Idyll, *37*; Kunstschau exhibition building, 159, 179; Palais Stoclet, 135, 143–7; *121–4*; Pavilion for the German Werkbund Exhibition, Cologne, 159–60; *137*; Sanatorium Purkersdorf, 135–8, 144, 159; *112, 113, 114*; Tea Pot, 138; *115*; *Ver Sacrum* room, 30; *22*
Hofmannsthal, Hugo von, 12, 42
Hohe Warte, 125, 127, 128, 142, 143, 159
Hokusai, 78
Hollitzer, 148
Holosy, 201
Holz, Arno, 42
Hölzel, 85
Hörmann, Theodor von, 23; *13, 31*
Huch, Ricarda, 42
Hütteldorf, 92

Jagerspacher, 170
Janikovsky, Ludwig von, 196
Jettel, Eugen, 23
Jettmar, Rudolf, 43, 108
Jung, Moritz, 152
Jungnickel, Ludwig Heinrich, 146, 205, 238

Kabarett Fledermaus, 148–53
Kainradl, Leo, 18
Kammer, 223
Karpellus, Adolf, 18
Keim, 141
Khnopff, Fernand, 27, 30, 36, 50, 62, 85; *Still Water*, 30; *20*; *Suspicion, 45*
Kirchner, E. L., 216
Klimt, Ernst, 49
Klimt, Georg, 38
Klimt, Gustav, 15, 16, 23, 25, 26, 30, 32, 37–8, 47, 49–62, 66, 68, 78, 79–81, 84, 85, 87, 102, 120, 123, 138, 179, 199–200, 201, 205, 206, 208, 209, 210–12, 213, 214, 219, 223–30, 237–8; *9*; *Adele Bloch-Bauer I*, 83, 181, 226; *153*; *Adele Bloch-Bauer II*, 226; *194*; *Altar of Dionysus*,

16; *Ars*, 78; *Avenue in the Park of Schloss Kammer*, 227; *197*; *The Baby*, 229; *200*; *Baroness Elizabeth Bachofen-Echt*, 226; *190*; *Beethoven-frieze*, 69–77, 80, 81, 123, 147, 210; *56, 58–62, 64*; *The Bride*, 229; *200*; *Church in Unterach*, 228; *199*; *Danaë*, 184, 187, 210; *157*; *Embrace*, 230; *149*; *Emilie Flöge*, 79, 147, 182, 183, 206; *67*; *A Forest of Fir Trees*, 66; *Forester's House in Weissenbach*, 228; *Frederike Beer*, 226; *196*; *Fritza von Riedler*, 83, 181; *151*; *Hope I*, 202; *176*; *Island on the Attersee*, 226; *198*; *Judith II*, 202; *177*; *Jurisprudence*, 26, 60–1, 80–3, 84, 206; *68*; *The Kiss*, 77, 83, 147, 182, 206, 226; *127*; *A Lady*, 66; *Leda*, 184, 210, 229; *157*; *Litzlbergkeller am Attersee*, 225; *193*; *Love*, 183; *1*; *Mäda Primavesi*, 225; *193*; *Margaret Stonborough-Wittgenstein*, 181, 187; *152*; *Medicine*, 26, 58–60, 61, 65, 73, 80, 81; *7, 49*; *Musik*, 77; *65*; *Die Musik I*, 77; *66*; *Die Musik II*, 62, 77, 79; *My Kingdom is not of this World*, 77; *Nuda Veritas*, 46; *40*; *Pallas Athene*, 37–8, 50, 79; *29*; *Philosophy*, 16, 26, 49–57, 58, 61, 73, 75, 77, 80, 81, 84; *44, 46*; *Poster for Secession Exhibition, 1898*, 28; *19*; *Reclining Woman*, 50; *Schubert at the Piano*, 45–6, 62, 79; *41*; *Seashore*, 66; *Serena Lederer*, 195; *Sonja Knips*, 37, 181; *27, 28*; *Still Pond*, 66; *21*; *Stoclet-frieze*, 38, 73, 74, 77, 83, 123, 146–7, 181, 182, 205, 223, 224, 226; *126*; *The Three Ages of Man*, 58, 184, 187; *154*; *Watersprites II*, 210; *Zug der Toten*, 210
Klinger, Max, 28, 44; *Beethoven*, 67–70; *55*; *Christ on Olympus*, 44; *38*
Klose, F., 43
Knips, Sonja, 37, 79; *27, 28*
Kokoschka, Oscar, 13, 130, 152–3, 161, 188, 189–200, 201, 205, 213, 214, 219, 223, 231; *Adolf Loos*, 193; *162*; *Anton von Webern*, 193; *Auguste Forel*, 193; *155*; *Carl Moll*, 163; *Count of Verona*, 196; *Dent du Midi*, 193; *156*; *Else Kupfer*, 197; *Ernst Reinhold*, 196; *Herwarth Walden*, 175; *Dr Hugo Caro*, 197; *167*; *Karl Kraus*, 193; *164*; *Ludwig Ritter von Janikowsky*, 196; *Marquise de Rohan-Montesquieu*, 193; *165*; *Mörder Hoffnung der Frauen*, 189, 192, 205; *161*; *Pietà*, 189; *140*; *Self portrait with Alma Mahler*, 198; *168*; *Sphinx und Strohmann*, 192; *The Speckled Egg*, 148–51; *Die Träumenden Knaben*, 152, 189–91, 200; *159*; *Die Traumtragenden*, 189; *The Warrior*, 189, 193; *Die Windsbraut*, 198; *169*
König, Friedrich, 18, 43, 124
Kosmack, Eduard, 212, *184*
Kotera, Jan, Villa Lemberger, 117; *99*
Krämer, Johann Viktor, 18, 23, 25, 65, 79; *Theodor von Hörmann, 13*
Kraus, Karl, 14, 55, 83, 87, 161–2, 193, 205, 206, 219–20; *164*
Krumau, 215, 216, 218, 238

Kubin, 238
Kunstgewerbeschule, 18, 62, 129–30, 156, 189, 190
Kunsthistorisches Museum, 25
Künstlerhausgenossenschaft, 18, 23, 28, 30, 34, 95
Kupfer, Else, 197; *166*
Kurzweil, Max, 18, 23, 40, 206; *35*

Laage, Wilhelm, 189; *160*
Lagae, 27
Lavery, Sir John, 27
Le Corbusier, 161
Lederer, August, 61, 212, 226
Lederer, Erich, 212; *185*
Lederer, Serena, 226; *195*
Lefler, Heinrich, 201
Leibl, 85
Lenz, Max, 23, 83
Lenz, Pater Desiderius, 108
Die Letzten Tage der Menschheit, 14, 17
Leutnant Gustl, 12–13
Levetus, A. S., 65–6, 138
Lichtwark, 57, 90
Liebermann, Max, 78, 85
Liechtenstein, Prince, 109
Liesing, 230
List, Wilhelm, 23, 43
Litzlberg, 223
Lodzinski, Poldi, 215; *187*
Löffler, Bertold, 146, 151, 152, 189; *129*; Costume designs, 130; Poster for Kunstschau, 180; *150*
Loos, Adolf, 87, 91, 111, 130–1, 161–77, 189, 193, 214, 219; *162*; Café Museum, 170–1; *143*; Haus Goldman und Salatsch, 87, 115, 171–3; *144*; Haus in der Nothartgasse, 173; *148*; Haus Scheu, 173, 175–7; *147*; Haus Steiner, 173–5; *145–6*; his own flat, 165; *138*; Kärntner Bar, 169–70; *142*; Steiner Plume and Feather Shop, 166–9; *141*
Ludwig, King of Bavaria, 12
Lueger, Karl, 15, 33
Luksch, Richard, 108, 153, 205
Lux, J. A., 68, 69, 89, 91–3, 97, 100, 104, 109, 110, 114, 142

Macdonald, Margaret, 62, 64, 130
Mach, 16
Mackintosh, Charles Rennie, 62–3, 64, 85, 128, 130, 131, 132–3; *51, 111*
MacNairs, 62
Maeterlinck, Maurice, 30, 42, 148
Mahler, Alma, 156, 198; *168*
Mahler, Gustav, 9, 14, 16, 17, 68, 71, 156–9, 180, 202, 205–6, 223; *4*
Mahler, Otto, 206
Maier-Graefe, Julius, 78
Majolika Haus, 100; *8*
Manet, Édouard, 78; *Bar at the Folies Bergères*, 78
Der Mann ohne Eigenschaften, 13
Massmann, Hans, 208; *182*
Matisse, Henri, 202
Matsch, Franz, 25, 49, 55

Mautner-Markhof, Editha, 108
Mayreder, Julius, 23, 25, 33, 119
Mayreder, Rudolf, 33
Mayrhofen, 228
Melzer, 238
Mengelberg, Willem, 17
Merkel, 238
Metzner, Franz, 180
Meunier, Constantin, 27, 44, 85
Meyer, Conrad Ferdinand, 42
Michelangelo, 56
Miethke (gallery), 84–5, 179, 226
Minne, 85
Moll, Carl, 23, 25, 84, 127, 128, 129, 143, 156; *163*; *Dämmerung, 14*
Monet, Claude, 78, 226
Monticelli, 78
Morris, William, 37, 90, 130, 133, 180, 189
Moser, Kolo, 18, 23, 25, 36–7, 39, 43, 47, 61, 63, 64, 65, 79, 84, 90, 108, 114, 119, 128, 129, 130, 131, 132, 133–4, 135, 138–40, 141, 146, 153–5, 156, 189, 224, 237; *9*; cover of *Ver Sacrum*, 117; *Design for glass mosaic in church 'am Steinhof'*, 108, 180; *90*; *Female Portrait*, 139; glassware, 141–2; *Hermann Bahr, 3*; *Die Kunst*, 36; *26*; *Lake Garda*, 155; *133*; *Lockte mich ein Irrlicht hin, 10*; *The Miraculous Draught of Fishes*, 64; *52*; *Poster for fifth Secession exhibition*, 47; *42*; *Self Portrait, 131*; *Three Women*, 155; *132*; vase and sugar bowl, 138; *116*
Mucha, Alphonse, 28
Mühling, 230
Müller, 43
Munch, Edvard, 65, 84, 85, 201, 202, 209, 216
Musil, Robert, 9, 12, 13
Muther, Richard, 49–50, 78, 123, 188, 199
Myrbach, Felician von, 23, 62, 130, 131, 156, 205

Neukunstgruppe, 212
Neulengbach, 216
Neumann, Wilhelm, 57
Neuzil, Wally, 215, 216
Nietzsche, 17
Nowak, Anton, 23
Nowak, Ernst, 18
Nüll, Eduard van der, 88, 90, 92, 115, 118

Oesterreichische Länderbank, 93–4, 104, 112; *74*
Oesterreichische Postsparkasse, 93, 99, 103, 108; *83–7*
Olbrich, Joseph Maria, 18, 23, 24, 25, 30, 34, 36, 37, 87, 90, 100, 115, 118–27, 156, 162, 164, 205, 238; *9*; exhibition hall on the Wollzeile, 121; *104*; Hofpavillon station, 118; *102*; 'ein kleines Haus', 125; *108*; Poster for second Secession exhibition, 25; Secession building, 34, 39, 102, 121–4, 139; *2, 105*; Villa Hermann Bahr, 125; *109*; Villa Friedmann, 124; *106*; Wohnhaus Dr Stöhr, 125; *107*

Olmütz, 225
Orlik, Emil, 65, 68, 189, 205; *Sigmund Freud, 6*
Ottenfeld, Rudolf von, 23

Palais Stoclet, 135, 143–7, 206; *121–4*
Perret, 177
Peschka, Anton, 208, 212, 238; *183*
Pfemfert, Franz, 218
Piffl, Friedrich, 109–10
Pissarro, Camille, 46, 78
Plecnik, Josef, 115; Haus Zacherl, 101, 115; *81*; Heilig-Geist-Kirche, 115; *100*
Pötzl, Eduard, 114, 181, 187–8
Powolny, Michael, 146, 151
Primavesi, Eugenia, 225
Primavesi, Maria, 225; *193*
Primavesi, Otto, 159, 225, 238
Primavesi, Robert, 159
Prutscher, Otto, 154
Puvis de Chavannes, Pierre, 27, 46; *St Geneviève Triptych, 28*

Raffaëlli, 27
Ravenna, 83, 226
Redon, Odilon, 78
Reichel, Oskar, 212
Reigen, 15
Reinhold, Ernst, 196
Reininghaus, Carl, 70, 212
Renoir, Pierre Auguste, 46, 78; *Loge de Théâtre*, 78
Riedler, Fritza von, 83, 181; *151*
Rilke, Rainer Maria, 42
Ringstrasse, 88–90, 162
Rodin, Auguste, 27, 28; *Burghers of Calais*, 65
Roessler, Arthur, 210, 212, 214, 216, 218, 238, 241
Rohan-Montesquieu, Marquise de, 193; *165*
Roll, 27
Roller, Alfred, 18, 37, 40, 43, 45, 83, 91, 130, 154, 156–9, 179, 180; *31, 32, 36, 134, 135*; Poster for the fourth Secession exhibition, 45; *39*; *The Sermon on the Mount*, 45; *Sinking Night*, 69, 156; *55*
Rops, Félicien, 27, 45, 85
Rosé, Hans, 230–1, 241
Ruskin, John, 91, 130, 133, 163
Rysselberghe, 44, 85

Salten, Felix, 57, 154
Sanatorium Purkersdorf, 135–8, 144, 159; *112–14*
Sargent, John Singer, 27
Scala, Arthur von, 130
Schachner, Friedrich, 114
Scherchen, Hermann, 16
Scheu, Gustav, 177
Schiele, Edith, 218, 230, 232–5, 241; *191, 209–11*
Schiele, Egon, 16, 179, 206, 208–18, 223, 230–7, 238–41; *Anton Peschka*, 208; *183*; *Danaë*, 229; *Dead Mother*, 216, 230; *174*; *Death and the Maiden*, 230, 238; *215*;

Edith Seated, 232, 238; *191*; *Eduard Kosmack*, 212; *184*; *Eugenia Primavesi*, 225; *The Family*, 231, 234–5, 238; *209*; *Franz Martin Haberditzl*, 232; *206*; *Friederike Maria Beer*, 218; *Grünwald's Desk*, 231; *205*; *Hans Massmann*, 208–9; *182*; *Harbour at Trieste*, 179; *Heinrich and Otto Benesch*, 208; *180*; *Houses and Roofs in Krumau*, 216; *189*; *Karl Grünwald*, 238; *Johann Harms*, 230, 231, 238; *203*; *Landscape at Krumau*, 238; *214*; *Man and Woman*, 218; *Mother with Two Children*, 238; *213*; *Nude black-haired girl*, 188; oval signboard, 230; *204*; *Paris von Gütersloh*, 231; *207–8*; *Portrait drawing of Edith Schiele*, 234; *210*; *Recumbent Woman*, 235–7, 238; *212*; *Ritter von Bauer*, 238; *Russian Prisoner of War*, 230; *202*; *Self Portrait with Decorated Drapes*, 214; *186*; *Sketch for Poldi Lodzinski*, 215; *187*; *Study of himself embracing his wife*, 235; *211*; *Sunflowers*, 218; *Vision of St Hubert*, 230; *Watersprites*, 209–10; *181*; *Winter Trees, 173*; *Young Mother*, 218
Schiele, Gertrude, 208
Schiller, 46, 71
Schimkowitz, Othmar, 100, 106, 108; *89*
Schindler, Alma Maria, *see* Mahler, Alma
Schindler, Emil Jakob, 25
Schmidt, Friedrich, 88
Schmidt-Rottluff, K., 216
Schnitzler, Arthur, 12–13, 15
Schoenberg, Arnold, 16, 17, 192, 201, 205, 223, 237; *170*
Schönerer, Georg von, 15
Schönthal, Otto, 179
Schubert, Franz, *41*
Schuster, Sektionschef von, 105
Secession building, 34, 39, 102, 121–4, 139; *2, 105*
Seemann and Company, 43
Segantini, Giovanni, 28, 64–5, 85; *Alpenweide, 31*; *Bösen Mütter*, 27; *17*; *Die Quelle des Uebels, 31*
Seligmann, A. F., 60, 213–14, 241
Semmelweis, Ignaz Philipp, 16
Semper, Gottfried, 90, 91, 92
Siccardsburg, August Siccard von, 18, 88, 90, 92, 115
Siebener-Club, 18, 119
Signac, Paul, 62
Sisley, Alfred, 78
Sitte, Camillo, 118
Skoda factory, 140; *118*
Slevogt, 85
Somov, 85
Special School for Architecture, 114, 118
Spitzer, Friedrich, 127, 128, 129
Stefan, Paul, 165, 202
Stoclet, Adolphe, 143
Stoclet, Jacques, 143
Stöhr, Ernst, 18, 23, 58, 80
Stoisavljevic, 156
Stonborough-Wittgenstein, Margaret, 181; *152*

Storck, Joseph, 130
Strasser, Arthur, *Mark Antony in his Chariot drawn by Lions*, 45
Strauss, Richard, 202
Strindberg, August, 192
Strobl, Alice, *43*
Stuck, Franz von, 28, 38; *Pallas Athene*, 38; *30*; *Wild Chase*, 62
Sullivan, Louis H., 161, 172

Tichy, Hans, 23
Tintoretto, 78
Toorop, Jan, 62, 65, 81, 85; *The Three Brides*, 81; *69*
Toulouse-Lautrec, Henri de, 78
Trakl, Georg, 87, 161, 219

Uhde, Friedrich, 27, 85
Unfallsversicherunganstalt, 115
Ungethüm, 114
Utamaro, 78

Vallotton, Felix, 46
Van Gogh, Vincent, 78, 202, 216, 226; *Plain at Auvers-sur-Oise*, 27, 78
Veith, Eduard, 49
Velazquez, 78
Velde, Henry van de, 37, 62, 90, 164
Verhaeren, Emile, 44
Ver Sacrum, 26, 28, 31, 33, 37, 39, 40–4, 46, 47, 50, 57, 58, 62, 65, 119, 121, 123, 139, 156, 162, 189; *117*
Vermeer, Jan, 78

Die Verwirrungen des Zöglings Törless, 13
Villa Friedmann, 124; *106*
Villa Hermann Bahr, 125; *108*
Villa Lemberger, 117; *99*
Villa Wärndorfer, 138
Vlaminck, Maurice de, 202
Voysey, Charles Annesley, 128
Vuillard, Édouard, 78, 202

Wagner, Otto, 16–17, 18, 23, 34–6, 63, 84, 87, 89, 90–115, 148, 127, 130, 136, 162, 171, 172, 180, 223, 237–8; *5*; Academy of Fine Arts, 112, 114; *95*; Church 'am Steinhof', 100, 103, 107–11, 115, 154, 199; *88–90*; Döblergasse apartments, 111; Exchange Building, Amsterdam, 92; *73*; Ferdinandsbrücke, *75*; First Villa Wagner, 92; *72*; Kaiserbad Dam, 96–7; *76, 77, 78*; Karlsplatz, 112–14; *97*; Linke Wienzeile Nos 38 and 40, 100–2; *8, 82*; Lupus Sanatorium, 112; *93*; Majolika Haus, 100; *8*; *Moderne Architektur*, 95; Neustiftgasse apartments, 111; Nussdorf Dam, 96–7, 98; *78*; Oesterreichische Länderbank, 93–4, 104, 112; *74*; Oesterreichische Postsparkasse, 93, 99, 103–7, 108; *83–7*; Russian Embassy, Vienna, 92; Stadiongasse nos. 6–8, 93; Stadtbahn, 97–100, 105, 118; *79, 80, 101, 103*; Stadtmuseum, 112, 114; *96*; Stubenviertel, 95, 96; *70*; University library, 111; *91*; Victory church, 111–12; *92*; War Ministry Building, 112; *94*

Wagner, Richard, 72
Währing, 108
Walden, Herwarth, 205; *175*
Waldmüller, 16
Wärndorfer, Fritz, 64, 132, 133–4, 142, 148, 225
Watteau, Antoine, 226
Webern, Anton von, 193
Wedekind, 148, 161
Weininger, 206
Weissenbach, 223
Wellesz, Egon, 192
Wels, R., 177
Weyr, Rudolf, 97
Whistler, James Abbott McNeill, 27, 28, 30, 226; *Violinist*, 78
Wickhoff, Franz, 57
Wiegele, Franz, 212
Wiener, Karl von, 205
Wiener Keramik-Werkstätte, 146, 151
Wiener Werkstätte, 39, 64, 132–54, 159, 160, 179, 180, 189, 225
Wimmer, Eduard Josef, 154
Wohnhaus Dr Stöhr, 125; *107*
Wolf, Hugo, 16, 43
World's Fair, St Louis, 84
Wright, Frank Lloyd, 175

Zola, Emil, 15, 58
Zorn, Anders, 36
Zuckerkandl, Bertha, 60, 188, 199, 205
Zum Blauen Freihaus, 18
Zweig, Stefan, 9–10, 11, 14–15, 219